Raw Creation

John Maizels

RAW CREATION

Outsider Art

and beyond

with an introduction
by Roger Cardinal

Phaidon Press Limited
Regent's Wharf
All Saints Street
London N1 9PA

First published 1996
© 1996 Phaidon Press Limited

ISBN 0 7148 3149 2

A CIP catalogue record for this book is available from
the British Library

Printed in Hong Kong

Contents

to Maggie and to Jennie and Lucy

Preface

As children we are all artists, every one of us in the world. As we grow, the creative impetus within us often fades, yet Outsider Art proves the existence of the unending power of human creation. Within each one of us is that spark, that shared universality of human creativity. For some, thankfully, the spark never dies, never finds itself crushed by the norms of adult behaviour and cultural conditioning. It is to these natural and intuitive creators that Outsider Art owes its existence.

At a time when the offerings of the conventional art world meet increasing scorn and disinterest, the discovery that there is something else out there, something that really is art, comes at first as a refreshing revelation. When one delves a little deeper it is impossible not to be overcome by the force and wonder of the heroic expressions of those who are ever true to themselves.

The road to the acceptance of Outsider Art has been a long and hard one, almost spanning the years of this century. No one can know what great works, considered worthless, have been lost or destroyed. Outsider Art has endured years of ridicule and dismissal and yet now the time has surely come for it to take its place firmly in the world of art. In the last decade Outsider Art has ceased to be a clandestine interest of a few devoted followers, themselves visionary in their beliefs. It has become by far the most exciting development in contemporary art we have seen for many years, one which will have far-reaching repercussions. It holds in question our whole way of thinking about the development of art in our time and our concepts of the validity of art education.

This book is an introduction, a guidebook to a phenomenon as yet not fully explored, the very last frontier of discovery in art. The breadth of its scope inevitably results in gaps and I apologise for the unavoidable omissions. For clarity the text is divided into three sections. In the first part we look at the early discoveries of the art of the insane and the impact this had. We examine some of the works from Dr Hans Prinzhorn's studies and the awesome creative power of Adolf Wölfli. It was Jean Dubuffet who was able to crystallize the phenomenon of an art that previously had no name. In Art Brut he gave an identity and a rationale to an expression he felt to be superior to academic art, one that fought the smothering effects of Western culture. His great Collection de l'Art Brut eventually found a home in a purpose-built museum in Lausanne, Switzerland. We also look at other developments in Europe and in the USA which resulted from Dubuffet's theories and actions.

In the second section of the book we examine the nature of expressions which lie on the margins of Art Brut and Outsider Art. Contemporary American folk art, the 'artistes singuliers' of France and those in Dubuffet's 'Neuve Invention' category have all in their own way become an important entity in the growth of interest in non-academic art. So too have works by self-taught artists from the Third World, from the Caribbean, from Africa and India.

One unique feature of Outsider Art, and one found in no other sphere of art, are visionary environments. The final section of the book looks at some of the greatest of these extraordinary creations, from the Palais Idéal of the postman Ferdinand Cheval, in France, to the towers of Simon Rodia in Watts, Los Angeles. In India we find the world's largest example of environmental creation with the work of Nek Chand in Chandigarh. We hope that in each of these three parts there are enough signposts and pointers for readers to continue to follow their own paths and to make their own further discoveries.

Acknowledgements

There are many thanks due. To Pat Barylski and Juliet Brightmore of Phaidon Press for their patience, hard work and support through the whole of this project, and to Phil Baines for proving that innovative design can have dignity. To Roger Cardinal for his encouragement and wisdom. To Phyllis Kind, Monika Kinley, Ann Oppenhimer, Geneviève Roulin and Elka Spoerri for their invaluable comments. To the trailblazer Seymour Rosen for his help and knowledge. To Alf and Joan Maizels for their continuing belief. To Sam Farber and Bob Roth for their unstinting support. To Maggie and Lucy for putting up with all my moods and hours of work.

To all those whose contributions, knowledge and advice have helped the completion of this work, including: Edward Adamson, Patricia Allderidge, William Arnett, Professor S S Bhatti, Paolo Bianchi, Wolf Bischoff, Caroline Bourbonnais, Laurent Danchin, Ted Degener, Judith Edwards, Nico van der Endt, Johann Feilacher, Bonnie Grossman, Carl Hammer, Rebecca Hoffberger, Bill Hopkins, Jeff Kastner, Ruth Kohler, Nathan Lerner, John MacGregor, Roger Manley, Leo Navratil, Gladys Nilsson, John Ollman, Kim Richardson, Marcus Schubert, Beryl Sokoloff.

And to my own hero, Nek Chand, and all the unsung heroes of Outsider Art.

John Maizels

Introduction

The acceleration of cultural interchanges in the modern period—an acceleration brought about by the multiplication of global travel circuits, the growth of trans-national markets and above all the stimulus of media technologies which have consecrated our century as the Age of the Instant Image—has afforded us, among many varied legacies and lessons, the opportunity at last to bring up to date our perceptions of art and to recognize its true dimensions as a worldwide phenomenon. We now have access to a map of art so intensely colourful and so detailed that it is hard to appreciate just how pallid and perfunctory it once was in its representation of whole areas of visual expression lying beyond the well-surveyed territories of the Western tradition.

It can be a startling and exhilarating experience to look back at the revolution in taste which took place in Europe during the last decades of the nineteenth and the first decades of the twentieth century. These years saw a whole series of Western artists abandoning orthodox aesthetic models and finding inspiration in the marginal arts—by which I mean all those many forms of visual expression whose values and styles are alien to those of the establishment. Gauguin's fascination with the folk sculpture of Britanny and the native arts of Polynesia (not to mention those of Java and Egypt); Picasso's briefer passion for Iberian and West African carving; Kandinsky's taste for Russian folk prints and Bavarian popular religious imagery, as well as his openness toward European naïve art and non-European tribal art; Klee's envious wonderment when faced by pictures drawn by children or mental patients; Brancusi's twin enthusiasm for Romanian folk art and African woodcarving; the devoutness with which Schwitters rehabilitated the imagery of consumerism within his collages; the parallel efforts of such movements as French Surrealism and German Expressionism to radicalize the sites of art by suddenly giving prominence to the creations of tribal peoples from Africa, Oceania or North America—all such variants of an essential Primitivism are exemplary in so far as they grant pride of place to the strange, the provocative, the magical, even the barbaric. Their collective impact brought about a fundamental change in European aesthetics, a change which continues to challenge us to think about the boundaries of acceptable expression and the permissible range of our responses.

What happens when radically different forms of art are introduced to unprepared audiences is that the reflexes of orthodox appreciation seize up and become inoperative. Such art refutes received wisdom and insists that we expose ourselves to new visual stimuli. Our ways of seeing and interpreting what we see need immediately to be adjusted. Primitivism—in the sense of a conscious effort on the part of European artists to embrace a style and an attitude entirely at odds with their training—teaches that art in the fullest sense need not be eurocentric, nor the sole province of accredited specialists. If it is an expression of human desires and imaginings, art can manifest itself just as potently in the most obscure and remote regions of the world as it can amid the supportive amenities of our urban centres; and it can appeal, moreover, to a far wider audience than would seem the case in the context of our official culture of ordained commentators and selection committees.

Though the process is often painful, our century is managing to carry forward this revolution in awareness in so far as Western galleries and museums now seek to address the immense variety of styles and meanings which the human creative impulse initiates across the world. To put it simply, there are always more kinds of art at the fringes of our knowledge than we could possibly imagine. The precept of suppressing all geographical, social and cultural priorities has brought about more and more adventurous recognitions of unsuspected modes of artistic expression, and especially those which, despite their relative proximity to official centres, were hitherto ignored as peripheral, if not redundant.

It is instructive to consider the shift in aesthetic tolerance which, from the 1880s onwards, became perceptible within French culture, where taste in art is habitually qualified by other orders of discrimination (especially pertaining to education and class). When Georges Courteline put together a pioneering collection of non-academic work, much of it naïve and anonymous, he dubbed it his 'Cabinet of Horrors', as if to answer any charge of bad taste by invoking it himself with his tongue firmly in his cheek. When Alfred Jarry paid homage to obscure popular woodcuts, or made supportive gestures toward the untutored painter Henri Rousseau, he still did so in an idiom of ironic deviousness. When Guillaume Apollinaire in turn moved from amused curiosity to an earnest commitment to Rousseau, he could not entirely suppress a note of condescension in praising him as 'without doubt the strangest, most daring and most charming of exotic painters'. In those same years, psychiatric collections such as that of Dr Auguste Marie, who showcased his patients' pictures in his cabinet at the Villejuif asylum, tended to be envisaged as documents symptomatic of clinical disorder, rather than as mature artistic achievements worthy of display in an art gallery context. Some revolutions advance slowly, and it would take some while before the activity of collecting popular prints from Épinal could be seen as more than the whimsical hobby of a privileged élite; or before self-taught painters such as Séraphine Louis or Louis Vivin were able to shake off such sentimental labels as Wilhelm Uhde's 'Painters of the Sacred Heart', and aspire to the status of artists pure and simple. Cultural habits die hard, and forms of art lacking any official seal of approval were long classified as exotic curiosities and denied a status conducive to proper discussion and appraisal. Not until the mid-twentieth century were principles of aesthetic tolerance and adventurousness sufficiently disseminated to allow one to speak about them without elaborate apology, addressing them evenly and on their own terms.

And then came Jean Dubuffet, whose revolutionary proposals for revisioning the field of creativity were to attack the ideology of metropolitan visual culture at its very base. Of course, we should remember that much of Dubuffet's trenchant theorizing was indebted to an agenda set by Gauguin, Apollinaire, André Breton and others; and that the five decades or so which preceded his interventions had in fact already seen the recognition and relative popularization of several modalities of untutored art, including rural folk art, with its decorative imagery and often functional objects, various sorts of vernacular and popular urban art, naïve painting and sculpture, children's drawings, mediumistic drawings, and the pictures, carvings and assemblages

of the mentally deranged. Yet it was Dubuffet's passionate promotion in the late 1940s of the notion of an Art Brut—an art at once savage and sophisticated, shocking and seductive—that was to prod Western aesthetics into perhaps one of its most critical efforts of rethinking.

The plain fact is that Dubuffet's penchant for polemic and mischief led him to propose an abrupt and vastly disturbing choice: either one could stick with authorized forms of cultural production and sink into a vapid anaesthesia, or one would have to grapple with a host of unpredictable and culturally illicit forms of expression. Dubuffet insisted that the arts of the European establishment were no more than sugar-coated sham, whereas the non-academic and unheralded art he was busily discovering—the work of psychotics such as Heinrich Anton Müller, Adolf Wölfli or Aloïse Corbaz, of mediumistic painters such as Augustin Lesage, Laure Pigeon or Joseph Crépin, or of perfectly sane yet recalcitrant individuals such as Pascal Maisonneuve, Scottie Wilson or Xavier Parguey—must henceforth be acknowledged as the only authentic touchstone of artistic creativity. From now on, the official masterpieces of the fine art tradition were to forfeit all their privileges: for Dubuffet wanted to turn taste inside out, relocating the centres of excellence in spaces which hitherto had lain in the darkness beyond the cultural pale.

I surmise that Dubuffet's championship of Art Brut was fuelled by an unusual confidence in his own intuitions, as if he knew he could always detect what would and what would not fit the category. His most impressive decisions, I would argue, were first and foremost a matter of unreflecting feeling, rather than of intellectual assessment. It was only afterwards that Dubuffet began writing about his finds, ingeniously interpreting them in the light of insights gained from his own practice as an artist, as well as using sheer infernal guesswork. The next stage came when he felt obliged to justify and protect them by drawing up a formal definition, laying down his decisive criteria of spontaneity, imperviousness to visual influences, freedom from contacts with the mainstream art-world, temperamental resistance to social norms and so forth. Curiously, the flow of his discoveries seemed to gather momentum the more he built exact and impermeable banks to channel it.

The question of how literally to take the doctrine of Art Brut in its purest and most extreme form continues to haunt contemporary debates about authenticity and artistic excellence in the field. What later emerged—and not before a certain amount of damage had been done as a result of his over-zealous application of his own rules, as witness his treatment of Gaston Chaissac—was that Dubuffet himself tired of hyperbole and began to concede that there are after all several shades of aesthetic pleasure, and that one might successively appreciate differing kinds of art. By the 1970s it had become clear that there would be no end to the emergence of interesting non-academic artists whose work was at once compelling and at odds with his strictest doctrine. No doubt it was the impressive coherence and sharpness of Dubuffet's primal intuition which was responsible for the fact that so many other people had become keen to discover work worthy of it. The frenzied haste with which some dealers and collectors have tracked down new specimens of Art Brut has led to a good many quarrels and frustrations (not all of them due to misunderstandings about what Dubuffet had actually said).

No doubt it was to be predicted that the pressure of other people's discoveries and opinions, including those emanating from parts of the world remote from European debates, would in time begin to override one man's singular specifications. That wonderfully unruly wave of enthusiasm for contemporary folk art which has gripped Americans over the last two decades or so, and the consistent expansion of interest in a wide range of non-establishment art forms, from the psychotic to the aboriginal, which has affected art lovers from Austria to Australia, have ushered in a period of ever more fluent and uninhibited connections. Fifty years since Dubuffet sharpened the modern eye, it begins to seem that his strictest criteria have lost their relevance in the face of the sheer prolixity and fertility of the material still coming to light. Not everyone would deplore the fact that Dubuffet's revolutionary doctrine has in turn been overthrown by mass enthusiasm, for critical scruples about taxonomy can seem fastidious in the face of the evidence that an increasing number of non-specialists are finding real pleasure in the marginal arts. All the same, given that I have spent several years maintaining sharp distinctions between Outsider Art, Naïve Art, Popular Art and the rest, I would deplore a thoughtless plunge into the indiscriminate: for I believe that the appreciation of art still does benefit from a consciousness of differences. What I think we now need is a balanced, generous effort of responsiveness toward the myriad forms of art, an alertness to novelty coupled with a healthy refusal to allow novelty to become an absolute or an abstraction.

Since its first appearance in 1989, the international magazine *Raw Vision* has maintained a vigilant gaze over all these busy domains, exposing its readership to a progressively more exciting if sometimes bewildering sampling of the marginal arts from across the globe. As its editor, John Maizels has been wilfully eclectic in sponsoring articles about individual creators, and sometimes groups, along with reviews of exhibitions and books of interpretation and critique, which together form a panoply of the most disparate approaches. One common denominator has remained constant: the notion of a certain intensity and purity of vision, a never-quite-defined yet palpable freshness of invention, or what Maizels here calls 'raw creation'.

It is this editorial experience, along with that of meeting artists and seeing their work, and his repeated pilgrimages to the sites of untutored creativity—whether it be the prominent museums of Europe or North America which permanently house specimens of raw creation, those public or commercial galleries which mount temporary exhibitions of such art, or the classic large-scale environmental installations made by Ferdinand Cheval, Nek Chand and others—which constitute John Maizels's excellent qualifications for the daunting task of making sense of what, by the mid-1990s, has become a bewildering mass of wonderful and varied material.

As a guide to self-taught art in this century, this book comprises a brief history of the discoveries and influential theories of enthusiasts from Hans Prinzhorn to Leo Navratil, from Dubuffet to Alain Bourbonnais. It is good to see that Maizels balances theory against the detailed exposition of the work of individual artists; while these do tend to be outstanding examples, I believe he wants to make it clear that he is a pluralist and an enthusiast, rather than the solemn defender of a limited, immutable canon. Certainly

his book is unprecedented in its breadth of coverage, and makes an immediate case for dispensing with any lingering hesitancy about exposing one's eye to artistic expressions as they emanate from unknown regions across the world. And *Raw Creation* is not a compendium of exotic eccentrics but a cosmopolitan gathering of equals.

It is noticeable that, as far as possible, each artist Maizels addresses is honoured with his or her true name, for anonymity or coy pseudonyms are absolutely a thing of the past. To recognize individuality and a distinctive style is indeed essential to the activity of appreciating art of such honesty and committedness. Maizels writes with equal zest about drawings, paintings, sculptures, assemblages and performances, though he seems especially taken in his imagination by single-handed installations and environments. However, what matters is not any material variability of scale but the central fact of the omnipresence of the maker within any true artwork. Even the tiniest drawing can be 'inhabited' or invested with personal meaning; and this sense of a caring, shaping subject is crucial to the impact of Outsider Art. (It is true that there are difficulties for those concerned to arrive at some sort of objectivity as regards aesthetic appreciation. Yet such difficulties should not be avoided, and this is probably one of the vexed yet necessary lessons which such art imparts.)

What is admirable about his exposition is that, rather than pigeonhole artists by reference to a rigid standard, John Maizels is quick to show that there is no discovery without context, no context without complexity, and no complexity without the need for empathetic understanding. There can be no shortcuts to insight into the work of so disparate and intense a sequence of creators as those to whom we are introduced in these pages. Maizels wisely situates individuals against their social background, and notes the often revealing circumstances whereby they were discovered and brought to public notice. The indispensable contribution of Dubuffet is discussed, yet he is seen as but one in a whole cycle of practical collectors and conjectural thinkers; while the qualities which emerge as touchstones (of authenticity, or of sheer visual pleasure) tend to lose any trace of absolutism as they are attributed to deviant and always idiosyncratic expressions. Dubuffet always maintained that the real failing of conventional art appreciation is its deference to the critical judgement of an élite minority: and it may well prove to be one of the greatest gains of the expansion of our interest across the fields of self-taught and person-centred art that we should learn to trust our own unmediated responses, finding that taste is equally a matter for self-determination. Readers of this book will, I hope, take pleasure in meeting dozens of inventive creators; yet while they may be struck by most of the work, they are unlikely to be able to enjoy all of it to the same pitch of intensity. It is natural that there should be fluctuations of response, and nuances of judgement. Let each reader determine his or her own preferences, entering into the egalitarian spirit of this enterprise and rejecting all dogma, even that of Art Brut itself.

Roger Cardinal

Part I: Outsider Art and Art Brut

Chapter 1: A DEVELOPING AWARENESS

The gradual recognition of the art of the 'insane'

Early 'psychotic' art
from Cesare Lombroso,
Genio e follia, 1864

Illustrations from
Marcel Réja, *L'Art chez
les fous*, 1907

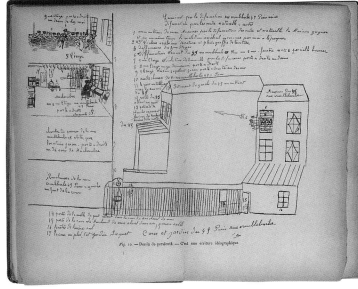

is one of the most fascinating stories in the frequently astounding field of self-taught art. In the closing decades of the nineteenth century, as some doctors became interested in theories of mental illness and more humane methods of treatment were introduced, a few enlightened psychiatrists came to realize the importance of the artistic expressions of their patients, some building up collections of pictures and objects. The Scottish doctor W A F Browne published *Art in Madness* as early as 1857, and in 1864 the Italian doctor and early collector of 'psychotic art' Cesare Lombroso published *Genio e follia*, in which he grappled with the tenuous link between creative genius and madness. Lombroso's study was followed over the next few decades by a string of publications in which eminent scholars in the psychiatric field considered various aspects of the art of the mentally ill. ¶ In the years preceding the First World War the work of three psychiatrists was particularly important. *L'Art chez les fous*, published in Paris in 1907 under the name of Marcel Réja, was in fact written by a psychiatrist, Dr Paul Gaston Meunier, who argued that the art of the insane had a direct relationship with the art of the 'normal', but also had a special quality of its own. Dr Auguste Marie, who began collecting the work of patients as early as 1900, opened his important collection, 'Le Musée de la Folie', at the Villejuif asylum in Paris in 1905. Also in this period Dr Charles Ladame built up an important collection from the psychiatric hospitals of Geneva and Solothurn. Until the activities of these early pioneers, patients' works were systematically destroyed or swept up at the end of each day, a practice that in the main continued for many years to come.[1] ¶ Even these eminent doctors, the first to be interested in the artistic works of the insane, tended to regard the material they studied as specimens, appendages to the analytic and psychiatric process. Patients were never referred to by their own names, but by initials or numbers. Although just about recognized as art, their work was still considered a lower form of expression than that by 'real' artists. ¶ By the start of the 1920s the stage had been set for further

Cesare Lombroso

1. For a detailed and absorbing survey of early contributions in the field of art and psychiatry, see John M MacGregor, *The Discovery of the Art of the Insane* (Princeton, 1989)

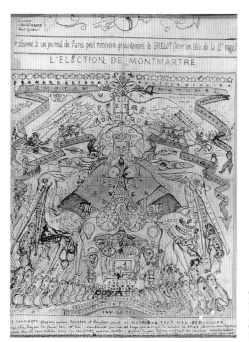

Cotton Xavier
L'Election de Montmartre, 1890
Ink, watercolour and coloured crayon
40×28cm
Collection de L'Art Brut Lausanne
Previously in the collection of Dr Marie

advances in the appreciation of the art of mental patients. In the realm of psychiatry, new theories and concepts, especially those of Sigmund Freud and Carl Jung, had already generated some respect for the power and importance of the unconscious. Meanwhile the great avant-garde movements of the twentieth century were gaining momentum. The small world of Western culture was gradually opening up, becoming more receptive to new influences and concepts, seeing new possibilities and alternative realities. In Paris Picasso's work clearly demonstrated the influence of African sculptural forms. The German Expressionists were also influenced by African and other 'non-Western' art traditions, and were interested in exploring the spiritual dimension of artistic expression. The Blaue Reiter (a group of Munich artists formed in 1911 and including Expressionists Vasily Kandinsky and Franz Marc) illustrated in their Almanac the works of 'primitive' peoples and the drawings of children alongside contemporary Expressionist images. Surrealism, with its emphasis on sources of creativity beyond rational thought, was becoming a potent intellectual and visual force. The very meaning and role of art was being redefined. The time was ripe, at last, to see in the art of the insane something more than random scribbles or pathetic fantasies, or even interesting clinical evidence. This work could now be seen for what it was—unique and fascinating art in its own right. ¶

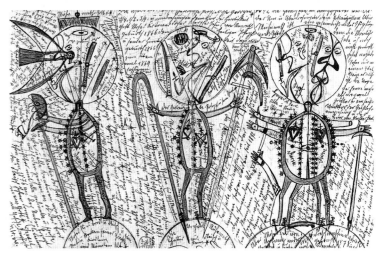

Johann Knüpfer (Johann Knopf)
Untitled
Pencil, pen and crayon on paper
20·9×32·9 cm
Prinzhorn-Sammlung, Heidelberg

In 1921 Walter Morgenthaler, a young Swiss doctor, published the first serious study of a 'psychotic' artist, Adolf Wölfli (see Chapter 2). The next year Dr Hans Prinzhorn of the Heidelberg Psychiatric Clinic published the first detailed study of the visual expressions produced by inmates of mental institutions. Trained as both psychiatrist and art historian, Prinzhorn had amassed a collection of over 5,000 drawings, paintings and objects created mainly between 1890 and 1920 by over 500 patients. At the instigation of clinic director Professor Karl Wilmanns, he had contacted hospitals all over Europe, but mainly in German-speaking areas, asking them to send examples of mental patients' work to him in Heidelberg. Prinzhorn's famous book *Bildnerei der Geisteskranken* (*Artistry of the Mentally Ill*) presented a detailed analysis, both aesthetic and psychiatric, of works from this great collection. Not only were many of the drawings, paintings and objects startling and disturbing, full of unusual imagery, and rich in detail and ornamental power—Prinzhorn also argued that they threw light on the creative process itself. ¶ It became evident from his

Dr Hans Prinzhorn

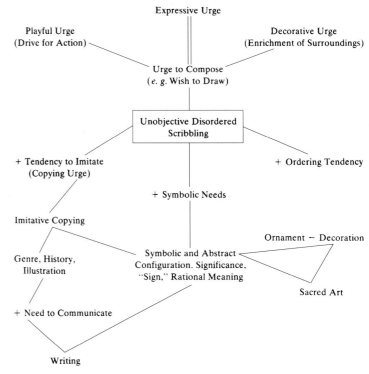

Prinzhorn's Schema of the Tendencies of Configuration

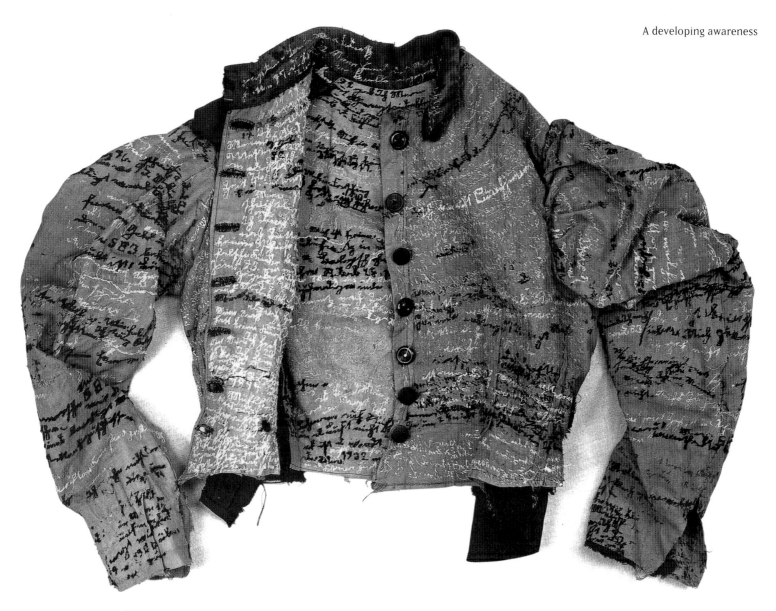

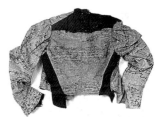

Agnes Richter
Embroidered jacket
Linen and yarn
Length 36·5 cm
Prinzhorn-Sammlung, Heidelberg

discoveries that visual creativity was to be found not only in the realm of the cultured or the educated, but was an undeniable human trait, present within each of us from childhood onwards. The works of the mentally ill gave Prinzhorn a particular insight into the creative drive, a process he felt to be affected by various basic human tendencies, either individually or in combination. He set out diagramatically six basic urges: expressive, playful or active, decorative or ornamental, ordering (rhythm and rule), copying and the need for symbols—and used this plan to help clarify creative action (see figure opposite). ¶ Prinzhorn rejected previous ideas that the art produced by those considered to be mad could somehow have different roots from the 'normal' creative process, arguing that all artistic expression stemmed from the same sources. It was his analysis of the art of the insane that helped him to understand these origins. He used the following analogy: As groundwater seeps to the surface and flows toward the stream in many rivulets, many expressive impulses run in many creative paths into the great stream of art. Neither historically nor according to psychological theory does there exist a beginning point. Instead there are many springs which finally transcend all life.[2]

2. Hans Prinzhorn, *Bildnerei der Geisteskranken* (Berlin, 1922; reprinted 1994), translated into English by Eric von Brockdorff as *Artistry of the Mentally Ill: A Contribution to the Psychology and Configuration* (New York, 1972; reprinted 1995), p.15

August Natterer (August Neter)
Above
Hexe (Witch), *c.*1919
Pencil on paper
19·9×16·5cm
Prinzhorn-Sammlung, Heidelberg
Right
Hexenkopf (Witch's head)
Pencil, ink and watercolour on cardboard
25·9×34·2cm
Prinzhorn-Sammlung, Heidelberg

¶ Prinzhorn's theories were fascinating, but his fame and that of his book rested on the extraordinary work he presented. The book was packed with scores of examples, from drawings on the tiniest scraps, even on toilet paper, to ambitious carvings and intricate paintings. Prinzhorn looked in detail at the work of ten inmate artists, the so-called 'schizophrenic masters', even though he did not have particularly close relationships with all these subjects, and some, who were not his patients, he hardly knew at all. Prinzhorn's great collection is still housed in the psychiatric clinic in Heidelberg, where it is carefully conserved and available for special study, and there are now at last plans to move the collection to a separate building for general viewing. ¶ In order to mask the identities of the patients Prinzhorn gave them pseudonyms or referred to them by numbers. Karl Brendel, for example, was the pseudonym for Karl Genzel (1871–1925), whose carvings are among the most powerful objects in the Heidelberg collection. Genzel was a bricklayer with several violent clashes with the law behind him. His mental state appears to have deteriorated following an amputation and he was described as suffering paranoid and megalomaniacal delusions. Even in the hospital, a large man hopping on one leg, he often had to be restrained by several warders at a time. One of his earliest works, modelled from chewed bread—a common material among prisoners and inmates at the time—was a gruesome bust. The head had two mouths and, lying neatly back to front, a fully exposed brain. Genzel went on to make carvings from pieces of hardwood (often discarded bits of old furniture): firstly reliefs carved within a heavy frame and later free-standing pieces, often painted or varnished. ¶ Characteristically

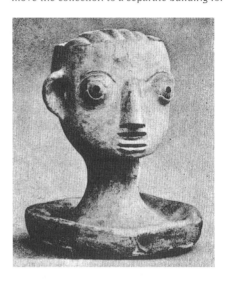

Karl Genzel (Karl Brendel)
Above
Head, c.1912–13
Chewed bread
Height 24 cm
Destroyed
Below left
Gebärender Christus
Wood
36·1×30·0×16·5 cm
Prinzhorn-Sammlung, Heidelberg
Below right
Jesus/Die Frau mit dem Storch (Jesus/Woman with stork;
the latter on the reverse)
Kopffüssler (head-footer)
Wood
18·5×12·5×3·0 cm
Prinzhorn-Sammlung, Heidelberg

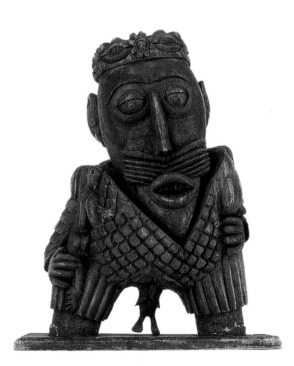

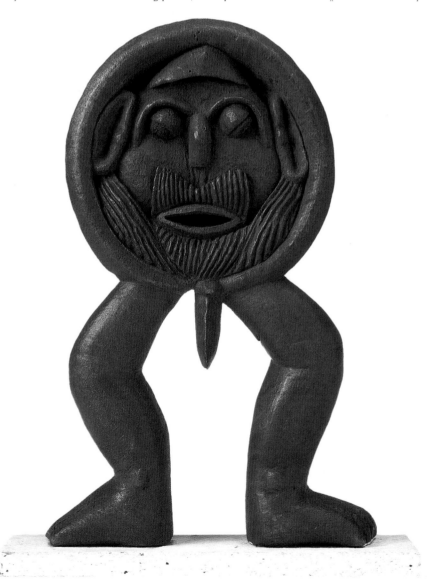

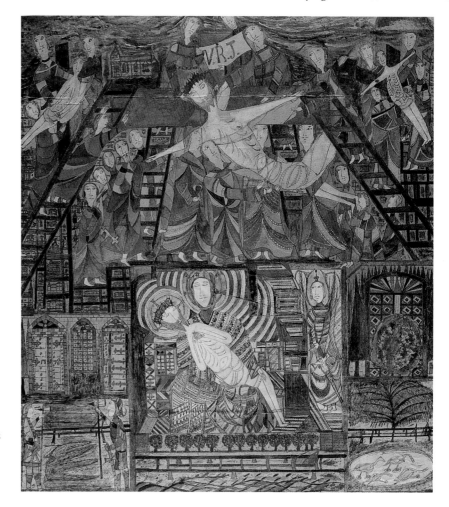

Peter Meyer (Peter Moog)
Right
Untitled, 1920
Pencil, coloured pen and tempera on
cardboard
53·8×48·6 cm
Prinzhorn-Sammlung, Heidelberg
Below
Handbound book with insertions
Prinzhorn-Sammlung, Heidelberg

up to 25 centimetres or so high and depicting figures with mixed, and often grossly exaggerated, male and female characteristics, the sculptures are charged with a compelling, almost demonic power. The highly detailed pieces often combine representations of Jesus (and of the devil) with animal and symbolic forms. Among Genzel's most idiosyncratic creations are his Kopffüssler (head-footers), a series of small figurines with no body, simply a head with legs and other appendages connected directly to it. Concluding his discussion of Genzel's work, Prinzhorn notes: Finally we must report a statement Brendel made about his work which is in complete agreement with the most famous words delivered by the world's greatest sculptors. We might even say that it is the best statement ever about the forming of a block: 'When I have a piece of wood in front of me, a hypnosis is in it—if I follow it something comes of it, otherwise there is going to be a fight.' One can hardly describe intuition and the struggle for configuration any more vividly.[3] ¶ Another 'schizophrenic master' was former innkeeper Peter Meyer (1872–1930; pseudonym Peter Moog), who had a sudden collapse into insanity which led him to an asylum in his late thirties. In his euphoric state he believed that he had incredible wealth and power, that he was a great poet and painter, and finally a servant of God. His surviving works, originally intended by him to hang in Cologne's cathedral, reflect his religious devotion. The little paintings in ink and watercolour sing out in their shimmering colours, the main subject of each picture surrounded by smaller tableaux or minute decorative detail. He produced a hand-bound book covered in his colourful work and containing tiny pouches and envelopes, each one holding further drawings, poems or messages. In explaining his own working method, Meyer noted: I find hundreds of faces in a floor mosaic or a speckled wall—God favours man with his fortune. Those are presents for those who serve Him with art...I often feel the power vibrating in the hand so that often it comes out all right in ink right away; but usually I have to

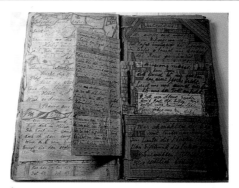

3. Ibid., p.130

4. Ibid. p.157

outline in pencil.[4]

Franz Karl Bühler (1864–1940; pseudonym Franz Pohl), whose drawings were originally realistic depictions of life around him carried out with conventional pictorial skills, gradually began to work in a more imaginative and expressive style, with swirling lines and heavy dark areas evoking a sombre and threatening atmosphere. August Natterer (1868–1935; pseudonym August Neter), whose intricate and delicately drawn human figures incorporated animal and plant elements, endowed his works with a strong underlying mystical power. Gustav Sievers's work includes cartoon narratives characterized by a series of rounded figures and huge-busted women depicted within perspectival space. ¶ Many works in Prinzhorn's collection employ language forms; some executed by patients in a minute painstaking script and others that break out in frenetic scribbling, words that create forms of their own, neologisms, invented symbols and secret languages and combinations of words and images. Religious images and language forms are combined in the works of Johann Knüpfer (1866–1910; pseudonym Johann Knopf), whose religious delusions were the inspiration for drawings in which strange figures with large round heads or human-faced birds were surrounded by delicately rendered texts. Agnes Richter (1873–?) embroidered tiny writing on the inside lining of the appliqué jacket she made from pieces of rag and found fragments. ¶ The influence of

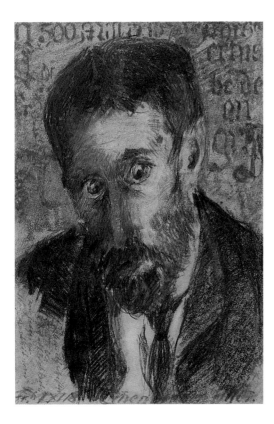

Above
Franz Karl Bühler (Franz Pohl)
Untitled (Self-portrait), 1918
Chalk on paper
27·7×18·9cm
Prinzhorn-Sammlung, Heidelberg

Right
Johann Knüpfer (Johann Knopf)
Die Herrlichkeit meines Heilandes Christi Christus
(Glory of my Saviour)
Pencil, coloured pencil and pen on paper
33×27cm
Prinzhorn-Sammlung, Heidelberg

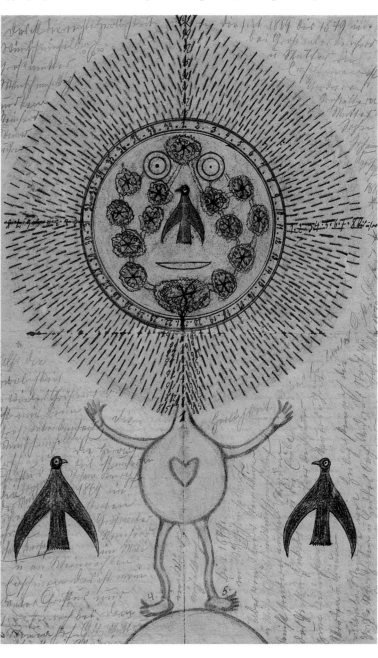

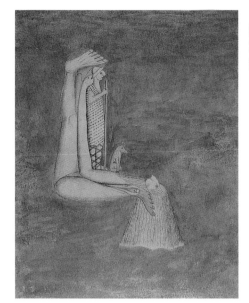

August Natterer (August Neter)
Wunder-Hirte (Miraculous shepherd),
c.1919
Watercolour over pencil on cardboard
24.5×19.5cm
Prinzhorn-Sammlung, Heidelberg

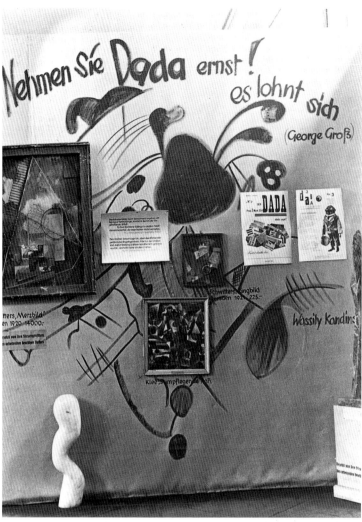

Above
Part of the Dada wall at the Entartete
Kunst exhibition, Munich, 1937
Below
Cover of the Entartete Kunst exhibition
catalogue, 1937

Prinzhorn's book was immediate and widespread. The work of the insane was at last taken seriously as art and contemporary artists were at the forefront of those who recognized it, some even travelling to Heidelberg to see the collection. Prinzhorn himself was well aware of the similarity between some works in his collection and those produced within progressive art movements of the time. The Surrealists were particularly enthusiastic, as the theories of automatism and irrationality so revered by André Breton were perfectly demonstrated by the patient-artists. It has been argued that many artists were directly affected by items in Prinzhorn's collection—that Max Ernst was strongly influenced by the carvings of Genzel; Alfred Kubin by the expressionistic work of Franz Bühler; that Natterer's delicate and detailed drawings inspired both Paul Klee and Ernst; and that Sievers's rounded and inflated figures were models for Richard Lindner's later work—though many such suggested links may be the exaggerations of art historians. Most profoundly affected of all was a young French artist, Jean Dubuffet. Prinzhorn's studies were to lead him on an epic quest of discovery (see Chapter 3), which was to have far-reaching implications for perceptions of both 'outsider' and 'cultural' art. ¶ Prinzhorn's discoveries provoked a rather different reaction from the Nazis. Hitler's hatred of contemporary art led to the infamous exhibition Entartete Kunst (Degenerate Art) which toured Germany from 1937. The work of the insane was shown in shoddy displays alongside works by modern German artists, a comparison that was intended to emphasize their shared 'inferior nature'. The concept of the exhibition was perverse, yet it was over fifty years before the works of the insane would be seen again hanging alongside the works of established contemporary artists in a major exhibition, this time in the Los Angeles County Museum of Art's exhibition Parallel Visions, which sought to explore the influence of Outsider Art on modern artists.[5] With the rise of the Nazis the clinic at Heidelberg was given a new director, Carl Schneider, a Nazi supporter who became the Chief Assessor of the 'euthanasia' programme. There was no place in the Third Reich for such 'inferior life' as the mentally ill, and their wholesale murder was justified for 'biological' reasons. Most of the artists described in Prinzhorn's work, whose drawings and objects have had so much influence, therefore became candidates for a programme of extermination, victims of those far more insane and dangerous than they had ever been.

5. The exhibition Parallel Visions was curated by Maurice Tuchman and Carol S Eliel at the Los Angeles County Museum of Art (October 1992–January 1993). It toured to Madrid, Basle and Tokyo. Catalogue: *Parallel Visions: Modern Artists and Outsider Art* (Princeton, 1992)

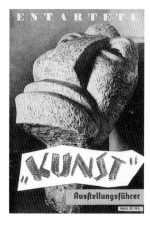

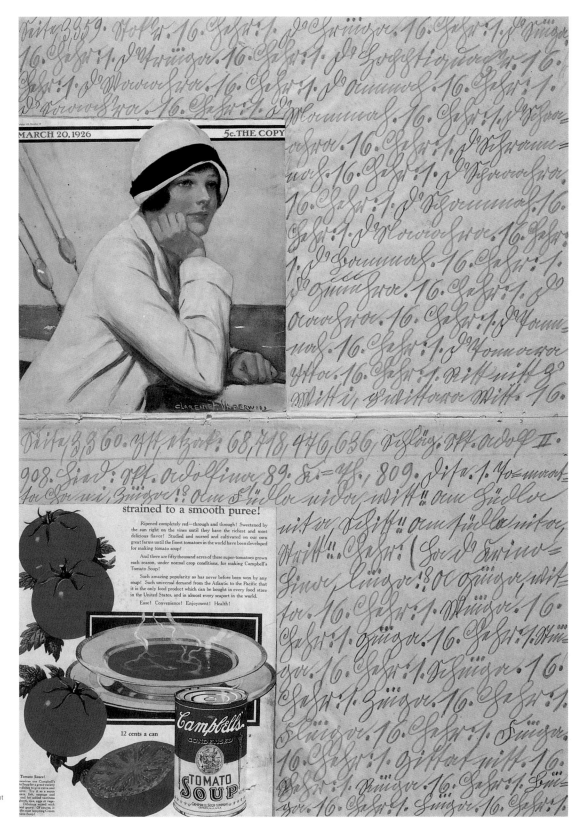

Adolf Wölfli
Campbell's Tomato Soup, 1929
Pencil, coloured pencil and collage on newsprint
70×50 cm
Adolf-Wölfli-Stiftung, Kunstmuseum Bern

Chapter 2: THE PHENOM-ENON OF ADOLF WÖLFLI

Adolf Wölfli (1864–1930), a patient in a mental institution for most of his adult life, was a prolific artist whom many today regard as a creative genius. His life, psychological condition and art were the subject of a book by his doctor, Walter Morgenthaler, *Ein Geisteskranker als Künstler (A Mentally Ill Patient as an Artist)*, published in 1921. Morgenthaler's familiarity with developments in contemporary art enabled him to see the significance of Wölfli's work. He was one of the first to argue that a mentally ill person could be considered a serious artist. ¶ Brutalized and abandoned as a child himself,

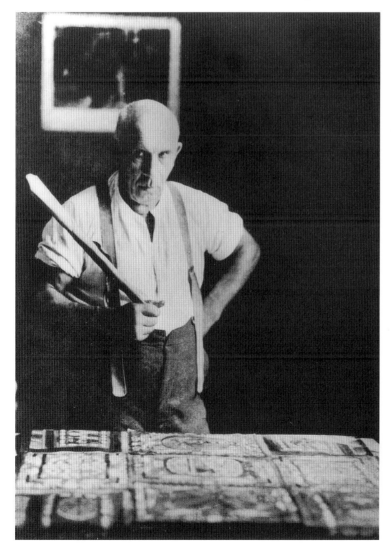

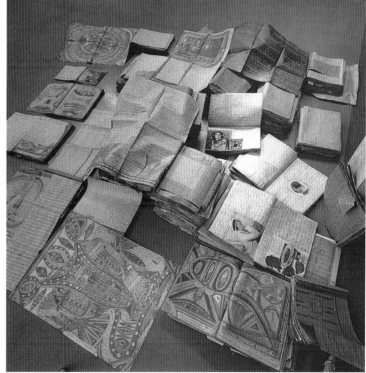

Left
Adolf Wölfli with his paper trumpet, 1925
Above
A selection of Adolf Wölfli's many illustrated volumes photographed in 1976

Wölfli had a history of attempted child molestation. He was admitted to the Waldau clinic near Bern in 1895, an unhappy, introverted and often violent patient. After a few years of introspection and isolation, he inexplicably began to draw. None of his very early works survive—they were probably dismissed with patronizing amusement by clinic authorities and destroyed. However, a body of fifty large pencil drawings created between 1904 and 1906, before Morgenthaler's arrival at the Waldau clinic, have been preserved. These detailed and near-symmetrical compositions, many numbered in sequence, introduced a rich visual vocabulary that was to remain with Wölfli all his life: highly repetitive and detailed decorative borders and bands which sweep around each composition, the use of musical manuscript fragments (still empty of notation at this stage), the introduction of lettering and word forms, the inclusion of small self-portrait heads and distinctive 'bird' motifs, even the introduction of collage. All these elements were combined to form richly textured compositions with flowing circular and linear forms. ¶ Drawing calmed Wölfli; it became an essential part of his existence. He worked every day, from morning to night, drawing, writing and composing. As well as being a skilled draughtsman, Wölfli was fascinated with algebraic forms and with musical composition, at times signing himself 'Adolf Wölfli, composer'. Morgenthaler wrote: Every Monday morning Wölfli is given a new pencil and two large sheets of unprinted newsprint. The pencil is used up in two days; then he has to make do with the stubs he has saved or with whatever he can beg off someone else. He often writes with pieces only five to seven millimetres long or even with the broken-off points of lead, which he handles deftly, holding them between his fingernails. He carefully collects packing paper and any other paper he can get from the guards and the patients in his area; otherwise he would run out of paper well before the next Sunday night. At Christmas the house gives him a box of coloured pencils, which lasts him two or three weeks at the most.[1] ¶ Wölfli received encouragement from Morgenthaler, and even before the publication of Morgenthaler's book in 1921 he had become a minor celebrity within artistic circles. His pictures began to be collected. He occasionally received visitors and acquired as gifts materials to help him with his work. ¶ In 1908 he embarked on his greatest endeavour: an illustrated epic of 45 massive volumes containing a total of 25,000 pages, 1,600 illustrations and 1,500 collages. The first eight books, entitled *From the Cradle to the Grave* (1908–12) narrate his own imaginary life story, his abandonment as a child being replaced by the exotic travels of the child Doufi, accompanied by his mother, relatives and friends. The events of his adult life are transformed into glorious and fantastical experiences. From the child 'Doufi' he becomes 'Knight Adolf', 'Emperor Adolf', 'St Adolf Great God' and finally, from 1916 onwards, 'St Adolf II'. His texts and accompanying drawings take him on endless grandiose journeys and explorations, suffering death, yet always being brought back to life once more to continue his adventures. ¶ Wölfli's musical scores were set out in the same manner

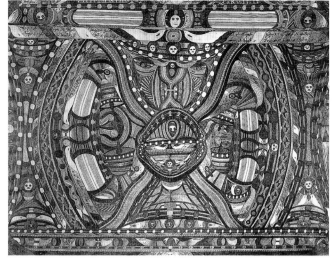

Adolf Wölfli
Medizinische Fakultät (Faculty of medicine), 1905
Pencil on newsprint
75·0×99·7 cm
Adolf-Wölfli-Stiftung, Kunstmuseum Bern
Previously owned by Carl Jung

1. Walter Morgenthaler, *Ein Geisteskranker als Künstler* (Bern and Leipzig, 1921; expanded edition Bern and Vienna, 1985), translated into English by Aaron H Esman as *Madness and Art: The Life and Works of Adolf Wölfli* (Lincoln, Nebraska and London, 1992), p.21

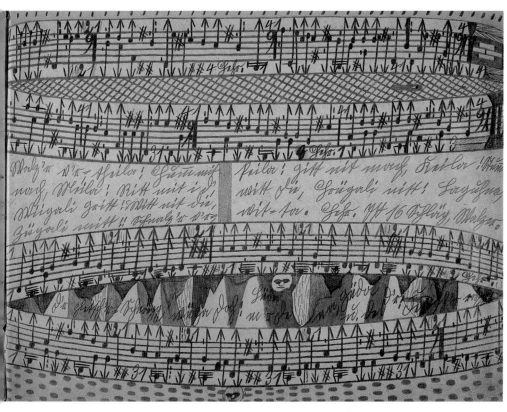

Adolf Wölfli
Untitled, 1913
Pencil and coloured pencil on paper
37×50 cm
Adolf-Wölfli-Stiftung, Kunstmuseum Bern

Untitled, 1913
Pencil and coloured pencil on paper
37×50 cm
Adolf-Wölfli-Stiftung, Kunstmuseum Bern

as his drawings and often were combined with them. The result is some of the
most extraordinary musical manuscripts of all time, although only now are
they being deciphered and performed. Wölfli played his music himself, on a
trumpet made of rolled-up paper. ¶ In the following seven volumes, the *Geographic and Algebraic Books*
(1912–16), he describes the founding of 'St Adolf Giant Creation'. Using his vast
imaginary fortune, he embarks on a massive construction programme, even
purchasing many of the countries he visits in his travels. The development of
his personal cosmos continued with the *Books with Songs and Dances*

2. See Elka Spoerri, Adolf Wölfli: *Raw Vision*, no. 4 (1991). p.20

(1917–22), *Dances and Marches* (1924–8) and finally his great requiem, the sixteen-volume *Funeral March* (1928–30). The drawings are an integral part of the narrative, illustrating particular passages of text, and indeed the graphic imagery and text often were intertwined. Attached and bound into the books, the drawings fold out several times to form large sheets. Many are on paper measuring 100 × 75 centimetres; one of the largest drawings, in Book 5 of *From the Cradle to the Grave*, measures 468 × 70 centimetres and is folded twelve times.[2] Wölfli's fantasy paralleled his real life in many

ways: The narrative begins with the fictitious emigration of the Wölfli family to America and is subsequently transformed into a journey 'researching nature' more or less over the entire globe. In his imagination Wölfli sees himself initially in the company of his mother, brothers and sisters; later the group grows larger and larger as more and more friends join it, and finally takes shape as the 'Naturvorscher-Schweizer-Avantt-Gaarde' (Vanguard-of-the-Swiss-Hunters-and-Nature-Researchers-Journey). Wölfli dates everything which happens on this journey exclusively and precisely within the years 1866 and 1872. In this way he is documenting for himself a fictitious childhood from the age of two to eight years.[3]

3. Theodor Spoerri, from the catalogue of *documenta 5* (Kassel, 1972)

Wölfli's perception of himself changed dramatically during the course of his autobiography. In *From the Cradle to the Grave* he refers to himself as: Naturalist, poet, writer, draughtsman, composer, farm labourer, dairy-hand, handyman, gardener, plasterer, cement-layer, railway worker, day-labourer, knife grinder, fisherman, boatman, hunter, migrant-worker, grave digger, and soldier of the third Section of the third company of the Emmenthal Battalion. Hooray! In the *Funeral March*, however, he has become: St Adolf II, Master of Algebra, Military Commander-in-Chief and Chief Music-Director, Giant-Theatre-Director, Captain of the Almighty-Giant-Steamship and Doctor of Arts and Sciences, Director of the Algebra-and-Geography-Textbook-Production Company and Fusilier General. Inventor of 160 original and highly valuable inventions patented for all time by the Russian Tsar and hallelujah the glorious victor of many violent battles against Giants. With

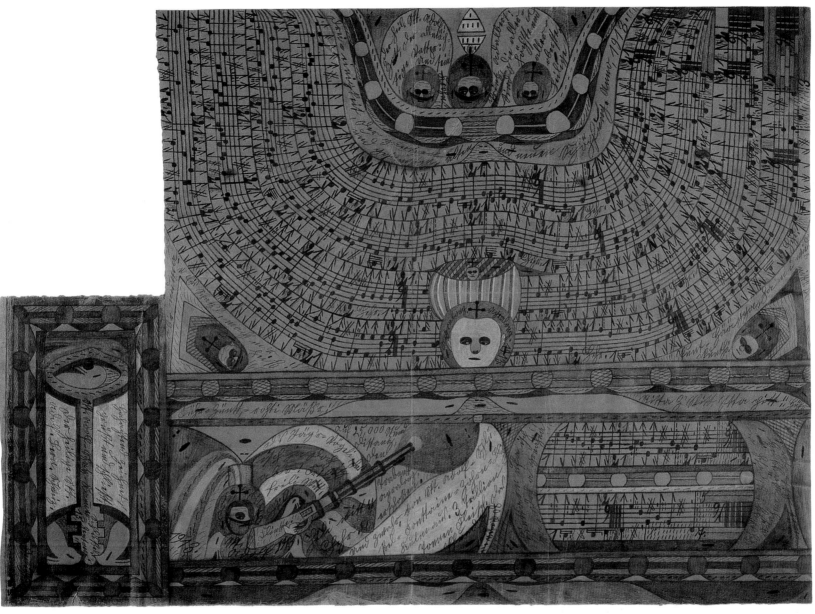

Adolf Wölfli
Skt · Adolf · Schatz · Kammer · Schlüssel (St Adolf ·
Treasure · Chamber · Key), 1913
36/69·1×78/96·2cm
Pencil and coloured pencil on paper
Adolf-Wölfli-Stiftung, Kunstmuseum Bern

Morgenthaler's encouragement Wölfli produced countless single-sheet draw-
ings in addition to his epic autobiography. Some, referred to as 'bread-art',
were sold to the visitors who began to appear at the Waldau clinic as his
fame spread. Others were given away as presents or used as barter for mate-
rials. Although smaller in scale and scope than the illustrations to his books,
they nevertheless have a compact power of their own. Many are a synthesis
of grander conceptions, with human forms surrounded by ornate decorative
and symbolic borders, while later drawings drew on his imagery of mandala
forms and symmetrical archetypal composition. Although not part of the
books themselves, these works still relate to Wölfli's great narrative and have
references on their reverse to specific events. ¶ Morgenthaler's interest in collecting objects and pictures created by
mental patients led him in 1916 to commission Wölfli to decorate two large
wooden panelled cabinets. These were to contain both his collection and that
of the Swiss Psychiatric Society, which later formed the nucleus of the
Waldau Museum. Wölfli drew directly on the irregular parts of the wood

framing, but for the larger rectangular areas drawings were made on paper and then glued into position. He used the same method in 1921 when he constructed a ceiling mural in his own small cell; the completed collaged drawing was 2.35 × 3.50 metres, exactly the same dimensions as the room. ¶ Wölfli worked in a continuous flow; he often began at the edge of the paper with the ornate borders and friezes that provide the main force of his compositions. Consisting of linking bells, circles, crosses, spirals, ovals, stars, triangles, birds, numbers, lines, marks and hatching, they both frame the work and give it a surging motion. On reaching his inner territory, he worked towards the centre, creating a complex web of linear and rounded elements which both engulfed and defined human forms and faces, often self-depictions. Birds, beasts, calligraphy, musical notation, buildings and cities, collaged pictures from magazines, events from his life before his internment, the life and exploits of St Adolf, even monetary and algebraic calculations: all are borne along by the sweeping force of his detailed and rhythmic decorative currents. The centres of his drawings are often dominated by mandala forms—his own face peering out from the centre, the master of his universe and yet somehow imprisoned within it. ¶ Little is known of the origins of Wölfli's

Adolf Wölfli
Der Gross ▫ Gott ▫ Vatter ▫ Huht mit Skt Adolf ▫ Kuss,
Riesen ▫ Fonttaine (The great ▫ god ▫ father ▫ hat with
St Adolf ▫ kiss, giant ▫ fountain), 1917
Pencil and coloured pencil on paper
38·0×50·2cm
Adolf-Wölfli-Stiftung, Kunstmuseum Bern

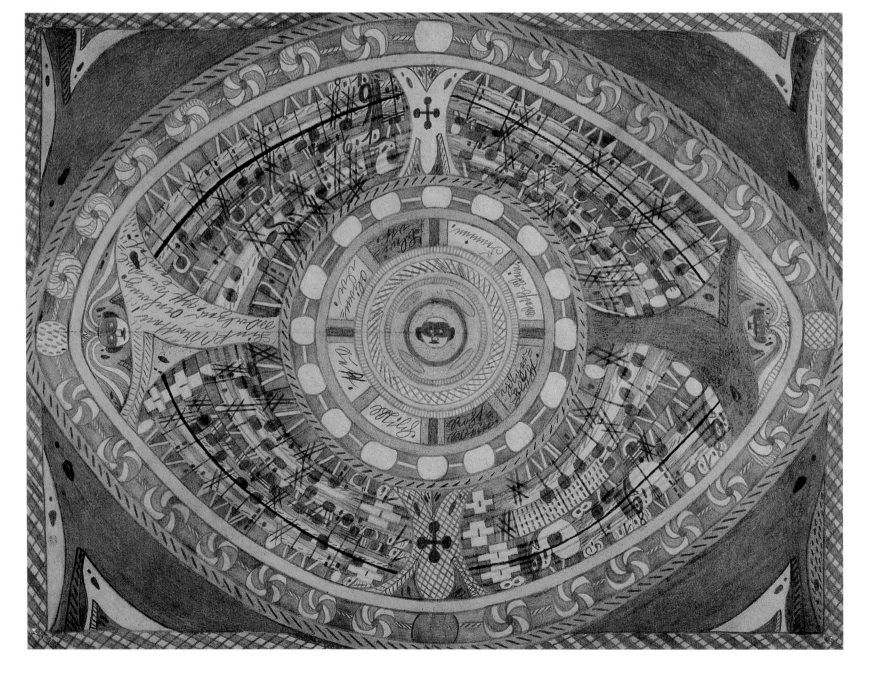

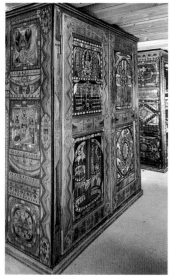
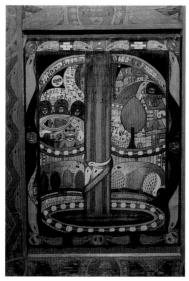
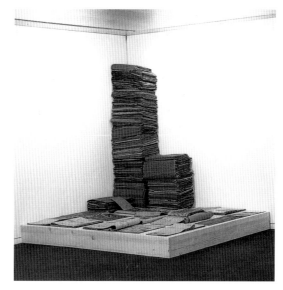

Adolf Wölfli
From left to right
Painted cabinets decorated by Adolf Wölfli to house his books and drawings, Waldau Museum, Bern

Painted cabinets, detail of door panel

Adolf Wölfli's 45 volumes of illustrations and collages, made between 1908 and 1930
Adolf-Wölfli-Stiftung, Kunstmuseum Bern

strange and powerful imagery. The scholar John MacGregor has argued that Wölfli was attempting to draw what he could actually see before his eyes, opened or closed, to come to terms with the psychotic hallucinations that overwhelmed him.[4] It may be that Wölfli's work embodies archetypes of the collective unconscious or describes hallucinatory forms that stem from deep within. In trying to decipher the extraordinary phenomenon that was Adolf Wölfli, Elka Spoerri, for many years the guardian of Wölfli's works as the curator of the Adolf Wölfli Foundation in Bern, has concluded: Although Wölfli was not active as an artist before the onset of his illness, he must be viewed as an artist who happened to become afflicted with a psychosis. The illness did not awaken any creative capacities that were not already part of his personality. His social origins, however—his life of great poverty and social regimentation as an orphan, hireling and labourer—never permitted him even to think of becoming an artist. His entire life story proved as fateful as his illness and internment.[5] ¶ In his thirty-five years of confinement at the Waldau clinic, Wölfli produced a unique and overpowering body of work. On his death in 1930, his small cell in the Swiss asylum where he had lived alone for so many years was stacked from floor to ceiling with his huge hand-bound books and drawings. These were moved to the Waldau Museum, where much of the work was stored in the very cabinets Wölfli had so carefully decorated. The cabinets are now on display at the new Waldau Museum, Bern, along with a few fragments of the ceiling mural that were saved at the time of the demolition of the old Waldau building. In 1975 all of Wölfli's other works held by the Waldau and Morgenthaler collections were entrusted to the newly formed Adolf Wölfli Foundation at the Kunstmuseum, Bern. In spite of Wölfli's stature and importance it is rare to find his work in any of the great art museums of the world. The first time that it was seen outside any specialist collection was at the German annual exhibition of avant-garde and contemporary art, documenta 5, held in Kassel in 1972. ¶ Wölfli's compelling vision and all-enveloping creative drive

4. John MacGregor, 'I See a "World Within a World". Parallel Visions: *Modern Artists and Outsider Art* (exhibition catalogue, Los Angeles County Museum of Art and elsewhere, 1992), p.271

5. Elka Spoerri, 'Adolf Wölfli', *Raw Vision*, no. 4 (1991), p.23. See also *The Other Side of the Moon: The World of Adolf Wölfli* (exhibition catalogue, Goldie Paley Gallery, Moore College of Art, Philadelphia, 1988), p.16

stand as testament to the power of the imagination and to the resilience of the human spirit. Adolf Wölfli was able to transcend the sadness and tragedy of his own life to create a miraculous personal cosmography, a visionary universe of epic proportions.

Adolf Wölfli
Irren-Anstalt Band-Hain (Mental asylum Band-Hain), 1910
Pencil and coloured pencil on newsprint
99.7×72.1 cm
Adolf-Wölfli-Stiftung, Kunstmuseum Bern

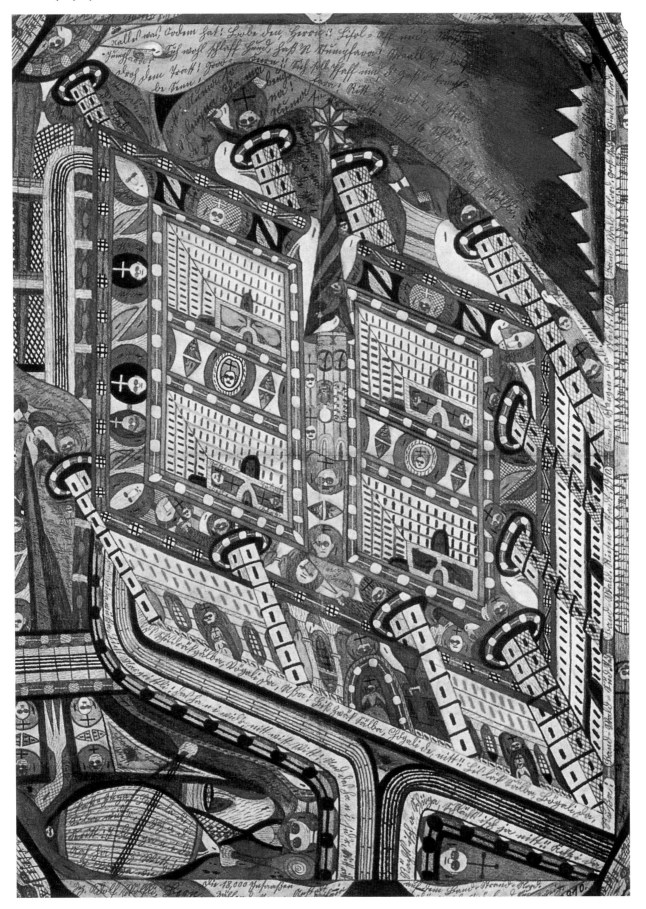

Chapter 3: DUBUFFET AND ART BRUT

The artist Jean Dubuffet was given a copy of Prinzhorn's great book *Bildnerei der Geisteskranken (Artistry of the Mentally Ill)* in 1923, a year after its publication. Although he did not read German, the visual impact of the book was profound. Since the early days of Dr Marie's 'Musée de la Folie', interest in the art of the insane had been slowly growing among intellectuals in Paris (see Chapter 1). Dubuffet was, of course, familiar with the works of the Surrealists and was aware of the freshness and originality of art produced by children. He had also come across the mediumistic drawings of visionary cloud formations by a 'Clementine R' while working as a conscript in the Meteorological Office. He realized that the works Prinzhorn presented fulfilled the Surrealist ideals of automatism in that they seemed to flow directly from the subconscious. Not only that, the works were as worthy as any other art—their compelling imagery an inspiration. ¶ Prinzhorn

Jean Dubuffet in Paris, early 1960s

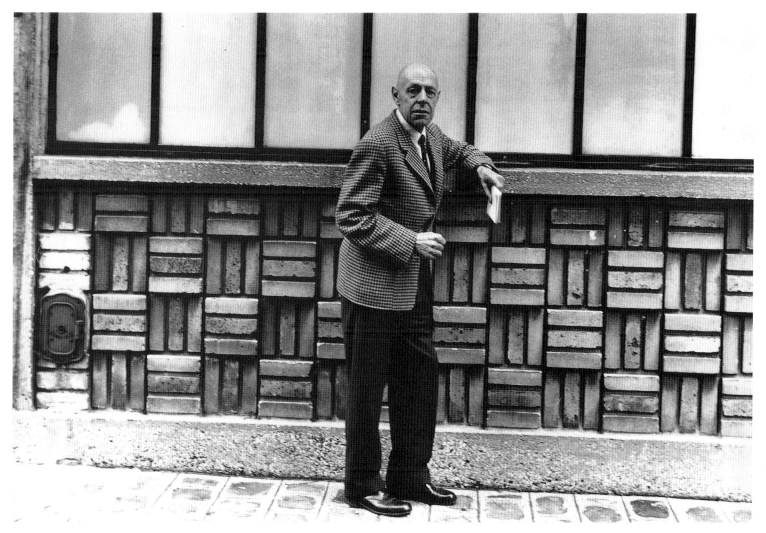

1. John MacGregor, 'Art Brut chez Dubuffet', *Raw Vision*, no.7 (1993), p.40. MacGregor's interview with the artist was held on 21 August 1976

reasoned that mental patients were able to exploit a truly universal creative urge, free of the cultural pressures which affect most of us. His theories were to act as catalysts to Dubuffet's own philosophy on the negative effects of culture and the formation of his concept of Art Brut: Interest in the art of the insane was 'in the air' when I was a student, in the 1920s. We were consciously in revolt against culture. I wasn't the only one. I was influenced by Max Jacob and Blaise Cendrars, and also by Dada. All this was part of the general cultural milieu in Paris. [1] ¶ Much activity centred around the Sainte-Anne hospital and the work of Dr Gaston Ferdière, an enlightened psychiatrist who was fully aware of the power and importance of the expressions of his patients. During World War II Ferdière left Paris for the Rodez Psychiatric Hospital in southern France, his most famous patient there being the Surrealist writer Antonin Artaud, who produced a series of harrowing self-portraits during treatment for for mental illness. ¶ By this time Jean Dubuffet was emerging from the family wine business, which had sustained him for over twenty years, and was preparing to make a firm commitment to the pursuit of his own art. By 1944 he had also decided to try to investigate further the works of the insane. One of his first visits was to Ferdière at Rodez where he was given many contacts in the psychiatric world, including Dr Ladame in Geneva who had built up an extensive collection of patient art. The next year, with a commission from the publisher Gallimard, Dubuffet set off for Switzerland. Apart from meeting Dr Ladame, he came across the works of Adolf Wölfli and Heinrich Anton Müller at the Waldau asylum, he met Aloïse Corbaz at the psychiatric clinic of La Rosière, near Lausanne, and saw the chewed bread sculptures of Giovanni Giavarini at Basel prison. He also encountered the paintings of Louis Soutter, Le Corbusier's cousin, a trained artist whose personality breakdown had led him to produce a series of fervently expressive works, many executed using his hands and fingers rather than a brush. ¶ Dubuffet needed a frame for his

Dr Gaston Ferdière with Antonin Artaud
at the Rodez Psychiatric Hospital, 1946

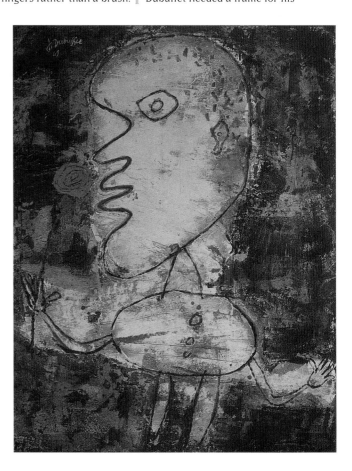

Jean Dubuffet
L'Homme à la rose, 1949
Paint and collage on canvas
116×89 cm
Kunstmuseum Hanover

Heinrich Anton Müller
Deux visages (Two faces), between 1917 and 1922
Pencil and chalk
85×80 cm
Collection de l'Art Brut Lausanne

proposed book for Gallimard. He was aware of the stigma attached to 'insane' and to 'psychotic art' and felt the need for a more dignified term. He decided upon 'Art Brut'. Although originally intended to refer to the work of the schizophrenic masters he had encountered, the term evolved in meaning as Dubuffet formulated his philosophy. He realized that pure intuitive and original expression was not only to be found among the insane; he had also come across mediums, visionaries, eccentrics and other social misfits who were similarly gifted.[2] His term 'Art Brut' was therefore not synonymous with 'art of the insane'. Indeed he claimed that there could no more be an art of the insane than there could be an art of people with bad knees. Much of the work produced by mental patients was, after all, mundane and repetitious and held no interest for him. Rather, Art Brut referred to art produced by rarely gifted individuals who worked completely free from normal cultural influences. Art Brut translates literally into English as Raw Art—raw because it was 'uncooked' by culture, raw because it came directly from the psyche, art in its purest form, touched by a raw nerve: We understand by this term works produced by persons unscathed by artistic culture, where mimicry plays little or no part (contrary to the activities of intellectuals). These artists derive everything—subjects, choice of materials, means of transposition, rhythms, styles of writing, etc—from their own depths, and not from the conventions of classical or fashionable art. We are witness here to a completely pure artistic operation, raw, brut, and entirely reinvented in all of its phases solely by means of the artists' own impulses. It is thus

2. Ibid., p.46

an art which manifests an unparalleled inventiveness, unlike cultural art, with its chameleon- and monkey-like aspects.[3] ¶ In a long series of essays and publications

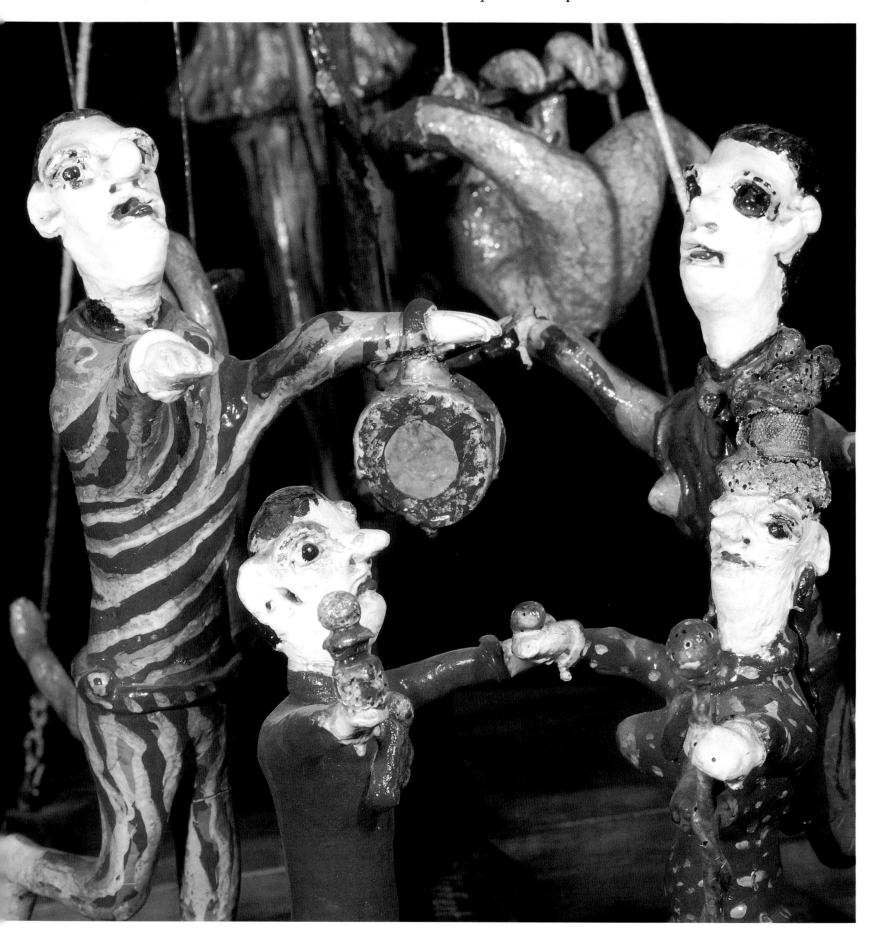

which were to involve him for the rest of his life, Dubuffet laid out his premise that culture was a stifling influence on individuality, on originality and on genuine creativity. He argued that for hundreds of years a cultural élite had been the arbiters of taste and fashion, insisting on their own criteria of quality and developing their ideas only within the concept of classical beauty. In Dubuffet's view no artist of genuine originality could survive in such a climate, only those who were able to adapt their work as styles and trends dictated were rewarded. Even the avant-garde played their role as part of the cultural establishment. True individuality of expression, original and meaningful art, could only be found outside cultural barriers. Dubuffet gave the name Art Brut to the art which in his own words, 'did not know its name'. An art so pure that its creators were not even aware that it was art at

all: Culture tightens its grip as soon as the word beauty is pronounced...Once the terrain is freed of the time-honoured measuring stick of beauty—an old tethering pole, a great phantom stake—we can return to the healthy horizontal, the wholesome barren state. The spirit has free reign once again.[4] ¶ Whatever led Dubuffet to his anticultural position, whether setbacks to his own aspirations as an artist from élitist circles or a genuine scorn for the stifling nature of bourgeois culture (long under attack from the Surrealists), his theories of the negative effects of the cultural world have an enduring truth. He argued that the cultural mainstream managed to suck in every new development, to anaesthetize its power and eventually asphyxiate genuine expression. Only Art Brut, the art of the artless, was immune. This alone could not be absorbed, smothered, devalued, indoctrinated or conventionalized by 'civilized' society: The works that make up the very substance of culture—books, paintings, monuments—must first be regarded as resulting from a misleading choice made by the cultured people of the time, and next, as providing us with altered thoughts— thoughts, moreover, that are only those very particular thoughts of cultured people, belonging to a minuscule caste.[5] ¶ For Dubuffet works of startling originality and

3. Jean Dubuffet, *L'Art brut préféré aux arts culturels* (exhibition catalogue, Galerie René Drouin, Paris, 1949), translated by Paul Foss and Allen S Weiss in *Art Brut: Madness and Marginalia*, a special issue of *Art & Text*, no.27 (December 1981–February 1988), p.33

4. Jean Dubuffet, *Asphyxiante culture* (Paris, 1968), translated into English by Carol Volk as *Asphyxiating Culture and Other Writings* (New York, 1988), pp.79–80

5. Ibid., p.18

Giovanni Giavarini
The Prisoner of Bâle
Opposite page
Gare mondiale (World station; detail), between 1928 and 1934
Chewed bread, painted
Height 92cm
Collection de l'Art Brut Lausanne
Left
La tribune, between 1928 and 1934
Height 158cm
Collection de l'Art Brut Lausanne
Right
Tête coupée à la barbiche (Severed head with goatee), between 1928 and 1934
Height 16cm
Collection de l'Art Brut Lausanne
Far right
Giovanni Giavarini, c.1927

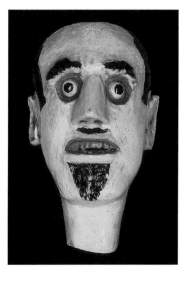

intuitive truth followed no rules and appeared in surprising places: True art always appears where we don't expect it, where nobody thinks of it or utters its name. Art detests being recognized and greeted by its own name. It immediately flees. Art is a character infatuated by the incognito.[6] ¶ By 1947 Dubuffet had organized the first exhibition under the Art Brut

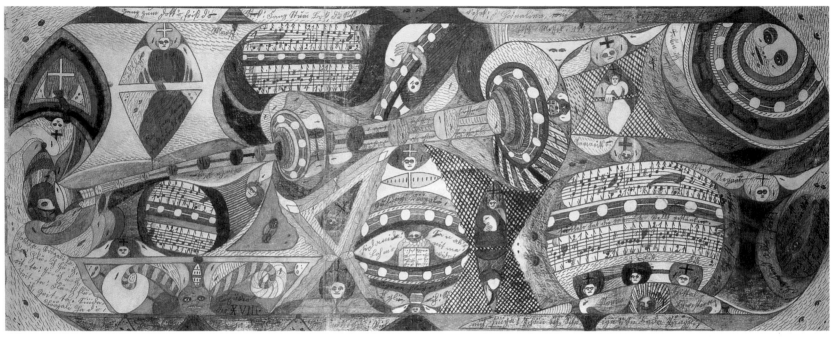

Above
Adolf Wölfli
Teleskop (Telescope), 1909
Pencil and coloured pencil on paper
37·4×97·2 cm
Adolf-Wölfli-Stiftung, Kunstmuseum Bern
Right
Jean Dubuffet in Paris, c.1963

banner as the Foyer de l'Art Brut at the René Drouin Gallery in Paris, and a year later he transferred the growing collection to a house in the Rue de L'Université owned by Gallimard publishers, under the care of the newly formed Compagnie de l'Art Brut. This new organization, which included André Breton as one of its founder members, was formed to seek out and document works of Art Brut. By the following year an exhibition of 200 works by 63 creators could be mounted at the Drouin Gallery. The exhibition was a celebration of Art Brut; unlike the previous psychiatric exhibitions, the creators were given the respect due to artists. Not only were they named and indentified, but Dubuffet's accompanying catalogue *L'Art brut préféré aux arts culturels* encouraged their elevation to greatness and set out his anti-cultural stance: What country doesn't have its small sector of cultural art, its brigade of career intellectuals? It's obligatory. From one capital to another they perfectly ape one another, practising an artificial, esperanto art, which is indefatigably recopied everywhere. But can we really call this art? Does it have anything to do with art?[7] ¶ By 1951, however, the activities

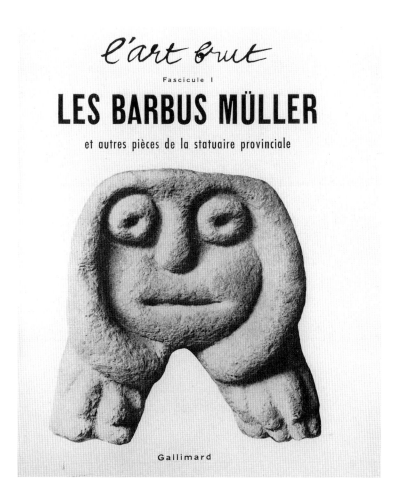

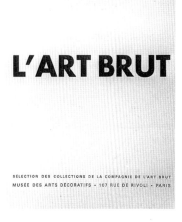

Left
The cover of *L'Art brut*, Fascicule 1, 1947
One fascicule only was published and the series was relaunched in 1964
Above
Catalogue cover for L'Art Brut exhibition,
Musée des Arts Décoratifs, Paris, 1967
Above right
Catalogue cover, L'Art Brut Préféré aux Arts Culturels,
Galerie René Drouin, Paris, 1949

7. Ibid., p.31

of the Compagnie de l'Art Brut began to run into difficulties. Discord arose between Dubuffet and Breton regarding both the role of the works of the insane within Art Brut and also its relationship with Surrealism. Breton insisted that Art Brut belonged under the Surrealist umbrella, while Dubuffet saw his discoveries as a unique strain of expression in their own right. Meanwhile, Dubuffet himself was devoting more energy to his own creative work and was less able to commit large amounts of time, money and effort to caring for and housing what had by now become a sizable collection. It was no doubt with some relief that Dubuffet accepted the offer of his friend and fellow artist, Alfonso Ossorio, to house the collection at his spacious home on Long Island. The collection was therefore shipped to the US, where it was to remain until 1962. ¶ While in America, Dubuffet addressed the Art Institute of Chicago in a lecture entitled 'Anti-cultural Positions', which detailed the negative effects of Western culture and its role in suppressing true creativity. With his collection safely ensconced at Long Island, he spent much of the next decade concentrating on his own work. It was not until his great retrospective exhibition opened in Paris in 1960 (travelling to New York the following year) that Dubuffet felt ready again to embark on his Art Brut quest. ¶ An exhibition of works from the Art Brut collection was held in February 1962

Above
The Art Brut collection at Alfonso Ossorio's estate, Wainscott, Long Island, New York, 1952
Right
André Breton at Ferdinand Cheval's Palais Idéal, Hauterives, France, 1931

at the Cordier-Warren Gallery, providing a largely uninterested New York audience with a rare viewing before the entire collection returned to Paris to be housed at Dubuffet's expense in a large building in the Rue de Sèvres, later to be the home of the Dubuffet Foundation, with the painter Slavko Kopac as its curator. In July 1962 the Compagnie de l'Art Brut was re-formed, this time with about a hundred members dedicated to the discovery and collection of Art Brut creations. Dubuffet was by now a wealthy and successful artist of international repute who found himself in a position to establish a lasting and influential role for Art Brut. He devoted more time and energy to promote a much wider awareness of Art Brut than had been possible previously. In 1964 the first of a series of *L'Art brut* fascicules was published; these offer detailed studies of creators from the collection.[8] In 1967 over 700 works by 75 creators were exhibited at the Musée des Arts Décoratifs in Paris, their importance emphasized in Dubuffet's catalogue: Those works created from solitude and from pure and authentic creative impulses—where the worries of competition, acclaim and social promotion do not interfere—are, because of these very facts, more precious than the productions of professionals. After a certain familiarity with these flourishings of an exalted feverishness, lived so fully and so intensely by their authors, we cannot avoid the feeling that in relation to these works, cultural art in its entirety appears to be the game of a futile society, a fallacious parade.[9] ¶ By 1971, Dubuffet's

8. The *L'Art brut* fascicules were published by the Compagnie de l'Art Brut in Paris between 1964 and 1973 (*L'Art Brut*, nos 1–9), and since 1977 have been published by the Collection de l'Art Brut in Lausanne (nos 10–18 to 1995)

9. Jean Dubuffet, *Place à l'incivisme*, translated into English by Chantal Khan Malek and Allen Weiss as 'Make Way for Incivism', *Art & Text*, no.27 (December 1987–February 1988), p.36

Catalogue de l'Art brut listed 4,104 works by 133 artists, with a further 1,000 creations listed under a newly formed category termed the Annex Collection (renamed Neuve Invention in 1982) consisting of works that did not meet Dubuffet's standards of purity for true Art Brut. In his mind not only were Art Brut works to be of an original and unique nature, free of any derivative or cultural influences, but their creators too had to be largely free of any cultural trappings. However, he was aware that many works of a unique nature and of visual power closely allied to those of Art Brut were produced by those with slightly more contact with society. These self-taught artists could be lorry drivers or waiters, housewives or postal workers, the unemployed or the elderly, certainly those with closer contacts with society than the outcasts, misfits, mediums and patients of pure Art Brut. Others may have been considered as *artistes bruts* when first discovered but drifted into the Neuve Invention category as their fame spread and they became more recognized artists, involved in exhibiting and attempting to make a living from their work (see Chapter 9). ¶ Dubuffet's antipathy towards the French cultural establishment was heightened by his inability to achieve any offer of permanent public housing for his collection, which by now was vast. Even the Pompidou Centre in Paris could offer it only limited space and would not guarantee that the works would be on permanent exhibition. Dubuffet had always found Switzerland to be a spiritual home for Art Brut. After all, it was here that Wölfli was first discovered and respected. Swiss doctors were at the forefront of those in support of Dubuffet's quest to honour and preserve the powerful creations of those who had previously been ignored and marginalized. It was thus that he entered into negotiations with the town of Lausanne. With the support of such local figures as the eminent psychiatrist Dr Alfred Bader from the Centre for the Study of Psychopathological Expression, the town council of Lausanne, in October 1972, ratified an agreement to provide a permanent home for the collection. The Compagnie de l'Art Brut was dissolved and work began on converting the Château de Beaulieu in Lausanne into one of the world's most extraordinary art museums. ¶ Dubuffet's epic task was nearing its end. His unique place in the development of the art of the twentieth century was ensured. Not only had he become one of France's foremost artists of the post-war period—one who was so inspired by the Art Brut creations he admired that he came close to emulating them in his directness of approach and his search for new and personal materials—he had also seen thirty years of gathering and discovery result in a permanent and public collection of this powerful and awe-inspiring art. Furthermore he gave credence to Art Brut by his stream of provocative and insightful writings. He took the art with no name and gave it not only identity but intellectual weight. It was no longer the quirky work of the insane or the outcast, it now had a secure place in perceptions of human creativity. It was not only equal to cultural art, but was actually superior—a purer and more powerful strain of creativity: The man of culture is as far a cry from the artist as the historian is from the man of action.[10]

10. Jean Dubuffet, *Asphyxiating Culture and Other Writings*, p.14

Jean Dubuffet at the opening of the Collection de l'Art Brut Lausanne, 1975
The sculpture is by Pierre Kerlaz and the paintings in the background are by Augustin Lesage

Chapter 4: THE ARTISTS OF THE COLLECTION DE L'ART BRUT

Shunning the term museum, the

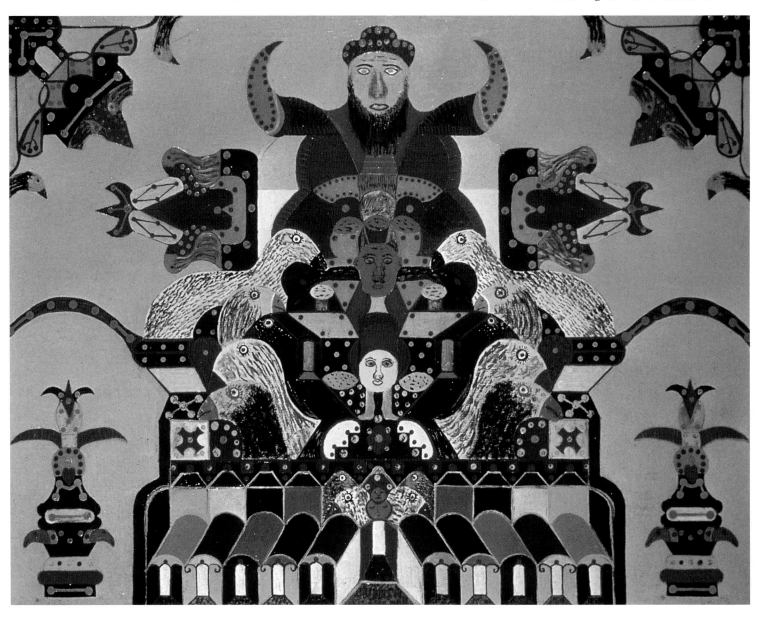

Joseph Crépin
Composition no.32, 1939
Oil on canvas
50×65cm
Collection de l'Art Brut Lausanne

Collection de l'Art Brut in Lausanne, which opened its doors to the public in 1976, is more a temple dedicated to the spirit of true human expression. Its black walls and the small enclaves designed for individual artists' work draw the visitor into a world of powerful images. Accompanied by a short and often harrowing biography of its creator, the work of each artist stands alone, often distinct in style, media and subject-matter from its neighbours. As the Collection brings together some of the most individually creative and spontaneous visionaries that Dubuffet could find, there is no overall style, no 'school' of Art Brut artists, no Art Brut 'movement'. Instead each creator's unique vision is recognized. ¶ In order to protect the Collection, Dubuffet decreed that nothing could be exhibited away from the museum. He feared that works could be devalued if they were shown alongside the 'normal' creations of contemporary artists. Likewise the name Art Brut is protected and can be used only for works in this collection or for newly discovered works that Dubuffet or his successors at the Collection officially designate as Art Brut. ¶ Dubuffet found an able lieutenant in

Above
Château de Beaulieu, Lausanne,
home of the Art Brut Collection
Right
Interior of the Château de Beaulieu,
with works by Carlo Zinelli

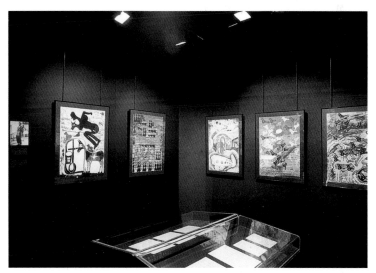

Michel Thévoz, a young curator at the Cantonal Art Museum in Lausanne.
Thévoz, and his friend Geneviève Roulin, had been frequent and enthusiastic
visitors to the Collection at its Paris home in Rue de Sèvres and had become
acquainted with Dubuffet and his curator Slavko Kopac. Before the new
Collection opened its doors to the public, Thévoz had already published his
seminal work *Art brut*, which not only traced the development of the
Collection and Dubuffet's own theories but also gave a detailed background to
many of the principal works. Dubuffet appointed Thévoz as his curator and
plucked Roulin from an accounting post in a Lausanne juke box factory to
begin her new role in life as his deputy. After Dubuffet's death in 1985 at the
age of eighty-four, Thévoz and Roulin assumed his mantle as the arbiters and
conservators of Art Brut, a task they were continuing in the mid-1990s. ¶ On entering the museum, the first images to confront the visitor are those
by the Dutchman, Willem van Genk (b. 1927). His depictions of cities around
the world, executed in garish colours, reflect the dream travels of a recluse.
Impressions based on travel books and other references present a manic pic-
ture of the world's great cities and their transport systems. Fascinated with
communism, which he hoped would bring a better life, van Genk executed a
series of paintings of Moscow, where buildings share space with tractors, air-
planes, trams and other modes of transport. His works are often covered in
writing, either reinforcing the images and the borders around them, or acting
as slogans or as titles to different areas of the painting. In *Parnasky Culture*
he combines his Russian theme with the harsh realities of Western life, using
gangsterism and American culture to make an anti-capitalist statement. ¶ Later in

Willem van Genk
Below
Parnasky Culture, 1972
Oil on wood panels
70×142 cm
Collection de l'Art Brut Lausanne
Above right
Tube Station, before 1986
Mixed media
74×124 cm
Collection de l'Art Brut Lausanne

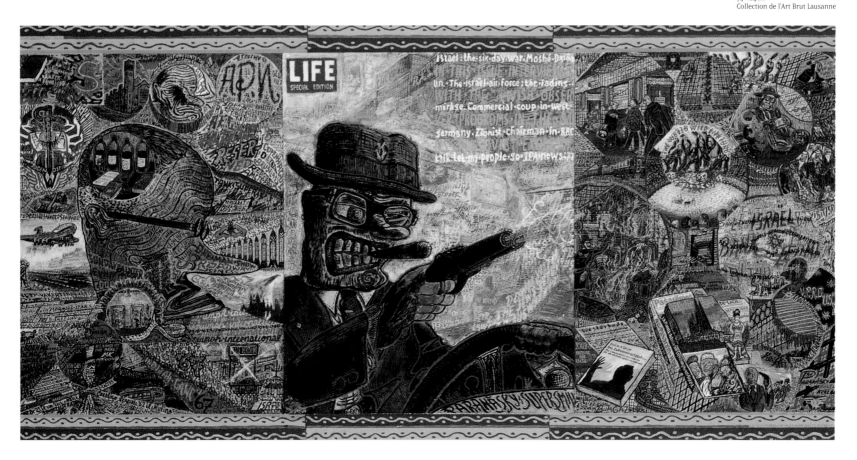

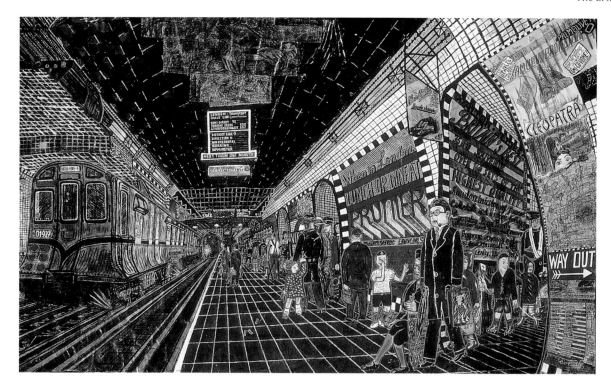

1. See Nico van der Endt, 'The Power of Willem van Genk', *Raw Vision*, no.3 (1990), pp.16–23

life van Genk drifted away from painting. In the mid-1990s he remained reclusive, finding it difficult to leave his house for fear of hairdressers. Within his home he has constructed an imposing model of a tram station out of paper and cardboard, but it is strictly not for exhibition.[1] He now concentrates on his large collection of plastic raincoats, replacing their buttons with a more imposing kind, and says he likes to feel that when he wears them he is protected by the different personalities he can adopt. ¶ One artist in the Collection whom Dubuffet came to know well was Aloïse Corbaz (1886–1964), an inmate of a mental hospital near Lausanne, whom he first met during his initial visit to Switzerland in 1945. Her work has generally been exhibited under her first name only, a common practice in early exhibitions to give anonymity to mental patients. She had an educated and cultured upbringing, and worked as a private teacher, which led her to the court of Kaiser Wilhelm II (as tutor to the daughters of his pastor) in the years before World War I. From a distance she became infatuated with the monarch and was unable to cope with her overpowering feelings. On her return to Lausanne she was overcome by psychiatric disorders, perhaps the result of long-standing problems worsened by this emotional upheaval. She was admitted to hospital in 1918, never to live outside an institution again. ¶ After a few years she

Below
Willem van Genk with part of his raincoat collection, c.1988
Below right
Aloïse Corbaz, 1963

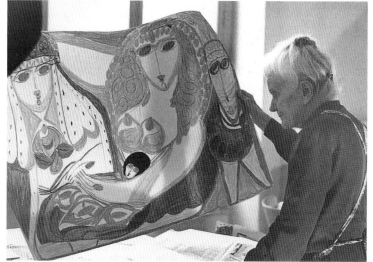

began to write and draw, a practice encouraged by hospital director Hans Steck and by Dr Jacqueline Porret-Forel, who worked with Corbaz from 1941.[2] Initially her drawings illustrated her text, which flowed out in a stream of consciousness, full of descriptive passages of love and romance:

Do not leave my arms in crowning the earth with their magnificent ballet of roses the married couples arriving in flowery gondolas passing under the florid magnolia arcs all the universe a gift to everybody everything to say a natural Christmas tree bark eternally to blossom...Under the great shade trees of Paris we took off in a dream tank of sovereign dignity a dream of Parisian paradise carried our leaders in our arms barefoot on the honeymoon stones continue rose-pearls of India in all colours...[3] ¶ Executed in coloured pencil, her drawings are

2. See Jacqueline Porret-Forel, *Aloïse et le théâtre de l'univers* (Geneva, 1994)

3. Quoted in Jacqueline Porret-Forel, *Another World: Wölfli, Aloïse, Müller* (exhibition catalogue, Third Eye Centre, Glasgow, 1978), p.28

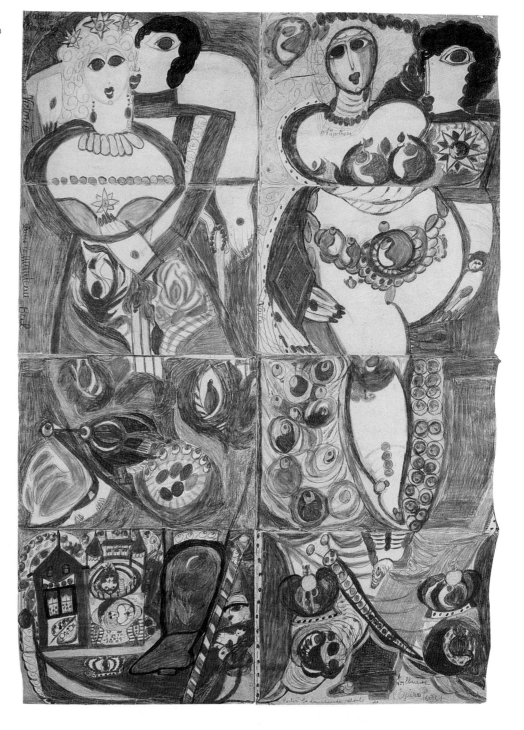

Aloïse Corbaz
Luxembourg, between 1952 and 1954
Coloured pencil on paper
164×117cm
Collection de l'Art Brut Lausanne

Aloïse Corbaz
Far left
Benito Cereno, 1947
Coloured pencil on paper
150×100 cm
Collection de l'Art Brut Lausanne
Left
Le Manteau du Matador (The matador's cape),
between 1948 and 1950
Coloured pencil on paper
171×58 cm
Collection de l'Art Brut Lausanne

dominated by a single flowing, rounded feminine presence. Bare-breasted
and resplendent, the figure is often accompanied by an upstanding young
escort in fine uniform. Sometimes the two figures, male and female, are
linked together in embrace, even sharing the same mouth or eyes. The eyes
on all her figures are simple blue ovals that seem to be both blinded and
staring; deep blue pools contrasting with the warm pinks and reds that flow
around them. ¶ In her youth, Corbaz had aspirations to be an opera singer and operatic
themes and references are commonplace in her works. She even used to sing
her favourite arias during quiet evenings at the Rosière asylum, where she
spent so much of her life. Perhaps her troubles had been too much for her
and she took refuge in madness, insulating herself from the cruel world
around her and immersing herself in the warmth of a beautiful self-made
realm of courtly passion. On her death in 1964, Dubuffet wrote: She was not mad at all, much less in
any case than everyone supposed. She made believe. She had been
cured for a long time. She cured herself by the process which consists in
ceasing to fight against the illness and undertaking on the contrary to
cultivate it, to make use of it, to wonder at it, to turn it into an exciting
reason for living. [4] ¶ On his first visit to Switzerland in 1945 Dubuffet encountered the work of
Heinrich Anton Müller (1865–1930). In the early years of the century Müller,
who was in the vine growing trade, invented a revolutionary vine pruning
machine, but the invention was unfairly stolen from him and used by others
for their own profit. The injustice of the situation seems to have brought on
Müller's psychiatric condition, and he was confined to the Münsingen clinic
in the canton of Bern, where he spent the rest of his days. ¶ At the hospital, Müller spent much time in a deep hole

4. Quoted in Michel Thevoz, *Art Brut* (London, 1975), p.133

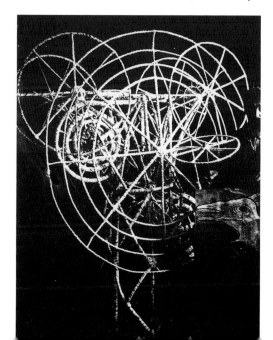
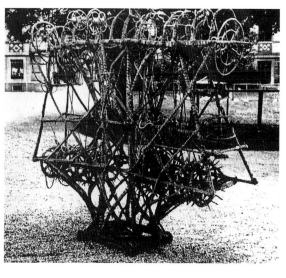

Heinrich Anton Müller
Far left
With one of his machines,
between 1914 and 1922
Left
Machine made between 1914 and 1922,
since destroyed

Aloïse Corbaz
Miekens, c.1955
Mixed media on paper
100×146cm
Collection de l'Art Brut Lausanne

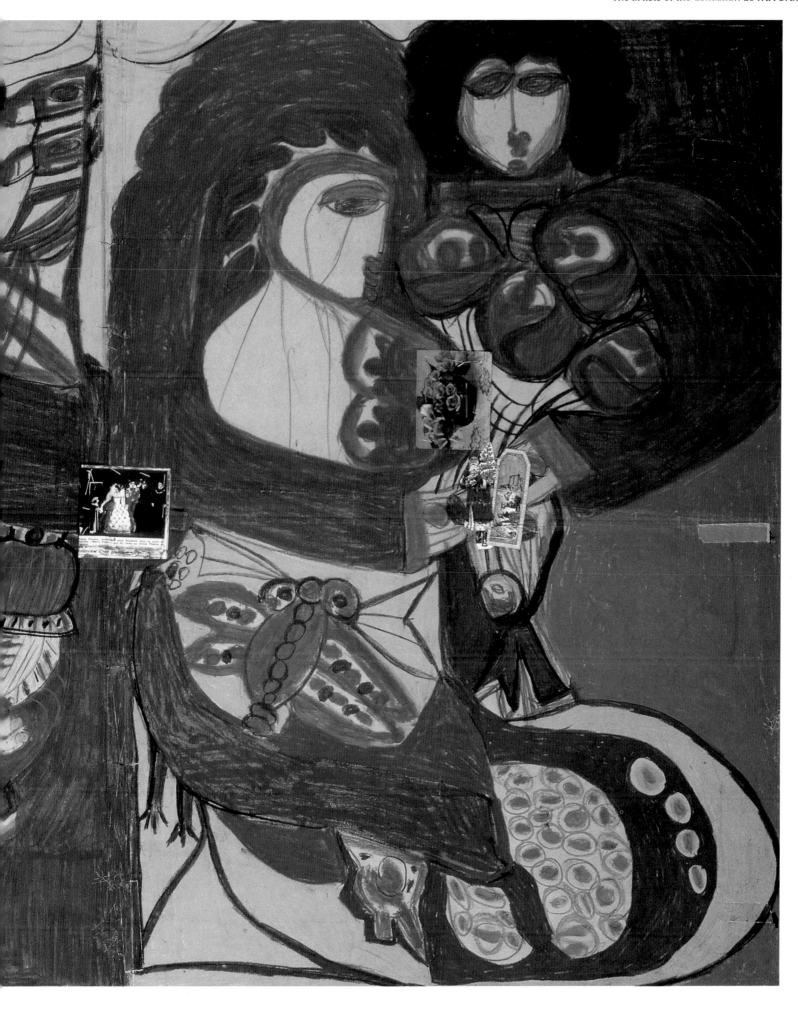

he had dug in the grounds, possibly in an effort to find solitude or privacy, but he was also active and inventive. He constructed a series of complex machines which were concerned with perpetual motion or simply with reducing gear ratios or creating energy for no apparent purpose. In later years much of his time was spent peering through a large telescope-like apparatus at a small object he had made, interpreted by his doctors as a female sex symbol. He also drew from time to time and it is his drawings that so fascinated Dubuffet. ¶ Executed on large rough sheets of paper with crude carpenters' pencils, they nevertheless show a high degree of control. Usually simple compositions, they comprise human and animal figures or occasionally just the head of a man, delineated with a strong line which imbues them with life and tension. The human forms are strangely distorted, and much has been made of the similarity between Müller's profiled heads and those produced by Dubuffet many years later. Müller's powerful drawings appear to be carefully executed and yet at the same time are flowing and spontaneous. However, in his later work, he moved away from this strong flowing line to one altogether more shaky and agitated. Dubuffet claimed that Müller went to great pains to produce forms as strange, or 'mad', as possible, and that he delighted in his own madness: Heinrich Anton manifestly loved nothing so much as his madness, this was his reason for living, and nothing enchanted him more than to project it onto living sheets of paper which he then fixed to the wall and gazed at. [5] ¶ Another hospital inmate whose work graces the Collection is Carlo Zinelli (1916–74), a victim of the trauma of war, who suffered hallucinatory and persecution manias and was committed by his family to a psychiatric hospital in Verona, Italy, in 1947. The conditions were cramped and unpleasant and the horror of the experience lingers in much of his work. Zinelli began by scratching graffiti on an exercise yard wall with broken pieces of brick. Later, as a result of the influence of the Scottish sculptor Michael Noble, the hospital established a studio, and it is thanks to this enlightened move that Zinelli was able to paint on a daily basis for the next fourteen years. ¶ In Zinelli's early work rows

5. Quoted by Michel Thévoz in *Another World: Wölfli, Aloïse, Müller*, p.39

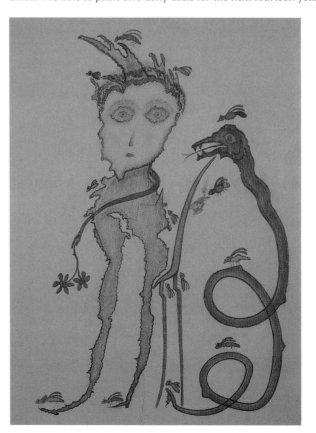

Heinrich Anton Müller
L'Homme aux Mouches et le Serpent
(Man with flies and a snake),
between 1925 and 1927
Coloured pencil on paper
57.5×42.5cm
Collection de l'Art Brut Lausanne

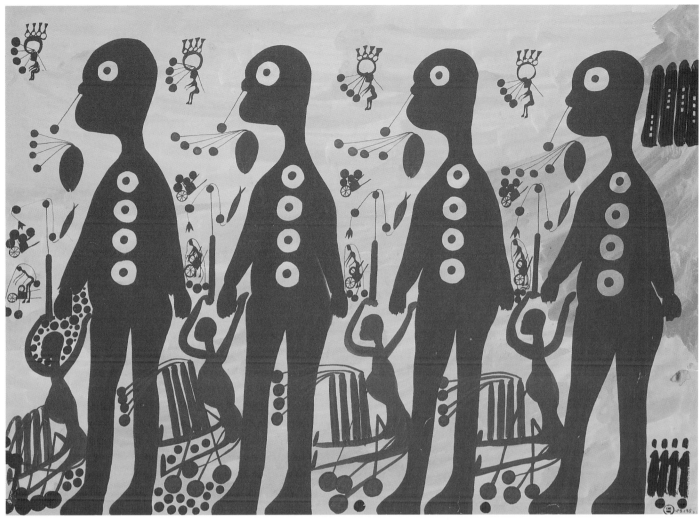

Carlo Zinelli
Quatre Personnages sur Fond Jaune
(Four people on a yellow ground), 1961
Gouache on paper
50×70 cm
Collection de l'Art Brut Lausanne

and rows of silhouetted figures echo the exercise yard and crowded
dormitories that he experienced. Occasionally other forms appear—boats,
birds and other beasts mingle with the mass of human figures or are depicted
in their own right. By 1960 he began to develop new techniques; he would
first cover the paper with a thin wash, either as a background or to create
distant forms and figures. Over this he would superimpose layers of larger,
darker silhouetted figures, usually in groups of four. Often silhouetted figures
of varied sizes are dominated by one or several large central figures of a man,
woman or bird, or the form of a boat. His most complex compositions,
crammed with tiny figures, take on the aura of an ancient tapestry or tribal
pictogram. Zinelli's later work introduced words and letters, both as
background elements and as integral parts of the composition. He repeated
the same letter-form in much the same way as he had previously dealt with
human forms. When the hospital was eventually closed and Zinelli moved
elsewhere, he found the trauma difficult and produced few new works. ¶ Not even the name is known of some inmate artists whose work is in
the Collection. 'The French Traveller' (Le Voyageur Français) is the name a
psychiatric patient at the turn of the century gave himself; his work was orig-
inally in the Paris collection of Dr Auguste Marie. Apparently a trained com-
mercial artist and designer, The French Traveller first painted a rather
prosaic watercolour of a landscape or flower arrangement. When he came to
sign his picture, what began as a humble mark in the bottom right-hand cor-
ner took off in a riot of colour of almost psychedelic proportions—another
world, another consciousness, which belies the apparent normality of the
first scene. His few known works seem to manifest schizophrenia in action,
or, as the Collection's curator Thévoz would prefer, the contrasting expres-
sions of normality and deviance.[6] ¶ Artists linked with spiritualism include

6. Michel Thévoz, *Art Brut*, p.128

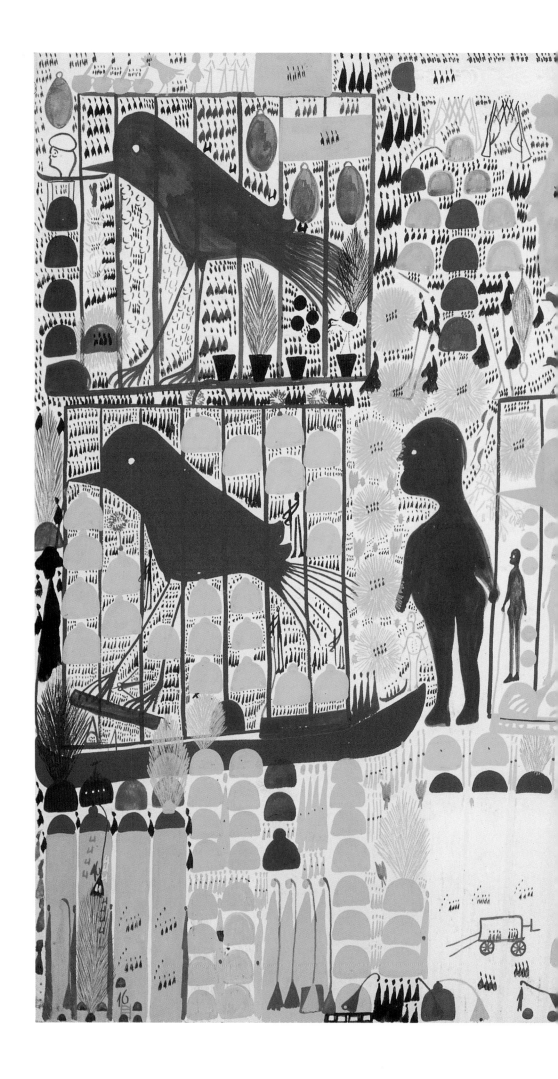

Carlo Zinelli
Oiseaux et Personnages (Birds and people),
between 1961 and 1962
Gouache on paper
35×50 cm
Collection de l'Art Brut Lausanne

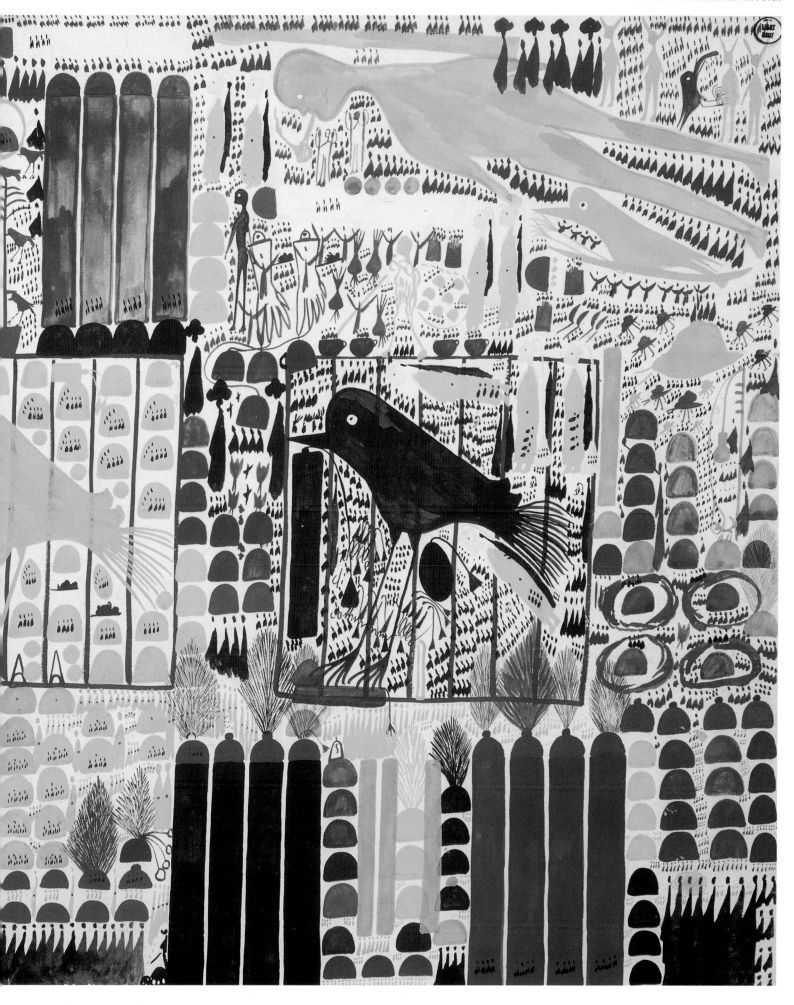

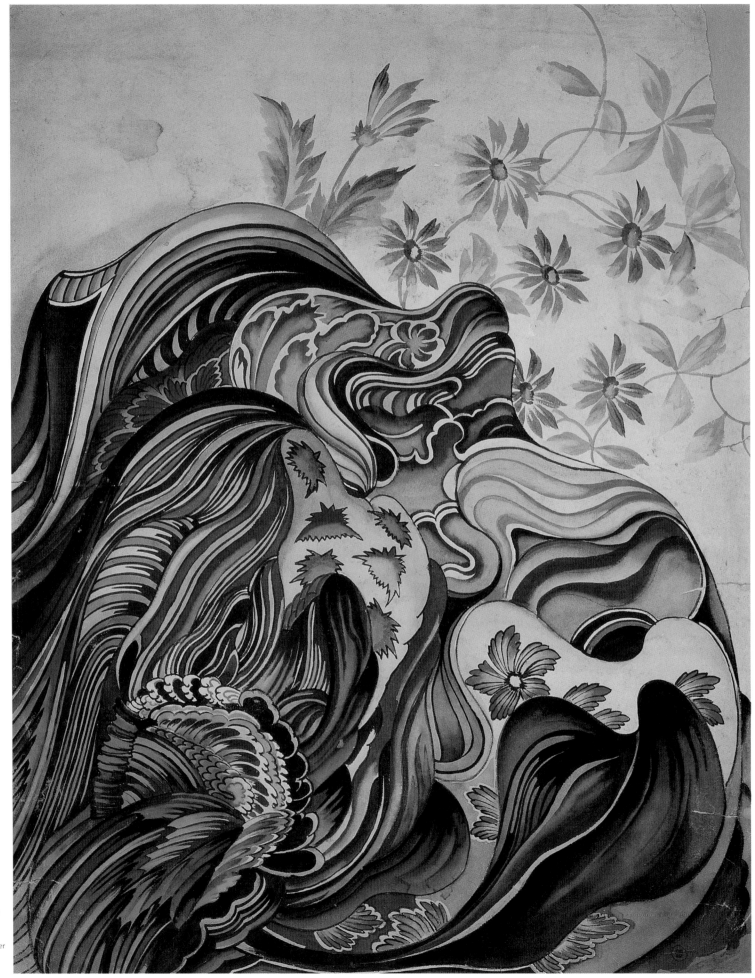

**The French
Traveller
(Le Voyageur
Français)**
*Composition aux
Fleurs* (Composition
with flowers),
between 1902 and
1905
Watercolour on paper
61·5×49·5cm
Collection de l'Art
Brut Lausanne

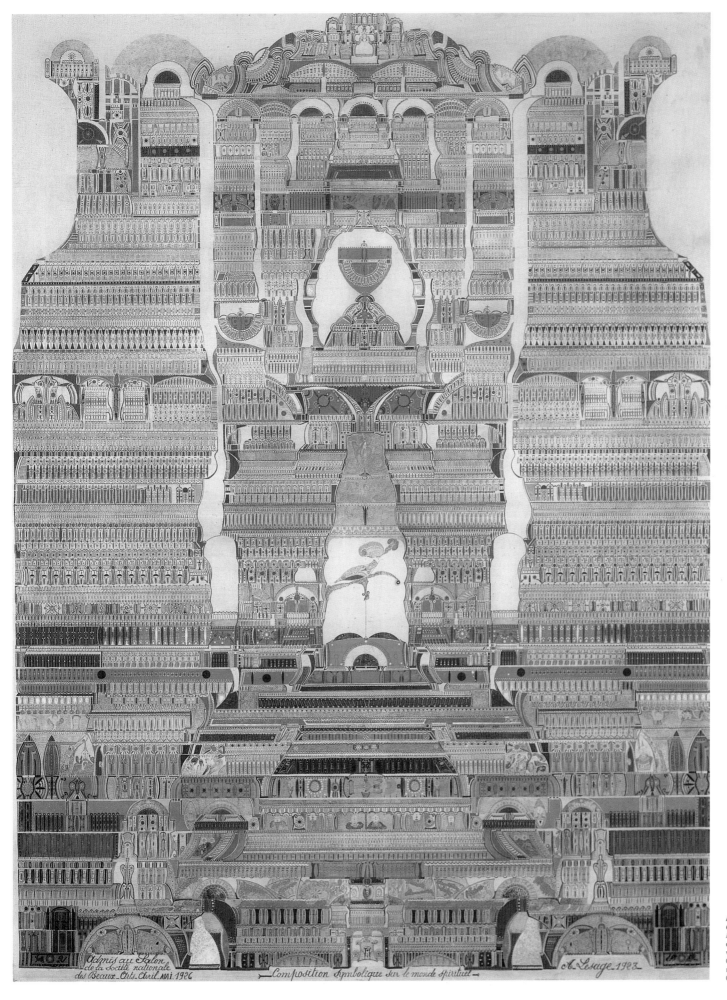

Augustin Lesage
*Composition symbolique sur le
Monde spirituel* (A symbolic
composition on the spiritual
world), 1923
Oil on canvas
158·5×177·0 cm
Collection de l'Art Brut Lausanne

Augustin Lesage (1876–1954) whose huge and highly detailed canvases are among the most imposing works in the Collection. Originally a coal miner, like his father before him, Lesage lived in a small industrial town in northern France. One day, while working at the coal face, he heard a voice telling him to be a painter. He became interested in spiritualism and was soon urged by spirit voices to buy the necessary painting materials. He bought paints and ordered canvas from the nearby provincial town of Lille and awaited its arrival. To his horror the canvas he had ordered was ten times larger than he expected. He had only very small brushes and was planning to start his work on a modest scale. The voices within him forbade him to cut the ten foot square canvas and so, with shaking hand, he began his first work by painting fine details in the top right-hand corner. ¶ After more than a year, the canvas was complete. Lesage had treated each square inch as he came to it, the whole growing in a natural and organic way, almost with a life of its own. Minutely detailed combinations of rounded forms flow across the canvas until more angular, symmetrical constructions emerge. Much of Lesage's works in the future would combine miniaturist techniques with grandiose architectural and decorative forms, unified in massive symmetrical compositions. ¶ Lesage went on to achieve a high degree of fame, both as an artist and as a spiritualist medium, so much so that he was able to give up coal-mining for the paint brush. He was at pains to disclaim any responsibility himself for the wonderful works he created. A picture comes into existence detail by detail, and nothing about it enters my mind beforehand. My guides have told me: 'Do not try and find out what you are doing.' I surrender to their prompting…I follow my guides like a child. [7] ¶ He originally signed his paintings 'Leonardo da Vinci', and then took on other personas, not signing his own name until late in life. How one is to understand his spiritualist claims is difficult to know; he could paint in perfect symmetry without recourse to drawing instruments and executed his vast detailed works in a seemingly endless flow of consciousness.[8] As his fame spread, Lesage became more educated, more aware of other art-forms, more a part of cultured society. His work became less spontaneous, containing allusions to the art of ancient Egypt and other references, and, in most estimations, it deteriorated, losing its magic and originality. ¶ Other artists in the Collection with a spiritualist base were Joseph Crépin (1875–1948) and Laure Pigeon (1882–1965). Pigeon began to draw in her fifties, after her separation from her husband, purely as a solitary, almost therapeutic activity. At least initially she believed that her drawings were guided by a spirit hand. In early works a continuous line formed a sinuous and delicate web of interlaced ribbon-like forms, occasionally breaking out into words or writing. All of her drawings are executed in strong blue ink with a great fluidity, the lacy outlines taking on the forms of ghostly, semi-transparent figures. In later work her forms are given greater solidity by infilling with pen strokes between the lines. Never considering her work to be art, she created almost in secret, and it was not until she died, aged eighty-three, that the full extent of her production became known. Hundreds of drawings, many on good quality paper, had been carefully dated and stored at her home. ¶ Country

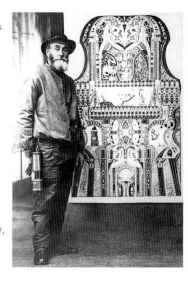

Augustin Lesage wearing his miner's lamp, c.1930-35

Laure Pigeon
Drawing '10 Novembre 1961'
Coloured ink on paper
65×50 cm
Collection de l'Art Brut Lausanne

7. Quoted in Michel Thévoz, *Art Brut*, pp.147–8

8. See Roger Cardinal, 'The Art of Entrancement', *Raw Vision*, no.2 (1989), pp.22–31

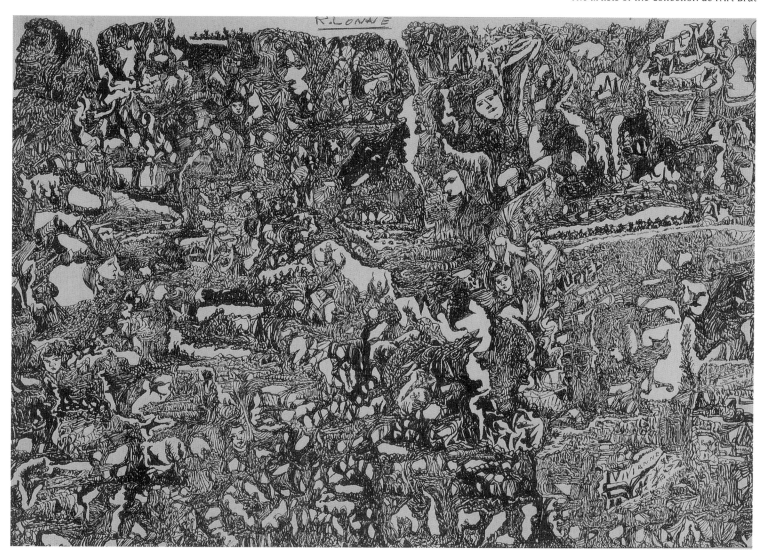

Raphaël Lonné
Above
Drawing, 1960
Ink on paper
21·5×32 cm
Collection de l'Art Brut Lausanne
Left
Raphaël Lonné, c.1965

postman Raphaël Lonné (1910–89) also claimed that the spirits moved him to create. Like Laure Pigeon he worked mainly in pen and ink, and once his pen had touched the paper he would not be disturbed until the drawing was complete. He worked in a total state of automatism, never halting to consider his next step, never changing what he had drawn. Lonné's first drawings in February 1950 were a direct result of a spiritualist experience. The roughly drawn pencil sketches of faces and beasts peering out from densely overlaid foliage display the imagery that dominates his later work. Within a month or two he had developed the more delicate style of pen drawing that became his hallmark. Conglomerations of tiny detailed heads, faces, figures, foliage and architectural forms were built up to create a flowing unified mass. ¶ The anonymous stone carvings known as the Müller Bearded figures (Les

Barbus Müller) are named for one of their discoverers, O J Müller, a Swiss. The carvings came to light in various places in the French countryside and could be the work of one person or more. Some may have been carved from stolen milestones; others are crafted from lava which gives the figures a dark and sinister presence. They have been proved to be of fairly recent origin, but have the archaic and timeless aura of ancient ritual folk art. ¶ The large drawings of Vojislav Jakić (b.1932) were added to the Collection just before it moved to Lausanne. Born in Montenegro but brought up in Serbia, Jakić had a hard childhood, both as someone from another province and as the son of an Orthodox priest, a profession frowned upon under communist rule. Although he received some education in Belgrade, for most of his life he has lived in the small town where he grew up. Since 1954 Jakić has worked on large-scale drawings, usually in ballpoint pen, and sculptures constructed of scrap wood, skulls and bones. His autobiography *Nemanikuce* (*He Has No Home*) juxtaposes real events with imagined terrors. His drawings often feature human figures and beasts in disturbing and oppressive configurations. The largest drawing in the Collection, executed on sixteen A1 sheets joined together, presents a mass of interconnected figures, heads, snakes and other small creatures. Some are modelled to give a sense of solidity, while others, simply described by line, overlap in an unnerving transparency. In other drawings no free space remains; the figures all are entwined in one coagulated mass of heads, hands, mouths and bulging body parts. The inscription on one of his works reads: This is neither a drawing nor a painting but the sedimentary deposit of suffering. ¶ Many small-

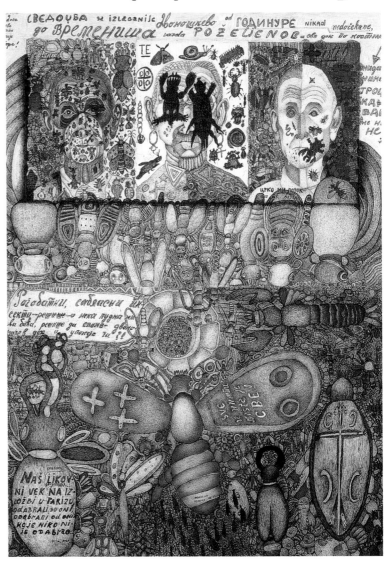

Vojislav Jakić
Les effrayants Insectes cornus...
(Frightening horned insects...), c.1970
Ballpoint pen and coloured pencil
1·41×1·00m
Collection de l'Art Brut Lausanne

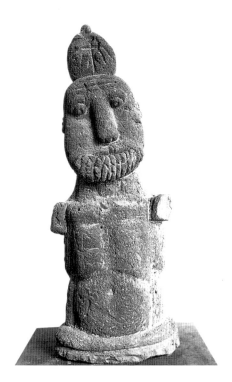

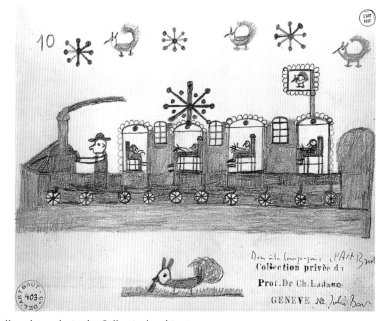

scale works in the Collection are displayed on the upper floors in a series of cabinets. Many of these striking Art Brut creations were donations from early psychiatric collections. The tiny drawings of Julie Bar (1867–1930) came from Dr Charles Ladame's famous collection at Bel-Air in Geneva. Bar suffered mental disorders which resulted in her entering an institution for treatment in 1916. Her works feature small human figures, drawn in profile or face-on, and such creatures as birds and cats. Bird beaks appear on some of the human figures and even four-legged animals seem to have beak-like mouths. Many of her compositions have a finely balanced simplicity; some employ houses which are open to the viewer, like a doll's house, and are surrounded by her elongated birds and decorative forms. ¶ Among the most intriguing small-scale works in the Collection's cabinets are the minutely detailed pencil drawings of Edmund Monsiel (1897–1962). During World War II, Monsiel's small shop near the Polish town of Lublin was requisitioned by the invading German forces. The event terrified Monsiel and, fearing arrest, he spent the rest of the war in hiding in the windowless attic of his brother's house. In this dark and solitary place he began to draw by the light of a candle, and he continued to draw over the next twenty years. When the war was over he remained isolated, entering society only to work at his job as a weighing machine operator. He was a quiet and deeply religious man who feared and hated the forces of evil in the world. The full extent of his creativity did not become apparent until his death, when hundreds of drawings were discovered at his home. Although many were lost or destroyed by a family that held his work in little regard, about 500 of these gems were preserved. ¶ The image of God, complete with moustache, dominates many drawings. Often the features are repeated. Where there was no space left on the small sheets of paper to fit in any more faces, Monsiel added just the eyes—hundreds of eyes may stare out of a composition. The perfection and clarity of the detail is extraordinary. While a crucifix or larger faces and figures may occur, it is the mass of tiny faces which completely dominates the drawings, streaming and flowing around and within everything else, until the whole surface buzzes with microscopic movement. ¶ The opening of the Collection de l'Art Brut in 1976 was

a milestone in the appreciation of these vital and unique works which no
established art museum would touch. Even today few art museums are pre-
pared to accept such works in their permanent collections. The Collection has
been a revelation to many thousands of visitors, some of whom have even
been inspired to found similar museums in their own countries.

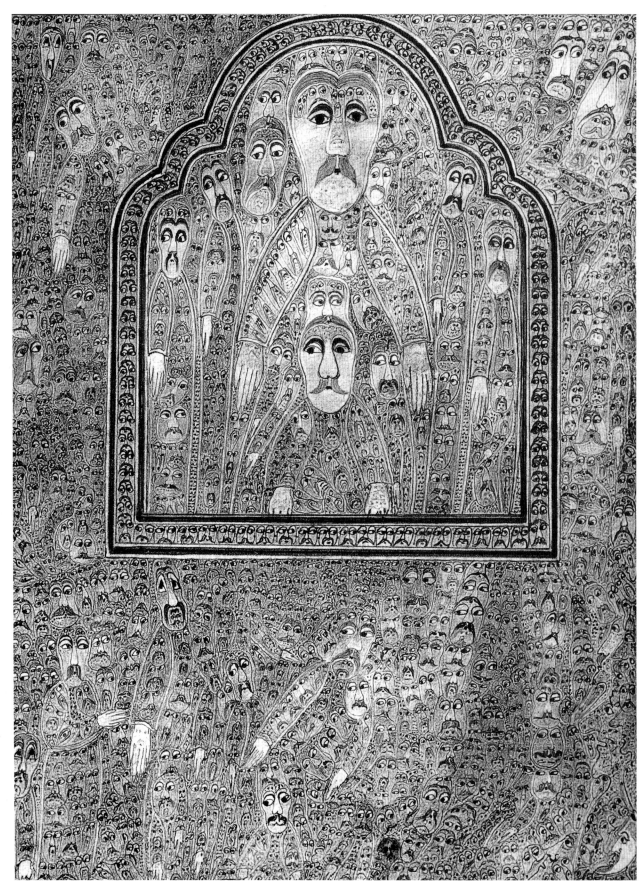

Edmund Monsiel
Untitled, c.1949
Pencil on paper
17·7×13·2cm
Collection de l'Art Brut Lausanne

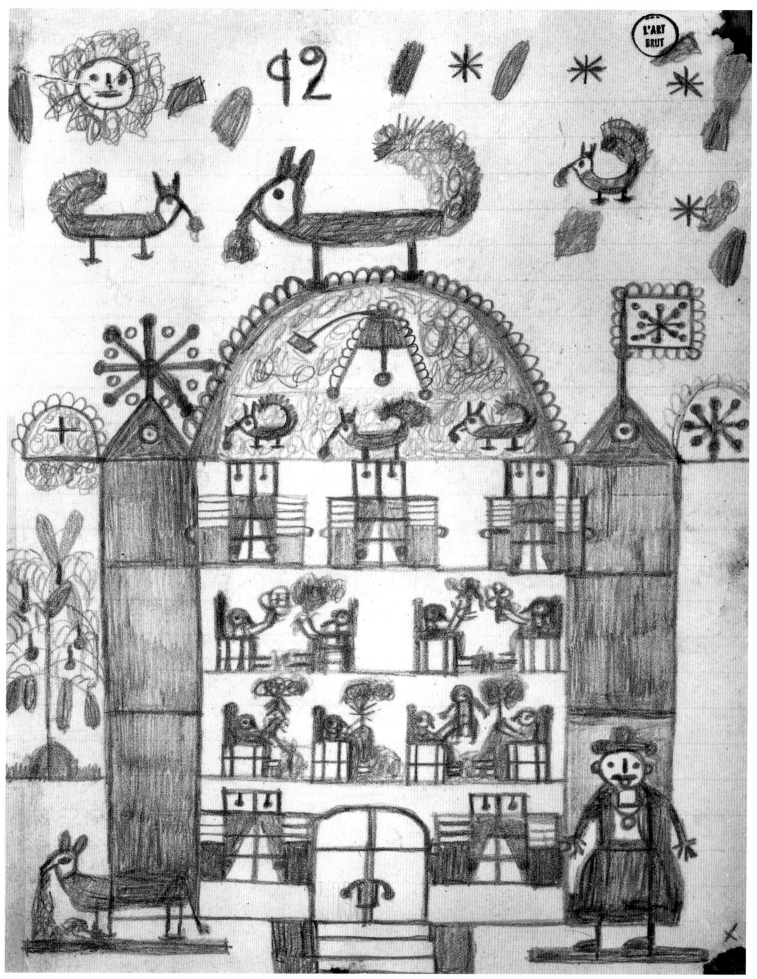

Julie Bar
House and birds,
c.1920
Pencil on paper
22×17 cm
Collection de l'Art
Brut Lausanne

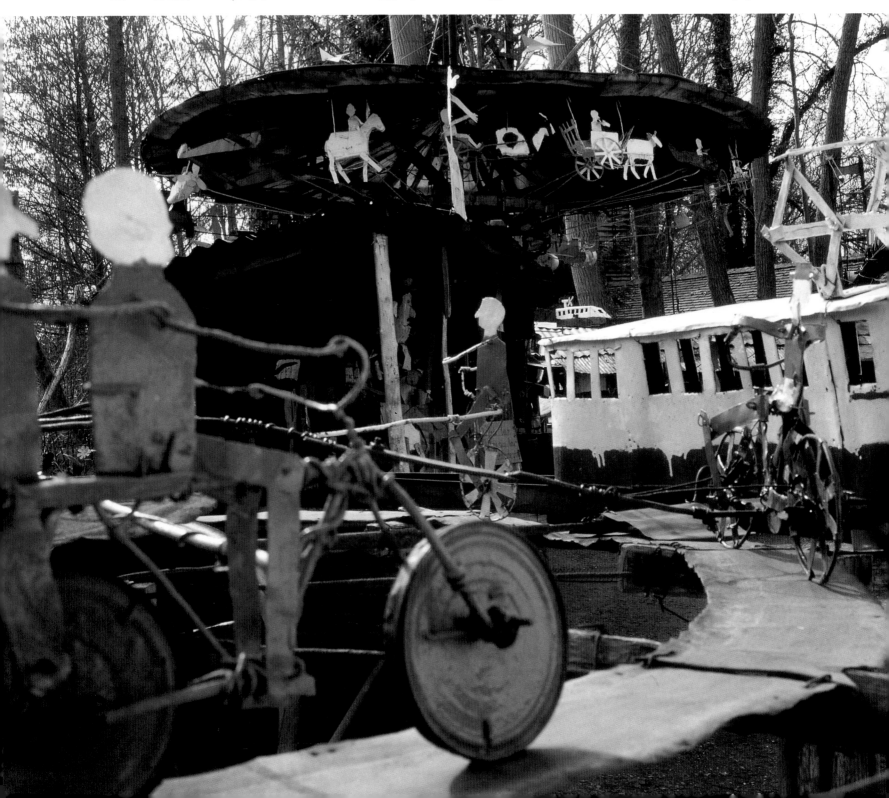

Chapter 5: OUTSIDER ART AND EUROPE

When the French newspaper *Le Monde*

announced the imminent departure of Dubuffet's collection to Switzerland in September 1971, Art Brut's devoted following in Paris were shocked. The architect Alain Bourbonnais contacted Dubuffet with a view to setting up some alternative to fill the void. Dubuffet provided the names and addresses of thirty-five living *artistes bruts*. A year later Bourbonnais opened a new Paris gallery, L'Atelier Jacob, with an exhibition of the work of Aloïse, on loan from Dubuffet himself. ¶ Bourbonnais's collecting, however, developed on different lines from Dubuffet's, which largely had psychiatric art as its starting point. Bourbonnais made contact with self-taught artists from all over France, and built up close relationships with many of them. As time went on there were fewer works of the mentally ill at L'Atelier Jacob and far more by self-taught rural creators, those whom Dubuffet might include under the term 'Neuve Invention' rather than Art Brut. This emphasis on popular and rural folk art gave the L'Atelier Jacob collection a distinct identity, with a broader rationale than that of Dubuffet's. It even included Bourbonnais's own works, the large puppet-like creatures, some constructed around bicycles, that he called 'Les Turbulents'. Bourbonnais saw the works in his collection as simply art 'hors les normes' (outside the normal), a term that Dubuffet himself had proposed as a means of avoiding the intellectual arguments surrounding Art Brut.[1] ¶ In 1978, through the

Left
Part of Le Manège de Petit Pierre at La Fabuloserie-Bourbonnais, Dicy
Below and below right
Alain Bourbonnais in and among his 'Les Turbulents'

1. Michel Ragon, *La Fabuloserie: Art hors-les-normes* (Paris, 1983), p.159

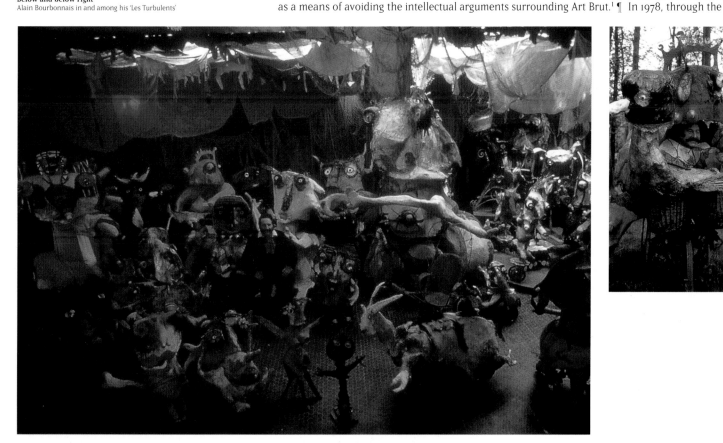

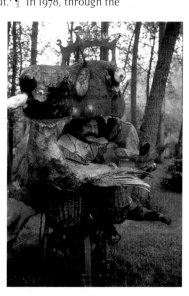

initiative of Alain Bourbonnais and the writer Michel Ragon, the ARC section of the Musée d'Art Moderne de la Ville de Paris staged Les Singuliers de l'Art, a huge exhibition with 345 pieces from L'Atelier Jacob. No actual works from the Collection de l'Art Brut were loaned, but artists whose work was represented in it, such as mediums Augustin Lesage and Raphaël Lonné, were exhibited alongside such self-taught Bourbonnais discoveries as Francis Marshall and Pascal Verbena. Artists on the fringes of culture, such as Boris Bojnev and François Ozenda, were also included, as was Bourbonnais himself, who, unlike Dubuffet, had no qualms about exhibiting alongside his discoveries. The exhibition contained no art of the mentally ill, but reflected a broad interest in intuitive creation with a strong emphasis on French rural expression. Large photographs documented the environmental creations being discovered around the country (see Chapter 12). The exhibition was hugely popular: it was viewed by an estimated 200,000 visitors. ¶ In 1983 L'Atelier Jacob closed and the Bourbonnais collection, which included some major outdoor sculptural pieces rescued from the threatened gardens of naïve country creators, was moved to La Fabuloserie at the Bourbonnais country home in the village of Dicy, near Auxerre. Housed in a series of interconnecting converted rural buildings, the collection, which after Bourbonnais's death in 1988 has been curated by his wife Caroline Bourbonnais, presents a fascinating mixture of works—humorous, mechanical, erotic—with a strong emphasis on the three-dimensional. ¶ The setting dis-

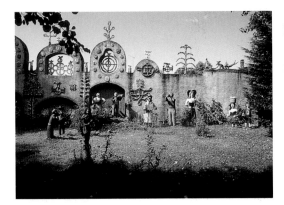

Left
Camille Vidal's figures in front of François Portrat's Le Mur du Parc in the grounds of La Fabuloserie-Bourbonnais, Dicy
Left below
Interior of La Fabuloserie-Bourbonnais, Dicy
Right
Charles Pecqueur's sculptural representation of Alain Bourbonnais in the grounds of La Fabuloserie-Bourbonnais, Dicy

Francis Marshall
Above left
La Confession, 1973
Rags, stockings, wood, rope, and other materials
103×62×60cm
La Fabuloserie-Bourbonnais, Dicy
Above
La salle d'attente (The waiting room), 1973
Rags, stockings, wood, rope, and other materials
102×220×69cm
La Fabuloserie-Bourbonnais, Dicy

plays to great effect the tableaux of Francis Marshall (b.1946), consisting of doll-like creatures of human size constructed out of stuffed stocking and tights material and topped with human hair. The ghostly figures with rough facial features are trussed up with rough rope and string and take on a timeless and disturbing presence as they sit around a frugal meal or in a waiting room—presumably waiting forever. ¶ The use of scraps of discarded material also characterizes the powerful constructions of Michel Nedjar (b.1947). As a child he played with his sister's dolls, and as an adolescent he collected scraps of material from around the Paris flea market to make his own. But Nedjar's dolls are no ordinary playthings; they are closer to the fetish objects of Africa or New Guinea than to anything seen in the West. Made of string, rags and feathers, they generate a psychic aura, an alchemical power. The harrowing nature of Nedjar's dolls and much of his later work is rooted in his horror at learning as a teenager of the Holocaust and the terrible suffering of his own family.[2] ¶ After his discovery by Bourbonnais, Nedjar was

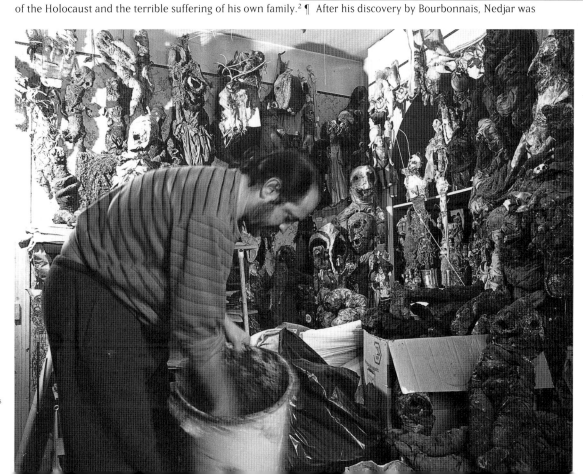

Michel Nedjar at work among his dolls

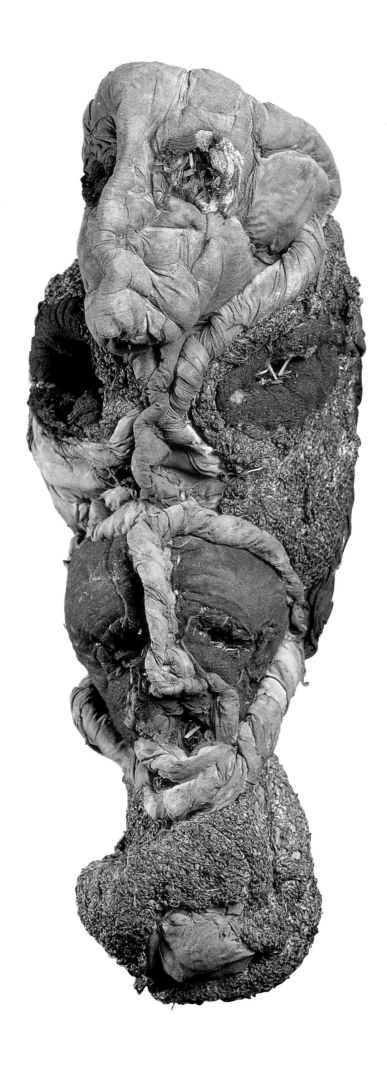

Michel Nedjar
Three Heads, 1981
Dyed cloth
54×23×37 cm
Outsider Collection and Archive, London

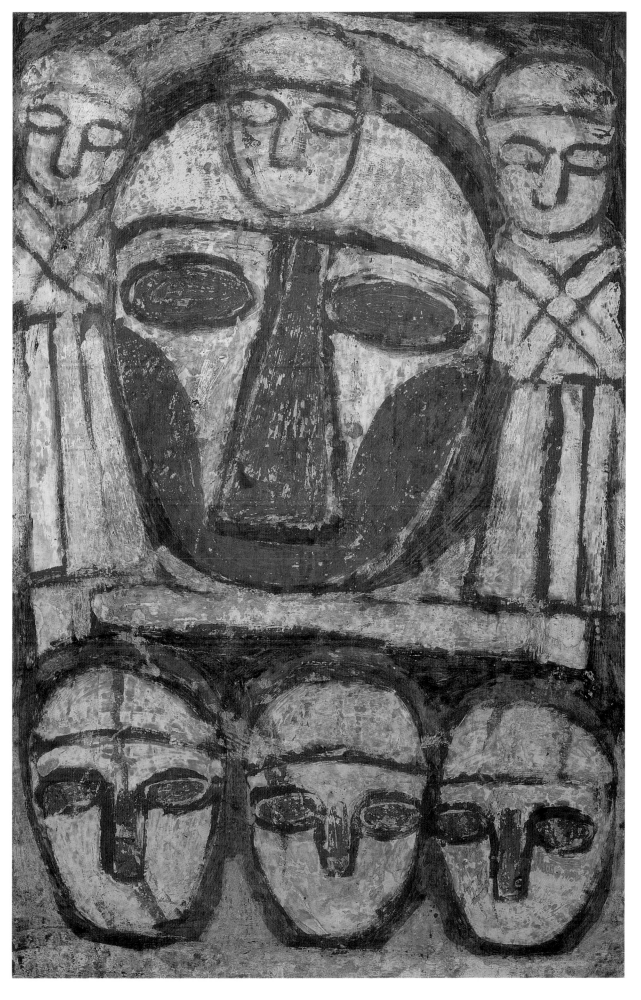

Michel Nedjar
Untitled, 1987
Paint and wax on paper
60×40 cm
Outsider Collection and Archive, London

represented in the Collection de l'Art Brut, but his subsequent fame and development as a professional artist exhibiting on both sides of the Atlantic has led him beyond Dubuffet's strict criteria for Art Brut. From his dolls he developed gargoyles, monstrous creatures of rags whose threatening faces loom down at the viewer. In later years he has produced a series of papier mâché reliefs of figures and faces which have the same archaic menace as his rag pieces. His more recent creations have been rough textural paintings of figures, faces and creatures, in which his early themes find new expression. Nedjar also has made a sizable collection of powerful—often magical— objects, many brought back from travels in North Africa, India and South and Central America, which hang on the walls of his small Paris flat. ¶ Another creator drawing on themes of magic who developed from being an *artiste brut* is Pascal Verbena (b.1941), who in the mid-1990s still worked as a Marseille postal worker, just as he did when Bourbonnais first met him. His intricate works are constructed from carefully crafted pieces of driftwood. These 'Habitacles', or abodes, house figures behind creaking doors and in secret compartments. Most of Verbena's pieces have hidden within them tiny scraps of paper containing some cryptic drawing or pictogram. He says: **I don't just take any old piece of wood, I gather them in winter at river mouths and on beaches when no one is around. I work on experience. I invent, that's my way of discharge. They're bottles thrown into the sea with messages inside.**[3] ¶ For some Art Brut supporters Bourbonnais's broadly based holdings did not compensate for the loss to Switzerland of the Art Brut Collection. Michel Nedjar, along with two other artists closely associated with Art Brut, Madeleine Lommel and Claire Teller, founded an organization they called L'Aracine to agitate for a French Art Brut museum. Their title, a play on the French word for 'root', was chosen to glorify the 'art that stemmed from the very roots of man'; they took as their symbol a mosaic sun created by self-taught artist Josué Virgili (1901–91). By 1986 they had secured an agree-ment with the Parisian suburb of Neuilly-sur-Marne to provide a building, and France's own Art Brut museum became a reality. ¶ The Collection of the Musée d'Art Brut, L'Aracine, has grown

3: *In Another World: Outsider Art from Europe and America* (exhibition catalogue, South Bank Centre, London, 1987), p.48

Above
Josué Virgili
Mosaic sun, symbol of L'Aracine
Right
Virgili among some of his creations

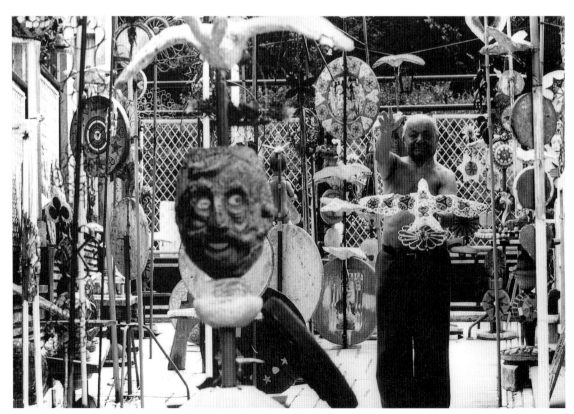

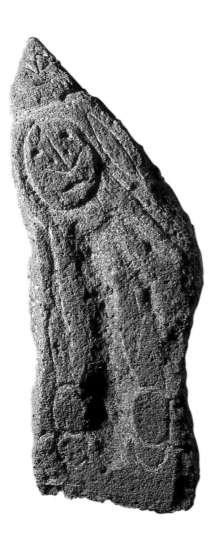

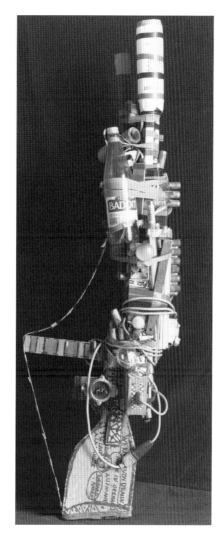

Far left
Joseph Barbiéro
Untitled, between 1965 and 1985
Stone
Height 65 cm
La Fabuloserie-Bourbonnais, Dicy
Left
André Robillard
Untitled, 1936
Mixed media
Height 145 cm
L'Aracine, Musée d'Art Brut

to over 3,000 works, standing second only to Lausanne as an Art Brut collection. Since 1983, Madeleine Lommel has acted as curator and guardian of the collection and a move to a larger building was planned in the mid-1990s. The collection has grown by purchase and donation to represent many of the great figures of Art Brut, including Lesage, Wölfli, Lonné, van Genk, the carver Auguste Forestier, the blind maker of complex machines Emile Ratier and the English mediumistic artist Madge Gill. ¶ Among artists represented in both the Lausanne Art Brut and L'Aracine

Jules Leclercq
Tapestry
92×120 cm
L'Aracine, Musée d'Art Brut

collections is André Robillard (b.1932), a hospital inmate originally confined at the age of nineteen for violent behaviour. Ten years or so later, while still in hospital, he experienced a sudden burst of creative energy. In a period of just a few months he constructed a series of dummy firearms made from any scrap he could find. The end results were not intended to be art objects, they were genuine objects of aggression which Robillard enjoyed carrying around, and a sense of menace stays with them. Other artists, such as Joseph Barbiéro (b.1901), the carver of volcanic stone heads and figures, or tapestry maker Jules Leclercq (1894–1966), are represented mainly at L'Aracine. ¶ On a humbler scale, a small private collection

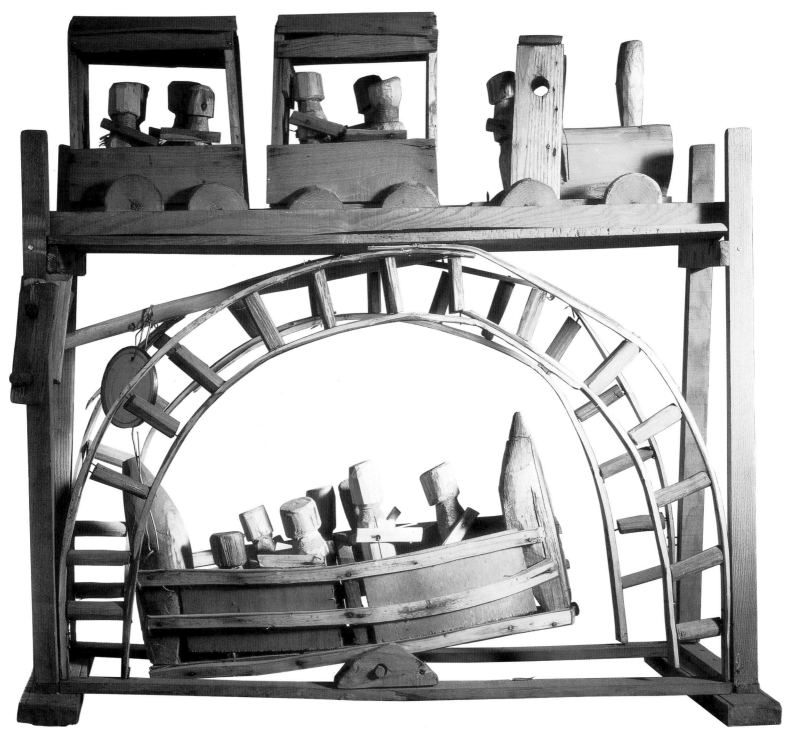

Emile Ratier
Above
Viaduct, 1972
Wood
85×90×45cm
La Fabuloserie-Bourbonnais, Dicy
Left
With his perpetual clock, *c*.1965
Pascal Verbena
Right
In his Marseilles studio with his Holocaust sculpture
in the background, 1982
Opposite page
Untitled, 1977
Wood
116×72×15cm
Outsider Collection and Archive, London

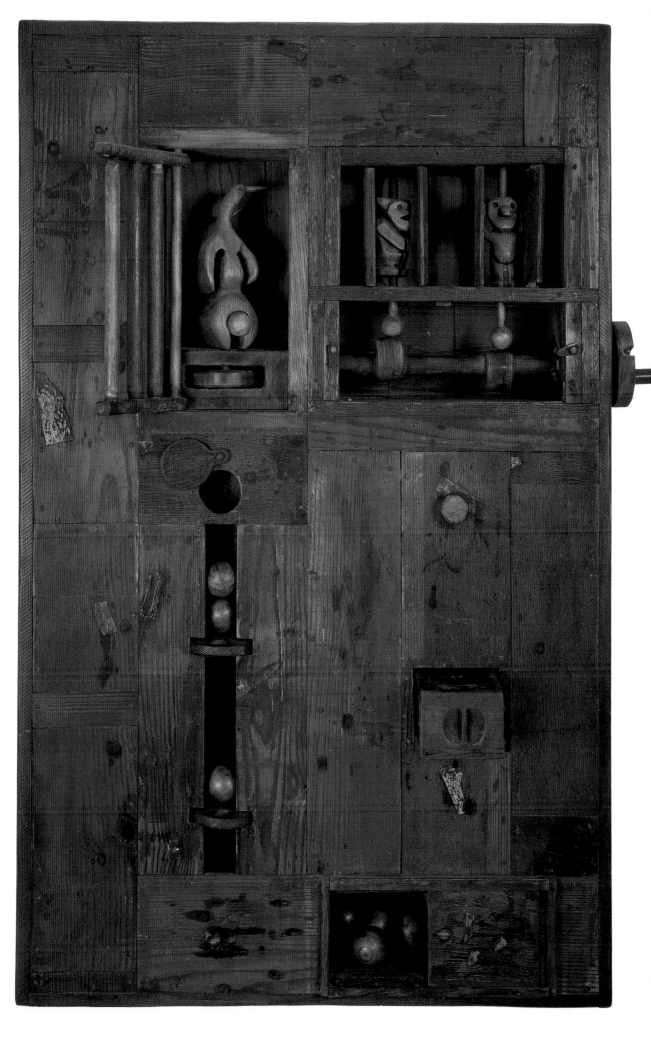

opened in 1969 in a medieval building in the southern French area of
Ardèche. The Petit Musée du Bizarre, under the direction of writer Serge
Tekielski, known as Candide, can claim to be one of France's earliest estab-
lished collections. A precursor to other small museums in France to be
opened over the following years, the collection of strange rural carvings and
artefacts is dominated by the imposing presence of the narrative works of
Gérard Lattier (b.1937). Painted on canvas mounted on rough pieces of wood,
Lattier's works depict historical and personal events in bizarre and some-
times horrific detail, all accompanied by a hand-painted text, often attached
to the paintings by strips of leather. The effect is reminiscent of medieval
altar pieces. ¶ In Belgium, the Art en Marge (Art on the Margins) organization was
founded in 1986 under the directorship of Françoise Henrion. Funded by a
variety of government and cultural bodies, Art en Marge became a centre for
the collection, exhibition and study of works on the periphery of established
culture. Although its exhibition programme has included such figures as
Willem van Genk, Madge Gill and Scottie Wilson, it lays particular emphasis
on the art of Belgian handicapped artists, such as Jean-Marie Heyligen
and Dominique Bottemanne. ¶ Across the Channel in Britain, there had been for many years an interest
in the art of the insane; after all, the Scottish pioneer Dr W A F Browne had
published his serious study *Art in Madness* as early as 1857. Recent collec-
tions of patient art had been built up in Scotland by Joyce Laing[4] and in
England at the Royal Bethlem Hospital in Beckenham, Kent, where a small
museum opened in the mid-1980s under the direction of Patricia Allderidge.
The nucleus of the Bethlem archive, which includes the work of Bethlem's
famous patient Richard Dadd, was the Guttmann–Maclay Collection, founded
by Dr Eric Guttmann and Dr Walter Maclay in the 1930s and housed at the
Institute of Psychiatry in London until the late 1970s. Edward Adamson, an
artist who worked for almost forty years with mental patients at Netherne
Hospital in Surrey, had also built up a vast collection of works by patients,
the most well known of whom were William Kurelek and Rolanda
Polonsky.[5] ¶ An awareness of Art Brut and Dubuffet's theories owes much to the activi-
ties of Roger Cardinal and Victor Musgrave. Cardinal, a humanities lecturer at
the University of Kent, had been involved with the study of Surrealism since
the 1960s and this led to an interest in the 'wild men' on the outskirts of the
movement. Cardinal's starting point was the postman Ferdinand Cheval and
his mammoth creation, the Palais Idéal, at Hauterives in southern France. ¶ A short but inten-

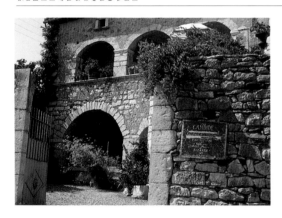

Left
Petit Musée du
Bizarre, Lavilledieu,
Ardèche, France

Left
Anonymous rural
creations
Stone
Petit Musée du
Bizarre, Lavilledieu
Right
Gérard Lattier working
at home, c.1986

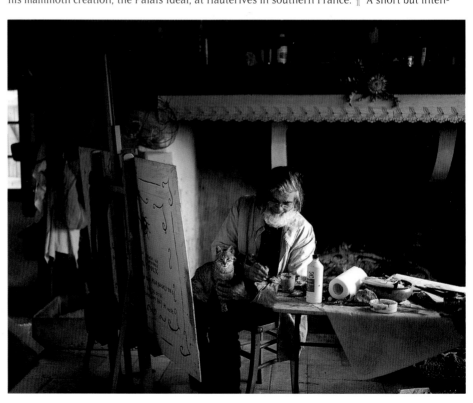

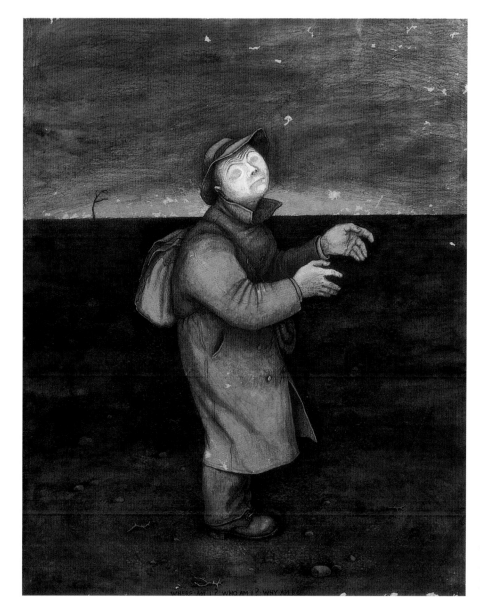

William Kurelek
Where am I? Who am I? Why am I?
Oil on canvas
38×51cm
American Visionary Art Museum, Baltimore
Edward Adamson Collection

sive period of study led Cardinal to Dubuffet's collection at the Rue de Sèvres, to the Prinzhorn Collection in Heidelberg and to the Wölfli Foundation in Berne. These collections were at the time held almost clandestinely. Letters of introduction had to be written and conservators approached to allow Cardinal to study the works behind closed doors. Within two years he had completed his classic work *Outsider Art*. Cardinal's book investigated a body of work which had never previously been considered together. He drew parallels between the early psychiatric collections, the Collection de l'Art Brut and the environmental creations which were gaining recognition on both sides of the Atlantic. His influential book led many of its readers to embark on their own voyages of discovery. ¶ Cardinal proposed the term 'Outsider Art' as the English equivalent of 'Art Brut', one that would appeal more than the original, while at the same time avoiding the complications of using Dubuffet's protected terminology. However, confusion arose as Dubuffet shifted certain artists included in Cardinal's book from the Art Brut category to that of Neuve Invention (at that time called the Annex Collection). Over the years 'Outsider Art' has moved even further away from being an exact synonym of Art Brut. ¶ When Dubuffet re-formed the Compagnie de l'Art Brut in

Gérard Lattier
Left
Il faut bien vivre! (You've Got to Live!), 1980s
Gouache on canvas stretched over wood
c.90×120cm; c.90×120cm

There's just been a drama in Hillside cul-de-sac: The other day my son Renaud calls me up on the phone in a distraught state; our neighbour has just come along enraged with the dead body of his pet rabbit in his arms. My bloody cat, Kilou, has just killed it: a pet rabbit which they had nourished on Nestlé's milk for four years. Everybody is crying in the house and the angry neighbour is threatening to kill the cat in revenge and Renaud, my boy, very upset, doesn't know what to do and is calling for help.

So I say to him, Renaud, my son, keep calm, we're coming home and I'm going to offer my condolences and take care of everything.

I return speedily with Annie and we find Renaud all upset with the body of the dead rabbit at his feet.

I go with my head hung low in shame to the neighbour's and find the family in tears; I cry a little myself and try to console them and to save the skin of my bloody cat, who hardly deserves it. I explain that cats are cats, and their instincts make them hunters, and we can't do anything about it; it's their nature.

And the neighbour says to me that he understands and apologises for his anger and asks me to bring over the body of the unfortunate rabbit so that he can throw it in the rubbish. So I ask him to leave the body to me so I can bury it at the foot of the lime tree so its death will serve a purpose; it will make the tree grow.

The neighbour agrees to that and I go home...And then I think that it would be a sin to bury such good food and that I would do just as well to make a stew...In the process of pulling apart the rabbit, me on one side and Annie on the other, suddenly there's a crack. The rabbit breaks in two and its insides fly everywhere.

What a mess! But nevertheless the rabbit has given us a good stew and everyone has had a feast, and even the cat Kilou has had a share despite the fact that he hardly deserves it, this bloody killer of a pet rabbit.

Opposite
La Révolte à l'hospice
(Revolt at the Old People's Home), 1984
Gouache on canvas stretched over wood
62×85cm; 66×82cm

Old people in my day, when they couldn't work any more, stayed with the family and told stories to their grandchildren; but now there's no room left in the house, so the elderly are replaced by the television and put into homes. At Villeneuve de Berg, where the old people of the Ardèche region are packed in, the bistros are filled with old men who play cards waiting for death; it's odd.

And my cousin, Michael Theron, who goes there to sell his cheeses at the market, told me the following story:

The little old people of Villeneuve de Berg have a pet hate: it's François, the village carpenter, a little mad and the maker of coffins.

This François is in the habit, every morning after drinking his coffee and eating his pastry, to go for a stroll to the home to see if one of the old ones hasn't dropped dead in the night...if that's the case, he goes whistling off to the morgue, with his folding rule he takes the corpse's measurements, perkily returns to Villeneuve de Berg, makes the coffin and arrives a few hours later with it in his wheelbarrow.

And the hearts of the little old people are chilled; they feel touched by the shadow of death and their day is ruined.

So, one day they decide to act and teach François a lesson that he won't forget! One morning when the morgue is empty one of them slips inside and lies down flat, rigid, on the table reserved for the dead...Along comes François, whistling, and rule in hand, he leans over the 'corpse' to take its measurements.

What a shock! The corpse leaps up and the dead person grabs him round the neck! In a state of panic François makes a bolt for it howling like a polecat, while the old people, hidden behind the door, are killing themselves laughing!

There's a hell of a row in Villeneuve de Berg and the director of the home gathers all the old people to chastise them, saying it isn't the done thing at all, these naughty practical jokes, and they will be deprived of television and dessert.

But it doesn't make a blind bit of difference, they have laughed so much, these little old people of Villeneuve de Berg, that it's well worth an orange.

François, thereafter, keeps his nose clean and waits quietly for a word from the administration before appearing.

And myself, Lattier, in wonder, have painted the story in homage to the little old people of Villeneuve de Berg who revolt against the sadness of death and in their old age carry out practical jokes so mischievous that they are deprived of television and dessert.

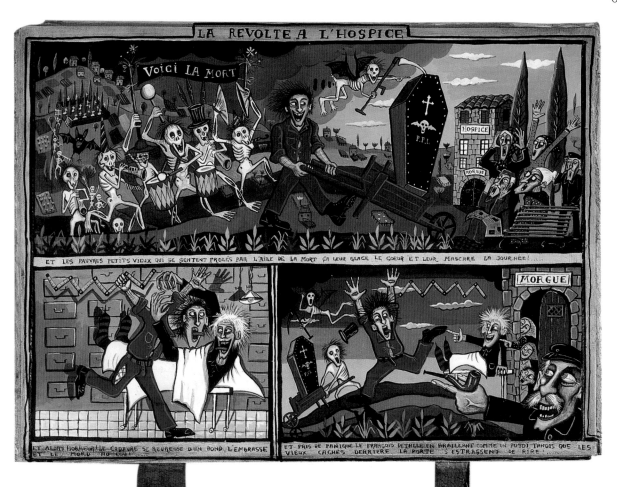

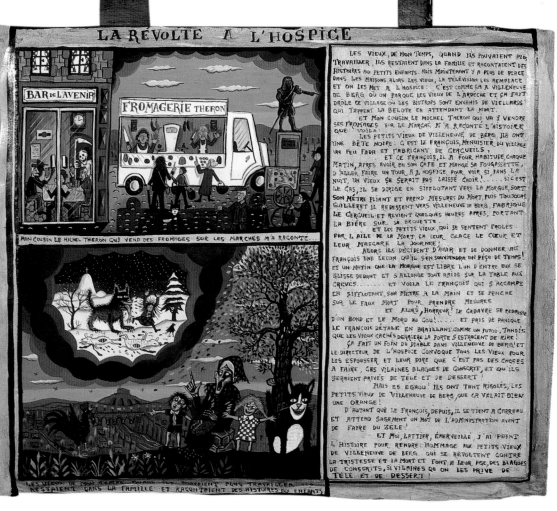

1962 the sole English member was Victor Musgrave, the owner of the avant-garde Gallery One in London. After some years of championing the Art Brut cause, in 1977 Musgrave approached the Arts Council of Great Britain with a proposal for a major exhibition of Outsider Art. Co-curated by Cardinal, the exhibition was held at the Hayward Gallery in 1979. ¶ With more of an Art Brut base than the Paris exhibition Les Singuliers de l'Art a year earlier, the Hayward's Outsiders brought together both works from mental institutions, by Wölfli and Müller for example, and many creations from the Bourbonnais collection. Indeed, Bourbonnais insisted on participating himself as a prerequisite of releasing works in his ownership, a condition which made it difficult to maintain a solid 'Outsider' front. ¶ Billed as 'an art without prece-

Below left
Perifimou, 1985
Below middle
Dr Leo Navratil, the Gugging artist Johann Hauser and Victor Musgrave at the opening of the Outsiders exhibition, Hayward Gallery, London, 1979
Below right
Scottie Wilson, c.1965

Below
Perifimou
Forbidden Territory, 1986
Acrylic on paper
37×56 cm
Outsider Collection and Archive, London

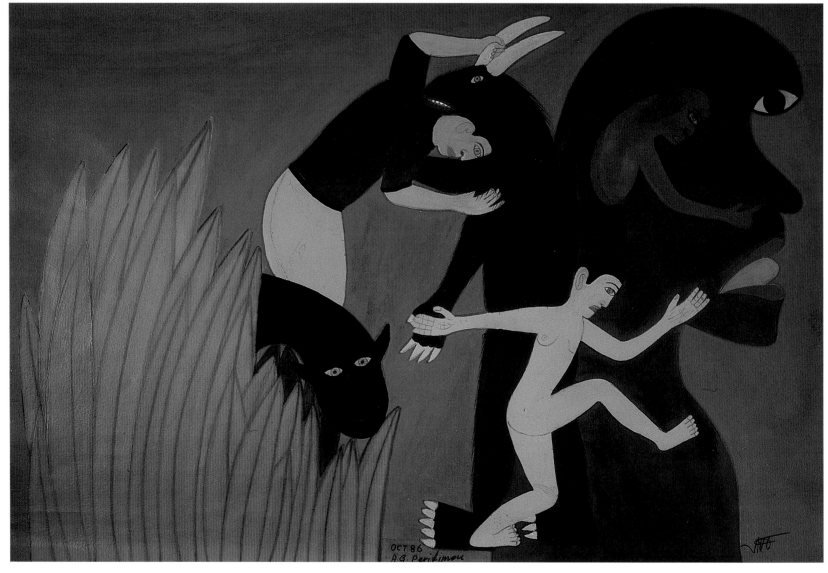

OCT 86
A.G. Perifimou

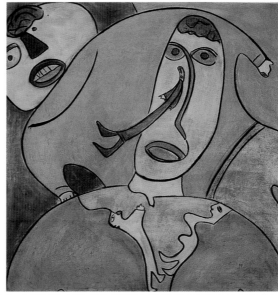

Albert Louden
Untitled, 1987
Pastel on paper
160×178 cm
Private collection

dent or tradition', Outsiders was a huge exhibition, dramatically presented in the Lausanne style, with black backgrounds and spot-lit works of raw creation. Musgrave himself was in daily attendance, a distinctive figure with his flowing hair and black cloak, discussing the show with visitors. Though immensely popular, the exhibition was soon set upon by Britain's insular art establishment. Critics and art historians perceived the threat to their cultural edifice that Dubuffet had always intended to be an inherent consequence of Art Brut. The great Wölfli's works were described as 'relentless psychotic drizzle'.[6] Other critics described the exhibition as **the work of lunatics...of interest to those concerned with mental medicine...the catalogue is awful too,[7] and unbelievably depressing—it is filled with quite dreadful and horrible and disturbing things...it has brought the lunatic into the city square.[8]**

The catalogue, which featured stirring pieces by Cardinal and Musgrave, also contained a foreword in which the Arts Council rather cagily distanced itself from the exhibition. ¶ To many the critical reaction was as shocking as the exhibition was inspiring, and for the first time in Britain Outsider Art found itself with a body of advocates and enthusiasts. In 1981 Musgrave founded the Outsider Archive, now supported by his companion Monika Kinley, as a body dedicated to the study and collection of Outsider Art and to the eventual establishment of a public exhibition space. Musgrave and Kinley sought out new artists and gradually built up a sizable collection. Their discoveries included Tate Gallery attendant Perifimou, the Bangladeshi Shafique Uddin, and van driver Albert Louden. ¶ One artist with whom Musgrave had been particularly friendly was Scottie Wilson (Louis Freeman, 1888–1972), who had exhibited at Gallery One as early as 1963. Wilson had been a junk dealer, making a living by salvaging what he could from the bits and pieces that fell into his hands. To this end he collected the gold nibs from old fountain pens. One day he found in his possession a particularly fine pen, large and free-flowing, so good to handle that he was somehow led to use it playfully to draw outlines and forms. Before long he became involved in his new activity, forming faces and little creatures, adding colour to the black hatching that held his compositions together. Often revolving around a central face or circular motif, the figures, which he termed 'Greedies', took on dark and sinister presences in contrast with the flowing flora around them. ¶ Signed simply 'Scottie', the drawings became a source of livelihood for Wilson, who held his own exhibitions in music halls and pier booths around Britain. He was even taken up by a London gallery, Gimpel Fils, who were forced to rescind their agreement when he set up his own stall outside the gallery, selling his work for a fraction of the price of those exhibited within. As Wilson's fame spread, he was championed by the London Surrealists and was even collected by Picasso. ¶ Musgrave also acquired works by Michel

6. William Feaver, the *Observer*, 25 February 1979

7. Terence Mullaly, the *Daily Telegraph*, 17 March 1979

8. Marina Vaizey, 'Critics Forum', BBC Radio 3, 24 February 1979

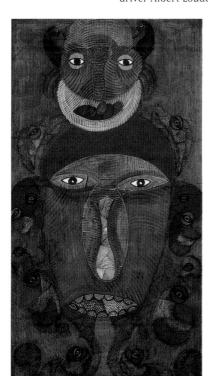

Scottie Wilson
Two Figures with Pink Eyes, c.1950
Ink and coloured crayon
51·0×27·5 cm
Collection de l'Art Brut Lausanne

Nedjar, Pascal Verbena and Madge Gill. Also well represented in the museums in Lausanne and Paris, Gill (1882–1961) was a classic mediumistic artist, and is one of Britain's most famous Outsider creators. Her overwhelming urge to create began in 1919 and continued until her death. She insisted that her works were the result of spirit intervention, referring to her spirit guide as 'Myrninerest'. She at first felt compelled to knit and embroider, then to write and draw compulsively. As an amateur medium herself, she began to hold regular seances at her home. ¶ Gill's compositions range from the humble postcards that she produced by the hundred to works on vast pieces of calico, some over 9 metres (29 feet) long, which she drew directly as she gradually unrolled the cloth. The overwhelming characteristic is the chequered, kaleidoscopic plane which supports female faces and figures, with eyes staring blankly. Some of her works dispense with the figurative, the entire space energetically filled with abstract geometric patterns. ¶ Of the contemporary English artists supported by the Outsider Archive, one of the most distinctive is Ben Wilson, a sculptor who has mainly worked with wood in natural environments, such as open woodland. His giant figures, often accompanied by huge pieces of furniture or shaky rustic steps and walkways, have a limited and precarious existence. Set in the open for all to see, many have been vandalized or destroyed. ¶ After Victor Musgrave's death in 1984, Monika

Madge Gill drawing in black ink on calico on the
billiard table in her sitting room, London, c.1936

Far left
Anna Zemankova
Left
Sava Sekulic

Kinley has continued to campaign for a British gallery of Outsider Art. Under her direction, the Outsider Archive increased its collection to include such artists as the Serbian Sava Sekulic and the Croat Dusan Kusmic, the Czech medium Anna Zemankova, Willem van Genk and a German patient, Theo. After a series of exhibitions and events, including a large exhibition of Outsider Art, In Another World, which toured the country in 1987 and 1988, she has seen, fifteen years after the original formation of the Archive, the approaching possibility of a public gallery for Outsider Art in Britain opening in London. ¶ In other parts of Europe the growing enthusiasm for Outsider Art has led to the founding of several centres. The Site de la Création Franche in Bègles, Bordeaux, under the direction of self-taught artist Gérard Sendrey, and the Art Cru Museum in Monteban directed by Guy Lafargue have added to France's representation. Both emphasize the works of France's self-taught creators and the *artistes singuliers* rather than traditional Art Brut. In Holland a new museum, De Stadshof, featuring both Outsider Art and naïve art, opened in opulent premises in Zwolle in 1995, while Switzerland's third location, the Museum im Lagerhaus at St Gallen, offers a broad range of Swiss Outsider, folk and naïve art. ¶ After seven decades of cramped existence inside the Heidelberg psychiatric hospital, the Prinzhorn Collection will shortly be moving to a public exhibition space. Also in Heidelberg, the Museum Haus Cajuth shows a collection of works from Central Europe and Italy, again focusing on the borders between Outsider Art and naïve art. While the Gugging Hospital in Austria is planning a large exhibition centre, Arnulf Rainer's large collection, heavily representative of Outsider creations from Central and Eastern Europe, remains a private collection, only occasionally being placed on public display.

Dusan Kusmic
Totems, c.1970-80s
Painted plaster
Left, height 1·05m
Centre, height 1·2m
Right, height 1m
Outsider Collection and Archive, London

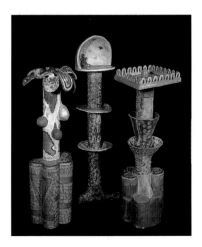

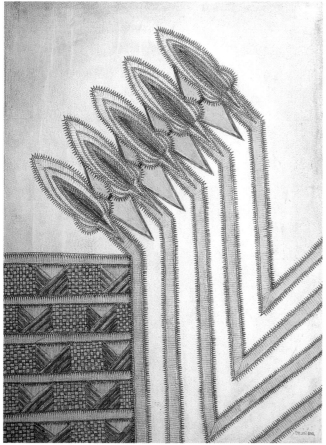

Opposite
Ben Wilson
Sleeping Giant, 1987
Branches and nails
Length 9m
Hadley Common, north London
Vanished
Above
Sava Sekulic
Three Horses, c.1974
Crayon and watercolour on card
23×36·5cm
Outsider Collection and Archive, London
Left
Anna Zemankova
Untitled, undated
Mixed media on handmade paper
42×31·5cm
Outsider Collection and Archive, London

Chapter 6: ART FROM THE CLINIC AT GUGGING

One disappointment for Dubuffet, and indeed for the collectors who followed, was that fewer original and vital artworks were being created in mental hospitals. It had taken Hans Prinzhorn only two years to build up his vast collection simply through contacts with hospitals mainly in the German-speaking world. However, sweeping changes in the treatment of patients had had repercussions on the manner in which they were able to express themselves. Patients were heavily sedated with drugs, traumatized by electric shock treatment, even lobotomized. Treatment often came to have as its aims control and management, pushing the patient into a state as close to outward 'normality' as possible. In many cases artistic expression has ceased to be a private and/or compulsive act, often becoming a structured art therapy activity—a public component of the institutional day, its results discussed and analysed as a diagnostic aid. ¶ One hospital in Europe stands out as a

Painted exteriors by the Gugging artists of their Haus der Künstler, Gugging, near Vienna

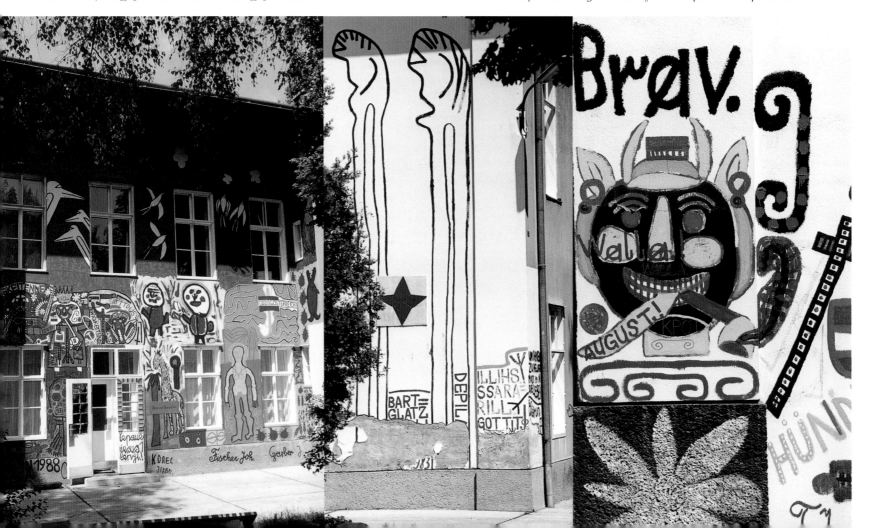

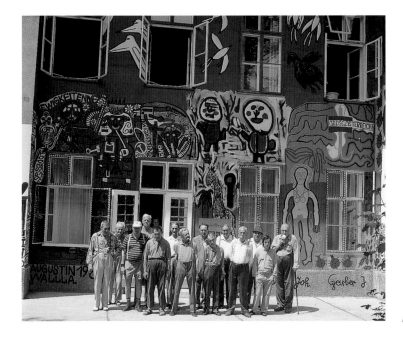

All the Gugging artists outside the Haus der Künstler, Gugging, 1993

haven of genuine creativity. Through the efforts of the highly gifted psychiatrist Leo Navratil, the natural flow of creation so admired by Prinzhorn, Morgenthaler and Dubuffet is flourishing in the mid-1990s at the mental hospital at Gugging, near Vienna.[1] ¶ As a young psychiatrist, Navratil became fascinated with the drawings of his patients and often used them himself in the diagnostic process, observing how depictions of the human figure would alter according to varying mental states. Although he believed very much that the images produced by patients were indicative of their psychological condition, he came to realize that some could produce work displaying real talent and originality. Navratil saw this artistic expression as a symptom of schizophrenia, a reaction which helped to stabilize the personality. The patient was 'statebound', the art within him a direct result of his illness. 'The artist inside him *was* his psychosis.'[2] ¶ The creative achievement of these patients is a symptom of illness, and the formative process at its base is a process governed by that illness, more precisely, an attempted reparation within the sphere in which the illness takes shape.[3] ¶ The works of Morgenthaler and Prinzhorn strengthened his beliefs and, in the mid-1960s, he made contact with one of the doctors who had been treating Aloïse Corbaz in Lausanne, Dr Alfred Bader. In Vienna, the work of Navratil's patients had aroused the interest of painters such as Ernst Fuchs and Arnulf Rainer. Navratil was encouraged by their enthusiasm for his work and the high esteem in which they held his patients' achievements. ¶ Arnulf Rainer had begun to search

1. The full name of the hospital is Niederösterreichisches Landeskrankenhaus für Psychiatrie und Neurologie, but it is generally known as Gugging as it is in the parish of Klosterneuburg-Gugging, near Vienna

2. Leo Navratil, 'The History and Prehistory of the Artists' House in Gugging', in *The Artist Outsider*, ed. Michael D Hall and Eugene W Metcalf Jr (Washington DC and London, 1994), p.200

3. Quoted in Roger Cardinal, *Outsider Art* (London, 1972), p.21

4. See Claudia Dichter, *Die Sammlung Arnulf Rainer*, catalogue. Vestisches Museum (Recklinghausen, 1994)

out patient art in the early 1960s. In 1963 he acquired from Eastern Europe (exactly where, he has never disclosed) a psychiatric archive including texts, pictorial works, medical histories and photographs. Over the years his collection grew to over 1,500 pieces to become one of the largest private collections of Outsider Art. Works by unknown patients, many created before the widespread introduction of drugs, are represented along with such well-known figures as Aloïse Corbaz, Scottie Wilson, Louis Soutter and Schröder-Sonnenstern.[4] ¶ The publication of his book *Schizophrenie und Kunst* (*Schizophrenia and Art*) in 1965 further enhanced Navratil's growing reputation, and in the next few years he not only made contact with Dubuffet but arranged the first of a whole series of exhibitions of his patients' work at galleries around Austria. Artists from the hospital were soon represented at the Collection de l'Art Brut and participated in the Outsiders exhibition at London's Hayward Gallery in 1979. ¶ By 1981 the hospital authorities, acknowledging Navratil's unique contribution, allowed him to move from his overcrowded and cramped accommodation into a specially converted building on the outskirts of the hospital grounds. Here the artist-patients, and one poet-patient, work and live together as a community, separate from the rest of the hospital. Now known as the Haus der Künstler (the Artists' House), it has no studio or organized periods of activity. Residents involve themselves in creative expression as and when they feel like it, with encouragement and materials at hand. ¶ The corridors and rooms of the Haus der

Details of painted exterior of the Haus der Künstler, Gugging, by (left to right) Johann Garber, Johann Fischer, and August Walla

Dr Leo Navratil and Johann Hauser

5 Leo Navratil, 'The History and Prehistory of the Artists' House in Gugging', p.210

Künstler are decorated with the works of Gugging artists; the exterior walls are covered in their murals. The patients in the little community gradually take on a new social identity—that of artists. (The hospital is not attempting to rehabilitate them back into society in their previous roles, as they are too ill for this.) The unit has a family atmosphere which counteracts the damaging psychological effects of institutionalization. Its domestic and creative environment stands in contrast to the institutional world surrounding it.[5] ¶ One of the original members of the group of artist-patients, Johann Hauser (1926–96), first began to draw in the 1950s. His powerful lead and coloured pencil drawings, often emphasizing the sexuality of the female form, are rendered with an intense physicality of expression, the paper being indented with the pressure of the pencil, even at times torn. His colour is applied so thickly that many of his pencil drawings resemble paintings. Hauser often used magazine pictures as his starting point to create his own far more compelling versions of the originals. A recurring motif in his work is a blue star, which the Haus der Künstler has adopted as its symbol. Dramatic changes of mood are discernible in his work, which at times displays a violent intensity of colour and at others a dark oppressive quality. ¶ In contrast

Johann Hauser
Above
At work, May 1995
Left
Blue star, symbol of the Haus der Künstler, Gugging

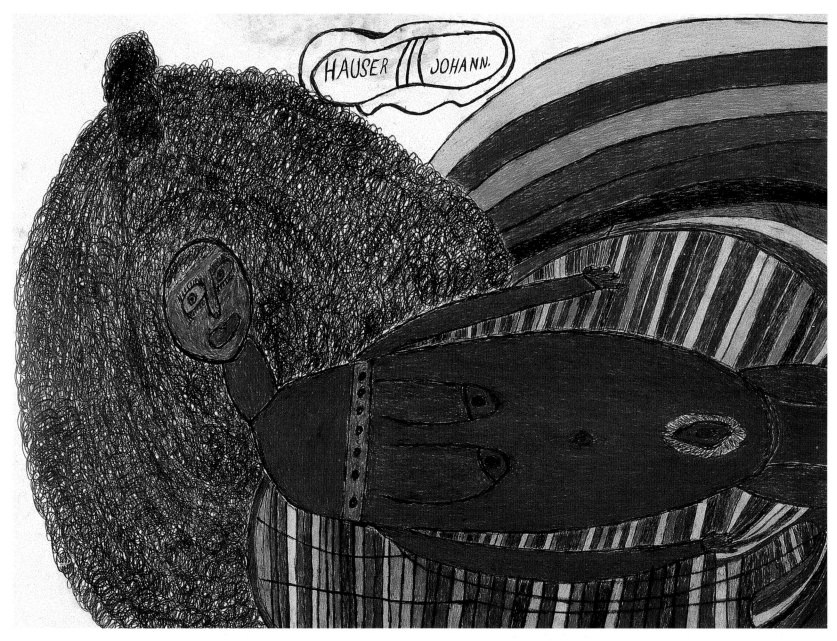

Johann Hauser
Above
Liegende Frau (Reclining woman), 1994
Pencil and coloured pencil on paper
62·4×88·0 cm
Haus der Künstler, Gugging
Left, from left to right
Frau (Woman), 1968
Pencil on paper
33·5×21·1 cm
Collection Arnulf Rainer, Vienna
Flugzeug (Aircraft), 1982
Pencil and coloured pencil on paper
30×40 cm
Collection Arnulf Rainer, Vienna
Flugzeug (Aircraft), 1971
Pencil and coloured pencil on paper
30×40 cm
Private Collection, Vienna

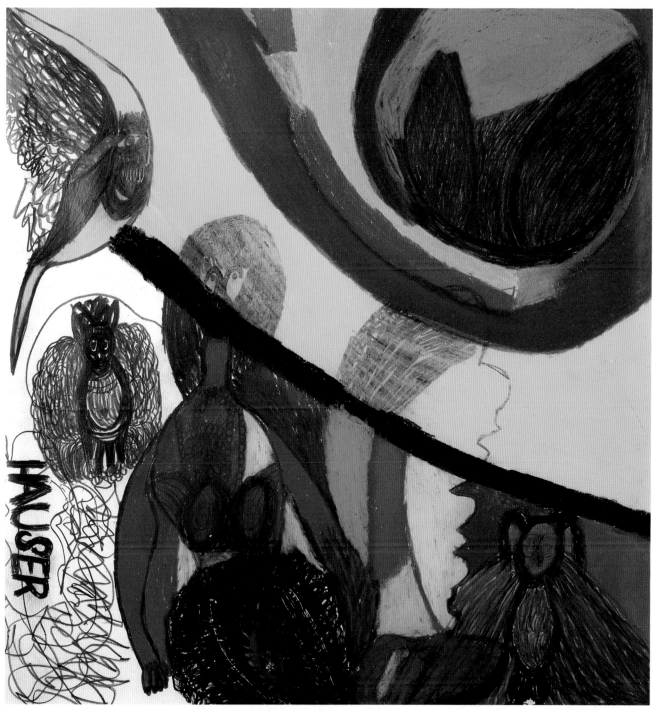

Johann Hauser
Above
Woman with Two Owls and a Moon, 1974
Pencil and coloured pencil on paper
44·5×42 cm
Outsider Collection and Archive, London

to Hauser's forceful way of working, Oswald Tschirtner (b.1920) has a controlled, almost ascetic, approach. His principal subjects are elongated human forms, 'Kopffüssler' (head-footers) portrayed singly or in groups. Hardly ever using colour, he relies on an economical use of line and a sublime sense of space. ¶ Among the most versatile of the Gugging artists is August Walla (b.1936), who has been a patient since childhood. He paints, draws, etches, constructs assemblages from discarded materials, writes and photographs (often using photographs to record his other work) in a constant creative outpouring that governs his life—and alters his surroundings. He reworks and interweaves themes of sexual identity, religion, politics and the environment, combining image, writing and symbol, all of which have equal weight in his works. Walla is a language enthusiast, often referring to his collection of foreign dictionaries to discover new words. ¶ As a youth he worked in the Walla family garden, making rough assemblages of scrap wood, metal and other discarded materials, painting his totemic constructions with words. Since he came to live at the Haus der Künstler, he has painted all the walls and ceilings of his room with figures and graphics, and his striking images also adorn much of the exterior of the building. He has also painted the outside of a small garden building around which he places objects that rot and decay, forming a living and changing environment. The surrounding trees are adorned with large letters, and cryptic messages appear on the road in front of the house. ¶ Another resident who has constructed a living sculpture in the

Oswald Tschirtner
Above right
In May 1995
Below
Sitzende Menschen (Seated people), 1994
Ink on canvas
1·6×1·2 m
Private collection, Bern

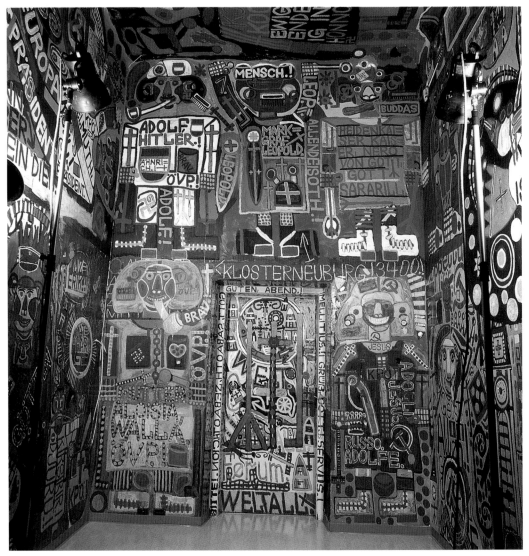

August Walla
Above
With his late mother
Right
August Walla's room at the Haus der Künstler, Gugging

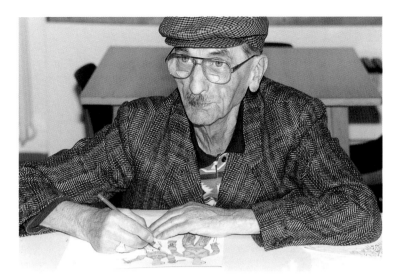

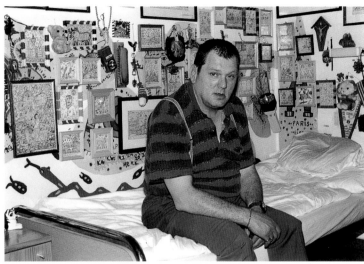

Haus der Künstler grounds is Johann Garber (b.1947). Using two tall tree stumps in front of the house, he has constructed the *Tree of Lust* and *Fan Blower Tree*. The *Tree of Lust* is surrounded by lumps of painted fungi that slowly rot and are gradually replaced by new growth. Within the building the large old boiler in the cellar is covered in Garber's brightly painted decorative imagery. ¶ Garber's principal activity, however, is drawing; he uses a fine line, cramming the paper with a mass of faces, figures (often involved in exaggerated sexual activity), plants and imaginary creatures. Around and within the images shimmer dots, lines, circles and other tiny decorative motifs, cementing the composition into a single dense entity. ¶ One inmate of the hospital, Johann Fischer (b.1919), was so inspired by the artists of the Haus der Künstler that he became one himself. His early drawings were of isolated objects and people, but his compositions gradually developed in complexity. Often crisply executed human figures and beasts are surrounded by strictly ordered blocks of calligraphy. The controlled colours, mainly yellows and browns, and the calligraphic text, evoke the feeling of historic charts or documents. ¶ Philipp Schöpke (b.1921) suffers from a condition

Philipp Schöpke
Zwei Figuren (Two figures), 1994
Pencil and coloured pencil on paper
29·5×21·0 cm
Haus der Künstler, Gugging

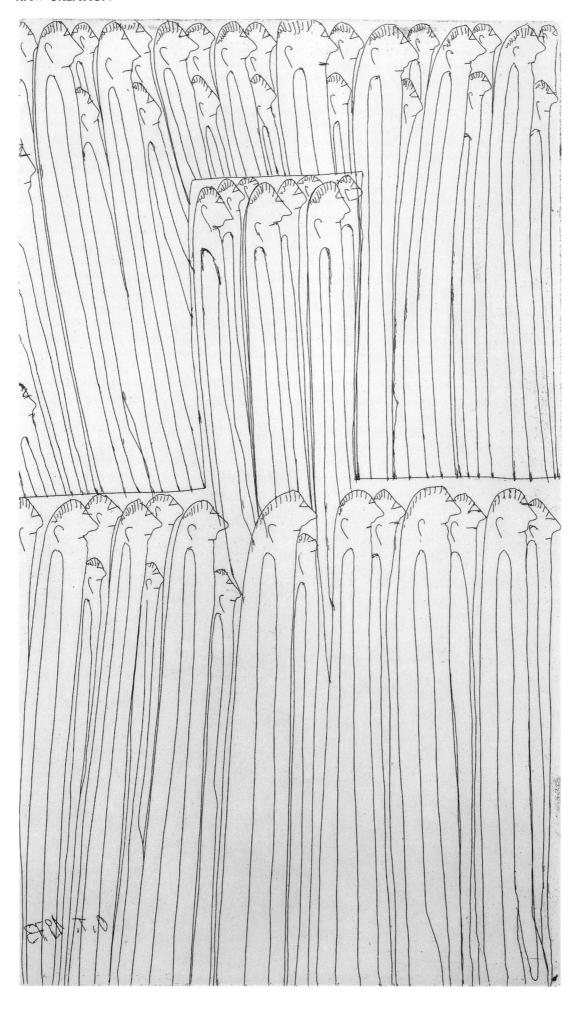

Left
Oswald Tschirtner
Untitled, 1978
Etching
29·3×17·5cm
Outsider Collection and Archive, London
(See also endpapers)
Opposite
Johann Garber
Tiere im Urwald (Animals in the Jungle), 1994
Ink on paper
62·7×44·2cm
Private collection, Bern

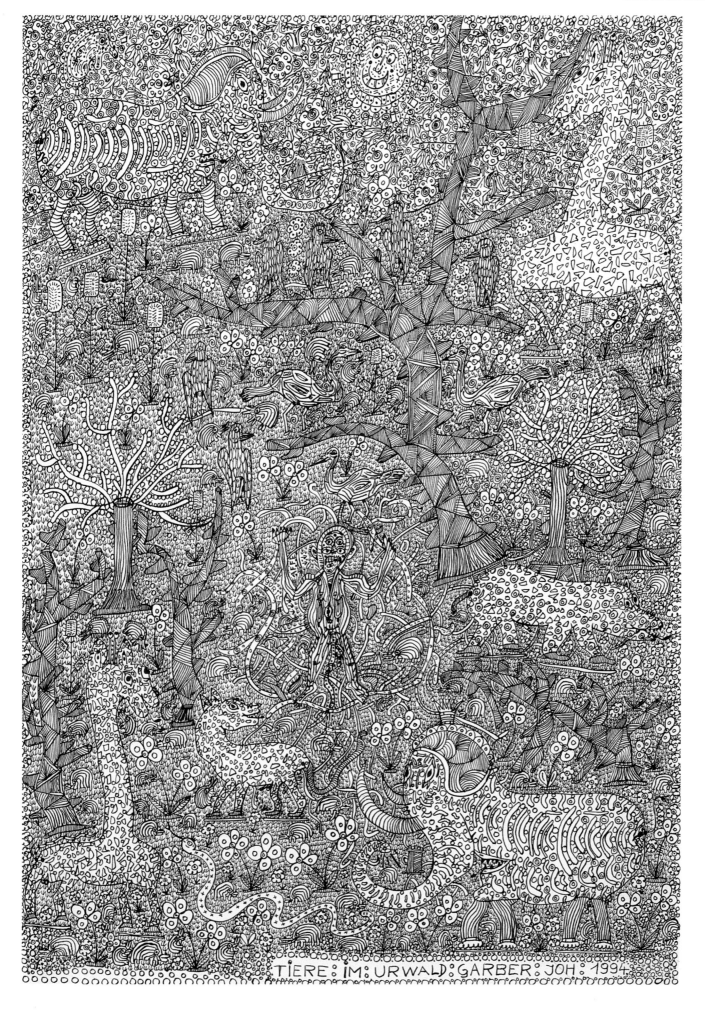

that leaves his hands constantly shaking, a state that reveals itself in the trembling line of his drawing. With Navratil's encouragement, he began to draw in the 1960s. His single-figure depictions, with titles such as *Mitzi* or *Franzi*, show a being with a huge head on which is a large mouth with countless teeth. The limbs are at times attached to a body, at others not. Internal and external organs—heart, ribs, stomach, intestines, genitals—are clearly depicted. Schöpke sometimes introduces coloured pencil over his pencil outlines. More recently, the colours form dense overlapping areas that bring vague human outlines close to abstraction. ¶ It was Navratil's devotion to and love of his patients that lay behind the achievements of the Haus der Künstler. Although Navratil's work has been largely ignored in the psychiatric world, the Gugging artists have become renowned as schizophrenic masters, even receiving in 1990 Austria's most prestigious art award, the Oskar Kokoschka Prize. In 1986 Leo Navratil retired after working at Gugging for forty years, and has since been ably succeeded at the Haus der Künstler by Dr Johann Feilacher. Feilacher has a slightly different emphasis than Navratil. Not following the 'statebound' theory, he believes more that his patients are talented artists in their own right, not necessarily as a symptom of their illness. He has further extended the range of exhibitions the Gugging artists participate in, and plans a large study centre and exhibition space at the hospital. Several of the residents of the Haus der Künstler have become well-known figures whose work can command high prices, and the artists of Gugging are now represented in all the major collections of Outsider Art. ¶ Although the reaction to the Gugging artists has come almost exclusively from the artistic community, there have been examples of one or two European hospitals attempting to emulate his success. In Florence the La Tinaia hospital has made great efforts to encourage some of its patients to express themselves freely within a small artistic community under the direction of Dr Massimo Mensi, and in Germany the Alexianer Krankenhaus near Münster has also proved that its gifted patients can produce works of originality.

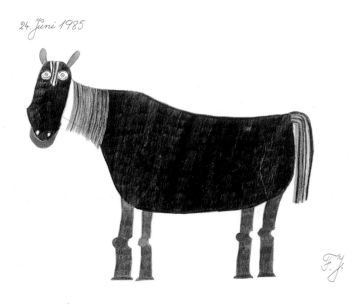

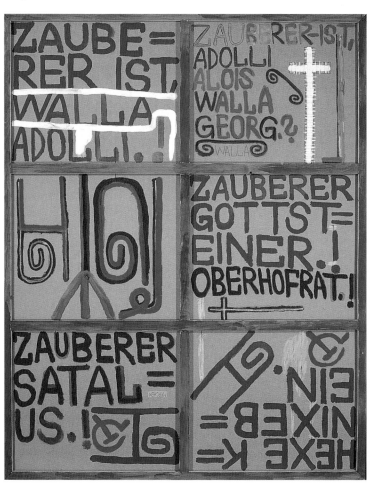

Above
Johann Fischer
Ein Bock, 1985
Pencil and coloured pencil on paper
30×40 cm
Haus der Künstler, Gugging
Right
August Walla
Marchen I (reverse) , 1989
Acrylic on canvas
200×160 cm
Niederösterreichische Landessammlungen, St Polten

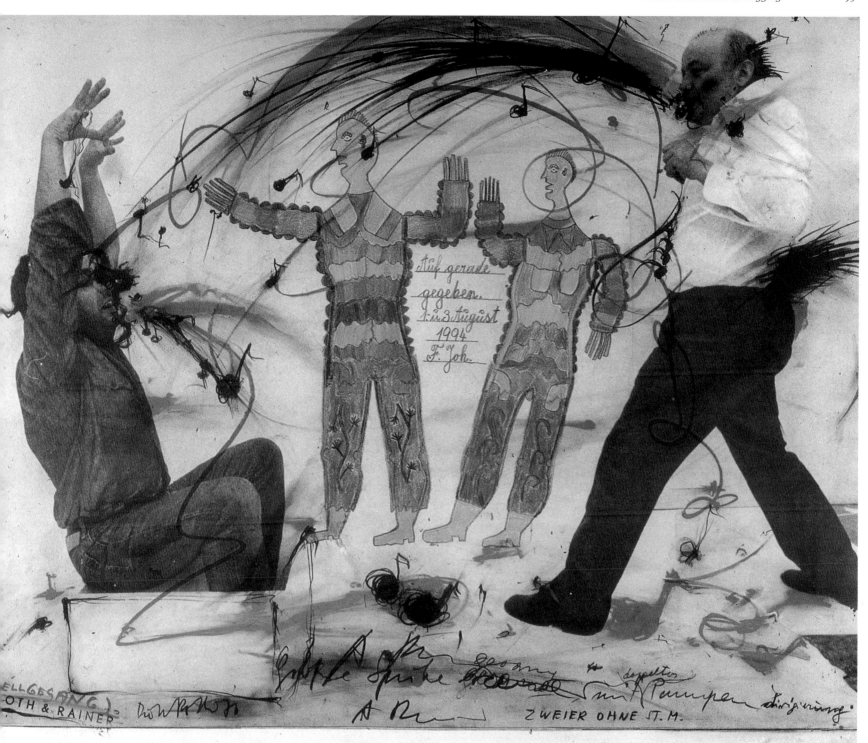

Arnulf Rainer/Johann Fischer collaboration
Auf gerade gegeben, 1994
Pencil, coloured pencil on lithograph
49.9×59.3 cm
Gallery Susanne Zander, Cologne

Chapter 7: ART BRUT & THE U.S.

While American interest in Outsider Art has been broad-based, es-chewing the debates on dogma and terminology that dominated devel-opments in Europe, Dubuffet's theories and Art Brut as an entity have played a significant role. The American story is perhaps best told by begin-ning with events in Chicago. Outsider Art had generated some interest even before 1951, when Dubuffet gave his 'Anti-cultural Positions' address at the Art Institute of Chicago (see Chapter 3), and many were receptive to Dubuffet's ideas. His Art Brut collection had been in the care of Alfonso Ossorio in Long Island for nearly a decade but had aroused little interest among New York's painters and art followers, who were largely involved in the exciting devel-opment of Abstract Expressionism. ¶ Chicago artists pursued their own paths. The group

Joseph Yoakum
'Waianar Mtn Range Entrance to Pearl Harbor and
Honolulu Oahu of Hawaiian Islands', 1968
Coloured pencil on paper
30×46cm
Private collection

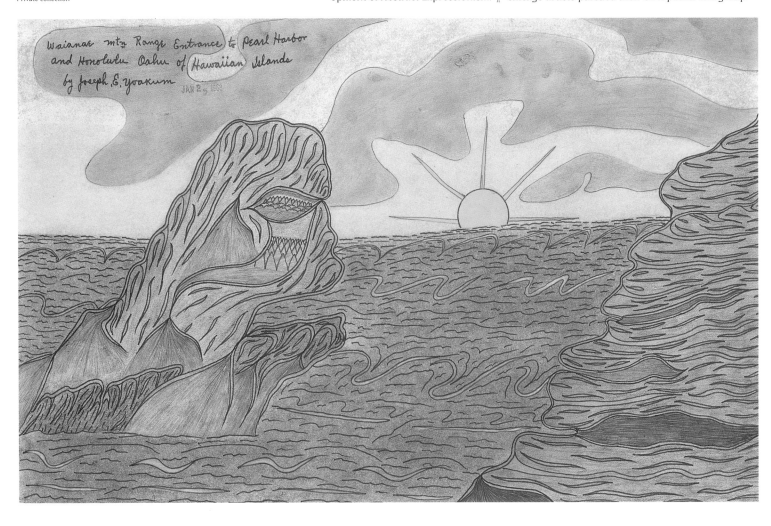

Martin Ramírez
Untitled, 1950s
Mixed media on paper
Private collection

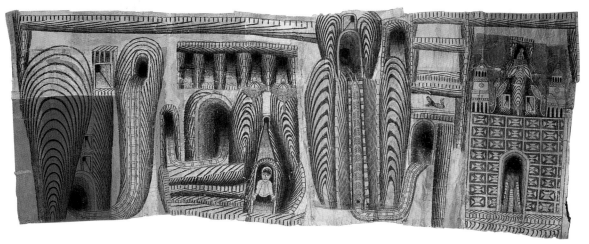

1. See Roger Brown, 'Rantings and Recollections' in *Who Chicago?* (exhibition catalogue, Ceolfrith Gallery, Sunderland, UK, 1980) and Michael Bonesteel, 'Chicago Originals', *Art in America*, no. 73 (February 1985), pp.128–35

of 1960s artists collectively known as the Chicago Imagists—Jim Nutt, Roger Brown, Gladys Nilsson and others—drew on a wide variety of imagery, from the 'low art' of comics and toys, to the art of oriental and other distant cultures. They even discovered their own 'Rousseau', a natural intuitive artist, Joseph Yoakum (c.1886–1972).[1] ¶ Yoakum's emergence as Chicago's principal Outsider artist in the 1960s was partly due to the involvement of teacher-artist Whitney Halstead, whose unpublished study of this unusual creator is held by the Art Institute of Chicago's library. The influence of the self-taught Yoakum on Nutt, Nilsson, Brown and on another of their teachers at the Art Institute, Ray Yoshida, was deep and long-lasting. They collected his work and organized exhibitions for him, and echoes of his visions can be seen in their own paintings. Yoakum, an ex-circus performer who claimed Navajo blood, said his lifetime of travel served as the inspiration for his landscape fantasies. Looking more like biological or geological cross-sections than conventional landscapes, they depict places he claimed to have visited; he would at times even muster up some accompanying story. The landscapes—rocks, mountains, waves and clouds—have a fluid, glowing presence. ¶ Another familiar figure to Chicago artists was the semi-homeless Lee Godie (1908–94), who existed by selling her rough portrait drawings, even on the front steps of the Art Institute. Proclaiming herself a famous French Impressionist, she produced intense portraits of large-eyed women, occasionally including famous personalities. She was not averse to painting her face as well as the scraps of paper and canvas she worked on. At times her paint was so thick it never really dried. She also produced 'books' of paintings tacked together with shoelaces and 'pillow paintings'—two paintings joined together and stuffed with newspaper. ¶ Jim Nutt had been aware of Art Brut since the

Joseph Yoakum

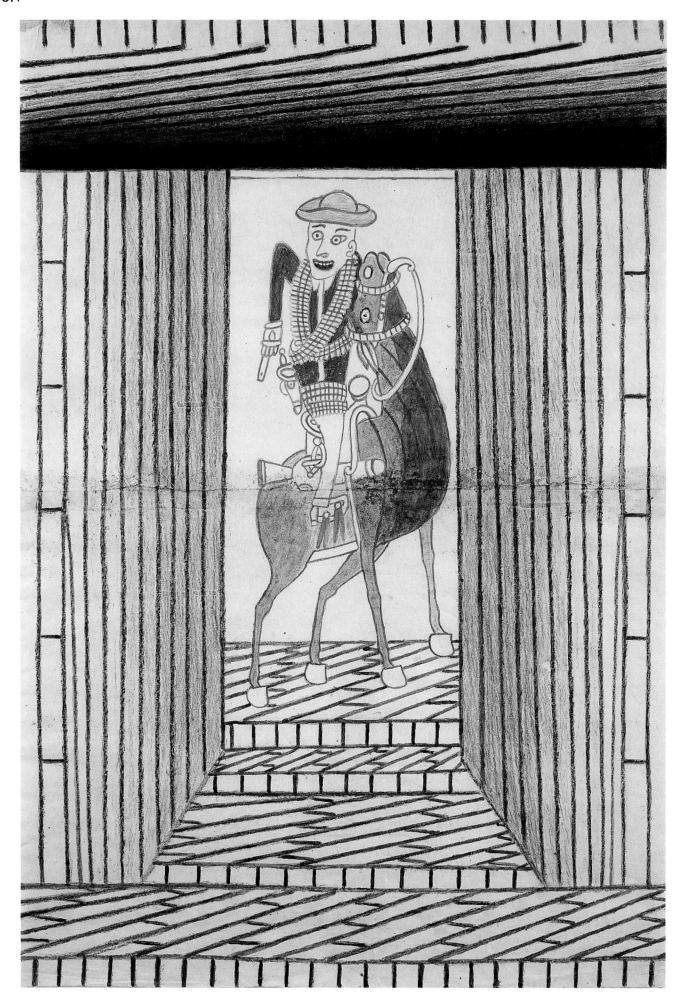

Martin Ramírez
Untitled, 1950s
Mixed media on paper
89×61 cm
Phyllis Kind Gallery

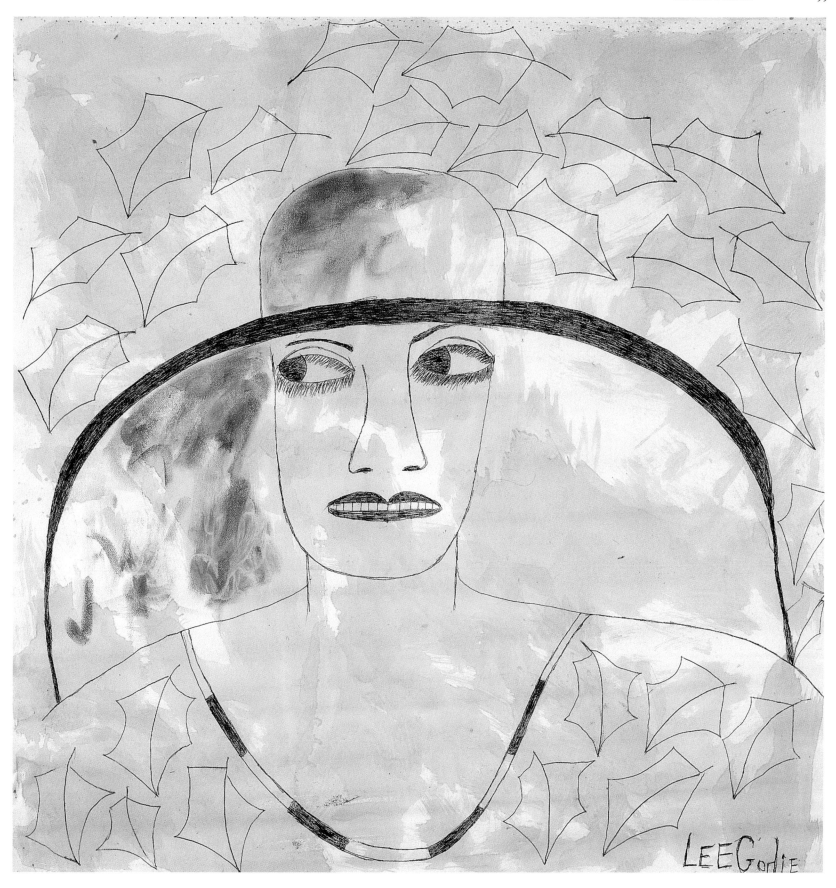

Lee Godie
Untitled, c.1984
Pen, watercolour and varnish on canvas
66·0×68·5cm
Private collection, courtesy Carl Hammer Gallery

2. Russell Bowman, 'Looking to the Outside'. *Parallel Visions: Modern Artists and Outsider Art* (exhibition catalogue, Los Angeles County Museum of Art and elsewhere, 1992), p.164

early 1960s, and when he and Gladys Nilsson moved to Sacramento, California, in 1968 they made an exciting discovery. In the university where he was to take up a teaching appointment, Nutt came across a strange drawing on crudely shaped paper. It was an art therapy teaching aid belonging to psychology lecturer Dr Tarmo Pasto, who explained that the work was that of a former patient at the De Witt State Mental Hospital, Martín Ramírez.[2] Ramírez (1895–1963), a mute Mexican immigrant, had been hospitalized since 1930, and did not start to draw until about 1950. He was virtually rescued by Pasto, to whom he gave a small bundle of secret drawings on one of his visits to the hospital. Until that time Ramírez's work had been systematically confiscated and destroyed at the end of each day under a strict hospital hygiene routine. It was Pasto who recognized his worth, saved his work and gave him encouragement and materials. This new lease of life allowed Ramírez to work openly on larger and more ambitious drawings, sticking several sheets of paper together to give himself more space. ¶ Ramírez's work is characterized by strong and distinctive draughtsmanship, simple compositions and contoured depths of perspective. Within the framed surroundings that are features of many of his drawings, lone horsemen, trains or female figures are set off by repeated sweeping lines that create deep troughs. Some have given these surrounding forms, these tunnels and caves, sexual significance, while others point to Mexican folklore, to the adventures of Emiliano Zapata and his famous escape from Mexico City through the lava tubes. Ramírez never found his voice to explain his work, but he at least found the freedom to express himself. When he died in 1960 he left over 200 drawings, some as large as 4 metres (12 feet) in height. Nutt and Nilsson eventually came to own many of his works and became guardians of his legacy. They introduced their Chicago dealer, Phyllis Kind, who already held a fascination for Yoakum's work, to that of Ramírez. Kind became more deeply involved in Outsider Art when she came across a Wölfli drawing. As her interest in Outsider Art developed, she became a pivotal figure in bringing such works before a wider American public, opening a New York gallery in 1975. ¶ It was in Chicago, too, that in 1973 a monumental, if eerie, discovery was made. Henry Darger (1892–1973) was an elderly tenant of the photographer and designer Nathan Lerner. Darger left his lodging for an old people's home and within six months had died. When Lerner prepared to clear his room, he found within it, stacked high all around, a mass of writings, pictures and papers. ¶ Henry Darger had led an isolated life. Orphaned and institutionalized as a

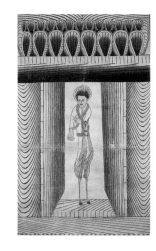

Martín Ramírez
Untitled, 1950s
Mixed media on paper
149×86 cm
Private collection

Henry Darger
Untitled, undated
Mixed media on paper
0·48×1·24 m
Private collection

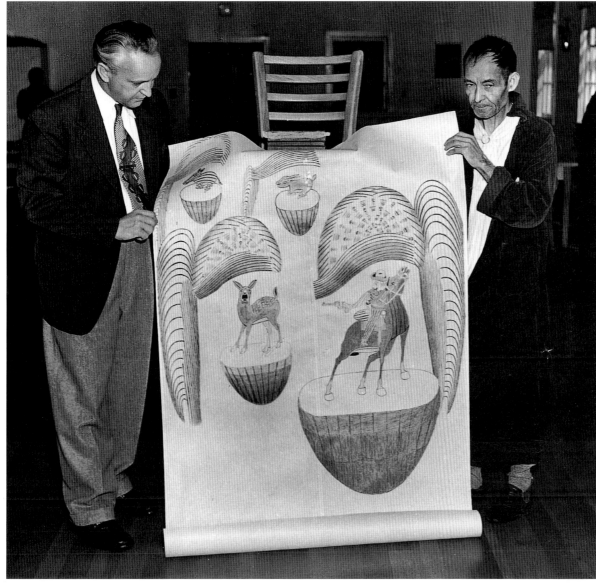

Left
Martin Ramirez (right) with Dr Tarmo Pasto at De Witt State
Mental Hospital, Auburn, California, c.1950s
Below
Henry Darger c.1970

child, he found menial employment in Chicago hospitals. He had only one friend—a man who eventually moved away from Chicago—and spent most of his non-working life alone in his room. Partly to compensate for a daily life of loneliness and inconsequence, partly no doubt as a result of his own childhood sufferings, Darger began to build up a vast fantasy world. He started work on a monumental book in about 1910 based on the themes of war and the sufferings of innocent children: *The Story of the Vivian Girls in what is known as The Realms of the Unreal, of the Glandeco-Angelinnean War storm, caused by the Child Slave Rebellion.* The length of the title reflects the eventual length of the book: it ran to fifteen volumes totalling over 15,000 closely typed pages. ¶ The work was full of extremely lengthy and explicit descriptions of vicious

battles, tortures and executions. The victims were almost exclusively the child-slave rebels, the perpetrators the adult male soldiers of the evil Glandelinia. Eventually the forces of good, led by the Christian country of Abbiennia and by the heroines, the seven beautiful and brave Vivian sisters, were rewarded with victory, but not before horrible suffering had been endured: Naked opened bodies were seen lying about in the streets by the thousand. Indeed the screams and pleads of the victims could not be described, and the thousands of mothers went insane over the scene, or even committed suicide...About nearly 56,789 children

Henry Darger
Below
Untitled, undated
Pencil and watercolour on paper
60·8×95·4cm
Private collection
Opposite
151 at Jennie Richee. Are Lost in the Wilderness in the Dark (detail),
undated
Pencil and watercolour on paper
0·6×2·76 m
Collection de l'Art Brut Lausanne

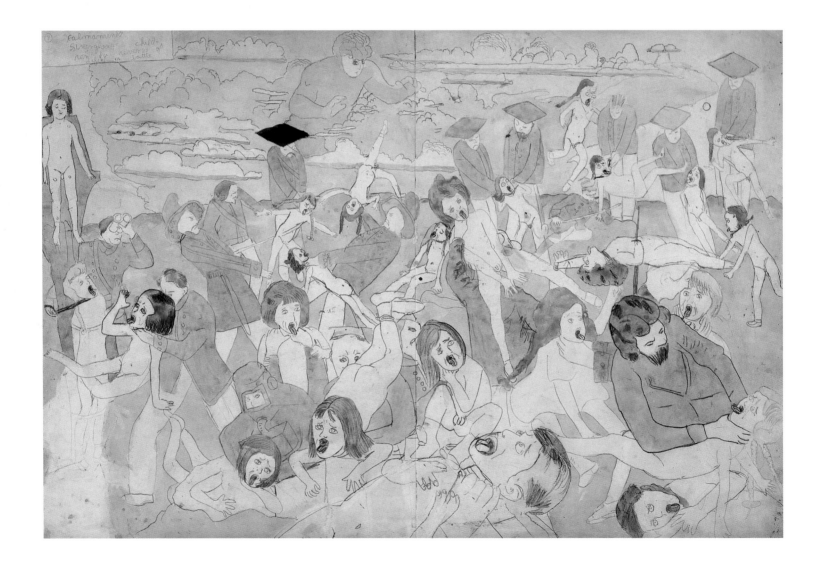

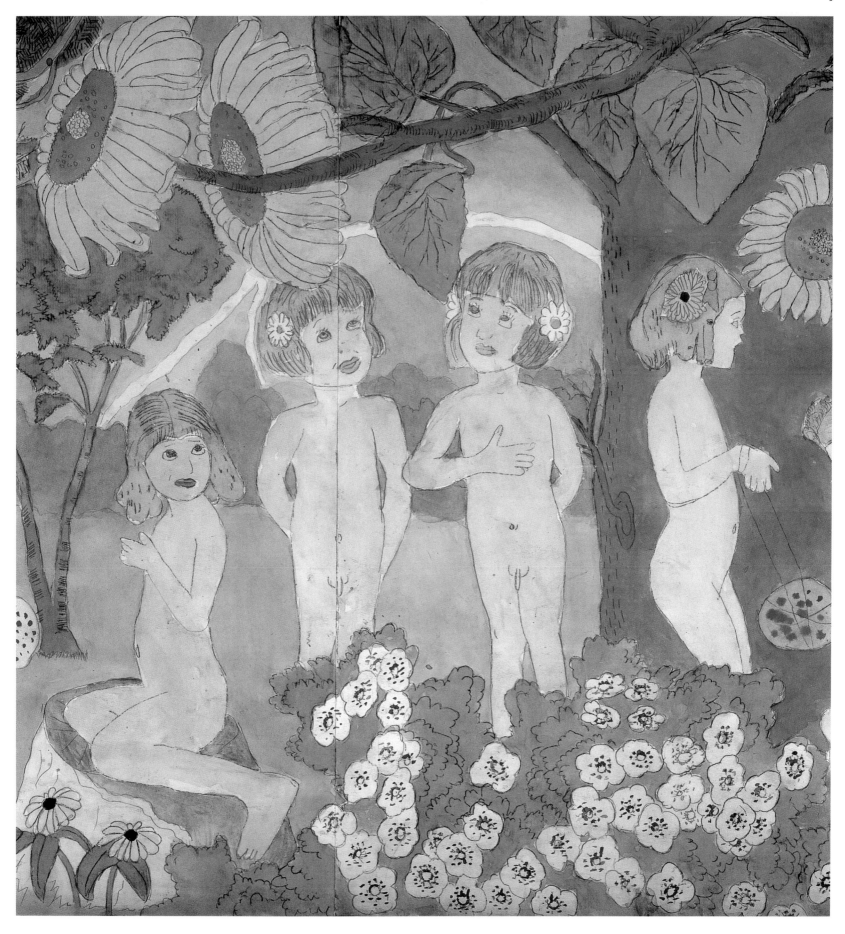

3. John MacGregor, 'I See a World Within the World', *Parallel Visions*, pp.263–4. MacGregor has been researching the works of Darger for many years and is the only person to have studied *The Realms of the Unreal* in depth

were literally cut up like a butcher does a calf, after being strangled or slain...with their intestines exposed or gushed out...Hearts of children were hung by strings to the walls of houses, so many of the bleeding bodies had been cut up that they looked as if they had gone through a machine of knives. ₃ ¶ The blood-soaked pages of *The Realms of the Unreal* are given some relief with descriptions of the beauty of the Vivian girls and their allies, the child-loving and protecting 'Blengins', large creatures equipped with fairy wings. Darger even makes an appearance himself, as the valiant Captain Henry Darger, fighting to protect the child-slaves. ¶ At some point Darger decided to branch out from his literary occupations to illustrate scenes from the book. Nathan Lerner found eighty-seven large watercolours, some 3 metres (9 feet) long, crudely stitched together to make three large books, and sixty-seven smaller drawings. Many of the works were double sided, often with starkly contrasting scenes: the idyllic rural setting of little girls at play being backed by scenes of appalling carnage and dismemberment. Darger had little confidence in his drawing and used a patchwork collage to build up his compositions, which, however horrific in content, show a charm and delicacy lacking in his written epic. He traced figures from every possible source (above all, comics and mail order catalogues) and at some considerable expense had them photographically enlarged so that he could trace over them again and add them to his pictures. Embellishments such as items of clothing, weapons and even penises (for the little girls) were added in pencil or watercolour. ¶ Nathan Lerner preserved Darger's room much

Henry Darger's room, Chicago, photographed by Nathan Lerner, c.1973

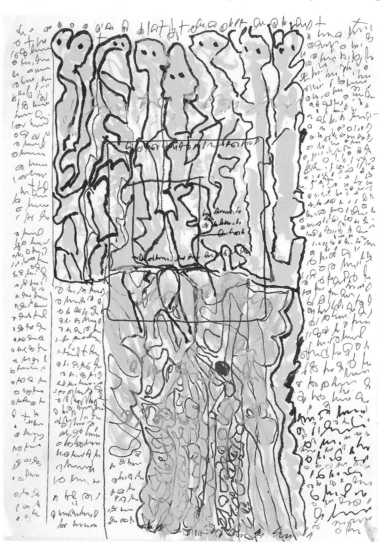

J B Murry
Untitled, 1980s
Mixed media on paper
36×28 cm
Private collection

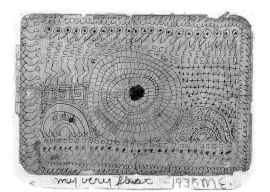

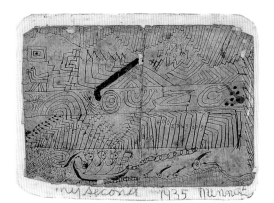

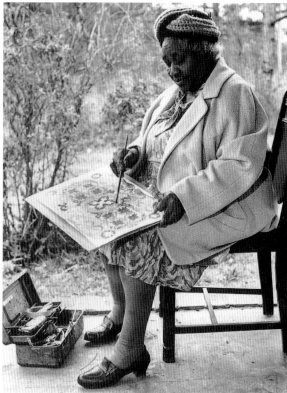

Minnie Evans
Left
At Airlie Gardens, Wilmington,
North Carolina, 1960s
Far left, top
My very first, 1935
Ink on paper
14×20 cm
Whitney Museum of American Art,
New York
Far left, bottom
My second, 1935
Ink on paper
14·6×19·4 cm
Whitney Museum of American Art,
New York

as he left it. In the mid-1990s the yellowing and decaying collage on the wall,
the piles of papers, even his collection of bits of string, were much as they
had been twenty years earlier. ¶ One of the characteristics of American Outsider Art is the powerful presence
of African-American creators from the southern states. Minnie Evans (1892–
1987) worked as a gatekeeper at lush gardens in North Carolina. Her stream
of mystical drawings began on Good Friday, 1935; her second drawing was
made the next day. It was to be another five years before she was to draw
again, but it was the start of a rich creative period. Her imagery gradually
developed as faces and flora emerged from symmetrical abstract patterns and
designs, sometimes accompanied by strange pictogrammic writing. Her daily
garden environment is reflected in her later work. As time went on, her
colours became stronger and more vibrant, her compositions singing with
serene faces and vivid flowers. ¶ J B Murry (1908–88) had no formal education and worked as a
share-cropper and tenant farmer in Georgia. Late in life he had a vision to
spread the word of God through a special 'spirit script'. He claimed his calli-
graphic shapes, produced while in a trance, were the direct word of God,
although they were only decipherable by him when he looked at them
through a glass of water. The brightly coloured letter-forms, held in strictly
ordered compositions, may take on human characteristics, or form abstract
patterns. ¶ At times the creative achievement seems little short of a miracle. Bill Traylor
(1854–1947) was born a slave in Alabama and worked for most of his life on a
plantation. He had little or no education and could neither read nor write. It
was not until he was in his mid-eighties that he began to draw and paint. The
artist Charles Shannon discovered Traylor at work on the streets of
Montgomery in 1939, just at the start of his creative period. Traylor slept at
the back of a nearby undertaker's shop; during the day he worked with pencil
stubs on bits of scrap cardboard, creating a world of sharply defined silhou-
etted figures and beasts. ¶ Shannon befriended Traylor and supplied him with

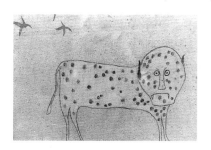

Bill Traylor
Untitled, between 1939 and 1942
Private collection

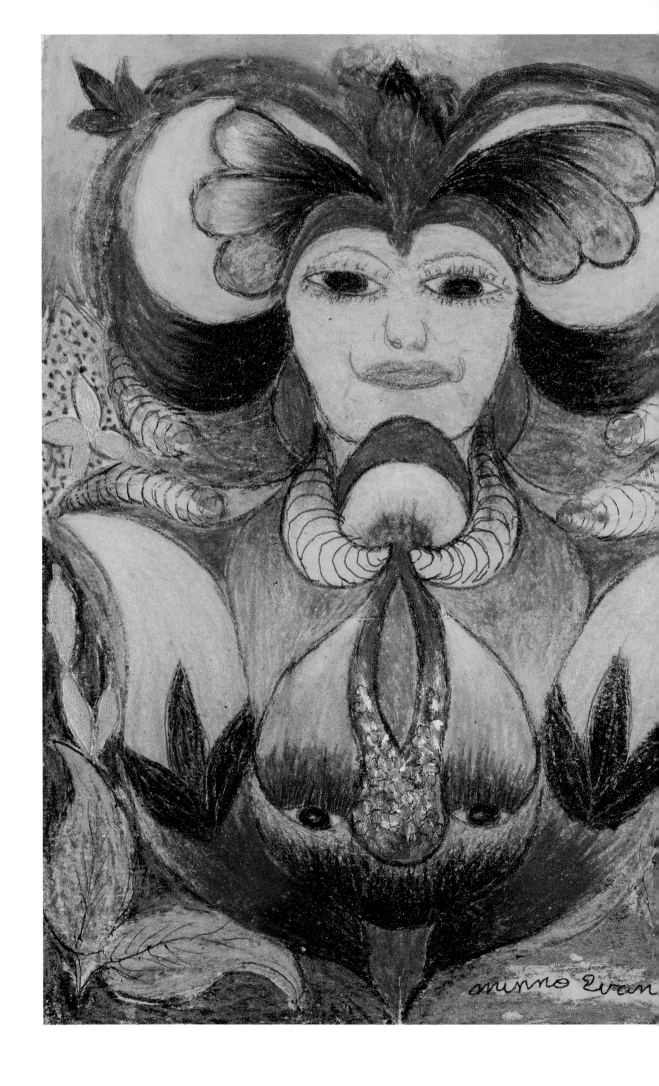

Minnie Evans
Untitled, 1946
Mixed media on paper
30·5×45·7cm
Abby Aldrich Rockefeller Folk Art Center,
Williamsburg, Virginia

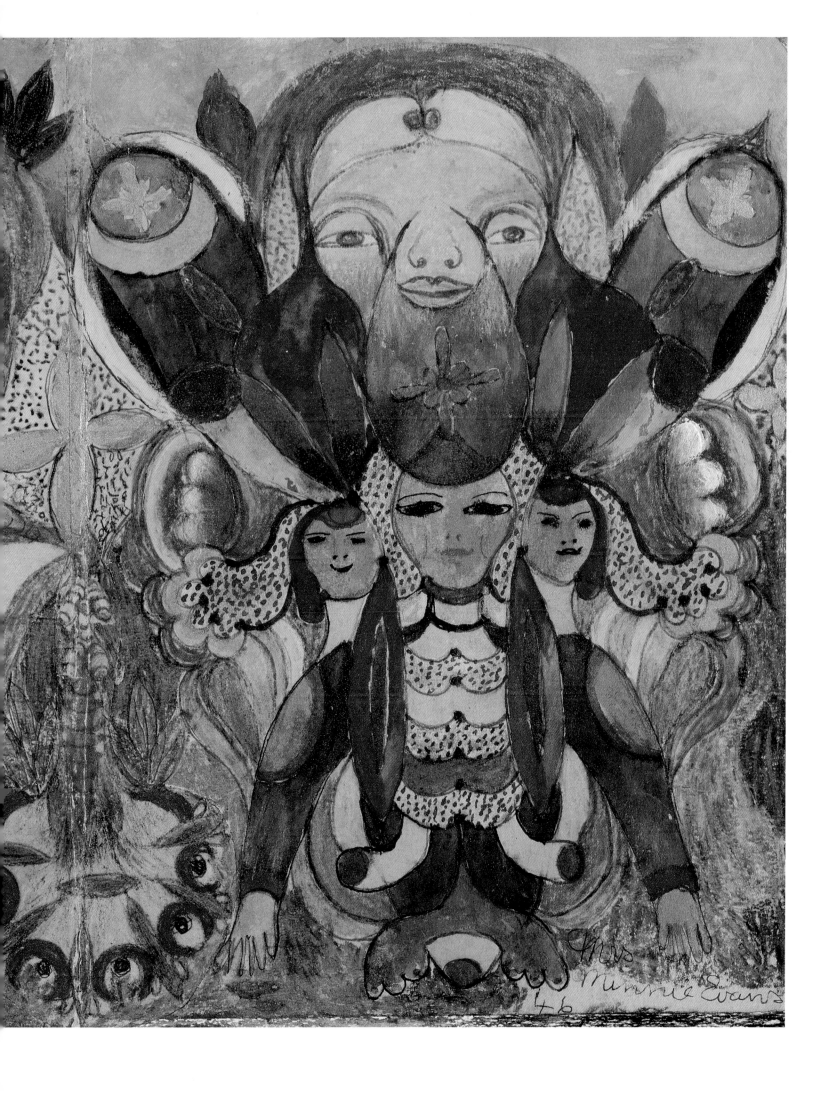

brushes and paints. He also stored and cared for Traylor's pictures, even organizing an exhibition of his work at a local art centre. Traylor's creative period lasted only until 1942, when he moved to the north to stay with his children during World War II. Although he returned to Alabama after the war, he was never able to recapture the creative spirit he displayed from 1939 to 1942. During this short period he produced over 1,200 drawings and paintings. ¶ Some pictures depicted local events and people; others were drawn from Traylor's memories of rural life. Traylor could usually say a few words about each one, to explain the humour of a situation or the stubborn character of an animal. His simple subject-matter is set in charming compositions, with abstract elements placed in space or combined in complex structures. He liked to work on rough cardboard, even incorporating blemishes and marks into his drawings. ¶ After Traylor's death in 1947, Shannon stored his work away for nearly thirty years. When it did eventually make an appearance, it was greeted enthusiastically and recognized as work of unique quality. The subsequent high prices that Traylor's work was able to command even led to a lawsuit, with relatives successfully claiming from Shannon some of the proceeds. ¶ Afro-American artist and prison inmate Frank Jones

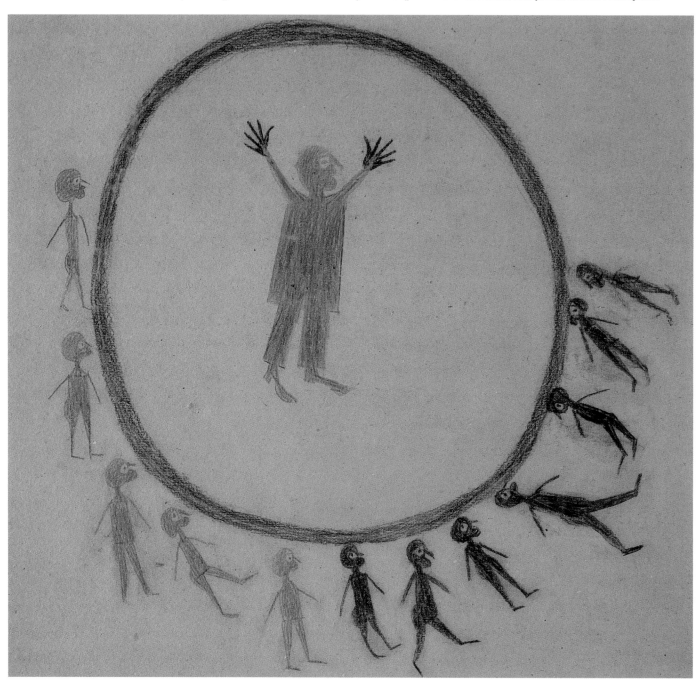

Bill Traylor
Preacher and His Congregation,
between 1939 and 1942
Coloured pencil and charcoal on
paper
33×36 cm
Collection Gael Mendelsohn

(1900–69) was sentenced to life imprisonment in spite of his claims of inno-
cence. In 1964, in the stark environment of a Texas jail, he began to draw,
using discarded pencil stubs and scraps of paper. His work often features
'devil houses'—intricate structures made up of box-like rooms surrounded by
devilish creatures and spiky ornamentation. Jones, who preferred to draw in
red and blue, produced over 200 drawings in a period of five years. His
figures, which both charm and threaten, seem trapped in the tight framework
of his compositions. ¶ At first Jones was only able to mark his work with his prison number 114591,
but he later learned to write his name. In spite of his pleas of innocence and
subsequent fame, it was not until shortly before his death in 1969 that he
gained his parole. At least his compulsive creativity had given him a certain
peace and won him the respect lacking elsewhere in his life. ¶ A recent development in both the United States and Canada has been

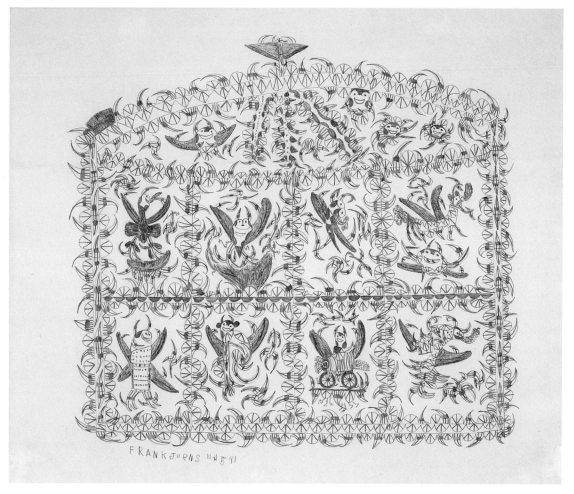

Frank Albert Jones
(signed with prison number)
Murray Devil House, between 1964 and 1968
Coloured pencil on paper
64·75×82·55 cm
Private collection

the establishment of creative workshops for the handicapped. One of these, the Creative Growth Art Center in Oakland, California, plays host to Dwight Mackintosh (b.1906), a former psychiatric patient released into society at the age of seventy-two after fifty-six years of institutional life. His first drawings, in flowing and overlapping lines, were figures with breasts, huge erect penises, fingers, toes, cheeks, eyes and ears laid down over the bodily contours, as if produced by an erratic drawing machine. Occasionally buses and other vehicles are depicted with human figures, in ghostly cut-aways combining human and motorized elements. The vehicles, all ancient models from Mackintosh's pre-hospital memory, are sometimes enhanced by a stream of calligraphic forms. Although recognizable letters can occasionally be identified, the writing becomes an integral abstract element in increasingly complex compositions. Mackintosh's later works show a dense use of coloured chalks and pencils. His later pen drawings are also heavily worked, with the contoured lines repeated and re-emphasized. Mackintosh works in a compulsive flow, even falling asleep during a drawing, thus, it might be argued, producing a pure form of automatism.[4] ¶ As the number of intuitive and Outsider artists recognized in the United States has grown and interest in their work has increased, the Collection de l'Art Brut in Lausanne (see Chapter 4) and its deliberations have seemed increasingly remote. The arbiters in Lausanne have officially designated the work of some US artists as 'Art Brut'—for example all those discussed in this chapter with the exception of Lee Godie.[5] However, categories have grown blurred. Many American enthusiasts have their own, much broader, views of the types of work that might be considered Outsider Art.

4. See John MacGregor's excellent study: *Dwight Mackintosh: The Boy Who Time Forgot* (Oakland, California, 1991)

5. Other artists officially designated as *artistes bruts* include: Larry Bissonnette (b.1957). Ted (Theodore) Gordon (b.1924). Joseph Hardin (1921–89), Justin McCarthy (1882–1977). Sister Gertrude Morgan (1900–80). Juanita Rogers (1934–81). Welmon Sharlhorne (b.1952). Inez Nathaniel Walker (1911–90) and P M (Perley) Wentworth (d. c.1960)

Dwight Mackintosh
Untitled, (Pig farmers), 1988
Felt tip pen and coloured pencil on paper
56×76 cm
Private collection

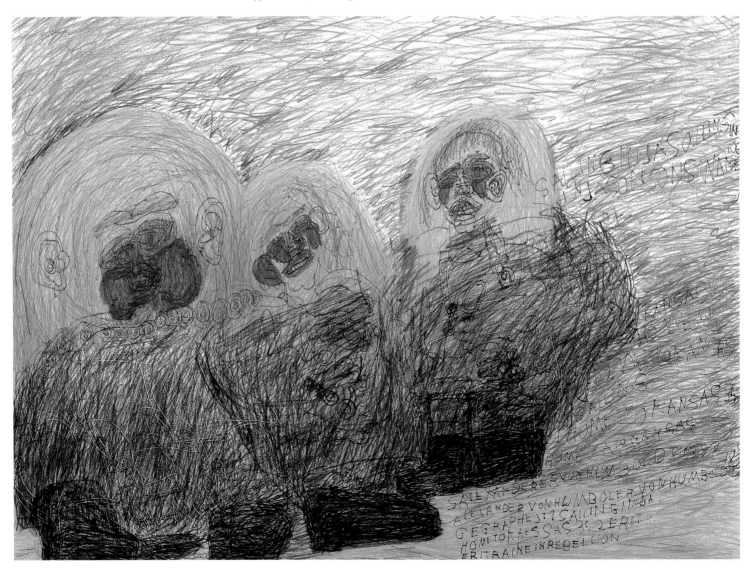

Part II: On the edge of the outside

Chapter 8: CONTEMPO-RARY FOLK ART IN THE U.S.

The folk art tradition of the United States has a completely different emphasis from Dubuffet's discoveries in the asylums of Europe. It has its roots in simple colonial crafts and everyday objects: weather vanes, duck decoys, quilts. It also features naïve portraits and genre painting. By the 1930s such folk creations were regarded by many as legitimate art objects. Exhibitions of nineteenth-century folk art were mounted at the Newark Museum in New Jersey and at the Museum of Modern Art (MOMA) in New York. There was also some early interest in contemporary folk art. In 1937 MOMA exhibited the relatively sophisticated limestone sculptures of the self-taught artist William Edmondson (c.1870–1951), and in the following year it staged the group show Masters of Popular Painting. In 1942 art dealer Sidney Janis exhibited the work of self-taught American and European creators side-by-side, calling the exhibition They Taught Themselves and publishing a catalogue with the same name. The following year MOMA opened an exhibition by self-taught painter Morris Hirshfield (1872–1946), who drew more on his eastern European background than American folk traditions. ¶ However, this interest in self-taught and intuitive artists was gradually overshadowed by other developments—including the Abstract Expressionist movement, led by New York artists, and the influx of important European artists escaping from World War II. As the United States became more firmly a part of the international art scene, the art establishment's attitude toward 'unsophisticated' folk art became less sympathetic. ¶ Although the work of

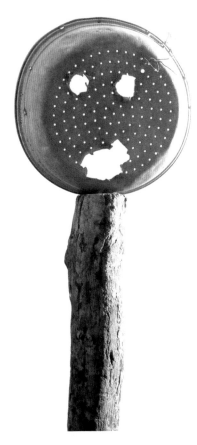

Hawkins Bolden
Above, *Punched Tin Strainer*, c.1990
Tin and wood
Height 152cm
Private collection
Right, from left to right
Pan Face with Milk Cans, 1987–9
Mixed media
46×51cm
Collection William Arnett
Cane Chair with Blue Jeans, 1987–9
Mixed media
79×61×71cm
Collection William Arnett
Board with Pan Face and Hose Tongue, c.1988
Mixed media
Height 107cm
Collection William Arnett

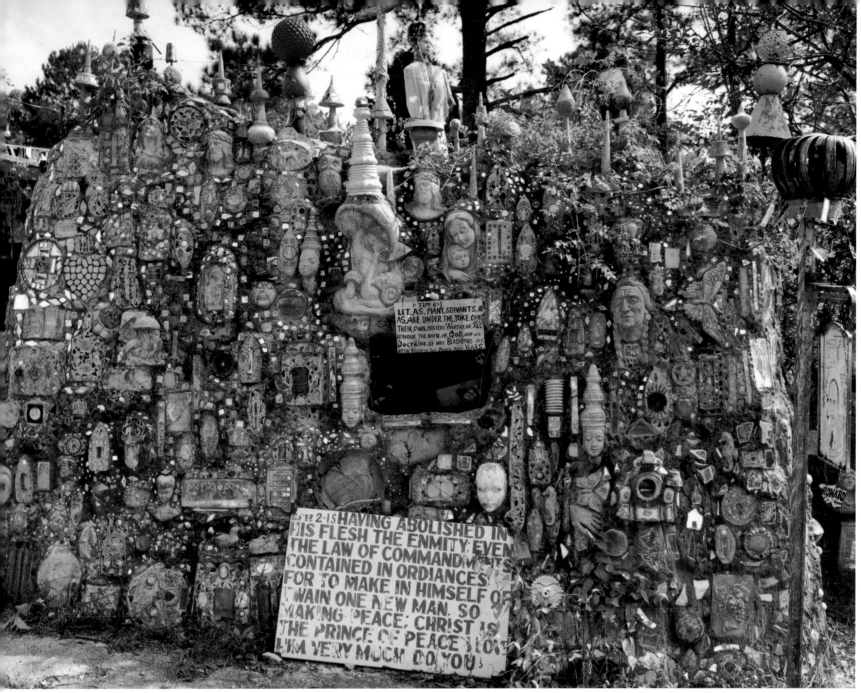

Howard Finster's Paradise Garden, Georgia

some self-taught creators was collected, it was viewed as separate from contemporary art. Memory painter 'Grandma' Moses (1860–1961) became particularly successful, her charming version of American rural life influencing perceptions of folk art over the next decades. When the Museum of American Folk Art was established in New York in 1961, its original emphasis was on colonial art and quaint evocations of country life. ¶ Still, Herbert Waide Hemphill Jr, one of the founders of the Museum of American Folk Art, built a large and wide-ranging collection, including not only wooden decoys and toys, shop signs, Hopi Indian dolls and naïve portraits but also the work of living folk artists whose creations expressed powerful personal visions. A selection from his collection was shown at the Museum of American Folk Art in 1970 in the exhibition Twentieth Century Folk Art and Artists, which also featured documentation of some of America's newly discovered environmental creations (see Chapter 13). In 1974 Hemphill and Julia Weissman published their influential book *Twentieth-century American Folk Art and Artists*, demonstrating again the importance of contemporary folk art creators.[1] ¶ Over the following decade, the distinctive role and unique character of

1. Herbert W Hemphill Jr and Julia Weissman, **Twentieth-century American Folk Art and Artists** (New York, 1974). About 400 works from Hemphill's collection of over 2,500 pieces were donated to the National Museum of American Art, Smithsonian Institution, Washington DC, in 1986

contemporary folk art was recognized, but there was no attempt to provide it
with an intellectual rationale of the kind that Dubuffet had given Art Brut.
Indeed, there are basic and important differences between the two. Art Brut,
and Outsider Art in general, glorifies the extreme expressions of those out-
side society's influences, seeing them as uniquely original creations that stem
from the inner psyche. Outsider creations often have no aspiration to be art
at all; they are more a compulsive flow of creative force that satiates some
inner need. Folk art, on the other hand, still echoes its homestead past. Its
makers are often fully aware that they are producing art and they will do
what they can to sell it, in much the same way as a producer of crafted furni-
ture or pottery. Indeed, many feel the term 'Outsider Art'—with its connota-
tions of the outcast and mentally disturbed—is demeaning and patronizing.
Many folk artists are fully part of their local communities, their social stand-
ing often enhanced by their artistic activities. ¶ Religion has been a powerful inspiration for many American folk artists.
In the life of the evangelical preacher, the Reverend Howard Finster (b.1916),
religious mission has merged with creative expression. Describing himself as
'man of visions', 'stranger from another world' and 'holy man of the South',
Howard Finster has become one of folk art's most famous practitioners, his
immense energy, charisma, warmth and desire to communicate sweeping
all before him.[2] ¶ Finster supported himself in a variety of ways, including repairing bicycles
and televisions as well as preaching. His belief that he could create an earth-
ly paradise which would further spread the word of God gave birth to
Paradise Garden in Georgia, a two-acre site which he filled with statues, exhi-
bition sheds, paintings, found objects and decorated signs. In its midst stands
the four-storey World's Folk Art Church, a place of worship surrounded and
filled by Finster's works and memorabilia. In both Paradise Garden and in his
thousands of paintings, Finster combines word and image. A profusion of
biblical quotations is outnumbered only by Finster's own pearls of wisdom,
home truths to suit every occasion. ¶ All his early work was made to embellish and

2. See John Turner, *Howard Finster: Man of Visions* (New York, 1989) and Tom Patterson, *Howard Finster: Stranger from Another World. Man of Visions Now on This Earth* (New York, 1989)

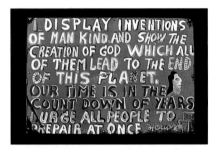

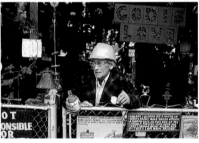

Howard Finster
Above, top
Sign from Paradise Garden
Above, bottom
Howard Finster
Right
Howard Finster reclining on his giant shoe in Paradise Garden

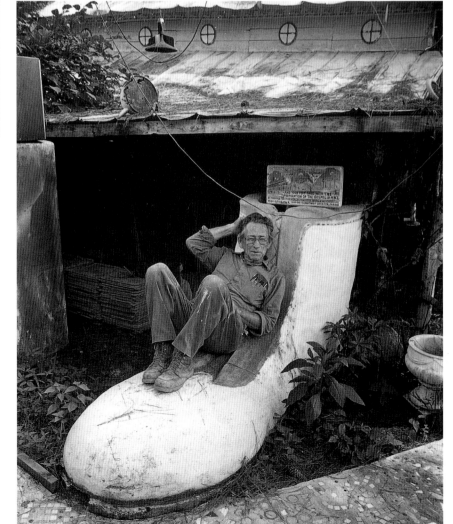

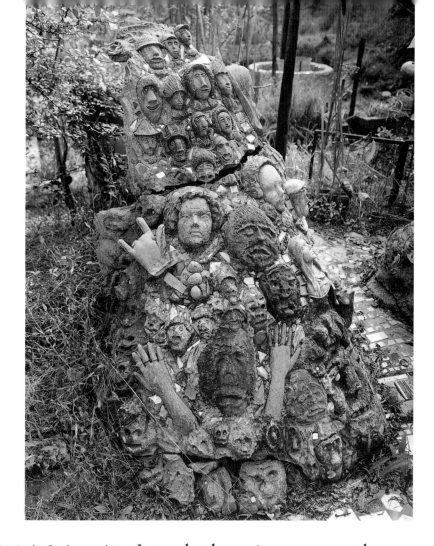

enhance Paradise Garden. One sign in the Garden proclaims: I took the pieces you threw away
and put them together by night and day
washed by the rain, dried by the sun
a million pieces all in one. ¶ Even his bicycle repair tools, embedded in a

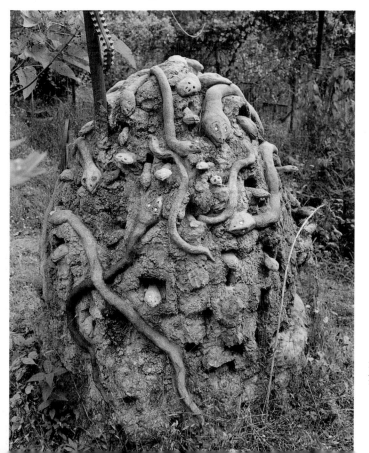

Howard Finster
Above and left
Sculptures from Paradise Garden

3. Quoted in John Turner, *Howard Finster: Man of Visions*, p.72

concrete path, became part of his creation, serving as a reminder of his transformation from bicycle repair man to sacred artist. Finster has commented: God wanted me to take this junk and make something out of it and show people who got things that they could do something where they stand. You see, I'm an example from God.[3] ¶ Though Finster has covered boots, lawnmowers,

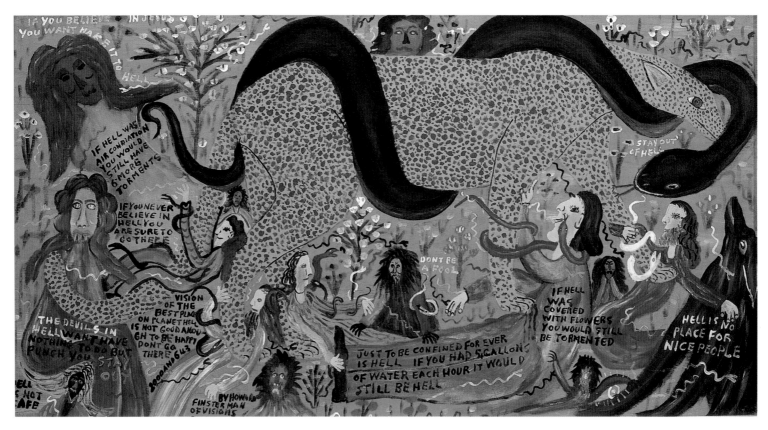

Howard Finster
Above
Hell is No Place for Nice People, 1983
Enamel on wood
61×107cm
Private collection
Right
Franklin D Roosevelt, 1976
Paint on burlap
63.5×69.2cm
Ricco/Maresca Gallery
Opposite
Vision of Mary's Angel, 1987
Enamel on wood
123×123cm
Phyllis Kind Gallery

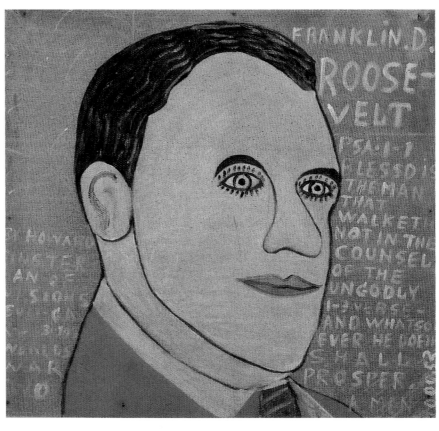

television sets, cooking pans, even a Cadillac with images and quotations, it is his paintings that best demonstrate his vision. His early works, rough but strong compositions, mainly illustrate biblical texts, some becoming visual sermons in their own right: the Southern evangelical oral tradition transformed into image and painted word. By the late 1970s his compositions had developed in complexity and sophistication, containing a host of detailed elements that he built up to a powerful whole. His visions of Heaven and Hell transcend their folk art background to vie with any other depictions of the subject. Other subjects include the worlds of distant galaxies, UFOs and commentaries on political and social issues. ¶ Always willing to spend time with visitors to Paradise Garden and to sell them a reasonably priced piece of art to take home, Finster fast became a popular figure. He even made a television appearance on Johnny Carson's *Tonight* show in 1983, designed record covers for rock groups and laid plans for his own fan club. In 1984 he was one of his country's representatives at the Venice Biennale. As his fame spread, Finster's output grew, to the point where he was working on up to fifty pieces at once, with family members helping to cope with the ever increasing demand. While turning out production line pieces, mainly painted cut-out shapes and simple works made from templates which he called 'dimensions', he still managed to execute single paintings of real quality. Over the years, as more and more visitors and eager collectors visited Finster, the Garden gradually became stripped of many of his works. ¶ Another American folk artist serving the will of God was Sister Gertrude Morgan (1900–80), a missionary on the streets of New Orleans, who, as the result of a vision, thought of herself as a 'Bride of Christ'. She dressed only in white and lived in a white house with white furnishings. She preached using a large white paper megaphone and painted on sidewalks, footpaths and streets to illustrate her sermons and attract passers-by. Nearly all her works were inspired by biblical—often apocalyptic—subjects: the Flood, New Jerusalem, Paradise, the Second Coming and the Book of Revelations were treated in bright primary colours, with sweeping written texts and evangelical messages. Hosts of angels were made all the more radiant by her technique of rubbing chalk into the bright paint. ¶ The work of some artists overlaps the

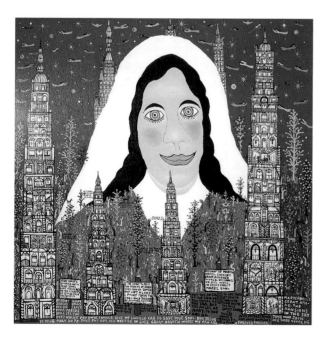

folk art/Outsider Art divide. For example, some individuals regarded firmly as folk artists have lived on the perimeters of society, producing works which reflect their inner world, with no regard to the market place. Among them is the African-American Hawkins Bolden (b.1914), who has been blind since childhood, but has constantly used his hands to construct and build. At first he made radios from discarded parts, and around his garden in Memphis he developed a whole series of assemblages, which seem charged with magical power. Originally serving as scarecrows and talismans to ward off birds and other unwanted guests, they were built around old posts and branches that serve as bodies or frames. Their heads are made of old tin pots or pans with prominent eye holes punctured through the metal. Discarded carpet scraps or other materials that serve as large hanging tongues and torn cloth used for clothing move with the wind, giving these creatures a strange life of their own. Bolden's immensely powerful works push the concept of folk art to its limits. ¶ Another African-American artist from the South who produced works of disturbing power was Bessie Harvey (1929–94), from Alcoa, Tennessee. Taking twisted roots and branches as her starting-point, Harvey glued and nailed to them pieces of cloth, feathers, beads and hair to build up figures. Staring black faces of painted clay and putty loom out of her demonic organic forms. Harvey claimed to experience religious visions and other emotive links to the spirit of her African past, and her figures seem to evoke African and voodoo sacred objects. ¶ So much has been made of the African connection in the work of African-American folk artists that 'Black folk art' has become a separate category in itself, acknowledged by the major exhibition Black Folk Art in America 1930–1980 held at the Corcoran Gallery of Art in Washington DC in 1982, which presented the work of twenty artists. Almost every nuance has been used to prove African roots. Although there is without doubt a genuine African heritage, it is not necessarily evident in the work of every artist and the theory has suffered from exaggerated claims of a shared African consciousness. Many characteristics are simply those common to all art works that evoke a 'primal' or magical power, and are equally evident among certain European examples of Art Brut.[4] However, the overwhelming presence of African-Americans among folk artists cannot be disputed, nor can their outstanding contribution to contemporary folk art. ¶

Hawkins Bolden

Three great painters of African-American folk art are Thornton Dial Sr, Sam Doyle and Mose Tolliver. All display genuine painterly skills rare in Art Brut or Outsider Art. The most forceful of the three, Thornton Dial Sr (b.1928), of Bessemer, Alabama, left a lifetime of manual work to concentrate on his art and has since been the inspiration for a dozen folk artists within his extended family. The heavy impasto of Dial's work, the sharply contrasting colours, the expressive brushwork, effectively convey themes of tension and conflict: the battle between the sexes, the unending struggle of the African-American against injustice and a range of dramatic political and social subjects. Struggle is personified by the image of the tiger, at times dominating the picture, at others hidden within it. The power and strength of this warrior beast take on symbolic significance for Dial, both serving as an inspiration and a personal totem.[5] A versatile and inventive artist, Dial has also produced large assemblages, usually human forms, combining found materials with painted surfaces. ¶ It was not until his retirement that Sam Doyle (1906–85) found

4. For a detailed analysis of theories of the African connection, see Robert Farris Thompson, *Flash of the Spirit* (New York, 1984) and Maude Southwell Wahlman, 'Africanisms in Afro-American Visionary Art', in *Baking in the Sun* (exhibition catalogue, University Art Museum, University of Southwestern Louisiana, Lafayette, 1987)

5. See Thomas McEvilly and Amiri Baraka,. *Thornton Dial: Image of the Tiger* (New York, 1993)

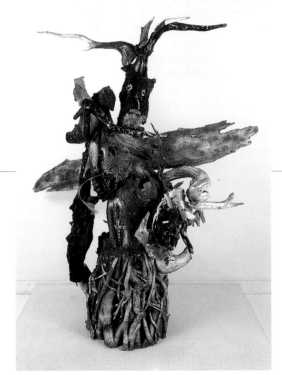

Bessie Harvey
Cross Bearers, 1992–3
Mixed media
1·73×1·52×0·68 m
Whitney Museum of American Art, New York

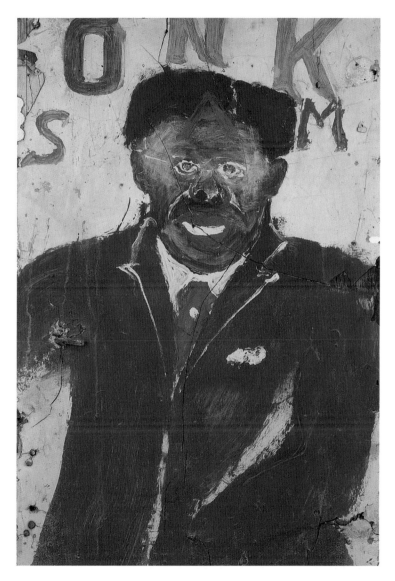

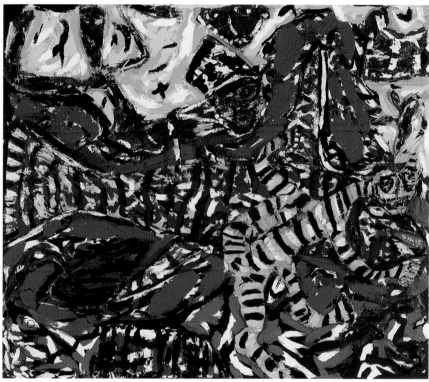

Left
Sam Doyle
Onk Sam, between 1978 and 1981
Enamel on board
80×53cm
Private collection
Above
Thornton Dial Sr
Oh What a Big Fish, c.1993
Mixed media on canvas
1·69×1·98×0·30 m
Collection William Arnett

time to paint. He lived on South Carolina's isolated St Helena Island, one of
the first territories to be wrested from Confederate hands during the Civil
War. Tales of slavery and emancipation, the lives of the people of this little
community and the heroes of Black America are the subject-matter of Doyle's
simple and freely painted works on sheets of metal or wooden board. The let-
ters or abbreviated words that he combined with his images give them a
poetic quality. His subjects have included Ray Charles, Joe Louis, Abraham
Lincoln addressing the islanders, Doyle's grandmother—the first black mid-
wife on St Helena—and even Doyle's chickens. ¶ Mose Tolliver (b.1919) from Montgomery, Alabama,
displays a more imaginative approach. An industrial accident left him with

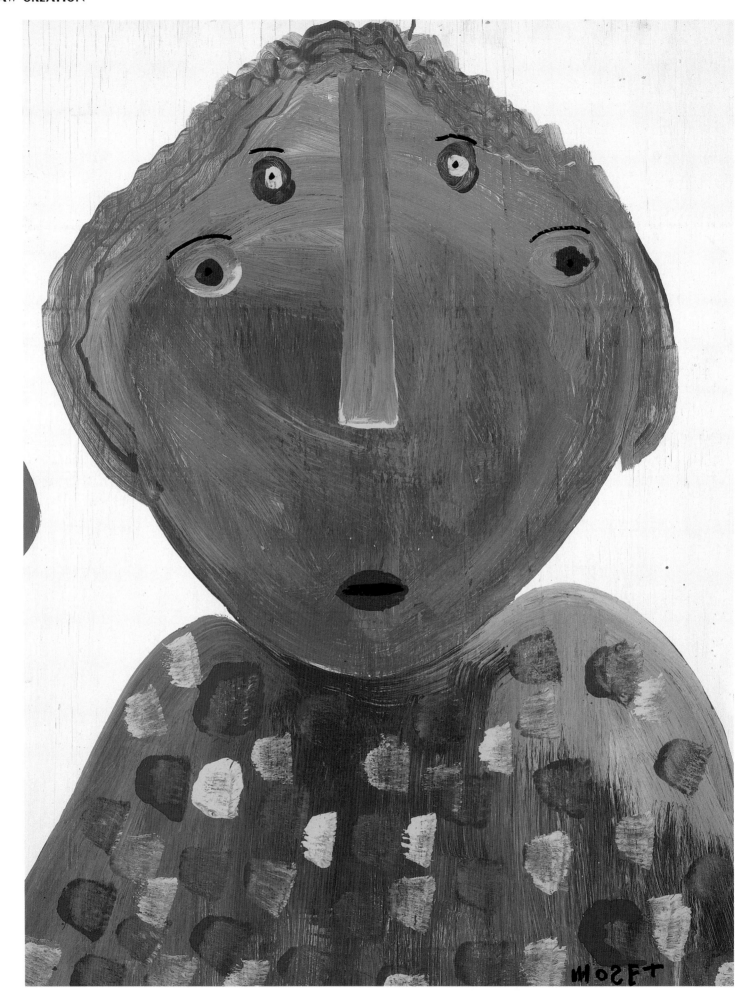

Mose Tolliver
Untitled, 1968
Enamel on wood
Collection William Arnett

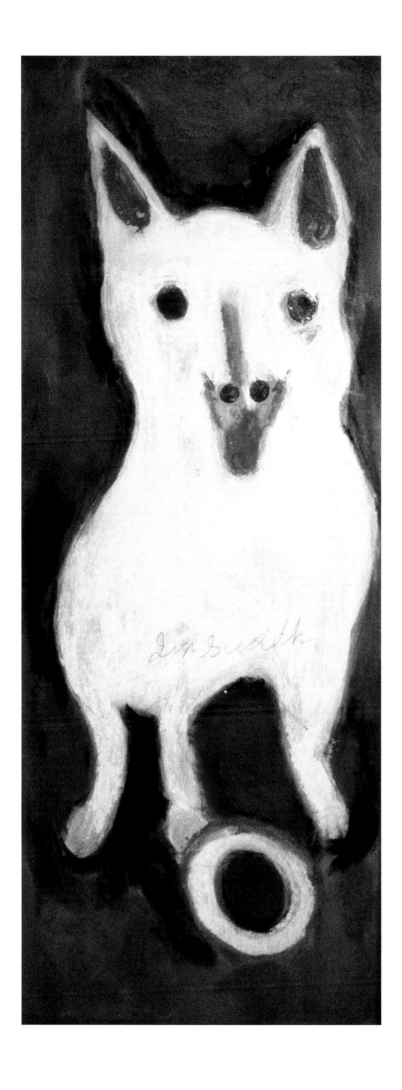

Jimmy Lee Sudduth
Toto, 1980s
Mud, pigments and paint on board
78·7×30·4 cm
American Primitive Gallery

time on his hands and he gradually moved from early paintings of birds to more involved and unusual subjects. One of these 'ladies on scooters', or 'moose ladies', a sexual fantasy of a spread-eagled female figure astride a phallus on wheels, is repeated in endless variations. In use of colour he is among the most sophisticated of America's folk artists, employing subtle and harmonious combinations of controlled hues. Painted in free-flowing house paint or enamel on board, his portraits express an intensely individual vision. When demand for his work suddenly increased, he produced up to ten paintings a day, even enlisting the help of one of his daughters to keep up production. ¶ Many self-taught artists employ unusual materials or techniques, but none more so than Jimmy Lee Sudduth (b.1910), the 'world's greatest mud painter'. Sudduth claims to have drawn consistently since childhood, producing his first painting in mud on a tree. He later used over thirty shades of Alabama mud for his works, adding syrup or sugar as a hardener and leaves and berries rubbed into the dry mud as additional colourants. His subject-matter is straightforward—local residents, farm animals, log houses, old churches and his dog Toto. He first exhibited his works at county fairs, attracting attention by playing blues on his harmonica. Since retiring from his work as a gardener, he has devoted himself to his art. When collectors and museums found that sugar and syrup presented conservation problems, Sudduth introduced house paint to his mud mixtures as a binder, bringing bright contrasts to his wealth of natural colour. ¶ After his retirement, Raymond Coins (b.1904) of North Carolina became

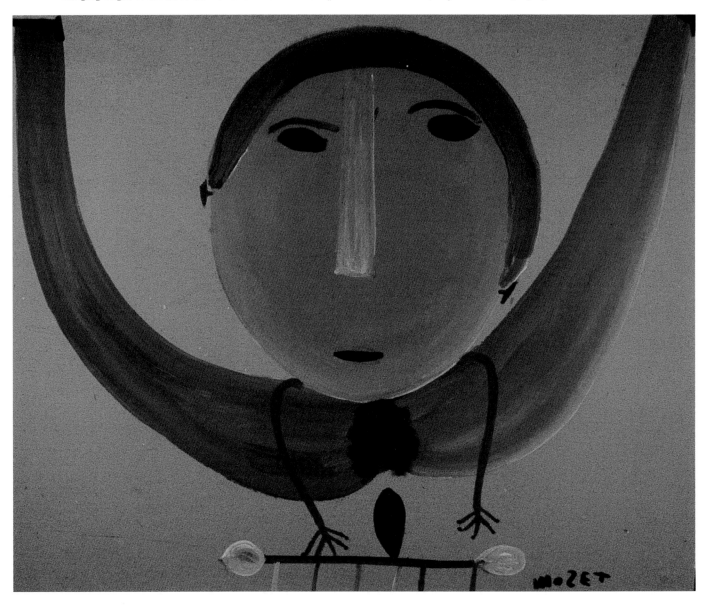

Mose Tolliver
Moose Lady, 1989
Acrylic and hair on wood panel
63.5×78.7cm
American Primitive Gallery

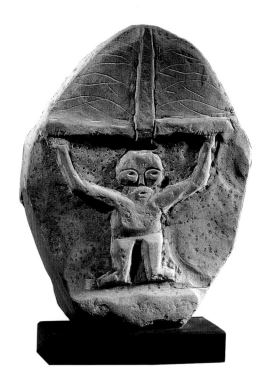

Raymond Coins
Crucifixion/Tree of Life, 1989
Steatite
40·6 × 33·0 × 4·4 cm
American Primitive Gallery

increasingly involved in his hobby—carving stone and bits of wood. Soon this became an obsession, as Coins worked from morning to night. Ideas for the small stone statues, originally termed 'doll babies', came to Coins while he turned a stone in his hand before working. He made busts and figures of angels, with staring eyes and round protruding mouths displaying an archaic power. He also carved bas-reliefs in soft soapstone. These tend to have religious themes, such as the Crucifixion or Garden of Eden. ¶ William Hawkins (1895–1990), an African-American urban folk artist from Ohio, reflected his environment in his large relief cityscapes. The bright and roughly painted works often included animals and creatures but invariably his own name and birthdate in large imposing letters. ¶ By the late 1970s contemporary folk artists

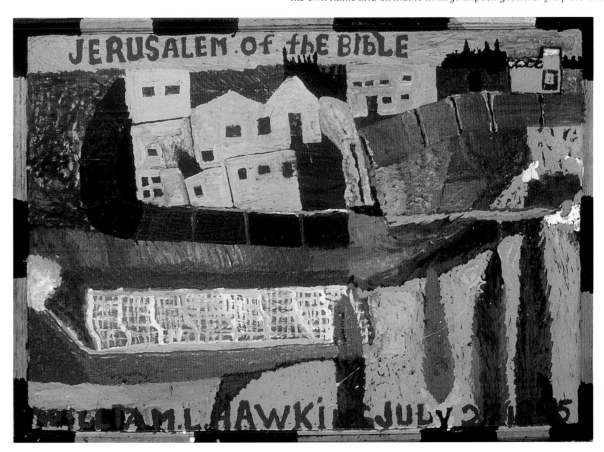

William L Hawkins
Jerusalem of the Bible, 1985
Enamel on board
84 × 117 c m
Private collection

were attracting increasing attention, but were still a minority interest among art enthusiasts. When Didi Barrett became editor of the Museum of American Folk Art's journal, *The Clarion*, in the late 1980s, she increased coverage of more recent creations in relation to early folk art. In 1979 Florence Laffal began publication in Essex, Connecticut, of a small newsletter, the *Folk Art Finder*, which introduces the work of newly discovered folk artists, and provides a forum for discussion and a means of exchanging information. For many years the *Folk Art Finder* was one of the few conduits of news and events in what was gradually developing into a strong community of interest.

¶ Growing enthusiasm for contemporary folk art led to the formation of the Folk Art Society of America (FASA) in 1987. With its centre in Richmond, Virginia, and under the presidency of founder Ann Oppenhimer, FASA has launched its own journal, *Folk Art Messenger*. Distancing itself from the world of New York galleries and from academic arguments, it concentrates on the artists themselves, their works and their followers. It has also shown a willingness to address the problems confronting folk artists when they face the effects of marketing and exploitation. ¶ Contemporary folk art has become in a few decades as important an influence in the US as Art Brut has been in Europe. Although they have distinctive features, both share a belief in the inventiveness of the individual and a respect for intuitive expression, a creative force unaffected by the demands of the cultural establishment.

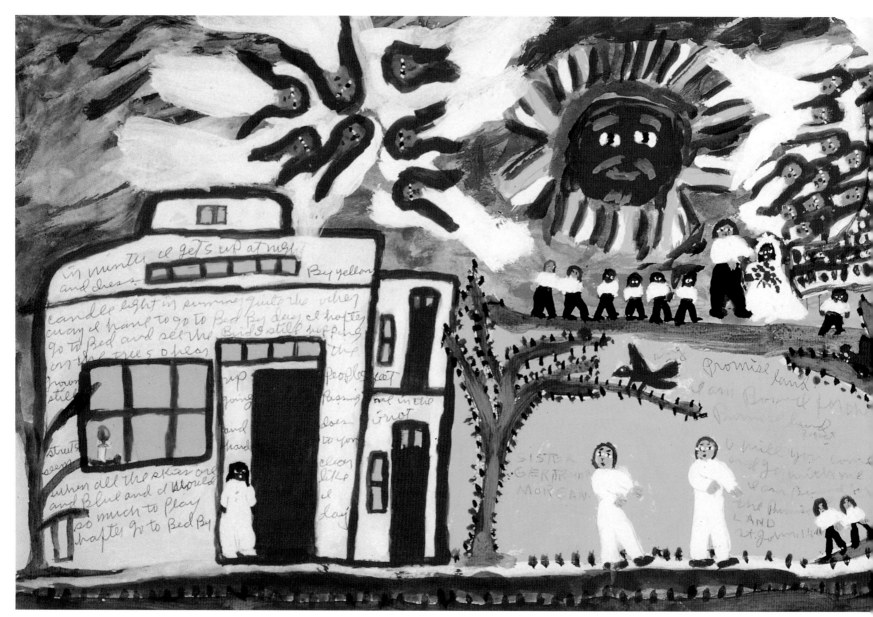

Sister Gertrude Morgan
Precious Lord Take My Hand, Lead Me On, Let Me Stand, between 1965 and 1975
37×107cm
Collection Kurt Gitter and Alice Yelen

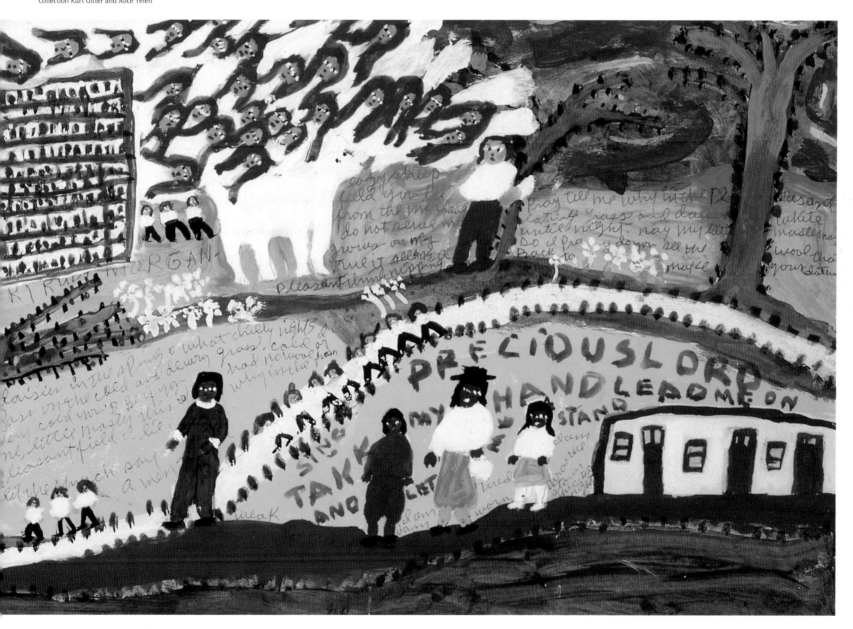

Chapter 9: MARGINAL ART: NEUVE INVENTION AND ART SINGULIER

The compilation of his catalogue for the Collection de

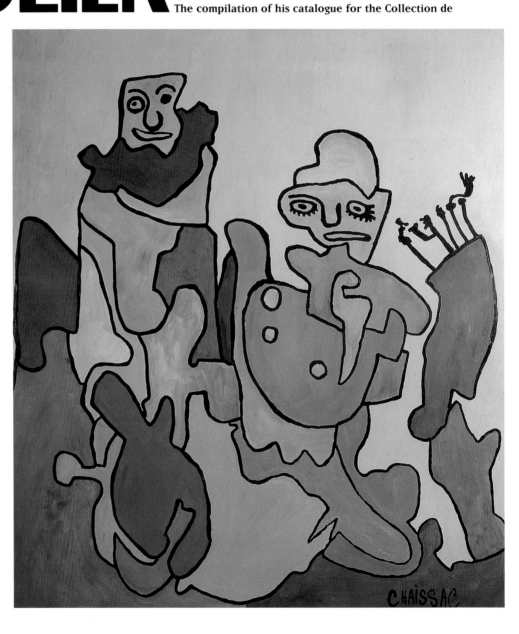

Gaston Chaissac
Untitled, c.1957–9
Oil on hardboard
1·45×1·22 m
Musée de l'Abbaye Sainte-Croix, Les Sables-d'Olonne

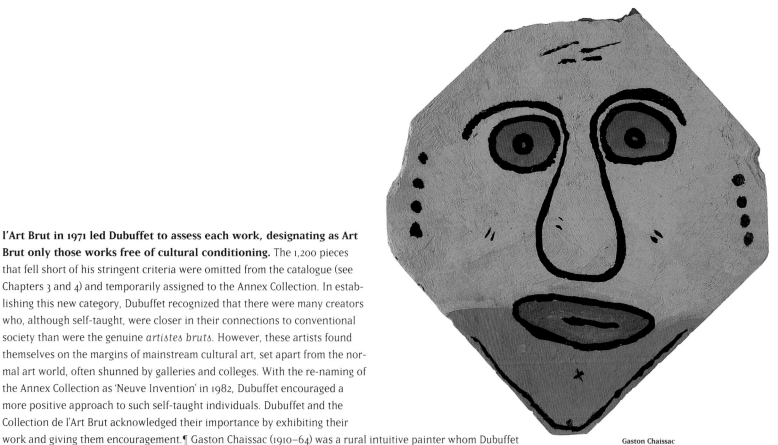

l'Art Brut in 1971 led Dubuffet to assess each work, designating as Art Brut only those works free of cultural conditioning. The 1,200 pieces that fell short of his stringent criteria were omitted from the catalogue (see Chapters 3 and 4) and temporarily assigned to the Annex Collection. In establishing this new category, Dubuffet recognized that there were many creators who, although self-taught, were closer in their connections to conventional society than were the genuine *artistes bruts*. However, these artists found themselves on the margins of mainstream cultural art, set apart from the normal art world, often shunned by galleries and colleges. With the re-naming of the Annex Collection as 'Neuve Invention' in 1982, Dubuffet encouraged a more positive approach to such self-taught individuals. Dubuffet and the Collection de l'Art Brut acknowledged their importance by exhibiting their work and giving them encouragement.¶ Gaston Chaissac (1910–64) was a rural intuitive painter whom Dubuffet assigned to the new category, although he had originally included him in his collection as an Art Brut artist. Chaissac, who had worked as a cobbler and saddlemaker, had been encouraged to paint and draw in the late 1930s by Paris artist Otto Freundlich. Although at first slightly influenced by Freundlich in terms of colour and approach, he fast developed his own unique vision and visual vocabulary. His early works were simple, almost childlike, images, but with time they grew in complexity. He often built up compositions from combinations of shapes painted in strong contrasting colours outlined in black. He made collages using wallpaper pieces and painted on stones, baskets, roots, all kinds of found materials. In later years he concentrated on his 'totems', rough pieces of wood or found scraps nailed together and painted. ¶ He was an artist of continual paradox and contradiction, 'an innocent aware of his innocence'.[1] He was untrained and his work—which he described as 'modern rustic painting'—was outside mainstream art, yet at the same time he had contact with mainstream artists. He received encouragement and materials from a number of them, including Dubuffet, and although he lived in an isolated village, through his prolific letter writing he was in communication with a variety of figures in art and intellectual circles. He had also held exhibitions of his work since 1938. Some of his stream-of-consciousness writings were published and were even hailed as 'proletarian literature'. Chaissac had been given the title 'Picasso in clogs' in 1946 and used the expression himself in his correspondence with Picasso, whose constructions he much admired. One can see influences, even direct references, to Picasso in

Gaston Chaissac
Above
Untitled, 1954
Oil on slate
36.0×33.5cm
Musée de l'Abbaye Sainte-Croix, Les Sables-d'Olonne
Below, left
Untitled, c.1960
Oil on wood
Musée de l'Abbaye Sainte-Croix, Les Sables-d'Olonne

1. Roger Cardinal, *Outsider Art* (London, 1972), p.126

Chaissac's work. ¶ Gradually Dubuffet became disenchanted with Chaissac's involvement with the art world, with his struggle for recognition and income, and the two eventually fell out in the late 1950s. There is no doubt that Chaissac's work had been something of an inspiration for Dubuffet's own, and perhaps this was a factor in their strained relationship. Chaissac, bitter and dejected, felt he had been used by Dubuffet for the promotion of Art Brut only to find himself excluded from it. By the early 1960s Chaissac was at last making a breakthrough into the Paris art world and his work was selling, albeit rather cheaply. Fame may have been just around the corner when Chaissac died in 1964, disappointed and depressed. This sophisticate with an approach so innocent created works of enduring quality; he is perhaps the most influential self-taught artist of the twentieth century.¶ Dubuffet had come across the works of Louis Soutter (1871–1942) on his first visit to Switzerland in 1945. A cousin of Le Corbusier, Soutter had trained as a musician—he was a virtuoso violin player—before studying fine arts in Lausanne, Geneva and Paris. A stream of professional disappointments and personal losses—including the deaths of his parents, brother and sister—left him alone and in a poor state of mental health. In 1923 his remaining family sent him to be cared for in an old people's home, where he lived until his death. It was during his stay that he began to draw once more, filling sketch books with pen and ink drawings. In his earlier works the pen scratches the surface, building up thick masses of lines forming buildings, figures and trees. In his final years his work grew ever more expressive. He abandoned his pen; dipping his fingers directly into the ink, he created his famous last drawings. The strength and rhythm of these works is striking. The dark faceless figures, seemly trapped in movement, evoke varying moods: from grace to hopelessness and torment. Soutter, a trained artist, thus moved away from his cultural conditioning and from mainstream approaches to art. In the years since his death, like Chaissac he has been much admired, even copied, by professional artists.¶ Friedrich Schröder-Sonnenstern (1892–1982) received little education and found himself on the margins of mainstream culture. An unruly child, he was placed in a series of reformatories from his mid-teens. Accused of theft, he responded with threatening behaviour, and found himself confined to a mental institution for five months. These early sufferings bred in him a life-long hatred of authority and its inherent hypocrisy. After years of petty crime and odd jobs, including a spell as a fortune teller and clairvoyant, he became ill and bed-ridden. An earlier spell of confinement—in prison—had given rise to an interest in drawing and painting, which he now pursued.[2] ¶ Schröder-

2. See Sheldon Williams, 'Schröder-Sonnenstern', *Raw Vision*, no. 2 (1989). pp.16–21

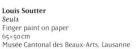

Louis Soutter
Seuls
Finger paint on paper
65×50 cm
Musée Cantonal des Beaux-Arts, Lausanne

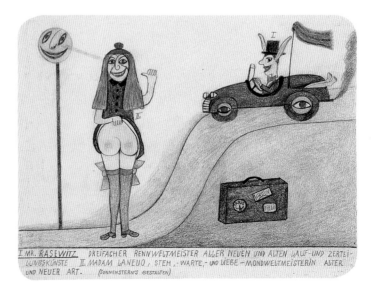

Friedrich Schröder-Sonnenstern
Mr Rasewitz, 1950
Pencil and coloured pencil on paper
21·1×28·0 cm
Galerie Brockstedt, Hamburg

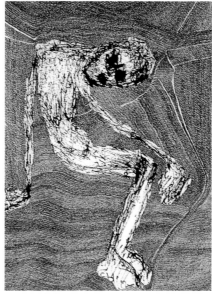

Rosemarie Koczy
Far left
Untitled, 1990
Ink on paper
35·5×26·6cm
Phyllis Kind Gallery
Left
Untitled (no.24)
Ink on paper
35·5×26·6cm
Phyllis Kind Gallery
Below
Deportation Trains 1943—45 (detail), 1992
Pastel on paper
1·45×5·87m
Phyllis Kind Gallery

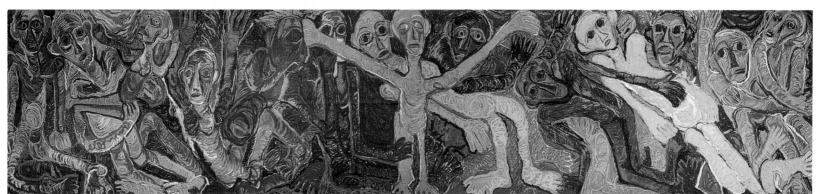

Sonnenstern's art expresses his hatred of authority through a combination of mystical vision and a mischievous anti-bourgeois sentiment. His grotesque caricatures, deformed monsters and distorted figures are given a crisp hard-edged treatment. Coloured pencil laid over thin washes creates great depth of colour and tone. By the mid-1960s Schröder-Sonnenstern's work was being collected and promoted in regular exhibitions. His new-found success, and the comparative financial security that accompanied it, did nothing to dampen the cruelness of his humour or the startling visual imagery of his compositions.¶ Another marginal figure, Rosemarie Koczy, was born in Germany in 1939. She took courses at the School of Decorative Arts in Geneva and became a successful tapestry maker. Her largely abstract early work evoked the imagery of nature; later she introduced intense and expressive human figures. However, she found the tapestry medium hampered expression and thus turned to drawing. ¶ Koczy wished to 'confront the anguish of human existence'[3]: lying behind all her work is the sufferings of her Jewish family at the hands of the Nazis, and their eventual extermination in the concentration camps. The human figures in her pen drawings—crouching, twisting, distorted—seem deformed by pain and suffering. They are surrounded by a mass of hatching that contains and dominates them. This complex ground is rendered with a finer pen after the free-flowing figures have been drawn, and takes many hours to complete. Years of tapestry making had accustomed Koczy to work with great patience,

3. See Simon Carr's interview with Rosemarie Koczy in *Portraits from the Outside* (exhibition catalogue, Parsons School of Design, New York, 1990)

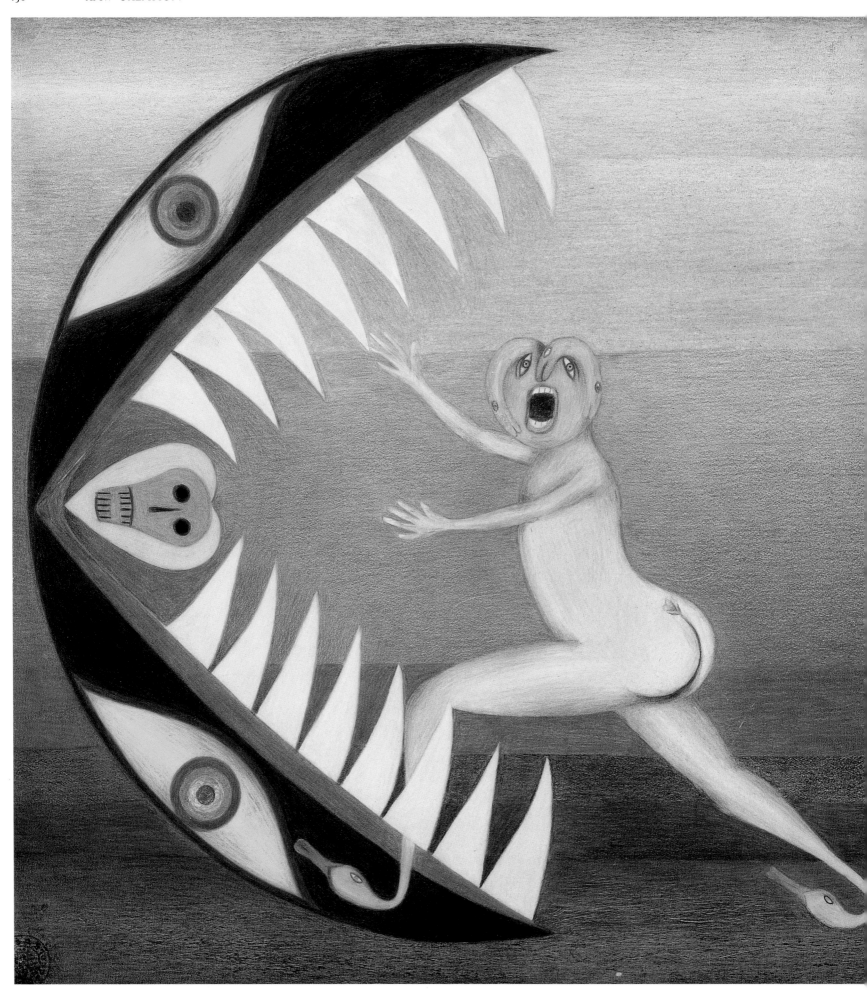

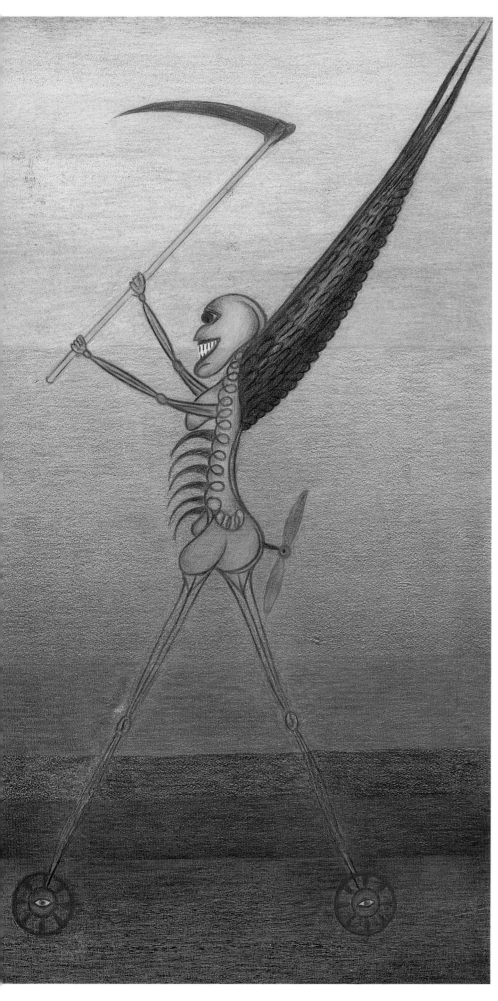

Friedrich Schröder-Sonnenstern
Left
Das Eiliskeitsdrama oder Poomuchel, der Lebensdauerläufer, 1956
Coloured pencil on card
51×73 cm
Galerie Brockstedt, Hamburg
Below
Friedrich Schröder-Sonnenstern

and the backgrounds to her drawings relate strongly to thread forms. For some time Koczy struggled to find a way to paint compositions with the same intensity as her drawings. Her earlier paintings depict large figures surrounded by contrasting colours. More recently the small hatching of her drawings has been transformed into bold and colourful strokes of paint that surround half-hidden staring faces.¶ Alain Bourbonnais, who established La Fabuloserie near Auxerre in France (see Chapter 5), collected the works of many artists who did not meet the rigorous requirements of Art Brut—including trained artists who had moved away from their cultural conditioning. One of the most striking was Mario Chichorro (b.1932). Trained as an architect in his native Portugal, Chichorro moved to southern France in 1963, where he found employment in an architect's office. On losing his job a few years later, he committed himself to pursuing a creative path.[4] His brightly painted reliefs, carved out of thick chipboard, present a series of pictures within pictures. The three dimensional forms accentuated by heightened colours and tones give his work a biting clarity. A mass of figures, often in semi-erotic activity, fill his compositions. Faces stare out, figures veer, fall and flow. Smaller scenes are often contained within an outlined face or distorted figure.¶ It is rare to find Outsider artists, or even marginal artists, working in groups or forming associations. However, in Provence, in southern France, a loose network of self-taught artists has emerged. Its starting-point was the friendship that developed between the ailing self-taught artist François Ozenda (1923–76), from Marseille, and Jean-Claude Caire, the doctor who treated him from 1973 when he went to live in the hills above the coast. When Ozenda died three years later, Caire started an association in his memory, with a regular publication of his writings and drawings.[5] ¶ Caire made contact with other self-taught

Mario Chichorro

4. See Leonard Emmerling, The Endless Universe of Mario Chichorro, *Raw Vision*, no. 5 (1991). p.14

5. Caire publishes *Bulletin des Amis de François Ozenda* three times a year from his home in Salernes, Provence

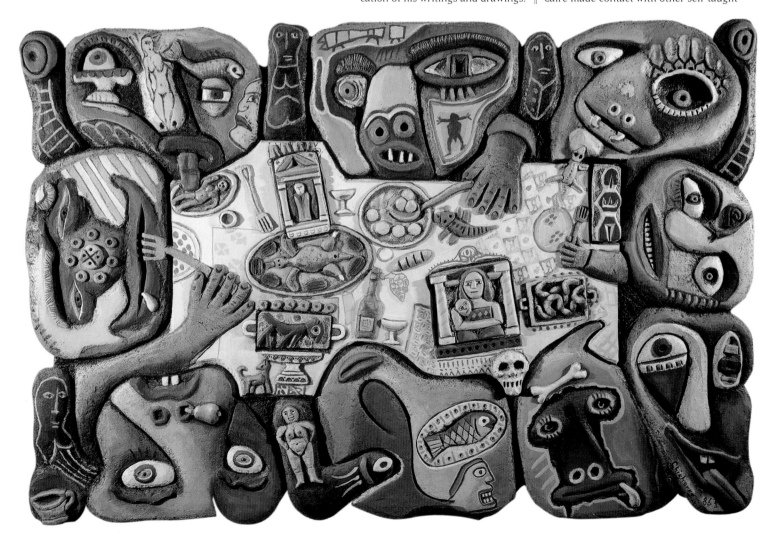

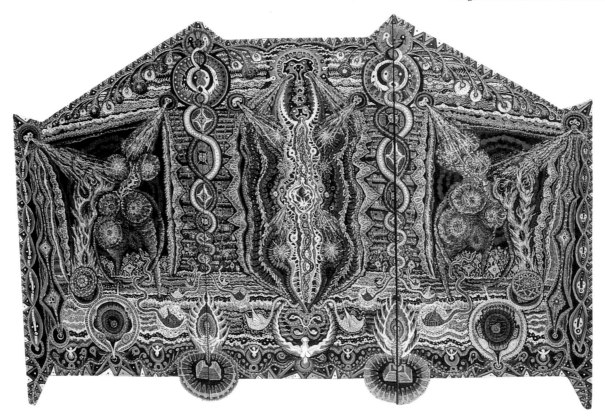

creators in the Provence region and did what he could to help them. His jour-
nal promoted their work and he encouraged them to hold joint exhibitions.
One such artist was Raymond Reynaud (b.1920), the 'master of Sénas', a for-
mer house painter who was fast building up a reputation as France's fore-
most self-taught creator. In Reynaud's drawings, faces and figures combine
with highly detailed decorative forms. His assemblages, masks and totems
are made largely from salvaged pieces of junk. Reynaud later began to make
large-scale paintings executed in his workshop in several huge sections with
the same detail and intense clarity as his drawings. Recent works are charac-
terized by sinuous masses of twisting colour and flowing organic forms.
Reynaud has been the inspiration for other self-taught artists, including his
wife Arlette Reynaud and his near neighbour Claudine Goux (b.1945). He
became the leading figure of a group of artists who have laid claim to the
term 'Art Singulier', taken from the 1978 Paris exhibition Les Singuliers de
l'Art, where the work of Ozenda was shown, as well as that of another leading
self-taught Provence creator, Ciska Lallier (1949–91).¶ One important figure in the group has been Danielle Jacqui, 'She Who Paints'

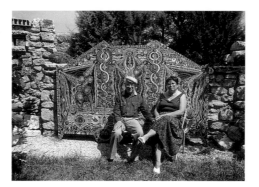

Raymond Reynaud
Above
Les Suzannes au bain, 1989
Oil and gouache on paper mounted on wood
269×179 cm
Left
Raymond Reynaud with Arlette Reynaud, Sénas, France, 1990

(b.1934). Every inch of the interior of her home, La Maison de Celle qui Peint,
is encrusted with mosaic or embellished with paintings. The exterior is cov-
ered in murals and hanging paintings. Her first creations were embroideries,
so detailed that each piece took over a year to complete. Her later paintings
are overpowering in their bright decorative detail. In a whirl of energy and
production she also makes assemblages and automatic drawings. ¶ Not all self-taught artists have

Danielle Jacqui in her sitting
room, La Maison de Celle qui
Peint, Port de l'Étoile en Provence,
France

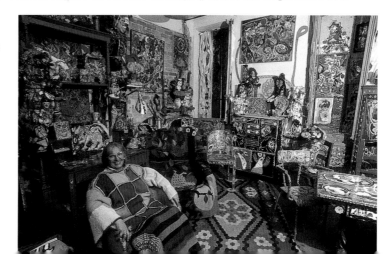

Opposite
Mario Chichorro
La Mauvaise Table, 1986
Carved and painted hardboard
Collection Michel Troisgros

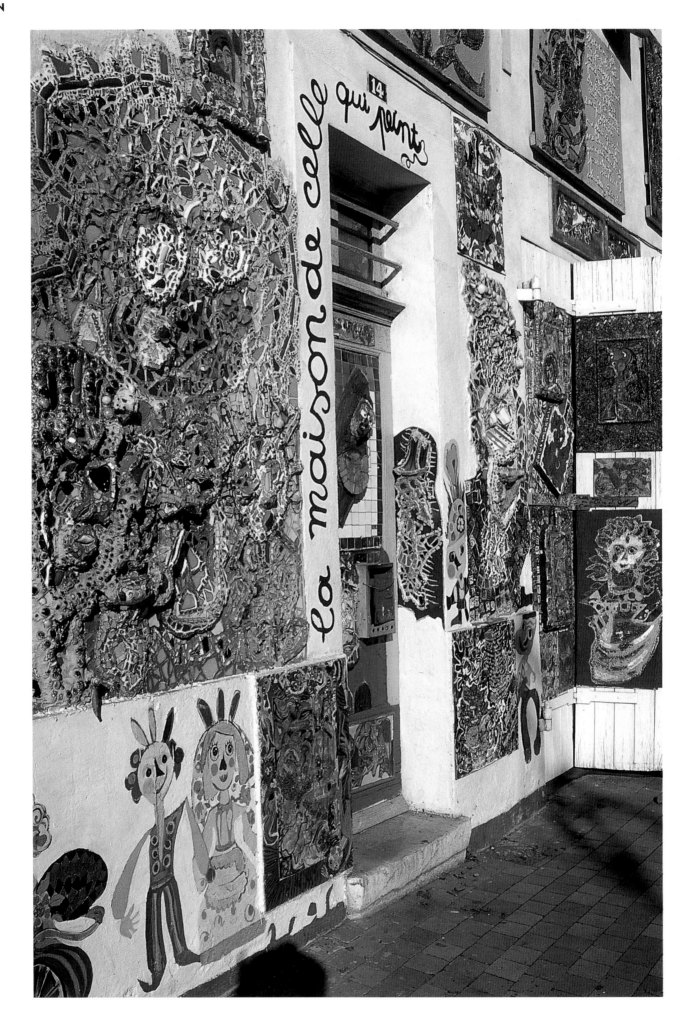

The exterior of Danielle Jacqui's
La Maison de Celle qui Peint

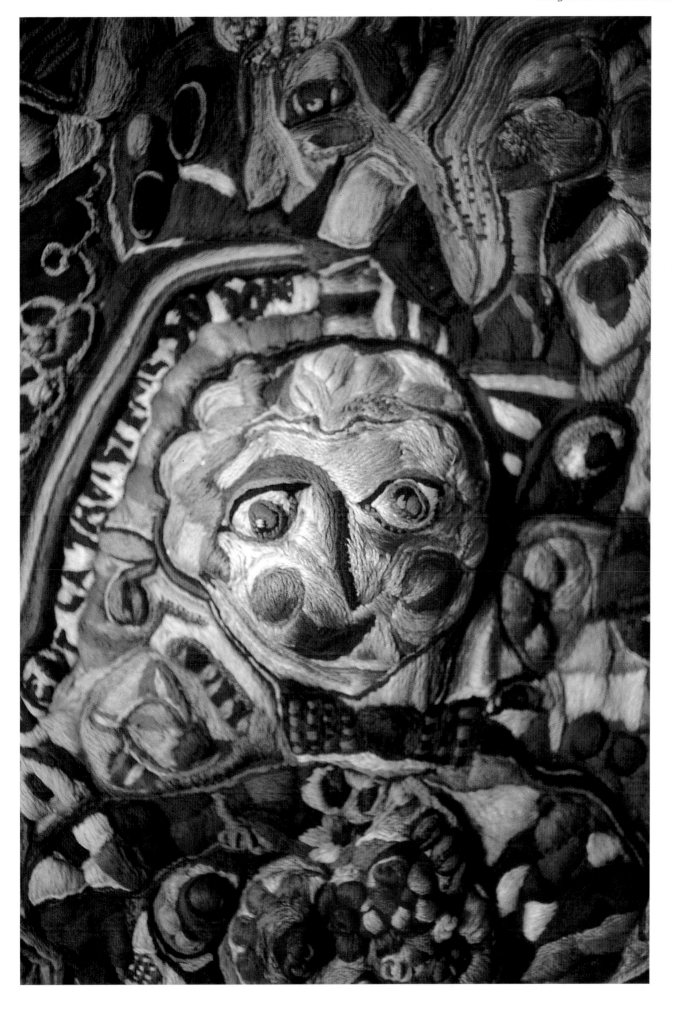

Danielle Jacqui
Embroidery detail

joined with the *artistes singuliers*. Raymond Morales is an ex-metalworker whose land near Marseille has been transformed into a terrifying world of giant rusting creatures and tormented souls. His unique vision and obvious talent have brought invitations from the group, but he has consistently rejected any association. He feels his genius will eventually be recognized by the mainstream art establishment and awaits a call from the Pompidou Centre in Paris to exhibit alongside Picasso and Miró. In the meantime holiday makers pay a few francs each to see his incredible sculptures.¶ In the United States the *artistes singuliers* would fall firmly under the folk art banner. In France they occupy a position between the visions of Art Brut and the more formal developments in twentieth-century French art. Self-taught art in France—albeit an unofficial, even semi-underground, influence—is becoming a significant factor in cultural developments. It bridges the divide between the two extremes of Art Brut and cultural art and has important implications for visual developments in the years to come.

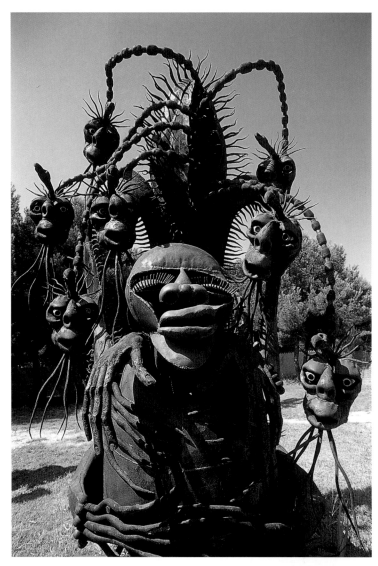

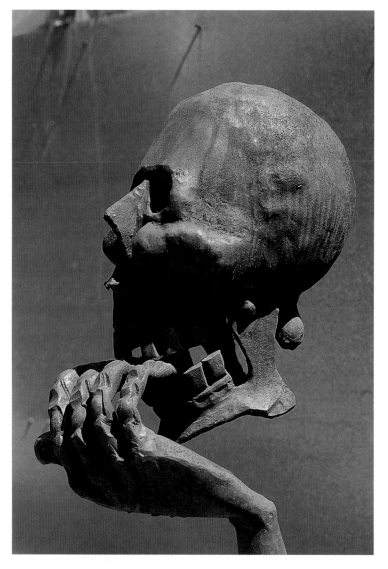

Raymond Morales and his metal sculptures

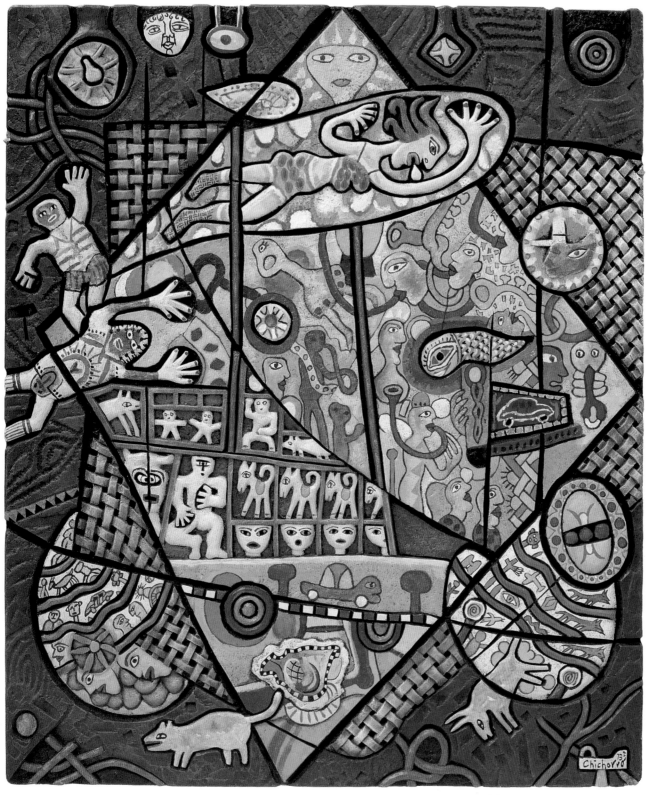

Mario Chichorro
Tableau-relief, 1973
Carved and painted hardboard
1·06×0·89 m
Collection de l'Art Brut Lausanne

Chapter 10 : BEYOND DEFINITION

Some works throw efforts to classify visual creativity into

Vahan Poladian in costume

confusion. Their originators may have little to do with art at all, intending their work for unusual practical purposes. Or they may believe themselves to be great artists, even though their work is completely ignored by the cultural establishment. ¶ Among works that defy classification are the uniforms and exotic costumes made by Vahan Poladian (c.1902–82), who spent his final years in an old people's home in a French provincial town. Many years before he had fled the Turkish massacres that ravaged his Armenian homeland, losing not only his land but much of his family. He spent years roaming the world, buffeted by the fates. Possibly as an invocation of his Armenian origins, in his last years Poladian created a wardrobe of uniforms—including headdresses, medals, brooches and handbags—made from cast-off clothing, costume jewellery and pieces of brightly coloured fabric. He daily paraded ceremonially through the streets of the town of Saint-Raphael, garbed in his dazzling creations.[1] Fully aware of the humour of the situation, he often accompanied himself with a few notes on his reed pipe. The management of the home allowed him full reign to create, even providing him with a workshop on the roof of the building. On his death his costumes were preserved and eventually donated to the Collection de l'Art Brut in Lausanne. ¶ James Hampton (1909–64) worked as a night janitor in a government building in Washington DC. After his death, a local lock-up garage that he rented had to be cleared of his belongings. Within this shabby space was discovered a creation that Hampton had been working on for the last fourteen years: the *Throne of the Third Heaven of the Nations Millennium General Assembly*. Built purely on religious inspiration, the construction filled the garage space with a shining presence. Hampton fully believed in the second coming of Christ and his creation reflected the stirring imagery of the Book of Revelation. It consisted of a mass of hand-made shrines, pulpits and altars symmetrically flanking a large throne; the walls displayed a series of tablets proclaiming the names of the prophets and disciples. Also among the resplendent artifacts were twenty-five heavenly crowns. ¶ It is likely that the unmarried and

1. See Lucienne Peiry, 'Vahan Poladian ou l'Arménie retrouvée', *L'Art Brut*, fascicule 17 (1992), pp.48–58 and Vahan Poladian: The Exile's Parade,' *Raw Vision*, no.10 (1994), pp.44–9

James Hampton
Far left
With his creations *in situ*, early 1950s
Left
Throne of the Third Heaven of the Nations Millennium General Assembly, c.1950–64
Mixed media covered in metal foil
3·20×8·23×4·42 m
National Museum of American Art, Smithsonian Institution, Washington DC

reclusive Hampton had already made a few pieces before renting the garage in 1950. By all accounts he worked through the night after finishing his janitor's tasks. His materials included cast-off furniture (the altars and main structure of the throne were made from old tables and chairs, the throne itself from an old armchair), old light bulbs, carpet rolls and cardboard. Practically all of the nearly two hundred elements in his creation were covered in shining gold or silver metal foil, some smoothly, others with a crumpled texture. Kitchen foil, gift wrapping paper and waste salvaged from bottle tops and cigarette packets were combined in a radiant, shimmering evocation of holy splendour. Each element was constructed independently, with one part simply attached to another. There was therefore no overall structural strength. Hampton also developed his own holy script, still to be deciphered, embellishing almost every part of the construction with symbols and letter forms. Soon after its discovery, the throne was rescued by the Smithsonian Institution's National Museum of American Art in Washington DC and later largely re-assembled and displayed. Although it has not as yet been possible to recreate Hampton's garage environment in its entirety, the throne has become a permanent fixture at the museum.[2] ¶ Another creator who, pursuing a personal quest, had no thought of producing art was Gustav Mesmer (b.1903). He had been sent to an asylum in his youth, in 1927, for interrupting a church service with shouting and ranting, and spent the rest of his life in confinement. His inventive mind led him to make such musical instruments as a double violin and a trumpet-guitar. His greatest fascination was unpowered flight, however, and for years he drew plans for possible man-operated flying machines. In his old age he was allowed to indulge fully his fantasies by the old people's home where he lived in southern Germany. The cellar beneath the home became his workshop, and it was here that he assembled his machines from old poles, umbrellas, tin cans and bicycles.[3] Known locally as the 'Icarus of Lauteral', Mesmer became a familiar figure as, wearing complex winged outfits, he rode his bicycle into the wind. His inventions included the 'umbrella helicopter' and the 'shoulder flap flying device', and although he never lifted himself off the ground for more than a second or so, he never gave up. ¶ In contrast, Eugene von Bruenchenhein (1910–83),

2. See Lynda Roscoe (Hartigan), 'James Hampton's Throne', in *Naives and Visionaries* (exhibition catalogue, Walker Art Center, Minneapolis, 1974), pp.12–19.

3. See Paolo Bianchi, 'Gustav Mesmer's Flights of Fancy', *Raw Vision*, no. 3 (1990) and Paolo Bianchi and Christoph Doswald, 'Der Traum vom Fliegen als fixe Idee', *Kunstforum*, no. 101 (1989)

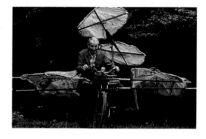

Gustav Mesmer
Opposite
With his 'umbrella helicopter', 1989
Right
Aged 87, waiting patiently for a favourable wind, 1989
Right, below
With his 'double hang-glider' mounted on a lady's bicycle, 1989

Eugene von Bruenchenhein
Above, top
Crowns, c.1960s
Painted ceramic
Height c.15cm, diameter c.30cm
Collection of G & S Partnership and Carl Hammer Gallery
Above
Bone chairs, late 1960s
Chicken bone, glue and paint
19·0×9·5×10·0cm (left) and 21·5×14·0×12·0cm (right)
Collection of G & S Partnership and Carl Hammer Gallery
Right
Untitled, 1957
Oil on board
61×61cm
The John Michael Kohler Arts Center, Wisconsin

4. See Joanne Cubbs, *Eugene von Bruenchenhein: Obsessive Visionary* (exhibition catalogue, John Michael Kohler Arts Center, Sheboygan, WI, 1988)

of Milwaukee, Wisconsin, fully believed himself to be an artist; he also described himself as 'poet and sculptor' and 'arrow maker and plant man'.[4] He created a vast quantity of photographs, paintings and unusual objects, known only to his closest friends and family, in the forty years before his death in 1983. He is best known for the thousands of intimate photographs in a period pin-up style that he took of his wife Marie. Dressed in all manner of skimpy and romantic outfits, she posed against lush fabric backdrops, assuming a wide range of semi-erotic roles. The earlier black and white prints, often hand-coloured by von Bruenchenhein, were followed from the 1950s by thousands of colour slides. The photographs are so personal and private that entering their secluded world seems voyeuristic. ¶ Von Bruenchenhein's paintings from the 1950s reflect his fear of nuclear war. Gradually his images of H-bomb mushrooms gave way to a more personal vision. He developed a special technique; using his fingers he rapidly manipulated the thin wet oil paint, a method perfectly suited to his compositions of deep sea monsters and outlandish spiky plants. Dramatic visions of cosmic turbulence and complex floating organic forms trailing tentacles characterize many works. His later paintings show towering cities and increasingly abstract floral forms. ¶ Von Bruenchenhein, who also described himself as a 'bone artifacts constructor', made a series of objects from salvaged chicken and turkey bones. These included small chairs made of glued and painted chicken bones and a series of bone towers, some up to a metre and a half (some five feet) in height. Ill health led to his early retirement from his job at a local Milwaukee bakery. Thereafter financial constraints meant he had to get his materials where he could. He dug his own clay and, using his domestic stove for firing, produced a range of ceramic sculptures including crowns and masks. He also made a series of large concrete masks that graced the outside of his humble

5. From his poem 'Sanctuary of the Mind', quoted in Joanne Cubbs, *Eugene von Bruenchenhein: Obsessive Visionary*, p.26

property. ¶ Although unsuccessful in his attempts to gain recognition, von Bruenchenhein was unswerving in his devotion to his creativity. He knew how different he was from other people, believed in his worth and continued to create even in total isolation. He wrote:

Fight the terror you may find
When you invade the forces of the mind
Test the strength of each conviction
Lest they lead to contradiction
Form with stone the ramparts of your life.[5] ¶ Another who felt he had a

Eugene von Bruenchenhein
Above
Untitled (Marie von Bruenchenhein), c.1945–51
Hand-coloured photograph
20·3×25·4cm
Collection of Dean and Rosemary Jensen,
courtesy of Carl Hammer Gallery
Left
Eugene von Bruenchenhein, 1950s

6. See Roger Manley, 'Hermon Finney', *Raw Vision*, no. 5 (1991), pp.20–5, and *Signs and Wonders: Outsider Art Inside North Carolina* (exhibition catalogue, North Carolina Museum of Art, Raleigh, 1989)

special calling was North Carolina clairvoyant Hermon Finney (1931–88). He carved his first figures as a teenager—a gruesome scene of a butcher's shop with human carcasses. His father put his talent for sculpture to use by setting up a roadside family business in garden ornaments and statues.[6] This was to become Finney's main source of income throughout his life as, in addition to making bird baths and other cast items, he carved countless strange alligators, sphinxes and eagles to adorn local gardens. ¶ He also constructed a whole series of horrific tableaux to accompany his little butcher's shop—a gory operating theatre, a torture chamber, a violent robbery and Hell itself. These scenes were assembled in lighted boxes to form an eerie diorama. Finney took the boxes, displayed in a trailer entitled 'Cripido—Sanguinary Scenes of Human Carnage', on tours around the parking lots of country supermarkets during the 1940s and 1950s. ¶ When he tired of travelling, Finney returned

Hermon Finney
Jasper the Red-headed Butcher, c.1952
Painted wood, glass, wire and other materials
92×71×71 cm
Private collection, North Carolina

to his garden statue business and began his series of large sculptures. Carving from single huge blocks of cast plaster, he produced an array of finely finished and detailed figurative forms. Much in evidence were the sleek bodies of young females, often contrasted with grotesque monsters or writhing in an enmeshing mass. Finney used glamour magazines as his references, even collecting and classifying various poses and positions for future use. Finney's paintings—depicting gory mythical events in flat delicate colouring—lack the strength and individuality of his three dimensional pieces. ¶ One of the most unusual discoveries in Outsider Art was made in Philadelphia in 1984. In a pile of rubbish lying in the street of a tawdry area of town, a local graphic artist found hundreds of strange wire objects. He was so fascinated that he felt compelled to rescue the works and take them home with him. For a couple of years they were kept at his house and it was not until he contacted a local art gallery that these artifacts reached a wider public. Although at this stage efforts were made to discover the creator, they were unsuccessful and the anonymous artist was dubbed the Philadelphia Wireman[7]. The works were first described as 'art' when they were exhibited at the Janet Fleisher Gallery in Philadelphia in 1987. ¶ The pieces themselves range in height from a few centimetres to nearly a metre and consist mainly of wire and cable tightly bound around various fragments of metal, plastic, packaging or other waste objects. It is thought that whoever created them must have been strong because there are few traces of tool marks. The rundown area where they were found, previously mainly an African-American neighbourhood, was on the verge of gentrification. Many believe the creator must have been an African-American male who either died or moved, at which point all his work was thrown away—a fate not that unusual for Outsider artists. The brute force with which the objects were made add to their unnerving power. Some writers have drawn analogies with the African *nkisi* tradition of magical power objects; others are convinced they were made with some function in mind. We shall never know.

7. See Mike McGonigal, 'Psychic Magnets: Ruminations on the Philadelphia Wireman', *Raw Vision*, no.5 (1991), pp.48–52

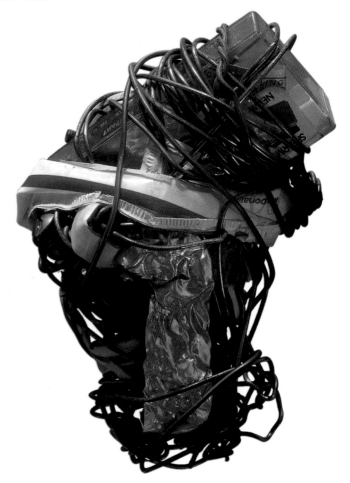

Philadelphia Wireman
This page and opposite
Sculptures of wire and found objects, *c.*1969–75
Height 2·5–61·0cm
Janet Fleisher Gallery

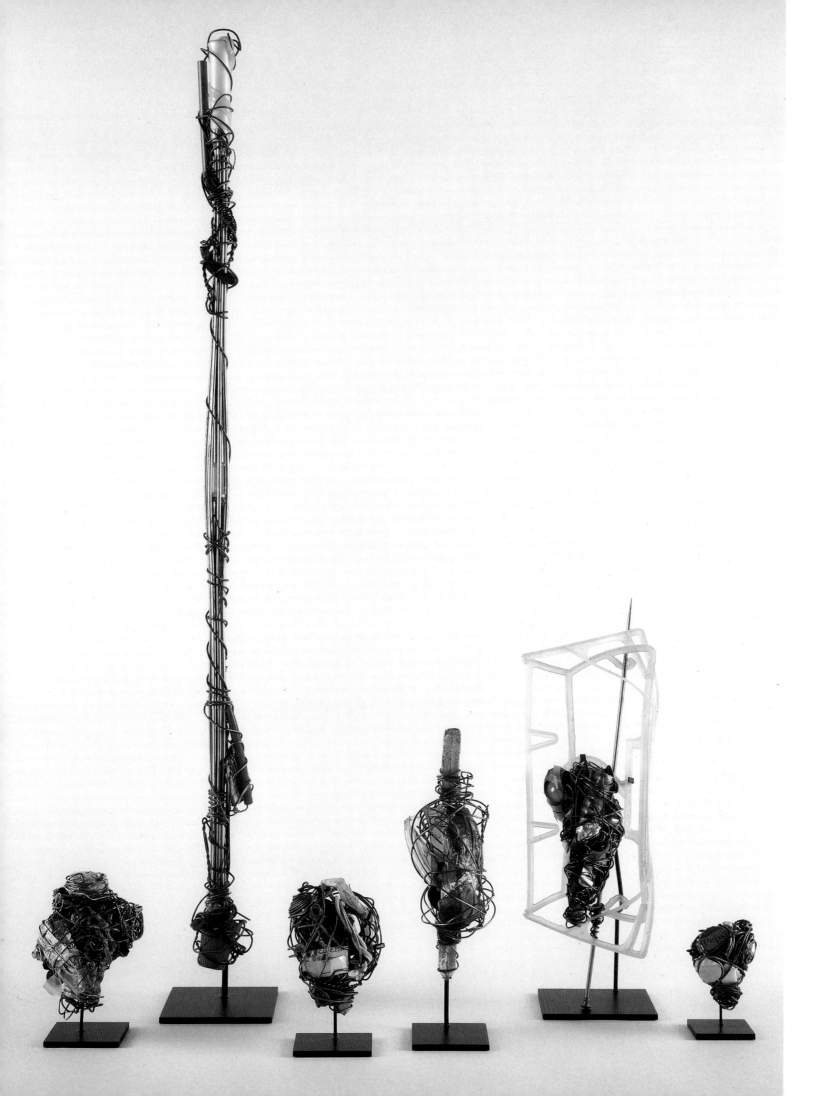

Chapter 11: TOWARDS A WORLD ART

Non-academic art from cultures beyond Europe and

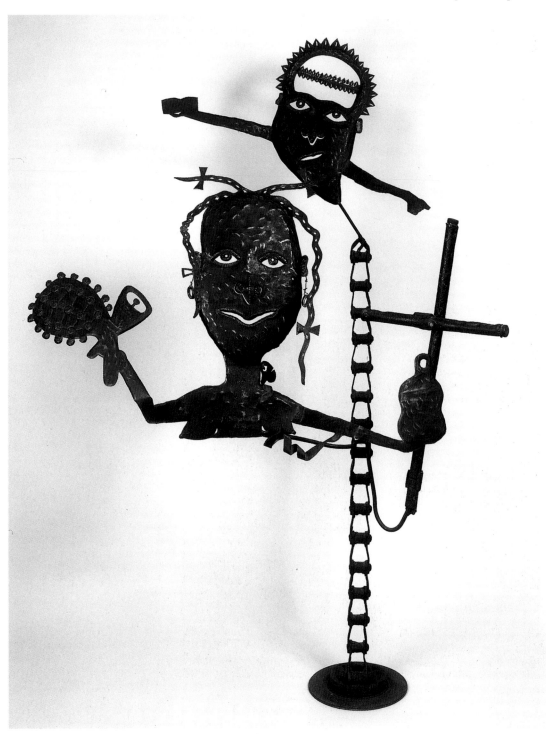

Gabriel Bien-Aimé
Mambo, 1993
Metal from oil drums and car parts
Height 145 cm
Collection Mr and Mrs Reynald Bourbon-Lally, Haiti

the US has suffered faint praise for its 'charming', 'naïve' and 'primitive' qualities. However, growing appreciation for the work of contemporary self-taught artists in the West has led to a greater recognition of the talents of their counterparts in other cultures. Many artists from diverse cultures producing both village and popular urban art have been recognized as imaginative individuals with their own vision and intuitive power. This chapter can only touch on a few examples of original creativity that have arisen in these countries over the last few decades. ¶ Among the first to attract attention in the West were Haiti's intuitive artists. In a society dominated by the imagery of the voodoo religion, those with artistic inclinations found an immediate role in forming the decorative *vevers* (symbols that invoked the spirits, or *loas*) and in making banners, murals and other proclamations of spiritual power. Hector Hyppolite (1894–1948), like his father and grandfather, was a voodoo priest (*houngan*) and as an artist his work was imbued with voodoo. He was encouraged by De Witt Peters, an American watercolourist and teacher who established the Centre d'Art in Port-au-Prince in 1944. The centre provided facilities and materials for local artists and before long Peters, and his associate Selden Rodman, had become catalysts for thriving art activity.[1] ¶ Hyppolite did not become as involved with the new art

1. See Selden Rodman, *Where Art Is Joy* (New York, 1988)

Hector Hyppolite in 1948

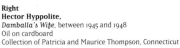

Right
Hector Hyppolite,
Damballa's Wife, between 1945 and 1948
Oil on cardboard
Collection of Patricia and Maurice Thompson, Connecticut

centre as many other artists, preferring to work on his own, a lone visionary expressing his personal interpretation of the *loas* and their mystical presence. During their visit to Haiti in 1946, the Surrealist theorist André Breton and Cuban artist Wifredo Lam both bought works from Hyppolite who became an unofficial ambassador for the new flowering of Haitian art. When he died in 1948, Hyppolite left behind him only some three years' work, yet this mystic and visionary became the inspiration for subsequent generations of Haitian artists. ¶ A leading figure in the development of Haitian sculpture in the 1950s was Georges Liautaud (1899–1991). Originally a blacksmith who made ornamental crosses for graves, he cut his first two-dimensional figures with hammer and chisel out of sheet metal reclaimed from oil drums. At times he added limbs and facial features or incised the surface with details. He was influenced by the flowing forms of the *vevers* which were marked out on the ground before voodoo ceremonies, and much of his work depicted the *loas* and other spirit-like forms that were a mixture of male and female or half-human and half-animal. The crudeness and force with which Liautaud's sculptures were constructed added to their raw power. Liautaud's flat cut-out technique became a hallmark of the Haitian style, although such later sculptors as Gabriel Bien-Aimé were to develop more sophisticated techniques, giving a smoother finish to their increasingly complex works. ¶ Of more recent Haitian artists, André Pierre and Lafortune Félix (b.1933) are perhaps the best-known. After initiation as a *houngan*, Félix had dreams and visions of voodoo spirits that led him to paint. His first efforts were murals of *loas* on the walls of the little voodoo temple where he officiated. Painted in house paint with chicken feather brushes, they attracted sufficient attention for him to receive encouragement and patronage. He became the leading colourist of Haitian art, depicting voodoo subject-matter in settings of lush vegetation. His soft painterly style and delicately rendered hues gave his work an atmosphere of mystery. One of his favourite subjects was the *loa* Baron Samedi. Voodoo remained a constant inspiration and, in spite of his developing fame, he continued as a *houngan* and was known to experience trances and spirit possession. ¶ Another important figure, Robert St Brice

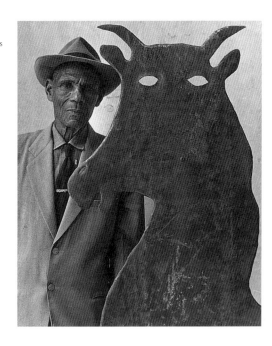

Georges Liautaud with one of his sheet metal sculptures, early 1960s

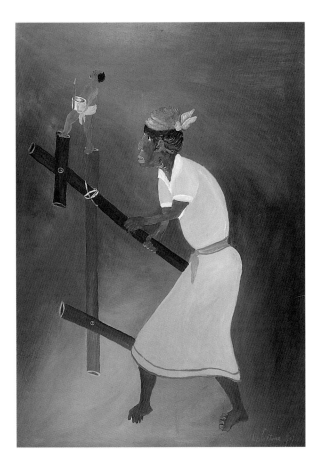

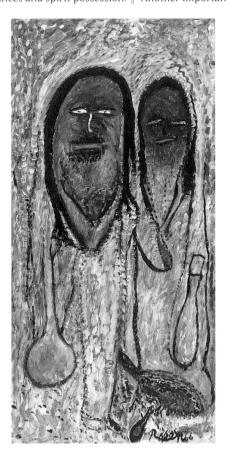

Left
Lafortune Félix
Maitre Jubilé, 1991
Acrylic on hardboard
Collection Mr and Mrs Reynald Bourbon-Lally, Haiti
Right
Robert St Brice
Houngan and Hounsi, 1972
Acrylic on masonite
1·22×0·61 m
Collection Mr and Mrs Reynald Bourbon-Lally, Haiti

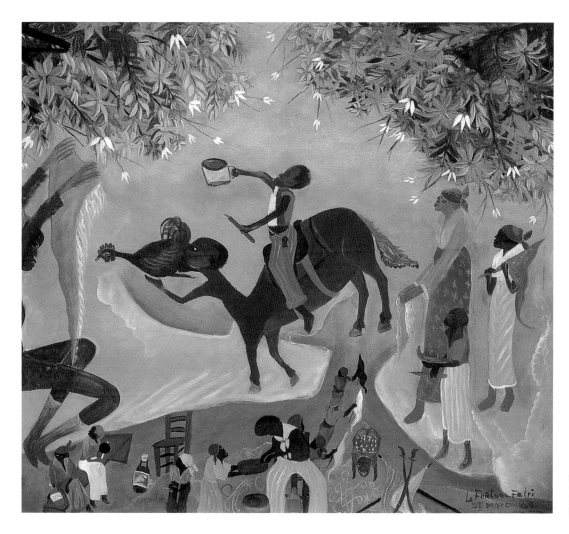

Lafortune Félix
Houngan with Centaur, 1982
Acrylic on board
61×61cm
Collection Elizabeth van Luokeren Campagne, Netherlands

(1893–1973), painted the *loas* as forms with firm facial features but only vaguely recognizable bodies that became part of an energized ground. His gestural use of paint, with clearly visible brush strokes accumulating across the surface, was unusual in the art of Haiti. ¶ In the 1970s a commune of peasant artists was formed as a protection against growing commercial pressures. Although instigated by patrons, the commune became an independent entity. Known as the painters of the Saint-Soleil, the artists further extended the vision and individuality of art in Haiti. While voodoo provided an atmosphere and an energy that permeated their work, their visions were more personal and their compositions more imaginative. Levoy Exil became known for his free-flowing ink drawings and large free-standing sculptures, while Prospère Pierrelouis's (b.1947) flowing figures and decorative brushwork made him the country's leading painter of the 1980s. Another leading member of the group, Stevenson Magloire, tragically died in a feud with the *tonton macoutes* just days before the US invasion of 1995. ¶ In recent years works of other self-

Levoy Exil
Aida, 1974
Acrylic on canvas
91×46cm
Collection Mr and Mrs Reynald Bourbon-Lally, Haiti

taught visionary artists of the Caribbean islands have come to light. In Jamaica Errol MacKenzie is perhaps the best known of a host of artists documented by writer Len Davidson.[2] MacKenzie's self-built dwelling is a work of art in itself. Like his Haitian contemporaries he claims inspiration from the spirits, although his work reflects an intensely personal mythology, a grim struggle between the forces of good and evil. In the Cayman Islands, the compulsive creativity of Gladwyn K Bush (Miss Lassie; b.1913) has transformed her simple home, which she has covered with brightly coloured murals depicting biblical scenes and flowing organic forms.[3] ¶

2. See Len Davidson, 'Errol MacKenzie: Anatomist of the Soul', *Raw Vision*, no. 9 (1994). pp.24–9. and *Intuitive Journey*, unpublished ms

3. See Henry D Mutoo with Karl 'Jerry' Craig, *My Markings: The Art of Gladwyn K Bush* (Grand Cayman, 1994)

Since the end of the colonial era, African art has seen dramatic changes. A new generation of artists has created a vibrant visual vocabulary, drawing on traditional African forms and European techniques. In contrast to the anonymous tribal creators of the past, these African artists, largely self-taught, have come to the fore as individuals in their own right. Commercial conditions have favoured such new expression, providing opportunities ranging from urban signs and hand-rendered advertisements to patronage by a growing middle class looking for works that reflect the reality of their contemporary lives. ¶ European awareness of African developments was reflected, for example, in the vast Paris exhibition curated by Jean-Hubert Martin in 1989, Magiciens de la Terre, conceived with a post-colonial rationale and displaying a host of Third World creators on equal terms with established artists from the Western mainstream. Collectors, such as Jean Pigozzi in Lausanne, have built up huge archives of contemporary African expression. Pioneering enthusiast Ulli Beier established the Iwalewa Haus in Bayreuth, Germany, to bring the works of Third World artists to a wider public. The large Africa Explores exhibition at the Center for African Art in New York in 1991 presented works of twentieth-century art ranging from both the traditional and the academically trained to the new vein of urban expressions. European venues for the show included the Liverpool Tate in the UK. ¶ Although African art has strong and deep

Errol MacKenzie and his house, Jamaica, 1993

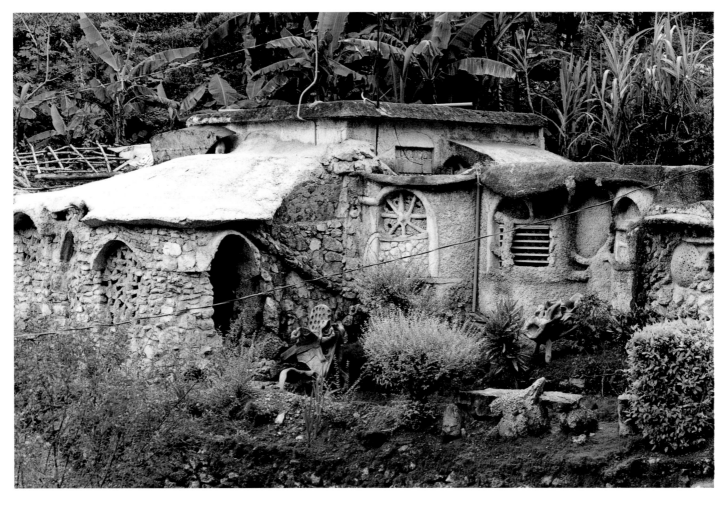

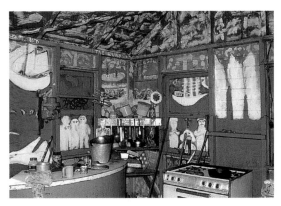

Gladwyn K Bush (Miss Lassie), her kitchen interior and two of her kitchen windows, Cayman Islands

4. See Andre Mignon, *The Jean Pigozzi Contemporary African Art Collection* (exhibition catalogue, Saatchi Gallery, London, 1993)

traditions, new materials and approaches have brought a growing individuality and inventiveness. Romuald Hazoumé (b.1962) from Benin may work with traditional subject-matter but his totems are hacked out with a chain-saw and his masks made from junk and reclaimed materials.[4] Hazoumé's upbringing was Catholic, yet his pieces possess strong overtones of indigenous religions and seem to transpose ancient forces into new guises. ¶ Some artists were directly encouraged by European contacts. Twins Seven Seven, the seventh son and only survivor of seven sets of twins, became the most famous of a number of new-wave Nigerian artists. He also developed skills as a musician, dancer, businessman and even politician. He had little formal schooling and was introduced to painting through one of the creative workshops established in Nigeria by Geraldine and Ulli Beier together with artist Susanne Wenger in the late 1950s.[5] He soon developed his own personal style, using contemporary painting techniques for complex depictions of Yoruba myth and symbol to evoke a mythic past. In his flowing compositions images of spirits and phantoms glowing with rich earthy colours emerge from dark, repetitive backgrounds. ¶ Many artists have taken as their subject-matter recent

5. See Susan Vogel et al., *Africa Explores* (exhibition catalogue, Center for African Art, New York, Tate Gallery, Liverpool, and elsewhere, 1991)

Romuald Hazoumé
Masks
Contemporary African Art Collection, Pigozzi Collection, Geneva
From left to right
Walkman, 1992
Plastic container, wood, earphones and other materials
Height 27 cm
Allo, 1992
Plastic container, telephone, toothbrush, cassette
Height 40 cm
Le vaudou, 1992
Plastic container, seeds, feathers, earth, metal, industrial paint and other materials
Height 48 cm

6. See André Mignon et al., *Africa Now* (exhibition catalogue, Groninger Museum, Groningen, 1991)

history, using art for political and social comment. The leading figure among a number of vibrant creators in Zaire in the 1970s was Chéri Samba (b.1956). At this time Kinshasa became a centre for urban art with paintings on sale at the stands of local street traders. Like those of other Zairian observers of city life, Samba's narrative works reflect the problems of African society while at the same time drawing on a deep reservoir of myth and imagination. Originally apprenticed as a sign writer, Samba developed a skill in newspaper comic strips and only later began to paint. His works, with their acid criticisms of human behaviour and society in general, contain inherent political messages that often set him at odds with Zairian officialdom. Sharp glaring colours and strong compositions give his paintings a startling force. ¶ A theme Chéri Samba has returned to many times is Mama Wata, the mythological water siren that has become a favourite subject for many West and Central African artists.[6] She is usually depicted as half-woman and half-fish and her erotic presence evokes mystical and magical powers. Samba's younger brother, Cheik Ledy (b.1962), originally his assistant, has also established himself as a committed commentator on African city life and political history. His strong figurative images have a powerful moralistic message. ¶ Frédéric

Frédéric Bruly Bouabré
Connaissance du Monde, series begun 1981
Top, left to right
L'Universelle Résurrection des Morts se déroulant en Vapeur devenant Nuages, ceux-ci se relèvent en Squelette (The universal resurrection of the dead unfolding in the vapour coming from the clouds and revealed in a skeletal form)
Partout où passe la Beauté visuelle elle interpelle son Amant le regard qui lui sourit (Everywhere visual beauty passes it calls out its loving regards to those who smile on it)
Bottom, left to right
La République Nigérian (Nigerian Republic)
Caroline
Wrakynson
Coloured pencil and ballpoint pen on board
All 15.5×11.5cm or 11.5×15.5cm
Contemporary African Art Collection, Pigozzi Collection, Geneva

Above left
Chéri Samba
Le Drapeau tricolore, 1990
Acrylic on canvas
1·44×1·88 m
Contemporary African Art Collection, Pigozzi Collection,
Geneva

Above
Cheik Ledy
Nelson Mandela, 1990
Acrylic on canvas
0·90×1·46 m
Contemporary African Art Collection, Pigozzi Collection,
Geneva

Bruly Bouabré (b.1923) from the Ivory Coast uses his art to reflect his own personal mythology and idiosyncratic world view. After a visionary experience in 1948, he became a prophet under the name of 'Cheik Nadro the Revealer', a member of the Order of the Persecuted. Divine truth, as communicated to him in dreams, became the underlying message of his art. He drew his philosophy and doctrine from great cosmic myths and his intuitive vision brought him into communion with animals, trees and stones.[7] His involvement in African history led him to invent a script for the previously exclusively oral Bété language. He also initiated studies into traditional tribal scar patterns and tattoos and Akan gold weights. His inventions, discoveries and commentaries are recorded in a never-ending series of small drawings in pen and coloured pencil, all of identical size. To Bruly Bouabré: Art is the perfect and eternal imitation of divine works in time and space.[8] ¶

7. See Jean-Hubert Martin et al., *Magiciens de la terre* (exhibition catalogue, Centre George Pompidou, Musée National d'Art Moderne, Paris, 1989)

8. Quoted in André Mignon et al., *Africa Now*, p.179

A functional art form was invented near Accra in Ghana by carpenter Kane Kwei (b.1924). African funerals have traditionally been grand affairs, especially if the deceased was a person of substance and importance. In recent years they have become even more so, with large and ornate memorial gravestones reflecting not only social status but also character and personal history. Among Kane Kwei's duties as an apprentice carpenter was the construction of coffins. The request of a dying uncle, who asked for something special, led him to make a boat-shaped casket in recognition of his life as a fisherman. ¶ Before

Kane Kwei
Hen-shaped Coffin, 1989
Enamel on wood
Length 2·3 m
Museum voor Volkenkunde, Rotterdam

9. See J. Martin and
S. Vogel, 'Kane Kwei',
Africa. Kunstforum,
122 (1993), pp.278–9,
and T. Secretan,
*Fantastic Coffins
from Africa*
(London, 1995)

long Kane Kwei's special coffins were much in demand and by the mid-1990s
he was head of his own workshop creating these exclusive commissions. His
usual designs are boats, fish, whales, hens, onions and cocoa pods, although
he has also produced airplanes, houses, exotic animals and a Mercedes-Benz
to despatch the dead to the next world.[9] Kane Kwei's creations were never
intended to be an art form. His coffins have a short life, but he makes special
orders, usually of reduced size, for collectors and exhibitions. ¶ The art of the townships of South Africa, documented among others by
sculptor and lecturer Gavin Younge, forms a vibrant and varied body of
work.[10] Self-taught artists range from the traditional to the startlingly origi-
nal. The sculpted figures of Phuthuma Seoka appear to have more in common
with the work of such American folk carvers as Miles Carpenter (1889–1985)
than with traditional African images. He explores the forms suggested by his
material to release the figures held within, thereby turning branches into tor-
sos and limbs. ¶ Seoka was a former contract worker from Northern Transvaal who started to
carve by creating a snake from a branch to dispel a recurring dream. He
worked as a hairdresser and sold herbal medicine from a roadside stall,
where he also made a little extra by displaying and selling his sculpted
figures. He is best known for his colourful barefoot walking figures, their
limbs strangely distorted by the natural form of the wood. With their highly
decorative surfaces, they cheerfully echo the township workers' daily trudge
to work. Other creations have included busts and heads of local dignitaries
and national figures. ¶ In many parts of the world artists who have worked

10. Gavin Younge, *Art of the South African
Townships* (London, 1988); and The Next Million
Years', *Raw Vision*, no. 4 (1990), pp.52–5

Phuthuma Seoka
Township Walk, 1985
Enamel paint on carved wood
Height 1·6m
Private collection

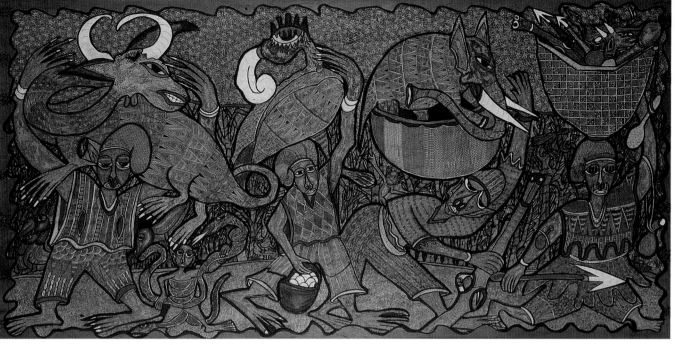

Twins Seven Seven
Blessed Hunter, 1990
Paint on plywood
1·22×2·44 m
Contemporary African Art Collection, Pigozzi Collection, Geneva

within traditional frameworks find themselves with opportunities to branch out in new directions. The Madhubani painters of the Mithila region of Bihar, India, are exclusively women. Until the 1960s, when the use of paper was introduced, the village women traditionally produced floor and wall paintings for weddings and other ceremonial occasions. Their subject-matter was usually religious, often such narratives as the legends of Rama and Krishna. ¶ One of the artists to gradually broaden her scope was Ganga Devi (*c*.1931–91). Even her early depictions of the tales of Rama and Sita show unusual originality.[11] Her later large work, *Cycle of Life*, reflected her own conflicts and struggles. After a visit to the United States for an Indian arts festival in 1985, she returned to Bihar and produced a whole series of pictures which vividly recorded her American experiences in the traditional visual vocabulary of the Madhubani tradition. ¶ The work of Ganga Devi shows how traditional

11. See Jyotindra Jain, 'Ganga Devi: Tradition and Expression in Madhubani Painting', *Third Text*, no. 6 (Spring 1989), pp.32–41; the English version of *Les Cahiers du Musée National d'Art Moderne: Magiciens de la terre*, no. 28 (Summer 1989)

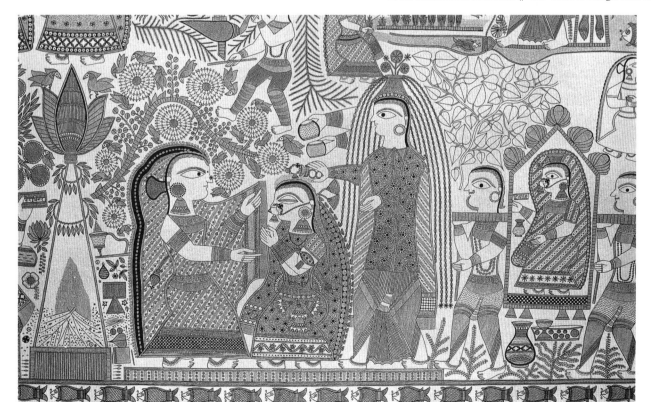

Ganga Devi
Wedding, a detail from *Cycle of Life*, 1983–5
Ink (two colours) on paper
3·24×1·47m
Crafts Museum, New Delhi

skills and structures have become vulnerable to wider influences. Her works show not only new materials, but also a growing sense of individuality. Many artists of the Third World still adhere closely to traditional approaches; others produce their own versions of Western art—often a mediocre 'international art' of the kind that fills galleries across the world. Yet there are others, self-taught or otherwise, who are too separate from Western culture to attempt or to desire to take a place within it and yet too aware, inventive and individual to work within traditional constraints. These artists, together with the intuitive creators of the West, are laying the foundations for a truly world art of the future.

Prospère Pierrelouis
Untitled, 1993
66·6×66·6 cm
Collection Mr and Mrs Reynald Bourbon-Lally, Haiti

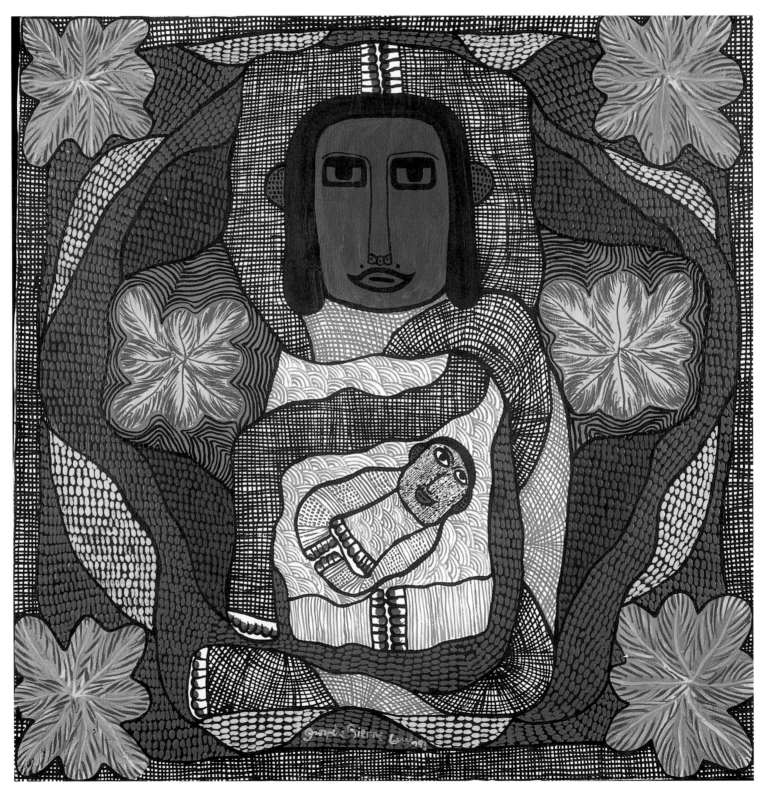

Part III: Visionary environments

Chapter 12: THE HABITANTS-PAYSAGISTES IN FRANCE

In many countries unusual structures, full of strangeness and individuality, have been built in gardens, forests, open spaces or hidden places. They are often the results of years of committed toil; what might have started as a modest project has become, in many instances, a lifetime's work. Such environments represent one of the most extraordinary forms of human creativity. The natural urge to decorate and embellish dwelling places has here undergone a qualitative change, resulting in unique testimonies to an individual's power of originality, and often inspiring works of art. France is particularly rich in these spectacular environments—only the United States can claim more. ¶ The creators of these remarkable constructions are just as

The north façade of the Palais Idéal

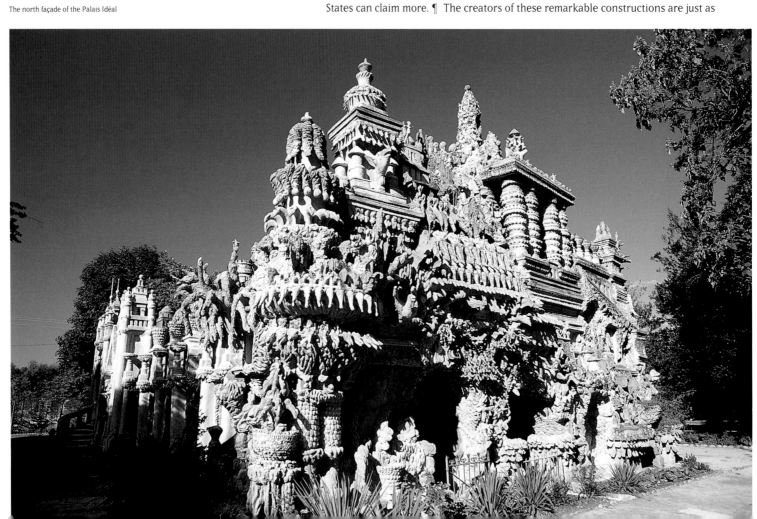

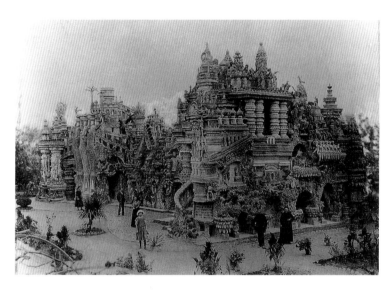

divorced from the world of conventional art as Dubuffet's *artistes bruts*. Most have no contact with art schools or galleries. Although there may well be ambitions of fame, there is little thought of financial gain by these singular creators, more an overpowering desire to express their creativity, to fulfil their fantasies, to make a meaningful world for themselves. Although some may think of themselves as builders, few would consider themselves artists. Their structures and environments tend to evolve organically rather than from a pre-conceived plan, their visions developing and changing as their ideas evolve naturally. Many visitors to these amazing visionary structures are overpowered by the transformed world they enter. ¶ The Palais Idéal in Hauterives, south of Lyons, one of the most famous of such environments, was the first to receive critical acclaim. Built single handedly over a period of thirty-three years from 1879 by country postman Ferdinand Cheval (1836–1924; 'Le Facteur Cheval'), the Palais Idéal remains one of the world's most astounding visionary structures. Moved by a dream, Cheval felt a deep desire to build a wondrous palace. By chance one day he literally stumbled upon a strangely shaped stone, one so fascinating that he brought it home with him. Thus his dream received the impetus to become a reality. Before long Cheval's garden was full of unusual rocks and stones gathered on his 32 kilometre country postal round, or on long walks with his wheelbarrow. The stones became his basic building material, bound together with chicken wire, cement and lime. In spite of local ridicule, he stubbornly toiled at his dream creation, both carving and modelling as he progressed. Half organic building, half massive sculpture, the Palais emerged with sculpted figures and beasts, encrusted and twisting vine roots, concrete palm trees, columns, steps, balustrades, turrets and a winding crypt. Cheval has commented: The distance from the dream to reality

Ferdinand Cheval
Left
Ferdinand Cheval in postman's uniform
Above, right
Building the Palais Idéal, Hauterives, begun 1879
Above
With his wife in front of the Palais Idéal, completed 1912

1. See Claude Prévost et al., *Le Palais Idéal du Facteur Cheval* (Hédouville, 1994)

is great; I had never touched a mason's trowel and I was totally ignorant of the rules of architecture. ¶

Cheval spent twenty years on the first two façades of a structure that was to be 26 metres in length and 14 metres in width. The east façade is dominated by the giant guardians César, Vercingétorix and Archimedes, while the magnificent north façade seems to drip with sculptured animals, flowing organic forms and repeated relief patterns. The two other façades are simpler in concept and concentrate more on architectural features. Winding stairs lead up to a Tower of Barbary, while the vaults below contain two empty stone coffins and a special shrine for Cheval's trusty wheelbarrow.[1] ¶ Cheval completed his epic

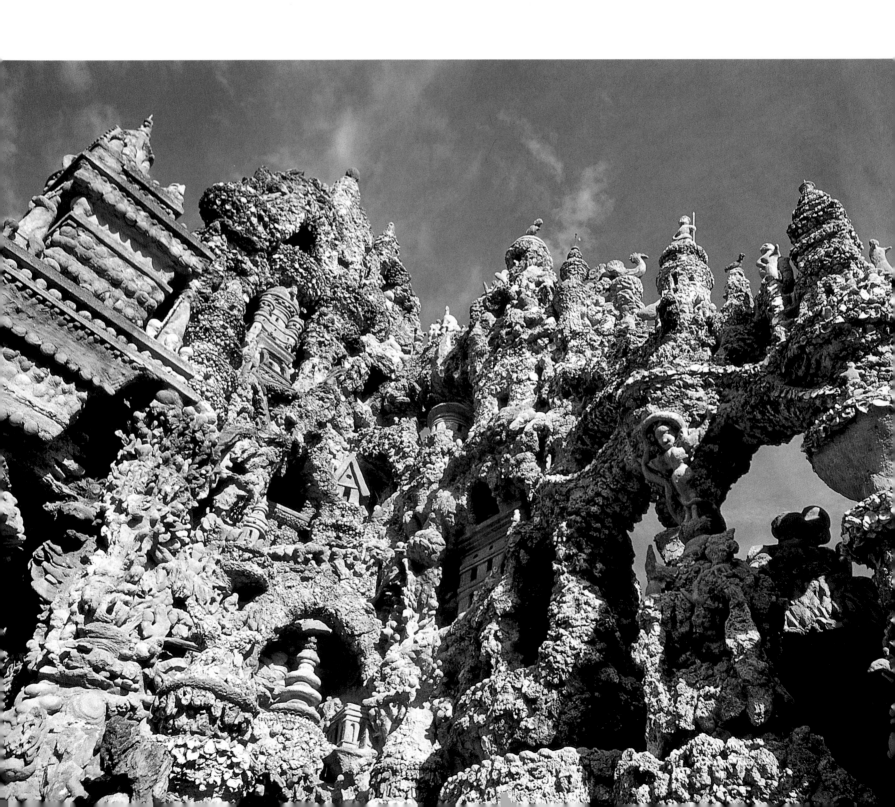

creation in 1912, an event which he refers to in one of the hundreds of
inscriptions on the Palais: 1879–1912
10 thousand days
93 thousand hours
33 years of effort.¶ Another inscription reads:

Everything you can see, passer-by
Is the work of one peasant
Who, out of a dream, created
The queen of the world. ¶

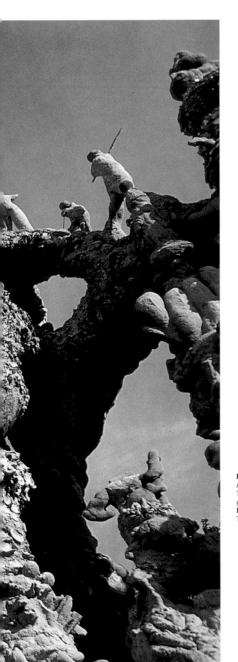

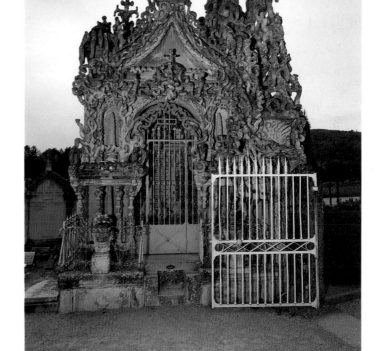

Ferdinand Cheval
Above and left
Three details from the Palais Idéal, including two of the giant
guardians of the east façade
Right
Tomb of Ferdinand Cheval in the Hauterives cemetery, 1916–22

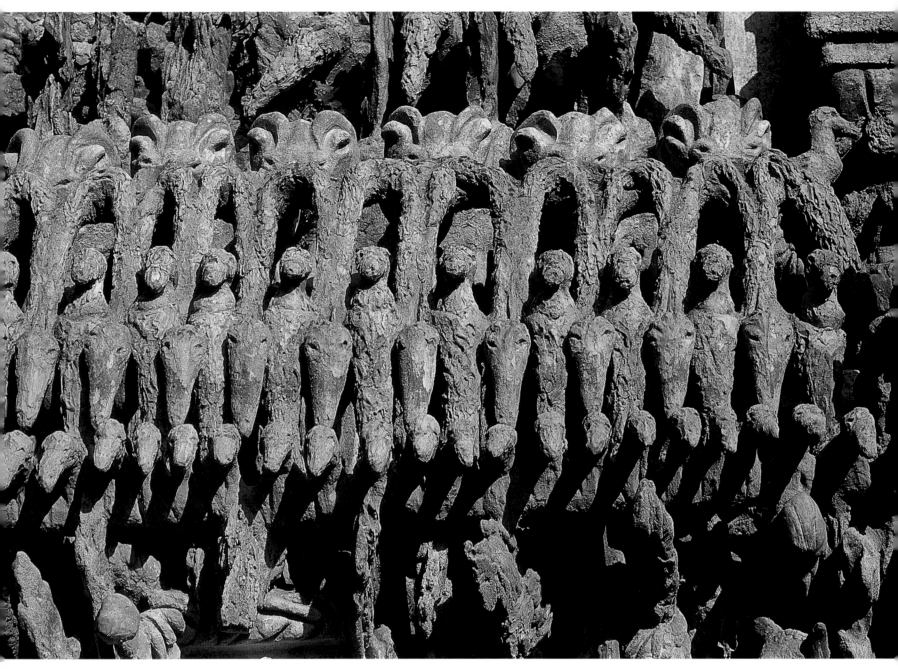

Ferdinand Cheval
Above and opposite
Sculpture from the Palais Idéal

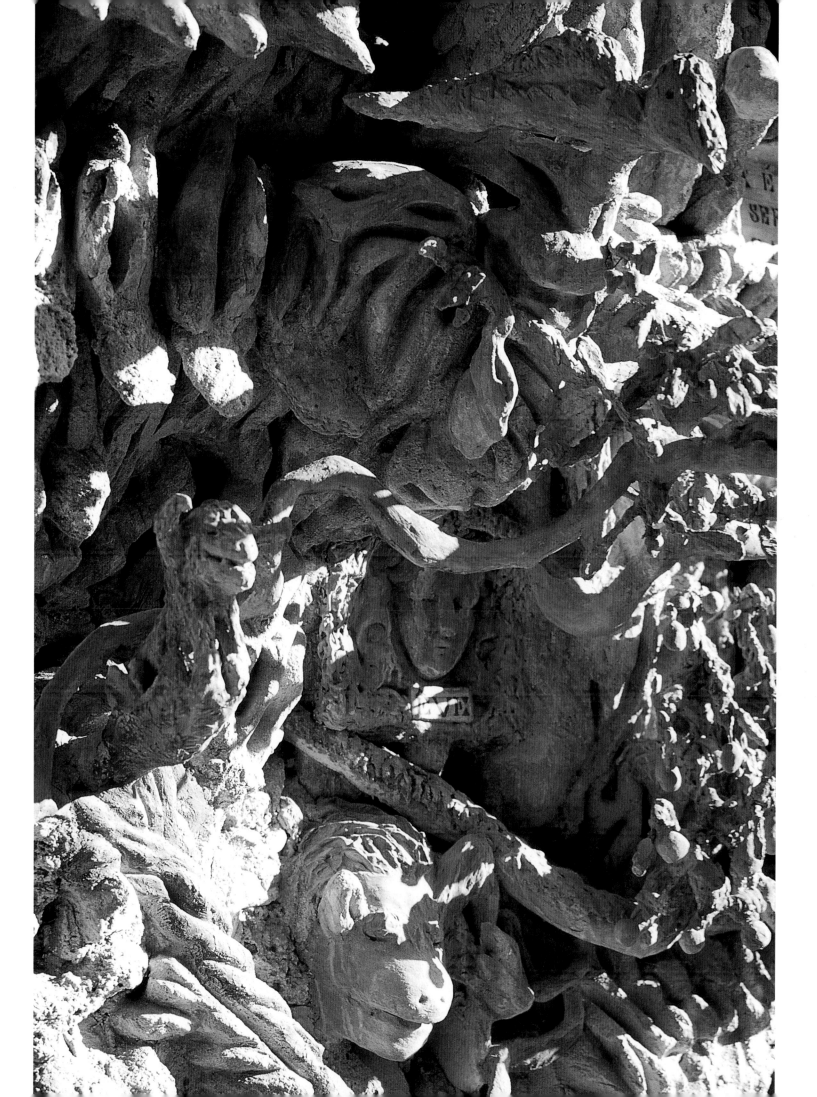

Cheval's plan to use the Palais Idéal as his own tomb appears to have been thwarted by local regulations. At the age of eighty, therefore, he began work on a tomb in the local churchyard. He completed this final work, a rectangular construction topped with a mass of limestone forms, two years before his death in 1924. ¶ Historical antecedents of the Palais Idéal are difficult to trace. The follies popular with the English landed gentry were carefully designed to amuse, the mysterious sculptures of the Bomarzo gardens in Italy were apparently created by skilled stonemasons on the instructions of the Duke of Orsini.[2] Cheval's work has more in common with nineteenth-century rural folk sculptors, such as those of the Miller of Lacoste or of François Michaud (1810–90), whose work still adorns the village of Masgot, near Clermont-Ferrand in central France,[3] or even the sixteenth-century carvings found at the Cave des Mousseaux in the Loire. ¶ The Palais Idéal received much attention from André Breton and other Surrealists, who admired Cheval's ability to realize his dream and regarded him as a master of mediumistic sculpture and architecture. For many years, however, the Palais was looked on mainly as a curiosity, an amusing day out for provincial coach parties. Gilles Ehrmann's book *Les Inspirés et leurs demeures* (*The Inspired and their Abodes*), published in 1962, was instrumental in changing perceptions. It placed Cheval's work in a broader context, by examining visionary environments as a more widespread phenomenon. With an introduction by André Breton, the book presented ten environments, almost all twentieth-century French creations. Although some have now perished, others, like the Palais Idéal, have been preserved as classics of French environmental vision. ¶ A hermit priest, the eccentric Abbé Fouré (1839–1910), was responsible for one such creation on the Britanny shoreline at Rothéneuf near Saint-Malo. With the help of an elderly assistant, he carved into the granite rocks figures of legendary local pirates, dedicating over thirty years of his life to this monumental creation. Although completed in the early 1900s, his work (*Les Rochers Sculptés*) has a timeless, ancient quality. ¶ Also featured in Ehrmann's

2. See Anatole Jakovsky, *Dämonen und Wunder* (Cologne, 1963)

3. See Bruno Montpied, Jacques Meunier, Robert Brousse et al., *Masgot: L'œuvre enigmatique de François Michaud* (Souny, 1993)

Abbé Fouré
Left
Abbé Fouré sitting in the chair he carved himself, c.1900
Above and right
Carvings from *Les Rochers Sculptés*, Saint-Malo, completed early 1900s

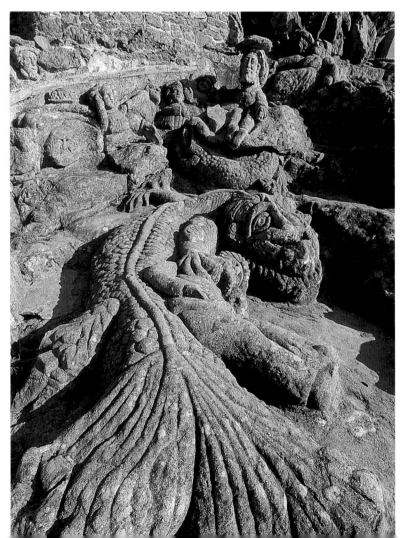

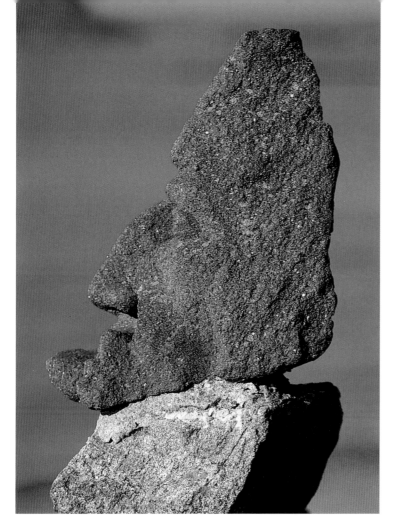

Left
Abbé Fouré
Face carved from the granite shoreline of *Les Rochers Sculptés*
Below
Raymond Isidore
Detail of crockery mosaic from Maison Picassiette, Chartres, his home, begun in the 1930s

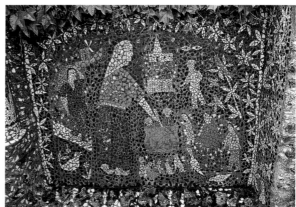

book was the Maison Picassiette in Chartres, the home of Raymond Isidore (1900–64) and his wife. ('Picassiette' is a play on 'Picasso' and *assiette*, 'plate', which also means 'scrounger' or 'plate-picker'.) A maintenance worker in the local cemetery, Isidore began to decorate the outside of his little house with broken crockery mosaics in the 1930s. He later turned to the interior, where mosaic and other decoration eventually covered every surface, including the furniture. Once the house had been completed, he went on to his most stunning creation—a series of little courtyards and shrines, every inch of which is adorned with bright mosaic set in coloured cement. The decoration is strongly influenced by the religious imagery of nearby Chartres cathedral but also contains charming personal details. In its heyday the beautifully encrusted house and garden were embellished with scores of mosaic flowerpots, even mosaic flowers. Both the intricate detail and the powerful overall effect still retain their fascination. ¶ Although Dubuffet took an interest in these environmental creations, and included elements rescued from them in his Collection de l'Art Brut, it was not until the 1970s that they were brought to a wider public. In 1977 Bernard Lassus published his detailed study of a host of previously unknown environments, *Jardins imaginaires*, in which he included many more humble efforts. He coined the term 'habitants-paysagistes' ('landscape dwellers'), which has been widely used as it vividly conveys the sense of the artist living in the midst of his or her creation, one of the most extraordinary features of such visionary environments. Lassus became an important figure in the move to honour and preserve many of these vulnerable creations. ¶ The 1978 exhibition Les Singuliers de l'Art in Paris displayed

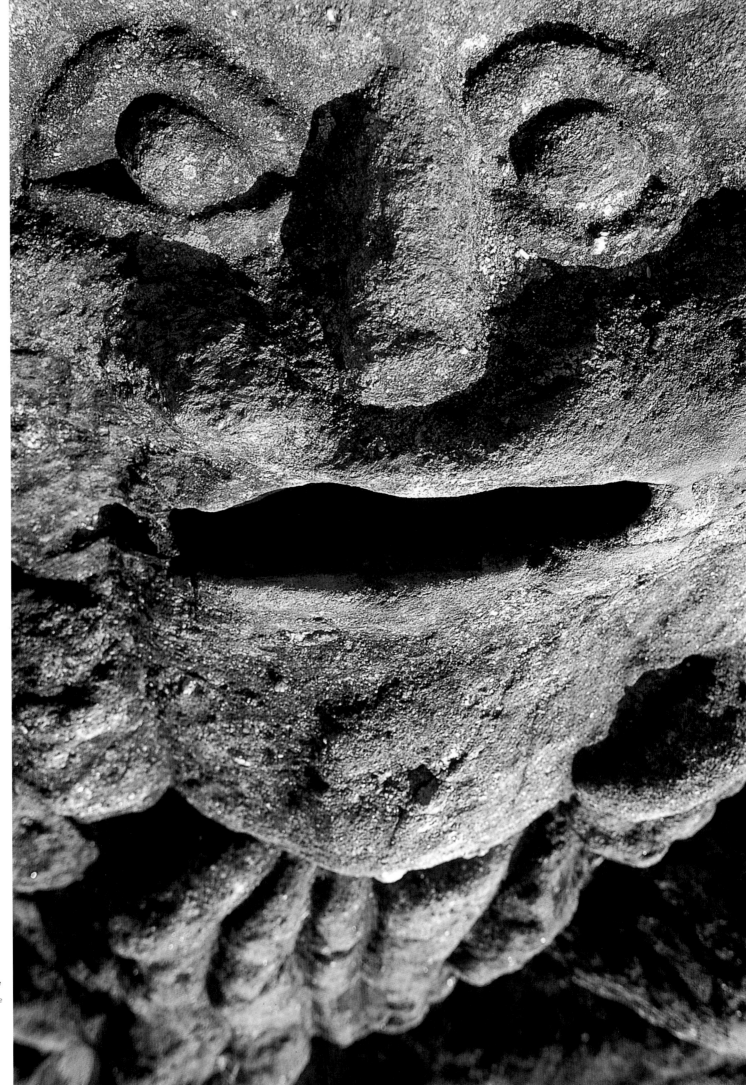

166

Abbé Fouré
Right and opposite
Faces carved from
the granite shoreline
of *Les Rochers*
Sculptés

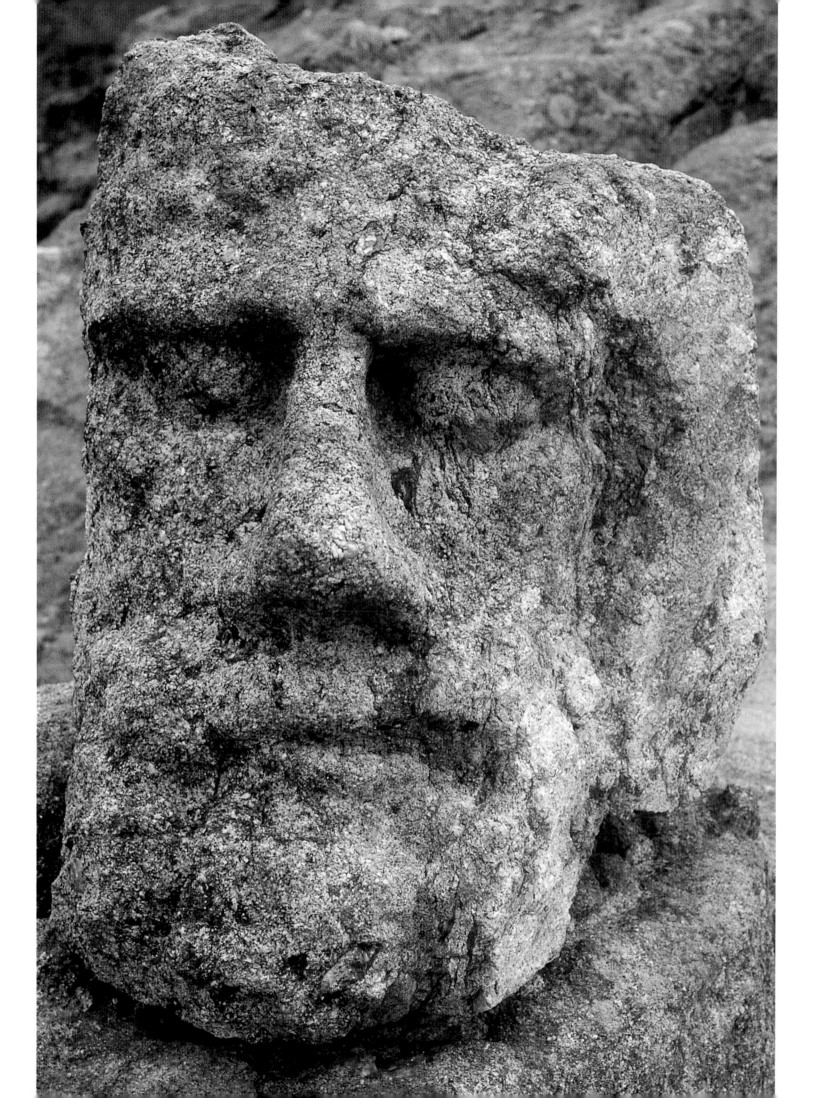

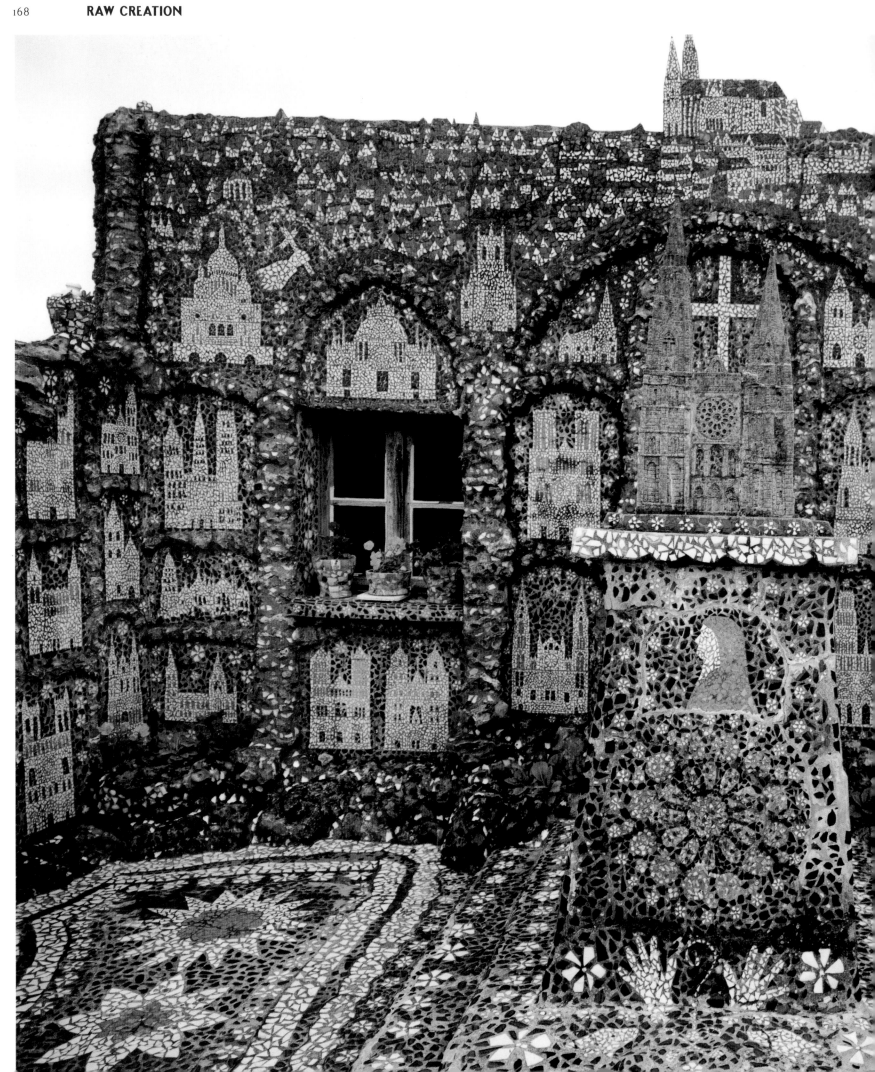

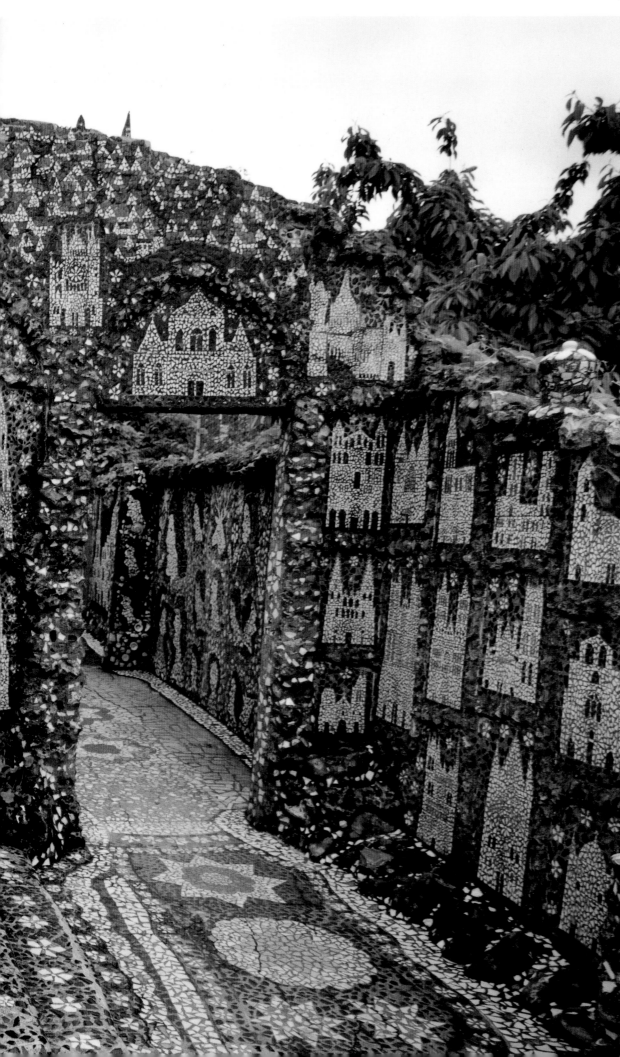

Raymond Isidore
Left
Mosaic courtyard with shrine from Maison Picassiette
Above
Details of crockery mosaic from Maison Picassiette

photographs of a variety of environmental creations. Some of the photographs were taken by Ehrmann and Lassus and others by Claude and Clovis Prévost, who were to spend the next twenty years documenting major French sites.[4] In the same year photographer Jacques Verroust's *Les Inspirés du bord des routes* presented still more visionary environments. Most of the creators to come to light were of fairly humble origins and and could not afford to purchase the quantities of materials that the large scale of their work demanded. Cement was often the only purchased item and the use of found and discarded materials was common. ¶ Like Raymond Isidore, Robert Vasseur in his Maison à Vaisselle Cassée in Louviers has made extensive use of broken crockery. The house, on which he and his wife toiled for years, is covered inside and out with thousands of sea shells, plates and crockery fragments. The work is less sculptural than Picassiette's, but the house and the garden, complete with multi-layered fountain and encrusted paths, shimmer with a decorative power. ¶ The Jardin du Coquillage near Chauny

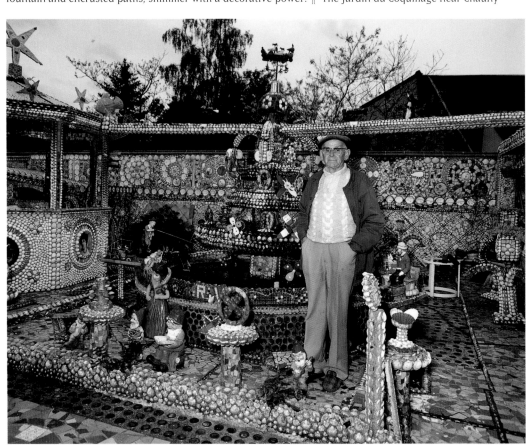

Robert Vasseur
Right
In his Maison à Vaisselle Cassée, Louviers, 1988
Above
Detail of weathervane
Below and below, right
Interior views of Maison à Vaisselle Cassée, 1988

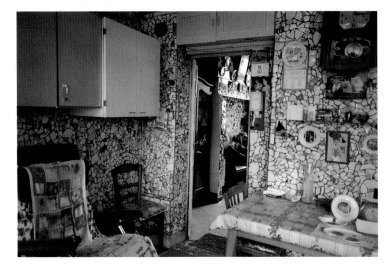

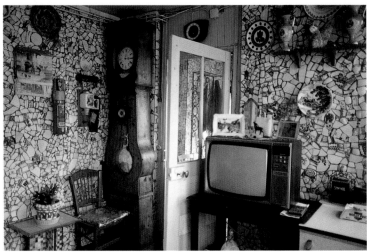

Bodhan Litnianski
Right
In his Jardin du Coquillage, Vitry-Noureuil, 1993
Far right
Detail of the wall of Bodhan Litnianski's house in Le
Jardin du Coquillage

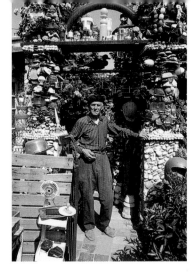

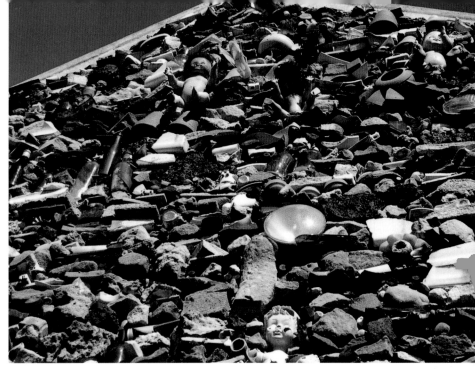

contains only a few shells, in spite of its name. It is constructed instead
almost entirely from discarded objects. Its creator, Bodhan Litnianski, after
building his house using a variety of stone, turned his attention to the little
piece of land around it. Tightly placed columns of junk cram the area in front
of the building. Over time many of the discarded objects he has collected
have taken on a period flavour, with clocks, old dolls, early cameras and
automobile accessories becoming attractive kitsch in their own right. ¶ In the shadow of the drab apartment blocks that surround him in the
Parisian suburb of Champigny, Maurice Lellouche built his ornamental sculp-
ture garden, Petit Musée. Lellouche, who made his living as a fruit trader,
spent years creating a series of free-standing and relief sculptures using the
shingle stones that he found in abundance on his land. His subjects range
from such popular figures as Santa Claus to poignant shrines for long-lost
canine companions. His years of isolation and loneliness, which he says gave
rise to his creations, are referred to in an inscription on one of the huge
tableaux that adorn the walls of his garden: It is loneliness
that has led me
to create. The interior

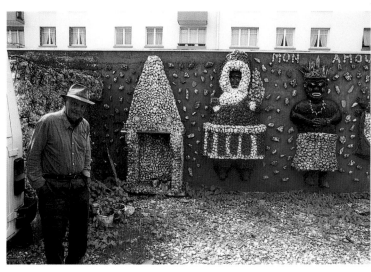

Maurice Lellouche
Above
In his ornamental sculpture garden, Petit Musée, near Paris, 1988
Above, right
A ship made of shingle from Maurice Lellouche's Petit Musée

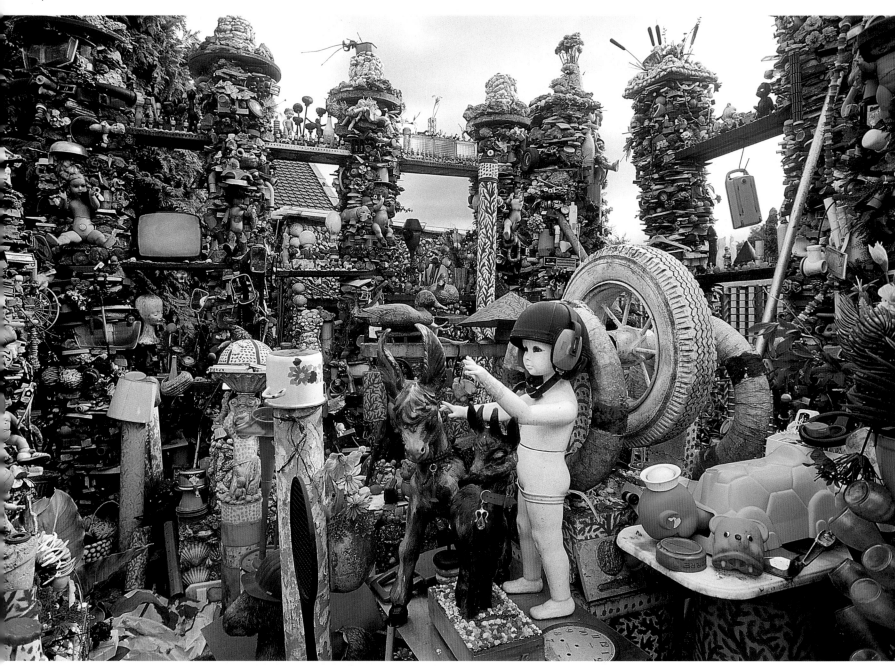

Bodhan Litnianski
Details of his Jardin du Coquillage, Vitry-Noureuil, 1993

of his house is also heavily embellished with textural forms. ¶

Charles Billy
Above, top
In Le Jardin de Nous Deux, Civrieux d'Azergues, Lyon, 1989
Above and right
Sandstone buildings from Le Jardin de Nous Deux

Other environment builders have used found materials of a more conventional nature. Charles Billy (1909–91), a retired corset maker from Lyon, used the golden sandstone he collected from local ruined farmhouses to created his architectural fantasy Le Jardin de Nous Deux. Employing skills similar to those of a medieval mason, he spent over fifteen years surrounding his neat house with a series of minutely detailed architectural constructions. Connected by a long winding path and adorned with numerous figurines and carvings, the buildings in their varied architectural styles reflect influences from many cultures and ages. The beautifully constructed site, richly adorned with plants, earned Billy the epithet 'the new Facteur Cheval'. ¶ Although

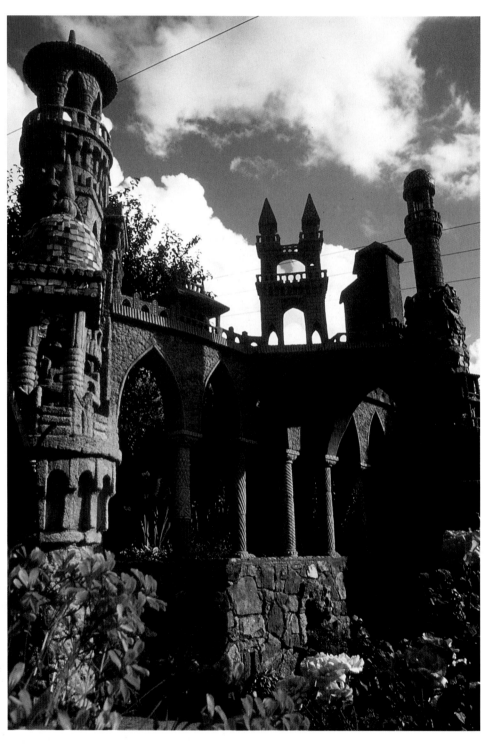

Charles Billy's creation is proudly guarded by his widow, other environments have not been so well cared for. Some families have been so ashamed of their relative's unusual activities that they have wasted no time in destroying many years of work. The garden environment of Edouard Pennel (d.1988) of Aire-sur-la-Lys, near Calais, was embellished with over 1,400 dolls of all shapes and sizes, a collection that he had built up over a lifetime. Within a month of his death the entire creation was destroyed by his family, and his collection of over 1,000 keys was thrown away.[5] The much larger environment Casa Reggio, built by Armand Schulthess (1901–72) over several acres at Auressio, Ticino, in Switzerland, consisted of hundreds of cryptic messages and idiosyncratic astrological and celestial forms. Within a few months of his death, it too had been completely destroyed by his relatives.[6] ¶ We will never know exactly how many environments have disappeared through such family vandalism without anyone ever having documented them. Even quite well-known locations can suffer once their creator has become old or infirm. Many of today's sites have an uncertain future. The topiary sculptures of Joseph Marmin in the Vendée described by Ehrmann have been lost. The sculptures of Fernand Chatelain (d.1988), a baker who adorned his house and garden near Alençon, are suffering from neglect and cannot survive for much longer. Over sixty concrete figures of people and various creatures still inhabit the site. They display a mischievous humour which, combined with their crude construction, gives them a raw power. Chatelain's early work includes a huge bread loaf shaped like the Tower of Pisa. Little interest has been shown by either his family or such bodies as the Musée des Beaux-Arts in Alençon in preserving any of his sculpture. In spite of several appeals, these wonderful creations may be lost forever. ¶ One conservation

5. See Francis David, *Guide de l'art insolite* (Paris, 1984)

6. See Hans-Ulrich Schlumpf: 'La Seconde Vie d'Armand Schulthess', *L'Art Brut*, fascicle no. 14 (1986)

Above
Edouard Pennel
With his collection of dolls, Aire-sur-la-Lys, Calais
Below, right
Armand Schulthess
Some of the cryptic messages at Casa Reggio, Auressio, Ticino
Below, far right
Ferdinand Chatelain
Detail of sculptures, Fye, Alençon

7. See Laurent Danchin, *Le Manège de Petit Pierre* (Dicy, 1995)

8. An excellent guidebook for visiting the environmental sites in France is Claude Arz, *Guide de la France insolite* (Paris, 1990); revised as *La France insolite* (Paris, 1995)

success was the Manège de Petit Pierre, a mechanical circus built by herdsman Pierre Avezard (1909–92) at Fay-aux-Loges near Orléans. In his old age he agreed to allow Alain Bourbonnais to take the entire construction to his Fabuloserie museum. Over a period of several years the complex mechanical parts of scores of automated figures, animals, trains, cars and airplanes were painstakingly reassembled and the magic that Avezard gave to the world now lives on in the Fabuloserie park.[7] ¶ The creators of such visionary environments are usually humble and hardworking members of their local communities. Many are manual workers and their creative efforts are carried out in their leisure time or after retirement. Their extraordinary creative commitment is evident from the length of time that these complex compositions take to build. All seem to want to produce something long lasting, a monument or shrine to themselves or their loved ones, some solid evidence of their hard work and creativity. As with all art, their creations in the end defy explanation; their meaning is in their powerful visual impact.[8]

This page
Fernand Chatelain
Concrete sculptures from his garden,
Les Centuars, Fye, Alençon, 1988
(See also p.230)

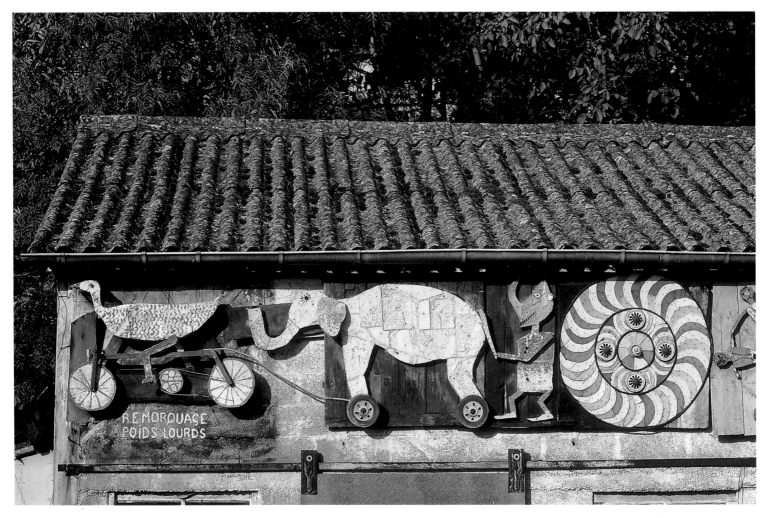

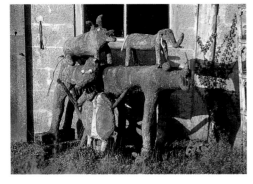

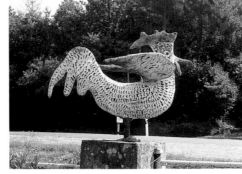

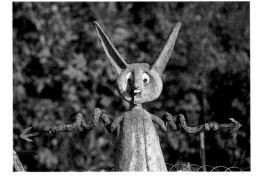

This page
Pierre Avezard
Details of Le Manège de Petit Pierre, La Fabuloserie-Bourbonnais, Dicy

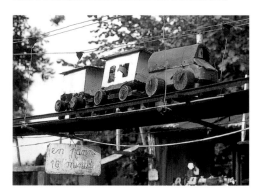

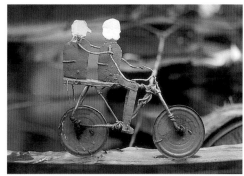

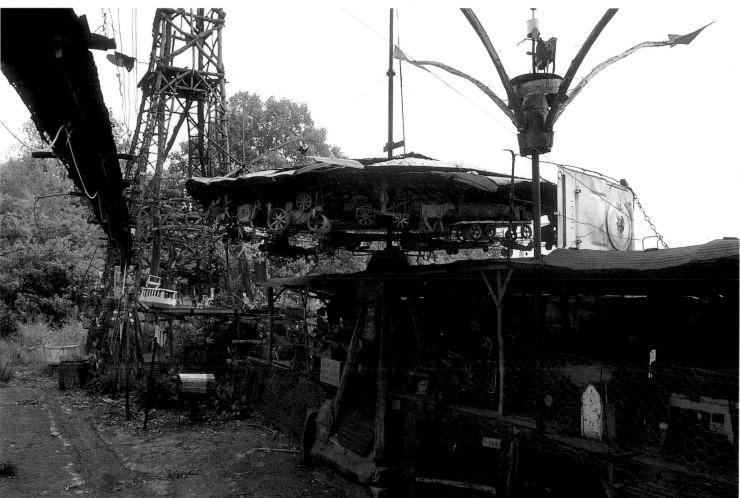

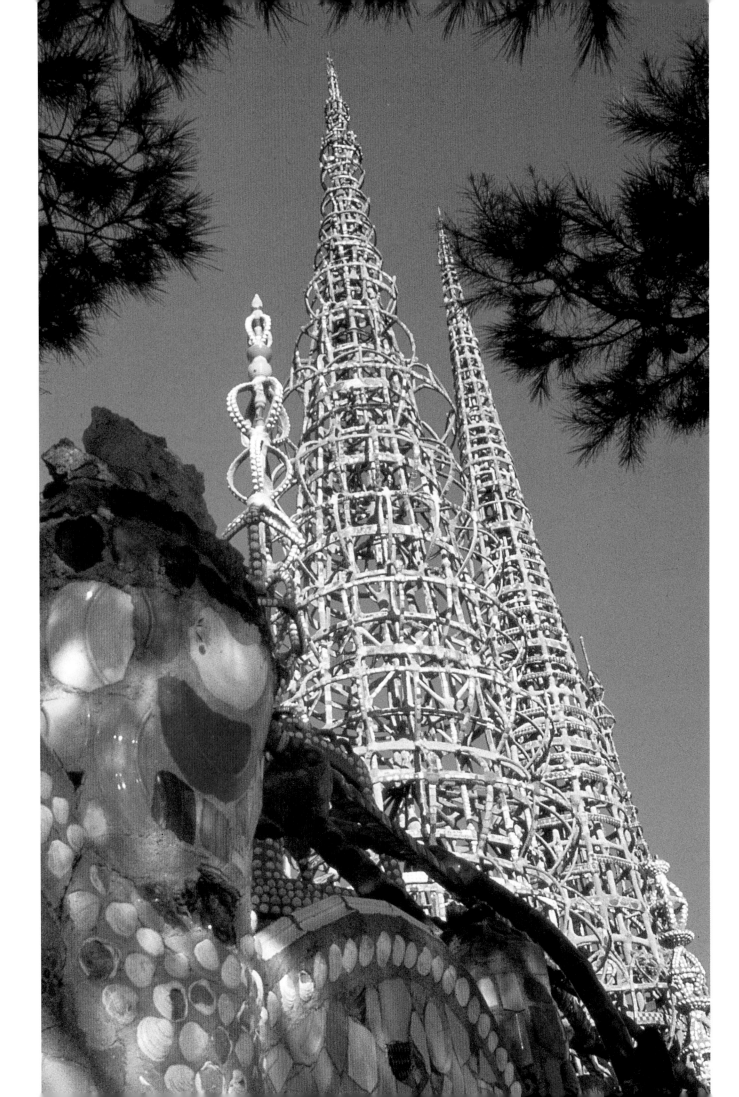

Chapter 13: PRESERVATION AND LOSS IN THE U.S.

In the United States interest in visionary environments grew independently from developments in France. Appreciation centred on individual creativity and the sense of wonder such environments evoke rather than Breton's Surrealist sentiments or Dubuffet's theories. A catalyst for growing public involvement was an attempt in 1958 by the City of Los Angeles to declare unsafe and demolish the huge towers constructed by Simon Rodia in the Watts area of the city. ¶ Rodia (1875–1965), an Italian immigrant, had spent thirty-three years constructing three huge towers and six shorter ones, the tallest some 30 metres (almost 100 feet) high, on his triangular patch of land. He built these immense structures and surrounded them with a complex walled garden in his spare time from his job as a labourer. The towers were made by binding together found lengths of metal with wire and cable, finally coating them with concrete. The metal bars and rods, often bent by Rodia by wedging one end under the track of a nearby railway line, were built up to form a complex web-like structure, the whole being encased in a bright mosaic of discarded crockery, pottery and glass with added patterns pressed into the wet concrete. There is speculation that Rodia's ideas originated from the southern Italian folk tradition of the *giglio*, a papier-mâché tower that was carried in religious festivals.[1] There is little to support the theory, however, and in one of his few explanations Rodia simply stated: I had in mind to do something big and I did. ¶ Rodia left the Watts area in 1954, simply deeding the towers to a neighbour. The city authorities met stiff opposition to their assertion that the towers were unsafe and the newly formed Committee for Simon Rodia's Towers in Watts eventually forced a climb-down by proving the strength of Rodia's structure. Testing machinery failed after exerting 10,000 pounds of pressure against the tallest tower for one and a half minutes, and the towers were saved. The controversy over Watts Towers drew attention to the previously ignored phenomenon of visionary environments in the United States. Even such figures as Sir Kenneth Clark and Buckminster Fuller had responded to their appeal. Photographer Seymour Rosen, one of the original members of the group that saved the towers, began a lifelong involvement in the documentation of similar creations around the country. A vast number of such sites was recognized across the whole of North America. Even as the Watts Towers were being saved in Los Angeles, another environment was gaining attention on the east coast. ¶ Between 1948 and 1971 Clarence Schmidt (1897–1978), a

1, 1 Sheldon Posen and Daniel Franklin Ward, 'Watts Towers and the Giglio Tradition', *Folklife Annual* (1985)

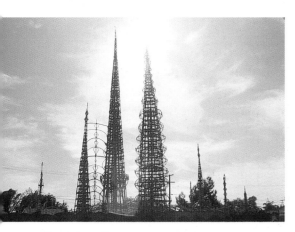

Above and opposite
Simon Rodia
Watts Towers, Los Angeles,
photographed by Seymour Rosen

former stonemason, transformed his one-roomed log cabin in the Woodstock area of upstate New York into a rambling seven-storey, 35-room structure. Rooms were added on one at a time in all directions; each had a sturdy timber frame which was filled in with wood and tar and set with window frames. Each level of the building had balconies and walkways that connected with the ground or the roof garden. The exterior was dominated by the mass of windows with panes of all shapes and sizes. The original log cabin became Schmidt's inner sanctum. A large tree grew through the building and its branches and trunk were covered in tin foil, plastic flowers and mirrors. Further branches wrapped in foil, Christmas lights and strong spotlights added to the illuminated effect of the House of Mirrors. Schmidt marvelled: Look! Look! Look! Look! God Almighty, has anyone, living or dead, done anything like this? Would you believe that I done all this?[2] ¶ Schmidt's embellishment with reflective surfaces and sculpture made from reclaimed junk extended to the roof garden and the land around the house. Unusually for an Outsider artist, many of his sculptures were wholly abstract constructions. He was not a popular figure with his neighbours in the Woodstock area, who felt his work was affecting local property prices. His standing was not helped when his creations inadvertently strayed over to a neighbouring property. In 1968 a mysterious fire broke out. It spread quickly through the timber and tar building and the House of Mirrors burnt to the ground. ¶ Schmidt, however, was soon back at work, creating a second home around

2. Quoted in William C Lipke and Gregg Blasdel, *Clarence Schmidt* (exhibition catalogue, Robert Hull Fleming Museum, University of Vermont, Burlington, and elsewhere, 1975–6), p.46

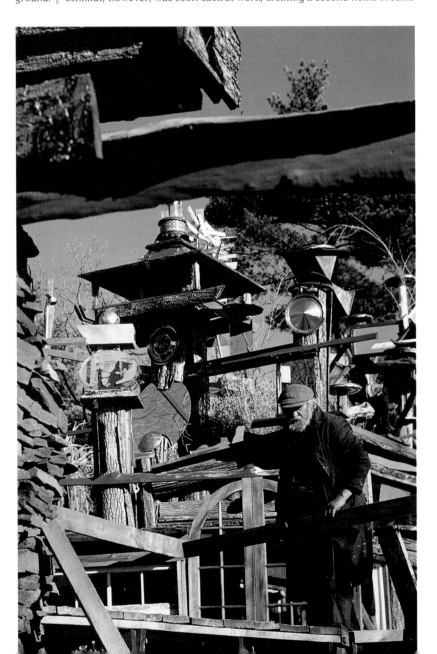

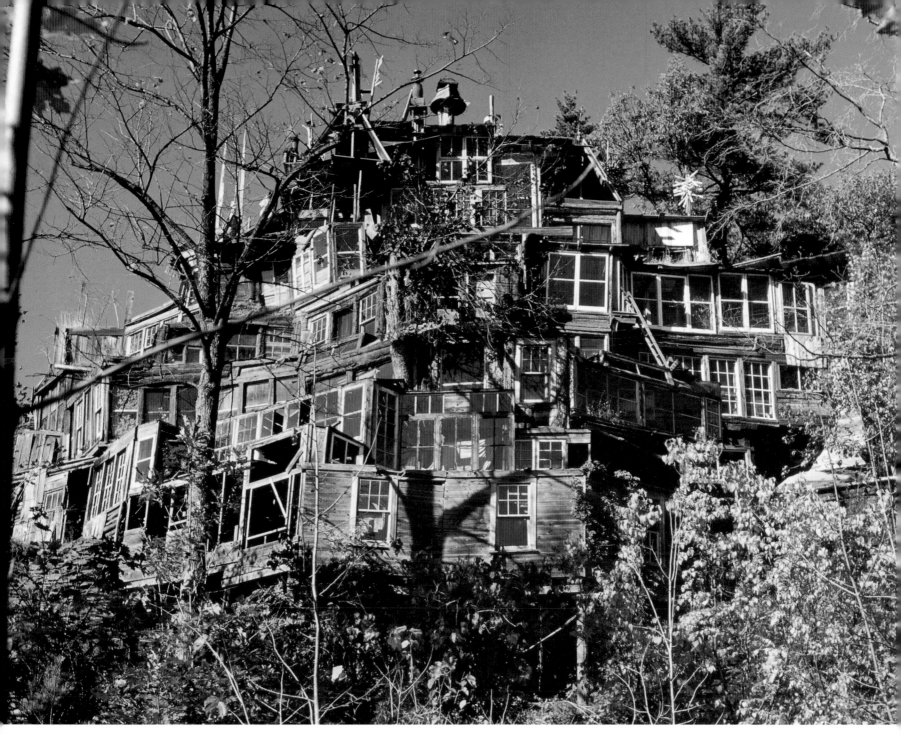

Clarence Schmidt
Above
House of Mirrors,
built between 1948 and 1968, when it was destroyed by fire
Opposite
On the roof of his House of Mirrors, Woodstock, New York
Below
Details of the Silver Forest, 1968–71

a station wagon, Mark II. He simultaneously created the Silver Forest, consisting of hundreds of small saplings and thin branches wrapped in silver foil and decorated with the heads and bodies of discarded dolls. But in 1971 his new home also burned down, and this time Schmidt could work no more. He abandoned his land and eventually moved to a nursing home where he died in 1978. ¶ The first photographic exhibitions featuring American environments were held in the 1960s, and environments were the subject of a growing number of publications. MOMA in New York included images of the Watts Towers in its 1961 exhibition The Art of Assemblage, and in its catalogue; the Los Angeles County Museum mounted a show of Rosen's photographs of the towers in 1962, and in 1966 presented I am Alive, an exhibition of his photographic images of popular Californian culture that included several environments. The arts journal *Horizon* published one of the first articles dealing exclusively with environments in 1964, with photographs of the Palais Idéal, Watts Towers and Schmidt's House of Mirrors. The subject received even wider attention in 1968 with the publication in *Art in America* of Gregg Blasdel's article 'The Grass-roots Artist'.[3] The young New York painter, who had developed a friendship with Clarence Schmidt, described fourteen creators in the article and bemoaned the fact that so much of their work was ignored or abandoned. In 1974 Jan Wampler's *All Their Own: People and the Places They Build* provided a survey of over twenty self-built environments and homes in North America. In the same year the largest exhibition to this date, Naives and Visionaries, was held at the Walker Art Center in Minneapolis, documenting nine sites.[4] In the following year Seymour Rosen's exhibition and book *In Celebration of Ourselves* drew attention to over thirty previously unknown California environments. ¶ Rosen's commitment to searching out unknown environments, helping their creators and doing what he could to preserve their creations eventually led to the formation of SPACES (Saving and Preserving Arts and Cultural Environments) in 1978. Aiming to document and preserve such creations *in situ*, SPACES, under Rosen's directorship, began a campaign to raise awareness of what Rosen termed 'contemporary folk art environments' in America and to seek ways of preserving many which were threatened. Rosen eventually identified over 300 large-scale creations across the country, as well as thousands of small garden or backyard environments.[5] Rosen and SPACES deserve credit for bringing these previously unknown and ignored creations before a wide audience and for battling to obtain official recognition. In 1977 the Watts Towers became the first of many sites to be placed on the National Register of Historic Places. ¶ Soon after its founding, SPACES had a struggle on its hands when city

3. *Art in America* (September/October 1968), pp.24-41

4. *Naives and Visionaries* (exhibition catalogue, Walker Art Center, Minneapolis, 1974-5). The exhibition, curated by Martin Friedman and Gregg Blasdel, included the following artists: James Hampton, Simon Rodia, J P Dinsmoor, Clarence Schmidt, Fred Smith, Jesse Howard, Herman Rusch, Tressa Prisbrey and Louis Wippich

5. See Seymour Rosen, *In Celebration of Ourselves* (San Francisco, 1979) and Seymour Rosen and Cynthia Pansing, 'The Work of SPACES: Saving America's Contemporary Folk Environments', *Raw Vision*, no.1 (1989), pp.36-41

Below
Tressa 'Grandma' Prisbrey
Right and below, right
Her Bottle Village, Simi Valley,
California

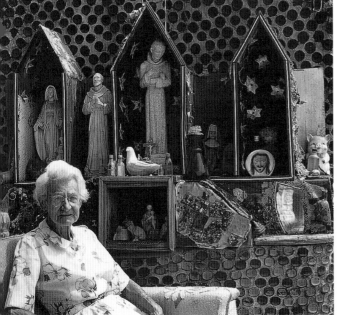

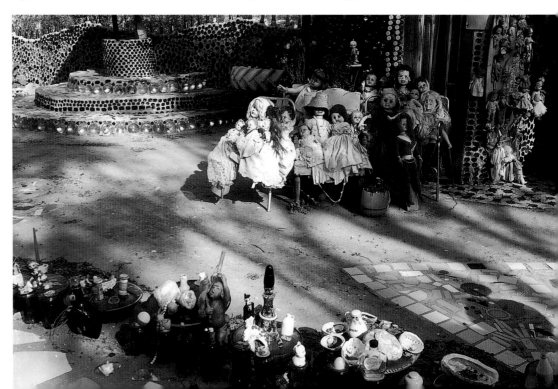

John Ehn
Below
Objects and sculptures from Old Trapper's Lodge,
begun 1940s, now at Pierce College, Los Angeles

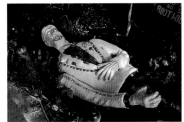

Calvin and Ruby Black
Below, top
Possum Trot, built in the Mojave Desert, now dismantled
Below, bottom
Some of the near life-size dolls from Possum Trot

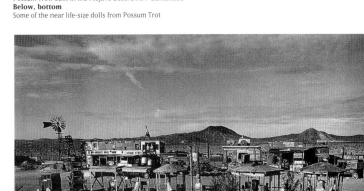

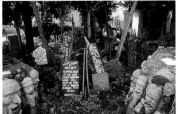

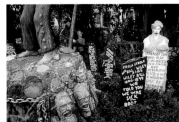

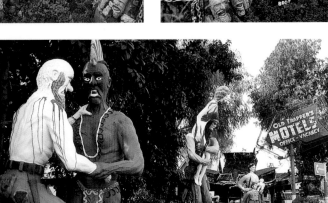

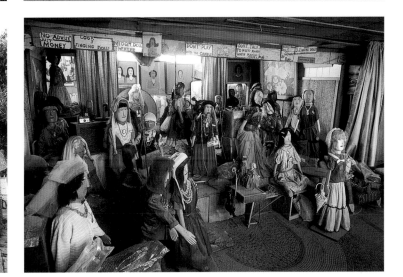

6. See Verni Greenfield, Tressa Prisbrey: More Than
Money, The Story of Bottle Village. *Raw Vision*, no. 4
(1991), pp. 46–51

7. See *SPACES Newsletter*, no. 8 (1988), p. 4

authorities in Simi Valley, California, deemed Tressa 'Grandma' Prisbrey's
(1896–1988) Bottle Village to be unsightly and unsafe. The site, covering a
third of an acre, consisted of twenty-two small buildings and various other
decorated structures, including a fountain and planters, arranged along a lit-
tle street.[6] It had been built by Prisbrey in a mixture of cement and found
materials over a period of some twenty years. Partly to take her mind off per-
sonal tragedies and partly driven by a need to create, she worked incessant-
ly, making frequent visits to the city dump to collect her building materials,
which included bottles, skulls, old tools, dolls and pencils. Bottle Village was
eventually bought by a specially formed Preserve Bottle Village Committee,
after a struggle that lasted several years. As a result of earthquake damage
funding has now been promised from the State of California for a large-scale
restoration programme. ¶ SPACES has not been able to preserve all works *in situ*. The bulk of Old
Trapper's Lodge, a mixture of found objects, tombstones and large sculptures
on the theme of the Old West, begun by John Ehn (1897–1981) in the 1940s,
was moved in 1988 to a new location on the grounds of Pierce College, Los
Angeles.[7] Some creations have been dispersed. Possum Trot, a strange collec-
tion of near life-size dolls, had been assembled by Calvin and Ruby Black
(1903–72 and 1913–80 respectively) at their roadside store in the Mojave
Desert. Their Fantasy Doll Show featured over eighty dolls, all carved and

8. Jocelyn Gibbs, 'Visions of Home', *Whole Earth Review* (Fall 1986), pp.106–12

clothed by the Blacks. Small speakers in their heads relayed voices from bat-tery tape recorders, while Calvin Black provided a musical accompaniment. Each doll held a little can for tips from the audience at the end of the show. After the Blacks had died Possum Trot was dismantled and the dolls dis-persed.[8] Although many survive in private collections, the full magic of the show has gone forever. ¶ The Kansas Grassroots Art Association (KGAA), founded in 1974, has aims similar to SPACES but its work is more localized. Environments in Kansas include the famous Garden of Eden, built by J P Dinsmoor (1843–1932). Dinsmoor, who had been both a Civil War soldier and a school teacher, arrived in Lucas, Kansas, at the age of sixty-five. He built a house in frontier cabin style using limestone blocks cut like logs. He then proceeded to sur-round the property with a series of concrete trees in which he placed over 150 sculptures of animals, flags and figures from the Bible and from contem-porary life. The Devil, Cain and Abel, Adam and Eve and the Serpent were all represented. ¶ On another part of the property he showed the figure of Labour being crucified by four representations of exploitative power: a Doctor, Lawyer, Preacher and Banker. He built a large mausoleum in which his embalmed body was to be displayed in a glass-topped coffin. After the death of his first wife, Dinsmoor remarried to a girl of twenty at the age of eighty-one, fathered two more children and died aged eighty-nine. The Garden of Eden was purchased in 1988 by the Garden of Eden Inc., a group of enthusiasts, many of whom are long-time members of the KGAA, to preserve the site and maintain it as a public museum. Lucas is also to be the location for the Great Plains Museum of Grassroots Art where the KGAA's own collection will be housed.[9] ¶ One success has been the restoration of Ed Galloway's (1880–1962) Totem Pole in neighbouring Oklahoma by KGAA volunteers working over weekends and during vacations.[10] Built between 1937 and 1962, Totem Pole Park was Galloway's tribute to the Native American. The main conical structure, made of cement over a stone and metal armature, displays relief figures of four great Indian chiefs, including Sitting Bull and Geronimo, and is surrounded by brightly painted ornamentation. ¶ The Orange Show Foundation in Houston, Texas, was formed to

9. See report by Lisa Stone, *Raw Vision*, no. 11 (1995), p.20

10. *KGAA News*, vol. 7, no. 2 (1987), p.1

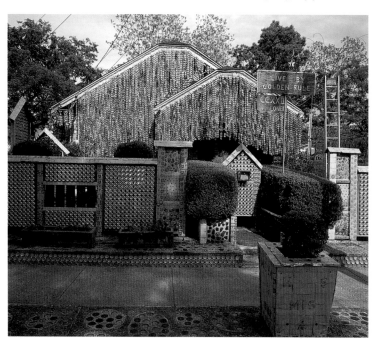 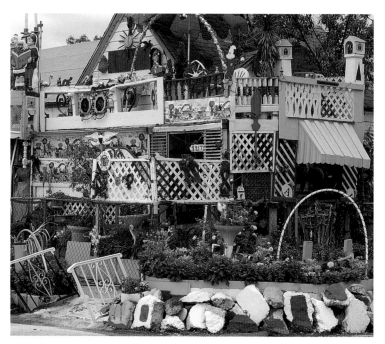

Above left
John Milkovisch
Beer Can House, Houston
Above
Cleveland Turner
Flowerman's House, Houston

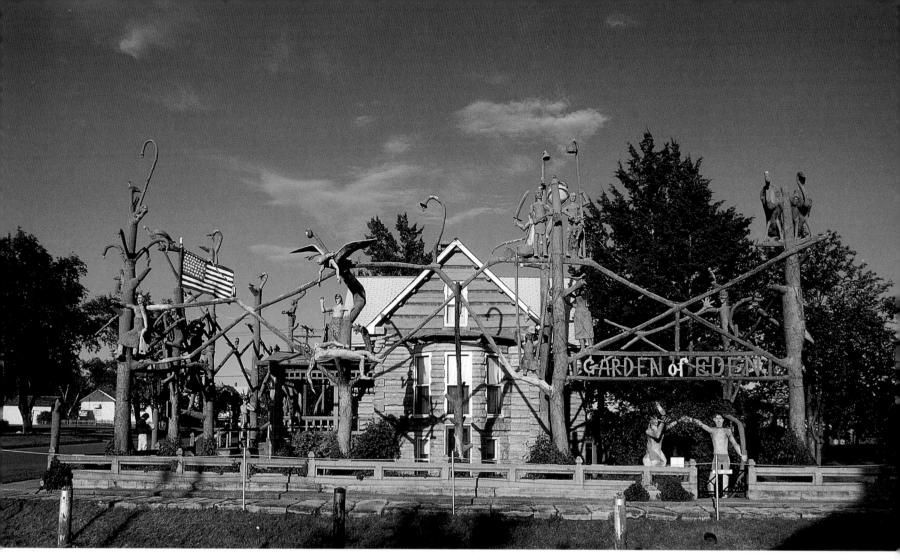

J P Dinsmoor
Garden of Eden, Lucas, Kansas

preserve the Orange Show, postman Jeff McKissack's (1902–79) personal monument to good nutrition and health, and to develop it as an arts and cultural centre. The site was built by McKissack over a 25-year period: its bright fairground atmosphere, with painted wagon wheels and parasols, glorifies the positive power of the orange. The Foundation also organizes an annual parade of Art Cars, bizarre vehicles that have been transformed into art objects. Further, it investigates and documents local folk art sites, including such creations as John Milkovisch's Beer Can House, which is covered with the tops and flattened sides of over 39,000 cans. ¶ Another Houston site, the Flowerman's House, is crammed with living and plastic flowers and ornaments, which even overflow onto the sidewalk. The brightly painted house and colour-soaked garden were built by Cleveland Turner, who made a pact to create a place of beauty in return for God's help in overcoming alcohol addiction. ¶ The upper Midwest is rich in folk art environments, many

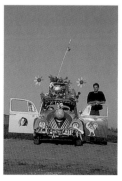
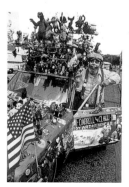
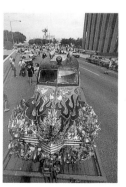

Jeff McKissack
Left
The Orange Show Foundation, Houston, Texas
Above
Art Cars in the annual Orange Show Foundation parade, Houston, Texas

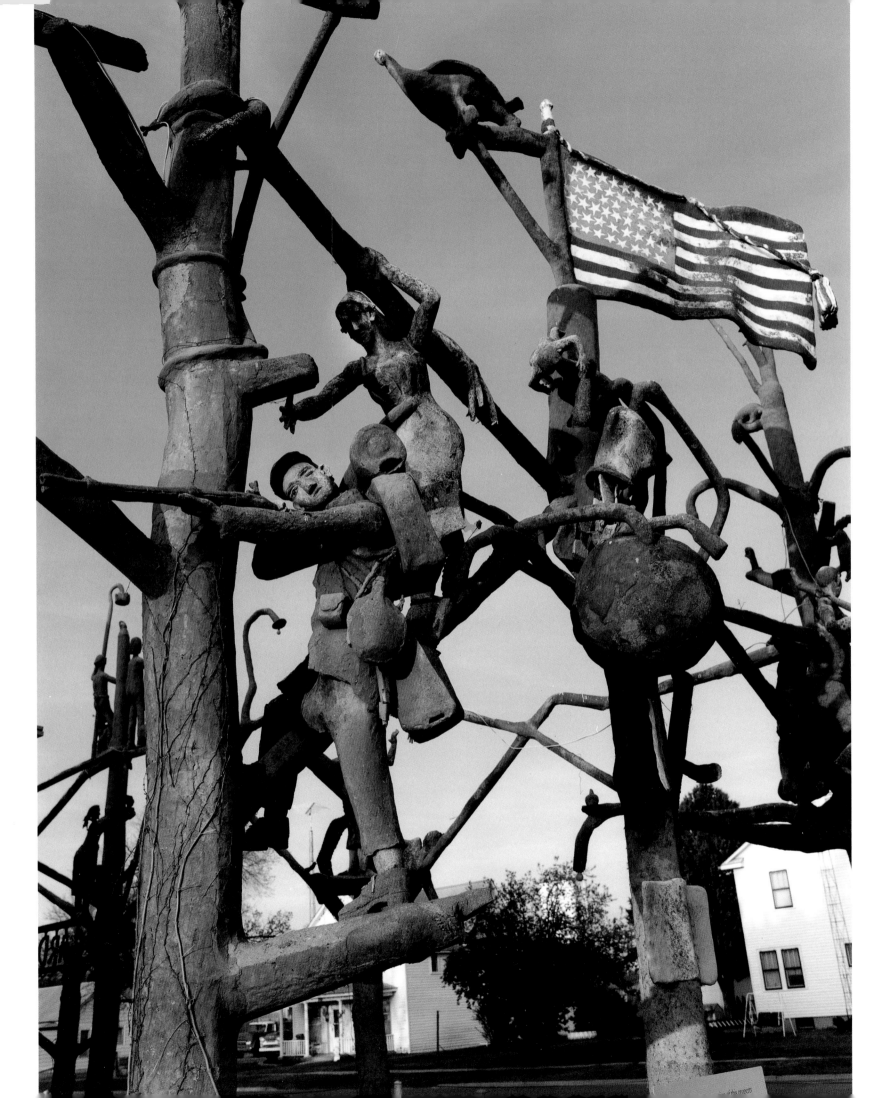

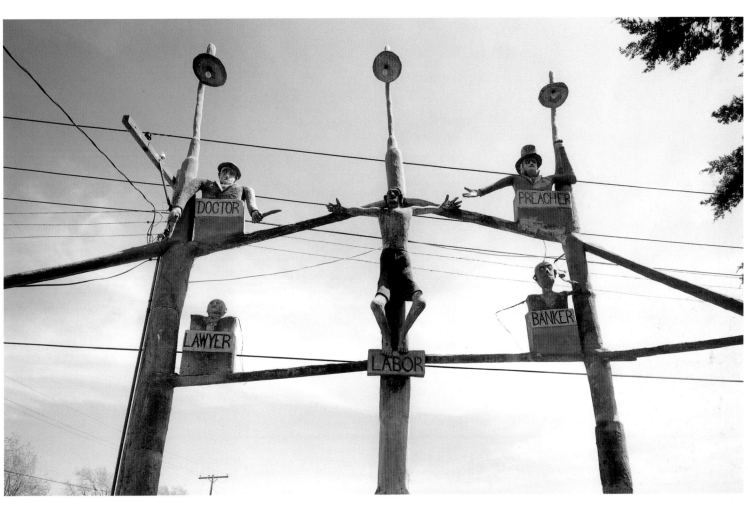

J P Dinsmoor
Opposite
Figures representing 'present-day civilisation'
beneath the Stars and Stripes at the Garden of Eden, Lucas, Kansas
Above
The Crucifixion of Labor at the Garden of Eden

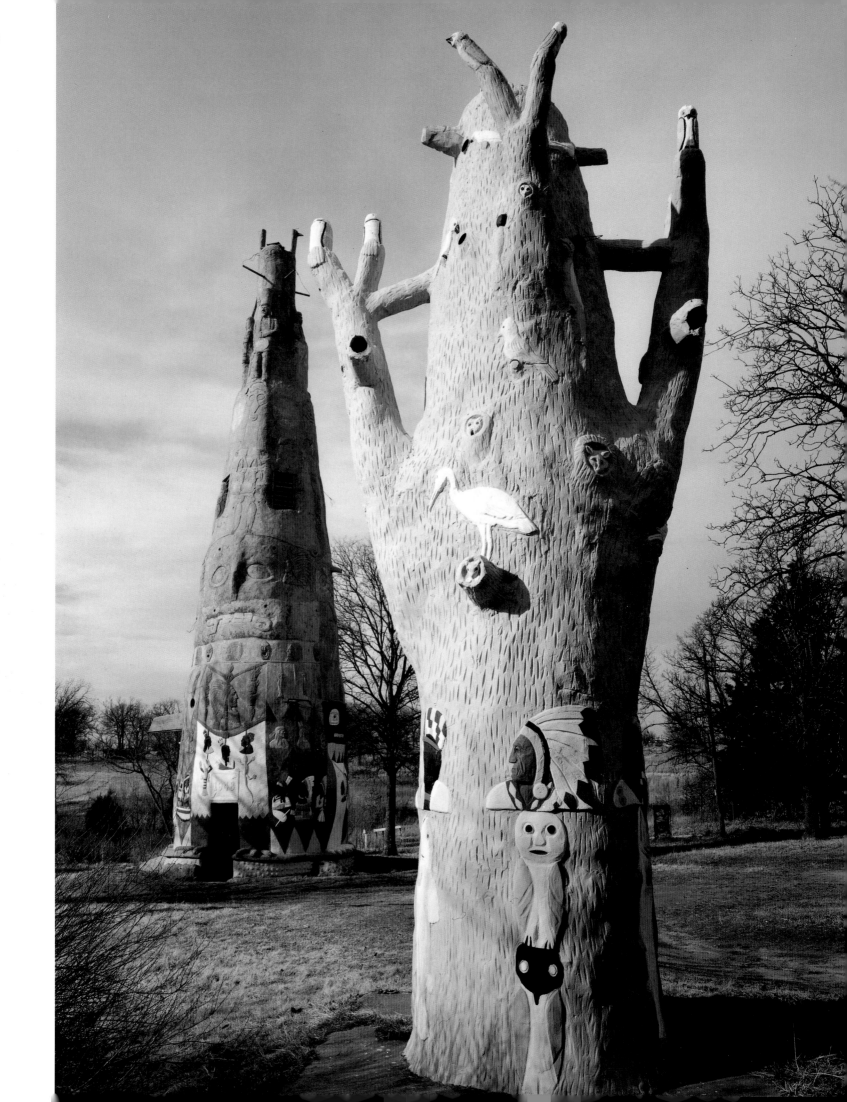

Ed Galloway
Opposite and below
Details from Totem Pole Park, Foyil, Oklahoma,
built between 1937 and 1962

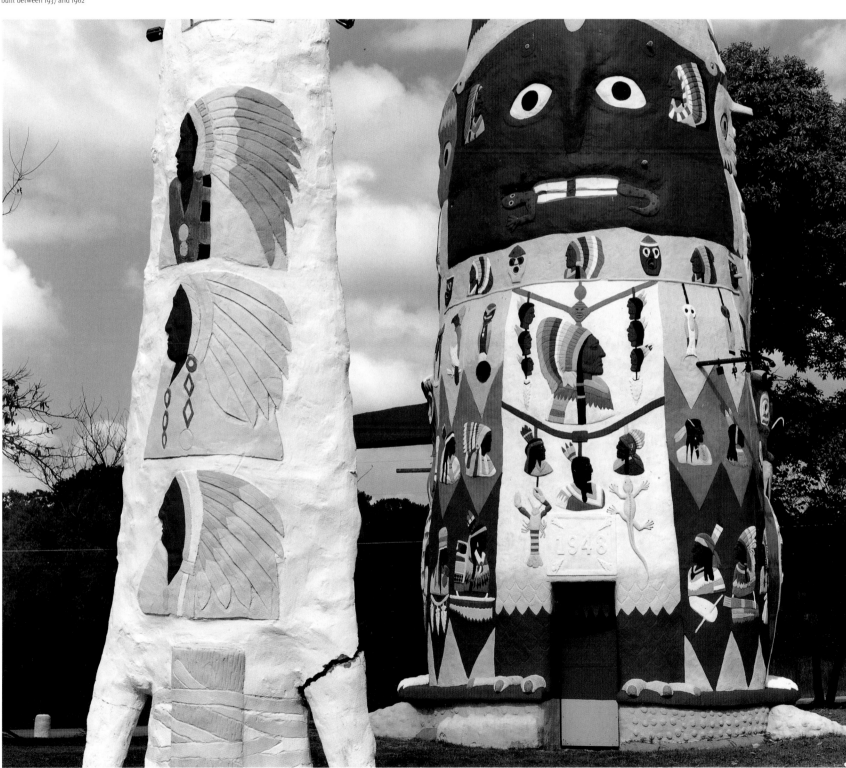

11. See Lisa Stone and Jim Zanzi, *Sacred Spaces and Other Places: A Guide to Grottos and Sculptural Environments in the Upper Midwest* (Chicago, 1993). This comprehensive survey gives locations of and directions to over forty environments

12. Lisa Stone and Jim Zanzi, *The Art of Fred Smith: The Wisconsin Concrete Park* (Phillips, Wisconsin, 1991)

reflecting strong religious motivation.[11] The Dickeyville Grotto, or the Grotto of the Blessed Virgin and Holy Ghost Park, was begun in 1924 by Father Mathias Wernerus (1873–1931). After first building a war memorial and then ornate urns and flower pots in his Wisconsin church grounds, he moved on to create a series of shrines and grottoes embedded with shells and stones. Helped by his sister Mary Wernerus and by children from his parish school, he created the grotto as an expression of religious patriotism, including the Pope and the saints alongside the Stars and Stripes and Christopher Columbus. A slightly earlier creation by Father Dobberstein (1872–1954) at West Bend, Iowa, the Grotto of Redemption, may have inspired Wernerus and other grotto builders in the region. The Holy Ghost Park is maintained by the Dickyville church. ¶ In Phillips, Wisconsin, former lumberjack Fred Smith (1886–1976) spent fifteen years creating over two hundred near-life-size figures in concrete and glass mosaic. They represent such national figures as Abraham Lincoln and George Washington, and such folk personalities as Kit Carson and legendary lumberjack Paul Bunyan, as well as local people going about their daily tasks. Smith commented: Nobody knows why I made them, not even me.[12] ¶

Below
Fred Smith
Concrete Park, Phillips, Wisconsin

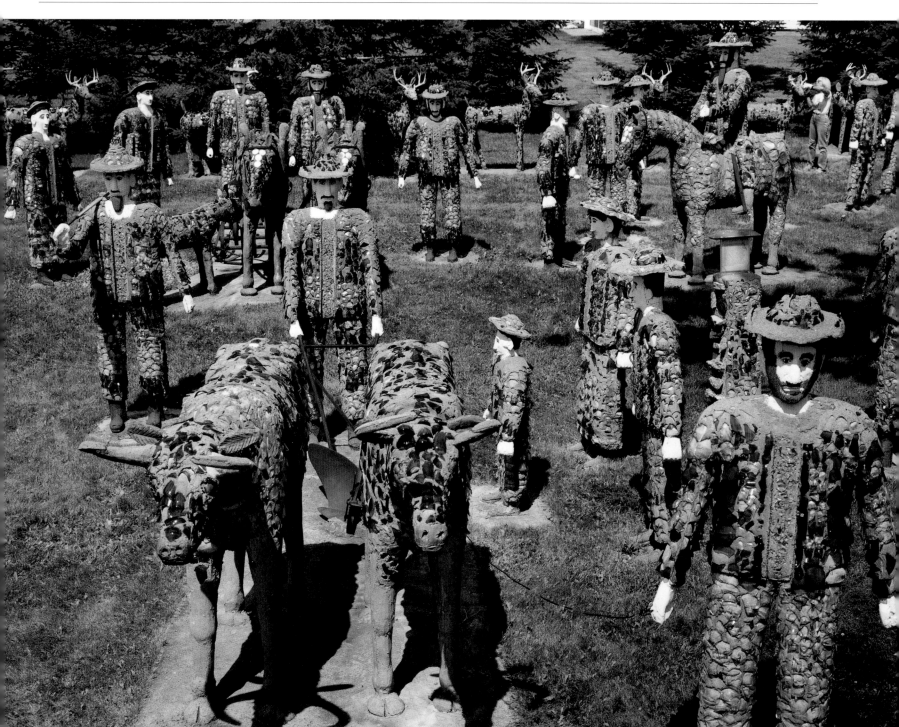

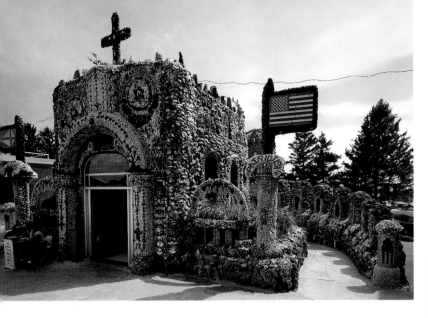

**Left
Fr Mathias Wernerus**
The Grotto of the Blessed Virgin and Holy Ghost Park,
Dickeyville, Wisconsin, begun 1924
**Below
Herman Rusch**
Prairie Moon Museum and Garden, Wisconsin

When Smith entered a nursing home, the whole site was bought by the Kohler Foundation, a family trust whose main interest had hitherto been educational. On the instigation of Ruth Kohler, and with the help of skilled preservationists Sharron Quasins and Don Howlett, the Foundation arranged for all the figures to be completely restored and then gifted the Fred Smith's Concrete Park to the local authority in Price County. Ruth Kohler's involvement in preserving folk art environments has led the Kohler Foundation—now with project coordinator Lisa Stone—to save several other sites, including the large-scale Prairie Moon Museum and Garden of Herman Rusch (1885–?). This graceful creation of multiple arch colonnades and towers, largely constructed of stones, rocks, glass and mirrors embedded in coloured cement, suffered years of neglect before being restored to its original resplendent condition.[13] ¶ In the South, apart from Howard Finster's Paradise Garden (see Chapter 8), another extraordinary environment is Pasaquan, built by Eddie Owens Martin (St EOM; 1908–86). Owens, known as St EOM, was a self-proclaimed mystic and fortune teller, who returned to his family home in Georgia after the death of his mother in the 1950s. He transformed the four-acre smallholding into a quasi-temple compound, with walls and buildings full of brightly painted imagery. The decoration combined certain features of the iconography and architecture of the East with Owens's own idiosyncratic vision. Dressed in resplendent robes complementing the dazzling surroundings, Owens served as the high priest of his one-man religion. In 1986 he decided to depart this life and did so with a single revolver shot to his temple. He bequeathed Pasaquan to the local Marion County Historical Society who, with help from the Jargon Society and the Columbus Museum, Georgia, are trying to maintain St EOM's unique creation.[14] ¶ In 1970 an eighteen-year-old hitchhiker, Roger Manley, took an offer

13. Other sites which have received or are receiving help from the Kohler Foundation include Nick Inglebert's Memorial Park, Ernest Hupeden's Painted Forest, the James Tellen Site, the Merikalski Stovewood Building and the Paul and Matilda Wegner Grotto. The J M Kohler Art Center in Sheboygan, Wisconsin, has held regular exhibitions of the work of self-taught artists since the early 1970s

14. See Tom Patterson, *St EOM in the Land of Pasaquan* (North Carolina, 1987)

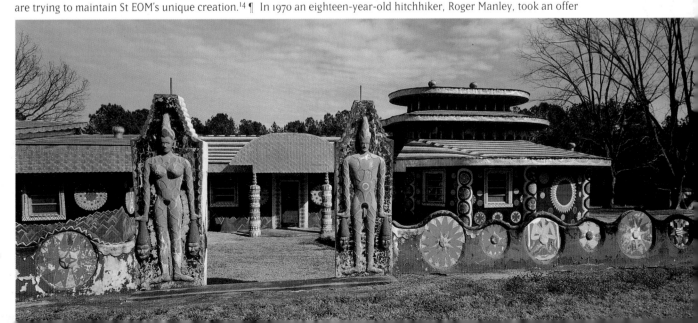

Eddie Owens Martin (St EOM)
Pasaquan, Buena Vista, near Cochrane, Georgia

of shelter from a storm. Stepping into a house on the Outer Banks of North Carolina, he found to his amazement that it was crammed with 5,000 small figures. The creator was 73-year-old Annie Hooper (1897–1986), who had constructed the vast array of rough sculpture from driftwood, putty, shells and cement. The figures formed some 300 tableaux representing such scenes from the Bible as the Sermon on the Mount, the Israelites Being Led to the Promised Land and Belshazzar's Feast. Only narrow paths through the sculptures allowed movement from one part of the house to another. ¶ The experience affected the course of Manley's life: he has become one of America's leading folklorists. He made many subsequent visits to the Hooper household and when Annie Hooper died he was given all her work to look after. He was helped in this daunting task by the Jargon Society, which originated from the publishing activities of the poet Jonathan Williams and has been involved in preserving and documenting sites in the southern states. The society financed a huge operation of classification, wrapping, transportation and storage, so that Annie Hooper's extraordinary creation could eventually find another home. In 1995 a six-month installation of her works opened at North Carolina State University in Raleigh, which is planning a permanent home for Hooper's creation when its new campus is opened. ¶ Roger Manley

Vollis Simpson
Giant whirligigs, Lucama, North Carolina

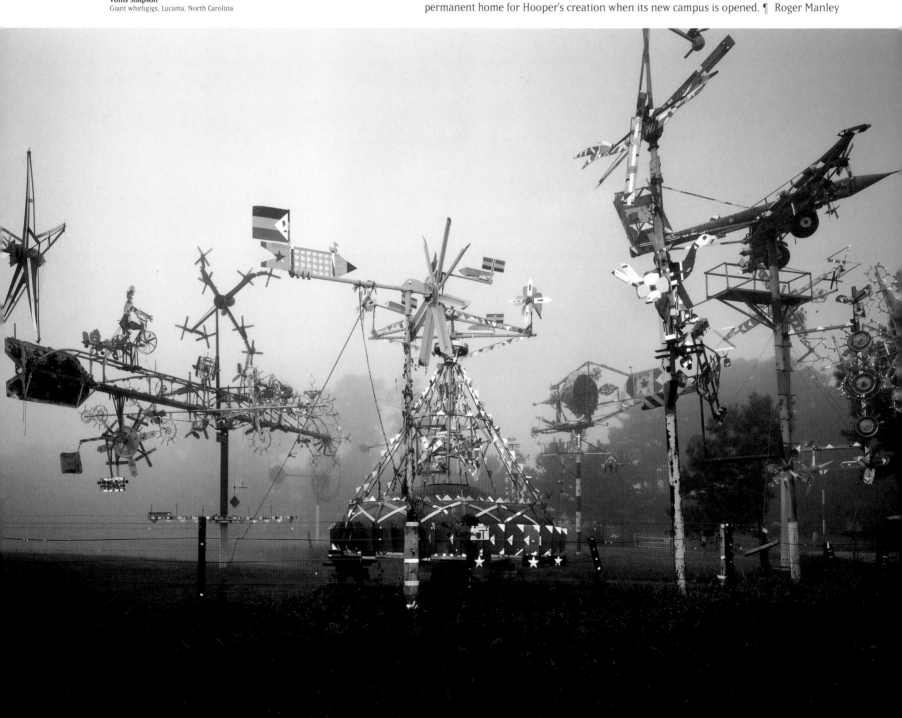

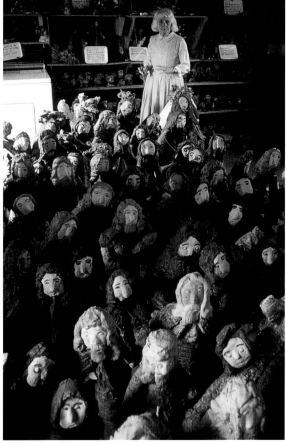

documented many of the folk art and Outsider creations in the area in the 1989 exhibition and catalogue *Signs and Wonders: Outsider Art Inside North Carolina*. Among the State's most stunning environmental creations are the giant wind-powered sculptures of Vollis Simpson (b.1919). On retiring from work involving manufacturing machinery to move houses, Simpson put his skills and his workshop to other purposes. He used wind energy to power his home heating system, but the massive whirligigs—some up to 10 metres (40 feet) in height—that he built to stand at a country cross-roads have no such practical function. Constructed from discarded vehicle parts and covered in car reflectors so that they shine out in the dark, the heavy machines are in constant movement and present an overpowering sight. ¶ Leonard Knight's (b.1931) Salvation Mountain at Niland, Imperial County, California, has been under threat from the local County government. Built of painted rocks and over 15,000 gallons of cast-off paint and other reclaimed materials, the man-made mountain has been judged a toxic health hazard. After protests by Knight and his many admirers, the authorities have, to date, refrained from demolishing and removing the colourful spectacle of brightly formed biblical messages. ¶ Some creations, despite conservation efforts and campaigns, have

Leonard Knight and the painted rocks of Salvation Mountain, near Slab City, Niland, California, 1995

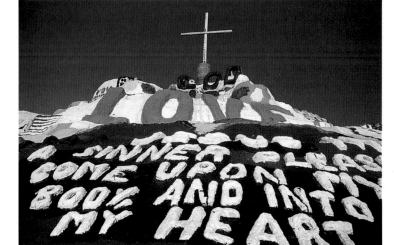

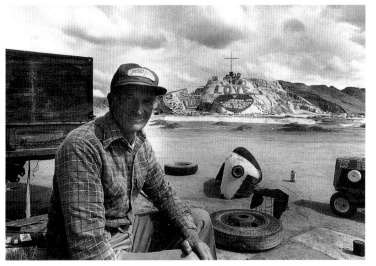

not survived. One example (and one of the worst cases of official vandalism) is Kea's Ark in Newark, New Jersey. Kea Tawana (b.c.1935) had lived on the edge, surviving in a harsh world by working on construction sites and living rough. She was a strong woman who was able to gather timbers for her work by demolishing abandoned buildings single-handedly and reclaiming what she needed. Plans for her Ark were first formulated in 1973 and in 1982 she began construction. ¶ Using skilled joinery techniques, she built up the huge framework of her 20 metre (80 foot) long, three-story vessel. Although it became a famous local landmark, its dominating presence angered city authorities and in 1986 Newark's Department of Engineering declared the Ark unsafe and ordered its demolition. In spite of lengthy court cases and a spirited campaign by many leading figures, Kea Tawana was ordered to move the Ark out of the city or face demolition. No alternative site could be found and eventually Tawana took a chainsaw to her creation and demolished the Ark herself.[15] ¶ She found herself further harassed by official threats to her

15. See Holly Metz, *Two Arks, A Palace, Some Robots and Mr Freedom's Fabulous Fifty Acres: Grassroots Art in Twelve New Jersey Communities* (exhibition catalogue, City Without Walls Gallery, Newark, New Jersey, and elsewhere, 1989)

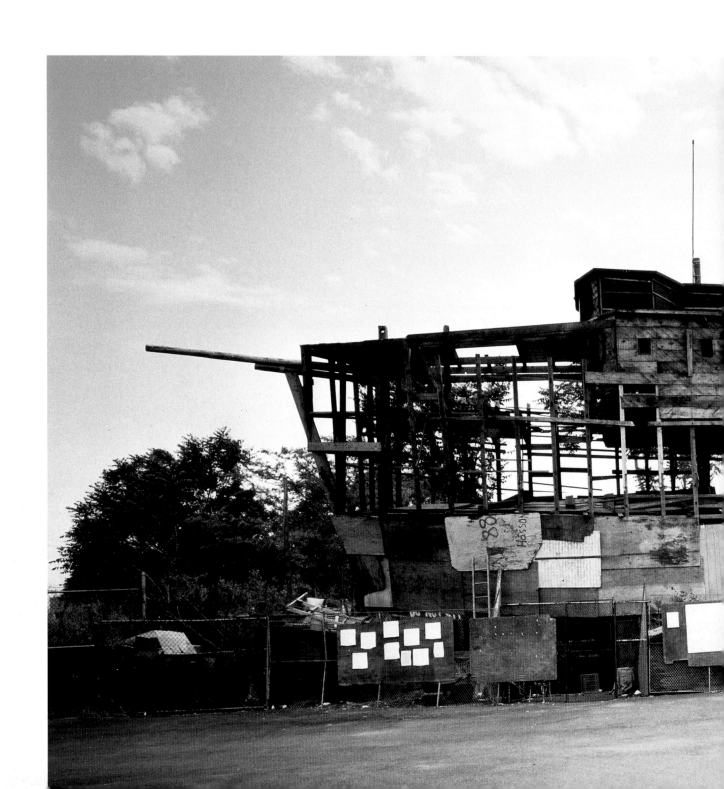

home, which was built over a large truck, but was ultimately given permission to tow it elsewhere. The tragic end of Kea's Ark, a shameful episode in America's folk art history, stands at odds with many successes in conserving such unique works.

Kea Tawana
Kea's Ark, Newark, New Jersey,
built from 1982, destroyed 1988

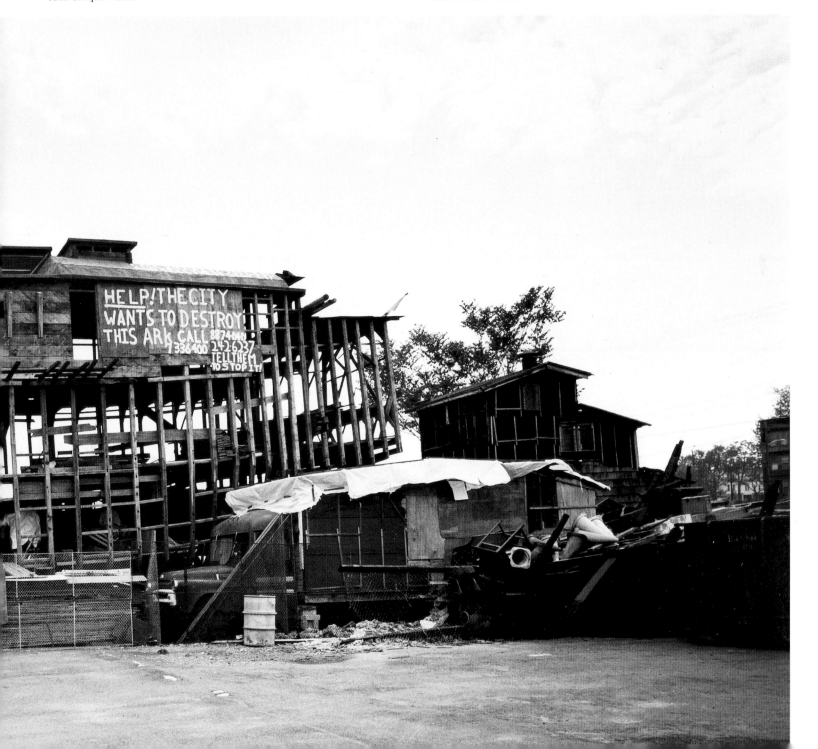

Chapter 14: INSPIRED SOPHISTICATES

Large-scale visionary

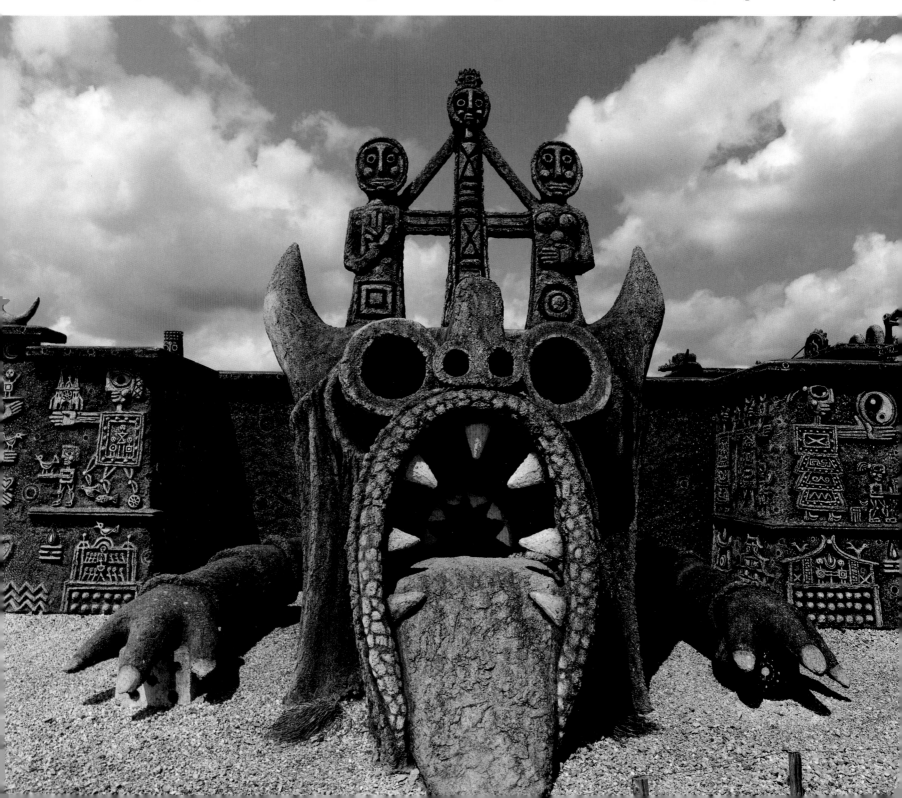

environments are not the sole domain of Outsider and self-taught artists. Trained artists and architects have at times transcended formal constraints and commercial interests to create a world of visionary splendour. Some have been inspired by the work of Outsiders. ¶ Although many visionary environments are essentially architectural, there have been few trained architects with the individuality and scale of vision of Antoni Gaudí (1852–1926), whose amazing creations include Güell Park in Barcelona, begun in 1920. Using cheap materials and broken ceramics Gaudí created a magical land of large creatures and organic forms, of walkways, grottoes and sinuous walls. The lush vegetation of the park today was all part of Gaudí's plan. A long winding bench follows the wall along the top section of the park; both bench and wall are covered in detailed Celtic designs, as are the undulating roofs of two houses. Beneath the upper terrace area the vaulting is flowing, the forms imitating nature. ¶ Gaudí began work on his most famous building, the

Antoni Gaudí
Above
Ceramic walkway at Güell Park, Barcelona, begun 1920
Left
Towers of the church of Sagrada Familia, Barcelona, begun 1883

Opposite
Robert Tatin
Open-mouthed dragon at La Frénouse, Laval, begun 1962

church of Sagrada Familia, in 1883. Dominated by its huge 90 metre (300 foot) towers, capped in bright ceramic, it is still a long way from completion. Progress was slow because of financial problems combined with Gaudí's intuitive approach (he changed his ideas as he went along, allowing them to develop naturally, rather than working to a prearranged plan). For the last few years of his life Gaudí lived on the building site and worked solely on the project. The Sagrada Familia's scale, its combination of stone and ceramic, of structural and sculptural elements, make it even in its unfinished state one of the world's most extraordinary buildings. In many ways such structures seem closer to those of Outsider visionary builders than to the work of contemporary architects. ¶ Another architect whose vision strayed from accepted lines was Juan O'Gorman (1905–82). In his professional life he was involved in many official building projects in Mexico. In the early 1950s he was co-architect of the Central Library of University City, Mexico City, where he masked the angular structure of the building with vast murals that cover all four sides. Executed in mosaic of natural coloured stone, they contrast with the building's conventional design. O'Gorman built a retirement home for himself near Mexico City, recently destroyed by a later owner. Here he was able to indulge his fertile imagination, adding irregular walls and roof to an existing cavernous grotto. Encrusted with mosaic and lava rocks, it was also embellished with Maya imagery similar to that used in his gigantic murals. A sign between the two large figures at the entrance read: I dedicate this house to Ferdinand Cheval, a forgotten genius.[1] ¶ Edward James (1907–84) also created a rather special building in Mexico. James was a wealthy Englishman from an aristocratic family who became an important patron of the Surrealists, especially of Dalí and Magritte. When World War II broke out he decamped to a mansion in Beverly Hills, California. Although he was still a patron of the avant-garde, he longed to be an artist or poet himself. ¶ On a trip to Mexico in 1945 he came across Xilitla, a remote and mountainous area, misty and mysterious, covered in thick jungle. He bought some 2,500 acres and set to work on a Surrealist-inspired palace in the jungle. The main building, with its arches and turrets, was surrounded by a series of bizarre and often unfinished structures, including temples, large round doors and steep staircases that led nowhere, huge concrete fountains and large plant-like structures. The house and its appendages were built by a large, well-paid team of builders and craftsmen, who received their instructions from James. In the afternoon he would promenade around his property completely naked, but with crutches for support; his three-inch-long toenails would not allow him to walk unaided. James loved the exotic vegetation and tropical animals, especially parrots and other brightly plumed birds. He even took a couple of cages along with him when he went travelling, letting the birds fly around in hotel rooms. ¶ He was fondly regarded by local inhabitants and

1. Anatole Jakowsky, *Dämonen und Wunder* (Cologne, 1963)

Antoni Gaudí
Church of the Sagrada Familia, Barcelona

Edward James
Right, far right and opposite top
Views of Xilitla, San Luis Potosi, Mexico

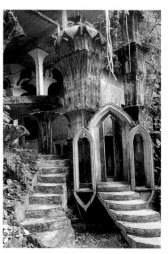

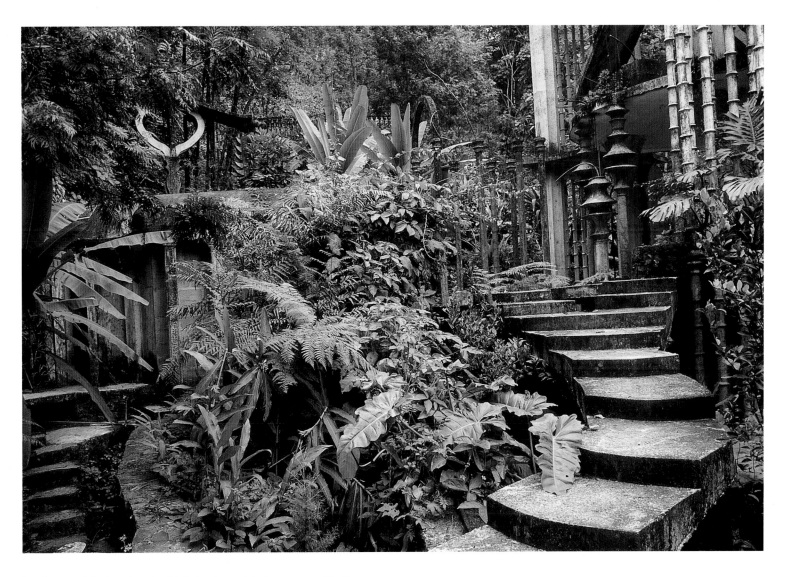

2. See Philip Purser, *Where is He Now?*
Extraordinary Worlds of Edward James (London,
1978) and John Carlin, 'King of a Jungle Paradise', *The
Independent*, 22 August 1987

faced none of the hostility that his behaviour might have aroused in Europe
or America. Although he was fully aware that his palace would never be
finished, he delighted in the confusion it would create for future archaeolo-
gists and enjoyed the surreal aspects of the situation. Since his death, the
vast deserted jungle mansion has begun its gradual decay into ancient ruins.[2]

¶ There has been much speculation on the extent to which Art Brut influenced
Jean Dubuffet's own work. Certain of his paintings appear to draw on the
works of Outsider artists and it seems likely that Dubuffet's large-scale sculp-
tural environments were inspired by visionary builders. Dubuffet made a
series of ever larger sculptures from the early 1960s. His Hourloupe series (he
invented this name for figures composed of coloured patches) was followed
by Hourloupe objects made from such materials as styrofoam and polyester.
After these came monumental sculptures in steel and polyester. One of his
first architectural environments, the Jardin d'Hiver (1968–70), was a room of
10×6 metres (some 33×20 feet) with rough stone-like white walls across which
flowed black lines. His free-standing Group of Four Trees, unveiled in New

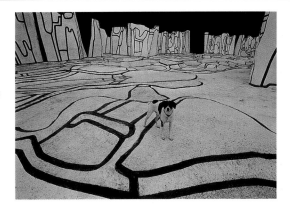

Jean Dubuffet
Inside La Closerie Falbala,
Périgny-sur-Yerres, Paris,
built between 1970 and 1972

York in 1972, was followed by the 20×30 metre (65×98 foot) Jardin d'Email, an outside environment with an 8 metre 'tree' at its centre. ¶ Dubuffet made several unsuccessful attempts to build large-scale environments. The Site Sculpture, a 58 metre (190 foot) square walk-in environment, was cancelled before it progressed beyond prototype stage. The Salon d'Eté (1974–5) was commissioned for the Renault headquarters in Paris, but a change of management resulted in this project too being cancelled, even though it was half-completed. Dubuffet lost the resulting lengthy court action, and large sections of the unfinished environment were simply thrown away. ¶ Meanwhile Dubuffet had embarked on an ambitious project on his own land at Périgny-sur-Yerres, just south of Paris. The Closerie Falbala, built over an area of 1,600 square metres (65,000 square feet) and surrounded by a wall up to 5 metres high, is reminiscent of expansive Art Brut environments. Once inside the visitor is in a world of bright white surfaces and sharp black lines—literally inside a Dubuffet painting. The whole building operation, costing over five million francs and involving architects and engineers, took over two years (1970–2), but once the hangar-like protection had been removed and the complex was open to the elements it suffered structural and surface problems, making further work necessary. In the centre stands the organic flowing form of the Villa Falbala, its stark black and white interior walls covered with intense murals.[3] ¶ Critics have seen in the work of Niki de Saint Phalle (b.1930) the

3. See *Catalogue des travaux de Jean Dubuffet*, fascicle no.31 (Paris, 1981)

Below
Jean Dubuffet
Villa Falbala, within La Closerie Falbala

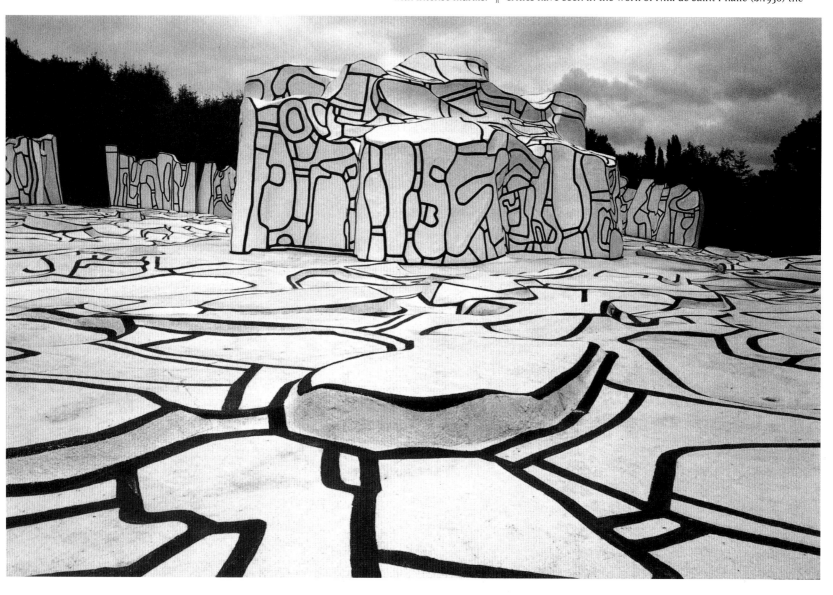

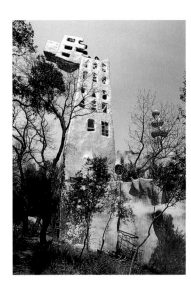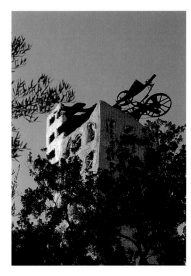

Niki de Saint Phalle
Views of the Falling Tower (tarot card XVI) in the Tarot Garden,
Capalbio, Tuscany, Italy, built from 1979 to 1995

influences of Picasso, Gaudí, Matisse, Dubuffet, Ferdinand Cheval and Art Brut in general. She established her reputation in the 1960s with large-scale sculptures of rotund women, known as the Nanas. A 24 metre (80 foot) prone figure, Hon ('She' in Swedish), was installed in 1966 at the Moderna Museet in Stockholm. Visitors could walk inside through the open legs, have a drink in the milk bar in one breast or watch a film in the other. ¶ Saint Phalle went on to make a permanent installation outside the museum, the Paradis Fantastique, in collaboration with Jean Tinguely (1925–91). It featured Saint Phalle's brightly painted rounded forms and Tinguely's kinetic sculptures. A series of outdoor installations followed including another joint creation with Tinguely, the bizarre La Tête in the Forest of Fontainebleau, near Paris. This led Saint Phalle to her most ambitious project, the Tarot Garden. Built on land near Capalbio in Tuscany and in progress since 1979, it is based on the twenty-two images of the Major Arcana of the Tarot; the structural elements are designed by Tinguely. Saint Phalle has made the Tarot Garden her obsession. She has no commercial motivation; indeed, the project is financed by her more usual art activities. ¶ Some of the Tarot Arcana,

Alan Davie
Painted interior of the Magician (tarot card I),
the Tarot Garden, Capalbio, Tuscany, 1987

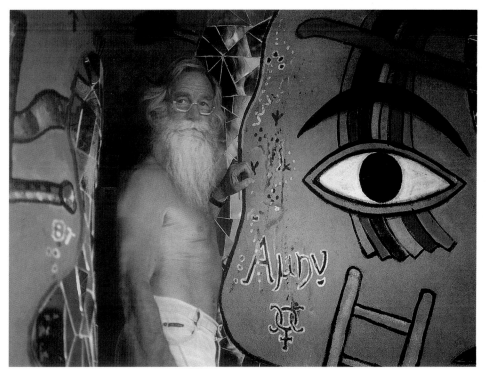

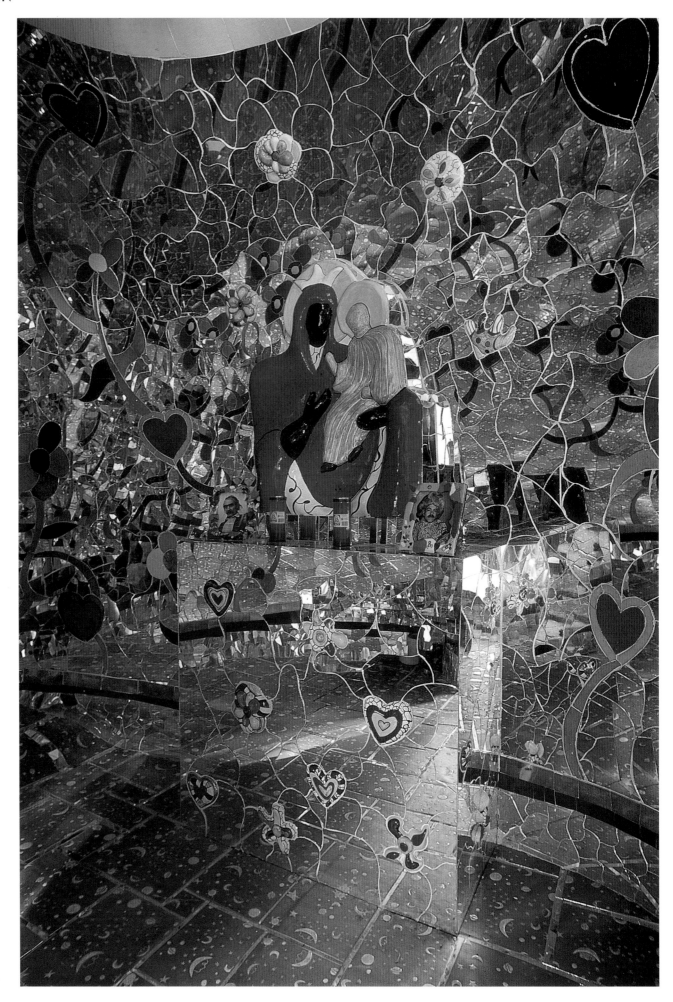

Niki de Saint Phalle
Interior of the Temperance Chapel (tarot card XIV),
Tarot Garden, Capalbio, Tuscany

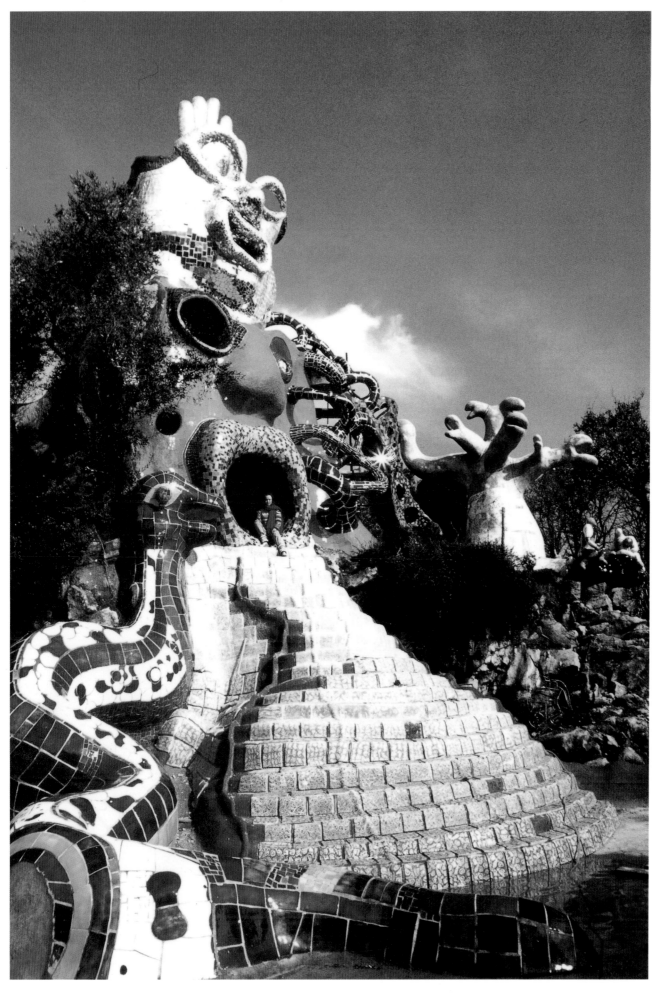

Niki de Saint Phalle
At the entrance of the High Priestess (tarot card II),
the Tarot Garden, Capalbio, Tuscany

such as the Sun, the Angel or the Pope, are represented by large walk-through sculptures, their surfaces covered in mirror or bright tile mosaic. Others are represented by unusual buildings: the large Falling Tower, with its irregular windows, is partly open at the top, with a sinister machine made by Tinguely pushing out. The deep blue of the exterior of the building representing the High Priestess is enhanced by rich mosaic of tile and mirror. The irregularly shaped interior of the gigantic sculptural building representing the Magician has been painted by English artist Alan Davie (b.1920), who has long been fascinated with mystic and arcane imagery. The Sphinx-Empress, one of the larger structures, also serves as Saint Phalle's house and studio. Like many of the creators of visionary environments, Saint Phalle is making her structures to last, carefully calculating strength and durability. Most of her creative energy is channelled into her massive masterpiece. ¶ One of Austria's leading painters, Friedensreich Hundertwasser (b.1928), was commissioned in 1977 by the city of Vienna to design a municipal housing project. The result was the 31-apartment Hundertwasser Haus, built between 1983 and 1985. Using an organic approach, Hundertwasser designed the building to have no straight lines apart from doors and windows. The exterior patchwork of colours evokes childhood memories of gingerbread houses. The interior flooring is of rough brick and undulates like a woodland path. A massive roof garden, holding over 900 tons of earth, not only insulates but also sustains 530 trees and shrubs to create wooded terraces for the inhabitants.[4] ¶ After leaving art college, Swiss artist Bruno Weber returned to his family home to build a studio for himself. The grounds around it are now inhabited by representations of beasts decorated with bright mosaics, including two large 'snake bridges'. The house has been transformed by the addition of huge faces looming out from the roof and by rows of highly decorated balconies. Weber and his wife Marianne hope their garden environment, now called Weinrebe Park, will become a visionary theme park.[5] ¶ The

4. See Karl Heinz Koller, *Hundertwasser Haus* (Vienna, 1993)

5. See Marcus Schubert, *Outsider Art II: Visionary Environments* (Kyoto, 1991)

Bruno Weber
Weinrebenpark, Dietikon, Zürich

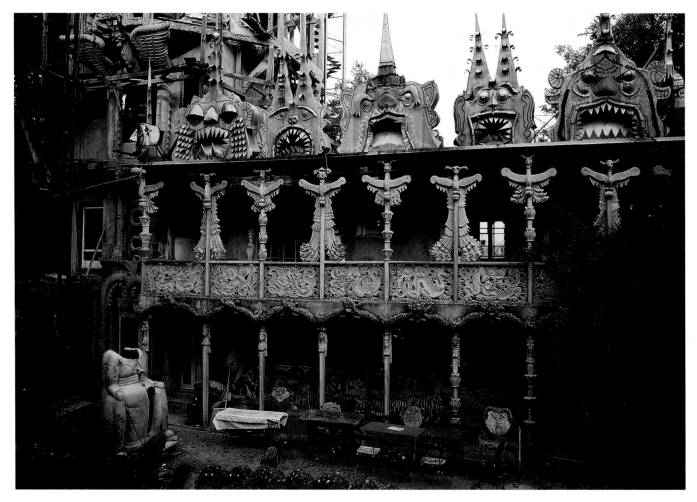

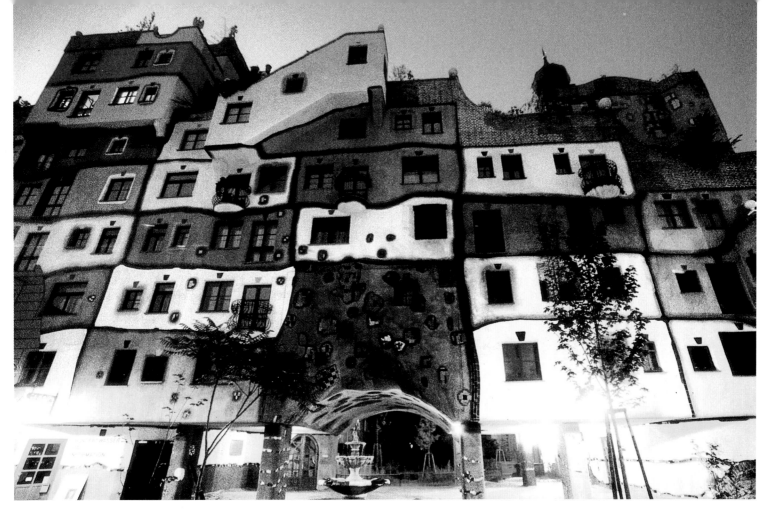

Friedensreich Hundertwasser
Hundertwasser Haus, Vienna, built between 1983 and 1985

Frenchman Robert Tatin (1902–83) first worked in a circus and was a house painter and carpenter. After serving in World War II, he bought a coal supply business in Paris and also set himself up as a ceramist. In 1950 he left for Brazil to continue with his work as a ceramic sculptor, winning the gold medal at the first International Biennial of São Paolo. He returned to France in 1956 to work as a full-time painter, holding regular exhibitions of his work. In 1962 he met his future wife Liseron and together they started to build La Frénouse in his home area of Laval. ¶ Made from concrete and sculpted cement, the large and complicated environment is entered via the Avenue of Giants, a series of larger-than-life sculptures of personal heroes. This leads to an open-mouthed dragon guarding the entrance to a temple-like courtyard. To the centre is Notre-Dame-Tout-le-Monde, a tall tapering structure embellished with mystical and personal symbols and crowned by the head of the Virgin. On the right of the courtyard is the Door of the Sun, where the two giants of Ying and Yang support the Wheel of Destiny turning between the horns of Imagination and Reason. On the left is the Door of the Moon, its highly ornamental façade dominated by the Muse of Unity with a boy and a girl on her knees, feeding at the source of creative vitality. The accumulative effect is of an ancient temple of a long lost religion. Tatin received the support of André Breton and was even visited by General de Gaulle in 1965. He is buried in a tomb near his house, which stands next to the environment. In the mid-1990s Liseron continued to live and work at La Frénouse. ¶ Roger Chomeaux (b.1907), known as Chomo, was an art school graduate. He had his first exhibition in Paris in the 1940s but was so disillusioned by the lack of interest that he turned his back on the art world. His wife inherited a few acres of land at Achères-la-Forêt near Fontainebleau, where he worked for many years as a virtual recluse. In time his work became known among enthusiasts of Art Brut. ¶ Chomo's Village de l'Art Préludien (Village of

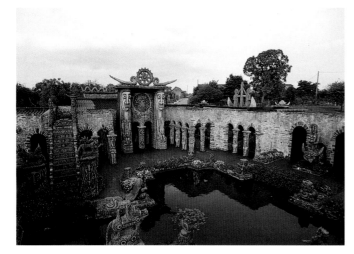

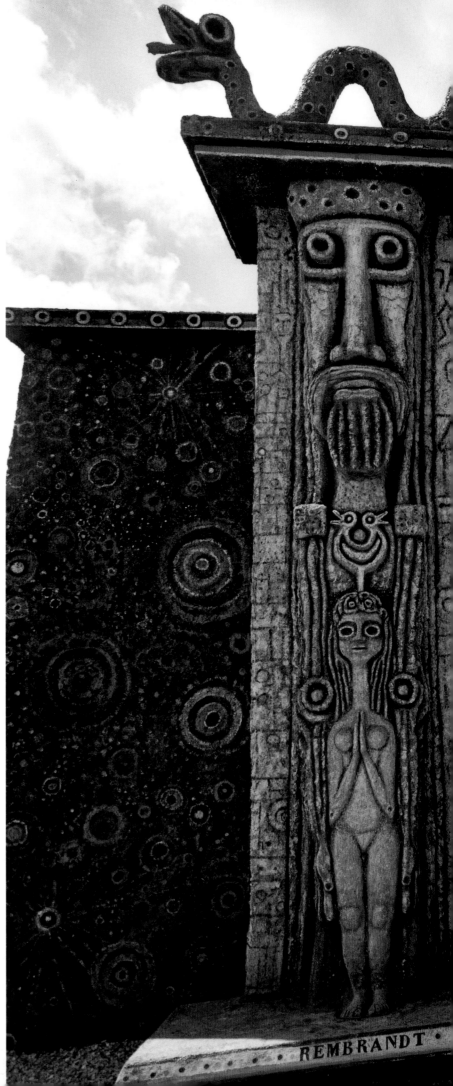

Robert Tatin
Environment at La Frénouse, Laval

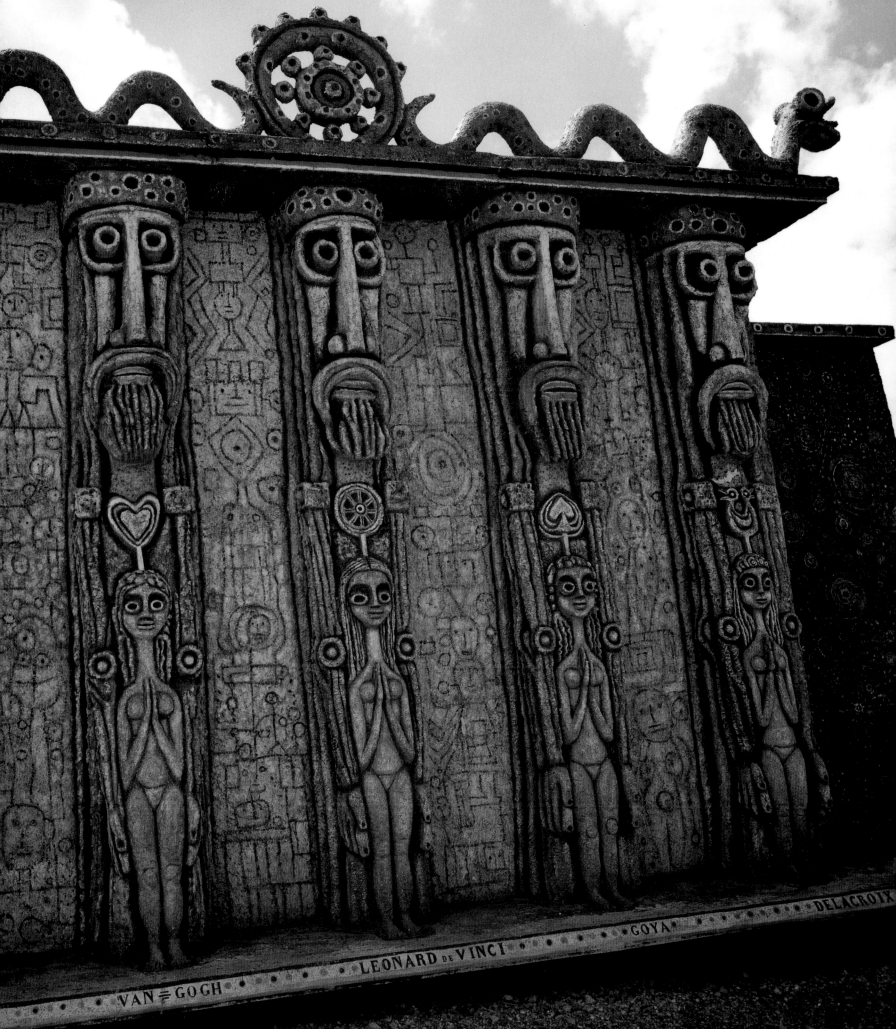

Prelude Art) is a collection of strange buildings surrounded by literally thousands of works—signs, sculptures and creations from reclaimed junk. The path from the nearby road leads through a small wood, where dolls and effigies look down from the trees. The main compound is surrounded by a stockade of twisted metal and cast-off objects. The buildings are crammed with work that Chomo has produced over the years. In an effort to modernize the French language, Chomo has transcribed the site's many signs and poems in a pure, phonetic version of French. His three buildings, Church of the Poor, Sanctuary of Scorched Wood and the Refuge are made from wood from the forest, plaster, discarded car parts, bottles and other found materials. The Corridor of Dreams is an underground twisting trench. ¶

6. See Laurent Danchin, 'Chomo: The Man Whose Death Approaches Speaks to You', *Raw Vision*, no. 2 (1989), pp. 44–51; and Roger Chomeaux and Laurent Danchin, *Chomo: Un pavé dans la vase intellectuelle* (Paris, 1978). The latter is an extensive verbatim record of Chomo's thoughts, philosophies and recollections

7. Chomo, as quoted in Laurent Danchin, 'Chomo: The Man Whose Death Approaches Speaks to You', p. 51

Chomo's work is in various styles. His series of alien-like figures carved from concrete blocks shows fairly sophisticated techniques. However, his archaic scorched wood sculptures display a rougher and more intuitive approach. Chomo has been the subject of a lengthy film, *Spiritual Disembarkation*, commissioned by him and made by photographer Clovis Prévost in weekly instalments over several years. Chomo's supporters included writer Laurent Danchin, who was instrumental in establishing the Fondation Chomo to protect and publicize his work. Danchin also helped Chomo to record his thoughts and recollections.[6] As prophet, poet, builder, painter and sculptor, Chomo occupies the margins of sophisticated and Outsider art. Visitors are often overwhelmed by the volume, inventiveness and individuality of the works and by the enthusiasm of their creator: What mark will you have left on this earth that will content your God?[7] ¶ The artists and architects described in this chapter

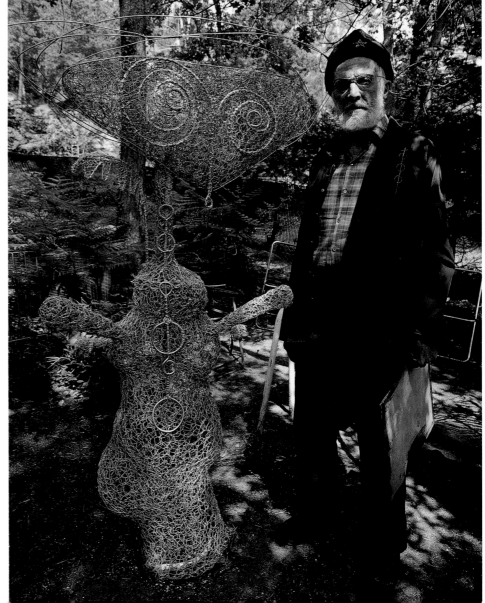

Roger Chomeaux (Chomo)
Above
Entrance to Village de l'Art Préludien, Achères-la-Forêt, Fontainebleau
Right
With one of his creations, 1987

illustrate the many links between the professional and the Outsider. Some such as Gaudí or Dubuffet begin with rough plans and hire teams of workers and advisors; others such as Weber or Tatin have worked largely alone in a more organic way. All have shown a visionary streak in attempting to realize their dreams or imaginative fantasies without concern for financial rewards or professional advancement.

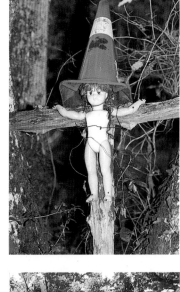
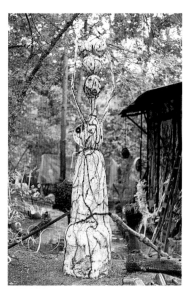

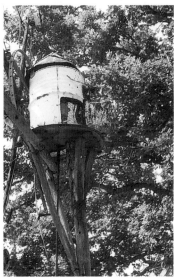
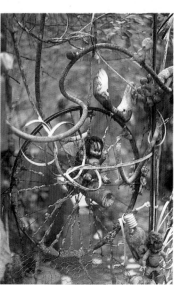

Roger Chomeaux (Chomo)
Signs, sculptures and creations from Village de l'Art Préludien,
Achères-la-Forêt, Fontainebleau

Chapter 15: WONDERS OF THE WORLD

Visionary environments are a world-wide phenomenon.

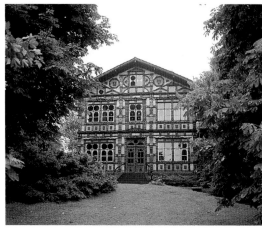

Karl Junker
Exterior and carved interior of his house at Lemgo, Hanover

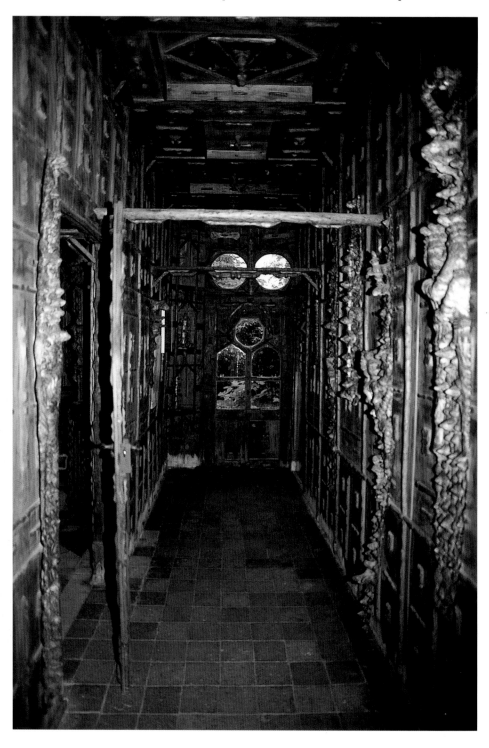

They range from the exotic eastern castles that Darwash Ali Salamah has built in his front garden in Jidda, Saudi Arabia, to the five-storey nude statue that Armando Garcia has created as his home in Tijuana, Mexico, or the elaborate Casa de Flor built by Gabriel dos Santos in Baixo Grande, Brazil. There are self-built visionary castles in Lebanon, Malta and Hungary; sculptural buildings in Israel; the carved stone garden (La Castello Incanto) of Filippo Bentevigna (1885–1967) in Sicily; the carved wooden Enchanted Garden of Bogosav Živković (b.1920) in Serbia; and the house of Karl Junker (1850–1912) in Lemgo, near Hanover, Germany, with intricately carved interior. In England the best known of a host of smaller scale environments are George Howard's Shell Garden in Dorset and the Concrete Menagerie of John Fairnington Sr and James Beveridge in Northumberland. The desire to create an environment of vision and personal meaning seems universal. ¶

This page
George Howard
Visitors, details and views of Shell Garden, Southbourne, Dorset, 1992

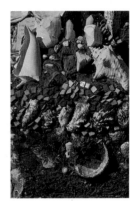

The best known of South Africa's visionary environments is Helen Martins's Owl House. Martins (1898–1976) lived most of her life in Nieu Bethesda, a small town in the Karoo area of Eastern Cape. She cared for her elderly mother, and on her death Martins gradually found a way to express her own individuality. She replaced some of the walls of the family home with large windows, many of coloured glass. Walls and ceilings were covered with coloured ground glass mixed into a binder. Mirrors positioned to reflect the sun, the moon and stars, and hundreds of candles and paraffin lamps, combined to make the interior shimmer with light. It has been conjectured that Martins struggled against the powers of darkness, that she literally needed to bring light into her life to combat the gloom and unhappiness within her.[1] ¶ In the

1. Studies of the Owl House by Susan Imrie Ross include The Owl House. *Raw Vision*, no. 5 (1991–2), pp.26–31, and 'Raw Vision—The Inner Image: Helen Martins and the Owl House', *Mantis*, vol. 4, no. 2 (Summer 1992), pp.6–31. See also A. Emslie, *The Owl House* (Harmondsworth, 1991)

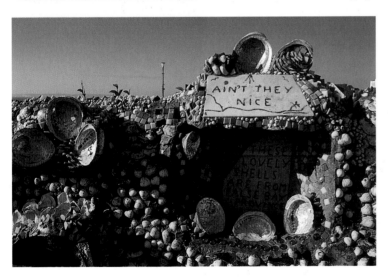

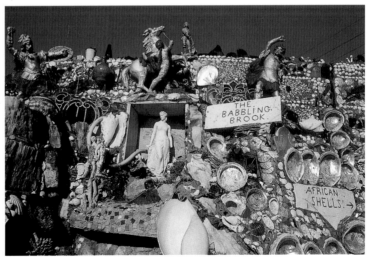

grounds outside she placed over 300 statues, towers and steeples constructed
of cement and glass over wire frameworks. Sixty-five cement owls gave rise to
the name the Owl House. A procession of camels faced the 'East' accompanied
by wise men, with arms outstretched to the sky. A sign declared This is my world. Helen Martins had the help of African labourers who

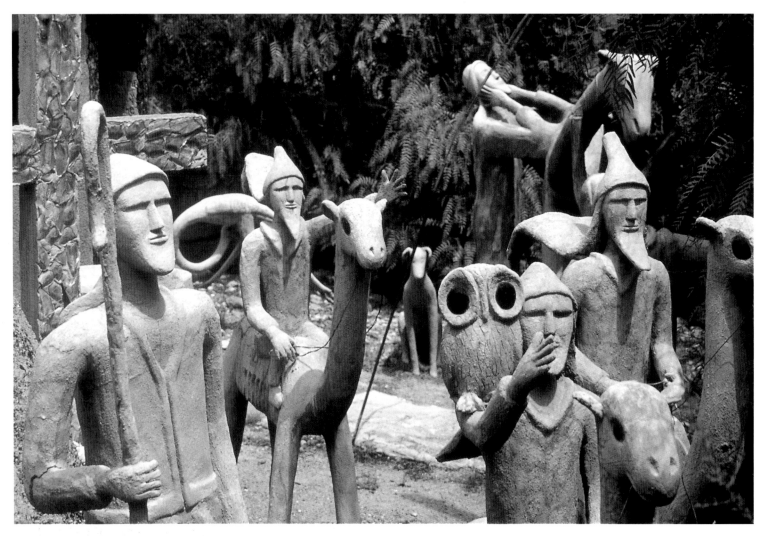

Helen Martins
Statues from Owl House,
Karoo, Eastern Cape, South Africa

worked under her direction. The majority of the sculptures were made by one assistant, Koos Malgas. Only one figure, the *Little Devil*, was made almost entirely by her. This semi-human headless creature with one human foot and one cleft hoof, lay on the floor of her kitchen and kept Helen company. Martins was virtually ostracized by the community during her creative life. In her later years she became depressed; arthritis was making movement increasingly painful and her failing sight meant that she was losing her battle with darkness. At the age of seventy-eight she committed a painful suicide by drinking caustic soda. ¶ Playwright Athol Fugard heard about Martins when he moved to the same town. Although they never met, he saw her struggle for individuality against the conservatism and hostility of her social environment as analogous to the struggle against the blind cruelty of apartheid. His play *A Road to Mecca*, written after Martins's death, centred on this theme. The Owl House has been declared a National Monument and is now a museum. ¶ Another South African creator, Nukain Mabusa (c.1910–81), was a farm labourer at Revolver Creek, Eastern Transvaal. According to South African artist John Frederick Clarke, who has documented the site, Mabusa began his creative journey by decorating two wooden chairs and then his little shack with brightly painted patterns.[2] Soon he had painted the stones and boulders that lay on the hillside behind his hut. Stripes, dots and pictograms representing birds and animals softened the harsh landscape around him.

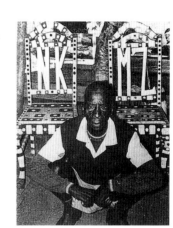

Nukain Mabusa

2. John Clarke, 'The Stone Garden of Nukain Mabusa', *Raw Vision*, no. 10 (1994–5), pp.50–4

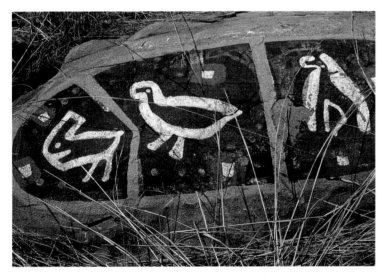

Nukain Mabusa
Painted stones and boulders at Revolver Creek, Eastern Transvaal, South Africa

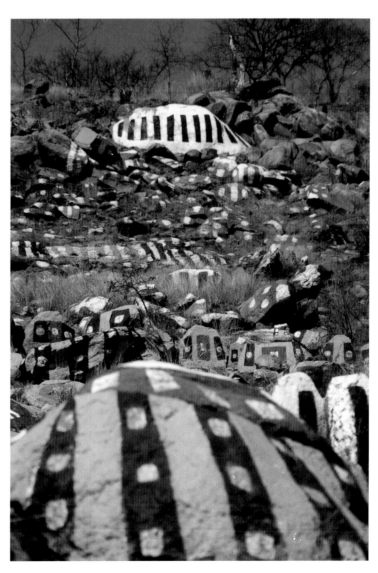

¶ In the mid-1970s Mabusa achieved a degree of local fame. A large donation of paint enabled him to give up his labouring job and work on his stone garden full time. However, his wish to be buried among his stones flew in the face of tradition and angered many of his neighbours. He abandoned the stones altogether in 1980, and within a year he had committed suicide. ¶

Like the Owl House, two much larger creations in Asia express the vision of a single creator while involving other workers. In northern Thailand Bunlua Surirat, a lay religious leader, has been constructing over the last twenty years a series of huge sculptures, helped by about a hundred volunteers and devotees who live and sleep at the site. In the 1960s and early 1970s Surirat worked in Laos, establishing a reputation among Buddhist communities. His largest construction was a 30 metre (100 foot) high world globe. When the communists took over Laos in 1975, Surirat abandoned his sculpture and moved across the border to Thailand. He and his followers bought 16 acres of land and began work again, duplicating some of the original sculptures and adding new ones. Many of Surirat's statues are constructed in cement over a wire and metal armature; larger ones have a solid brick interior over which a sculpted cement skin is formed. Surirat draws up the plans for each piece and usually takes a large part in the construction. ¶ His sculpture park, Sala Keoku, named in

Bunlua Surirat
Right
Sculptures in Sala Keoku
(Buddha Park), Nong Khai, Thailand
Below
General view of Sala Keoku
(Buddha Park)

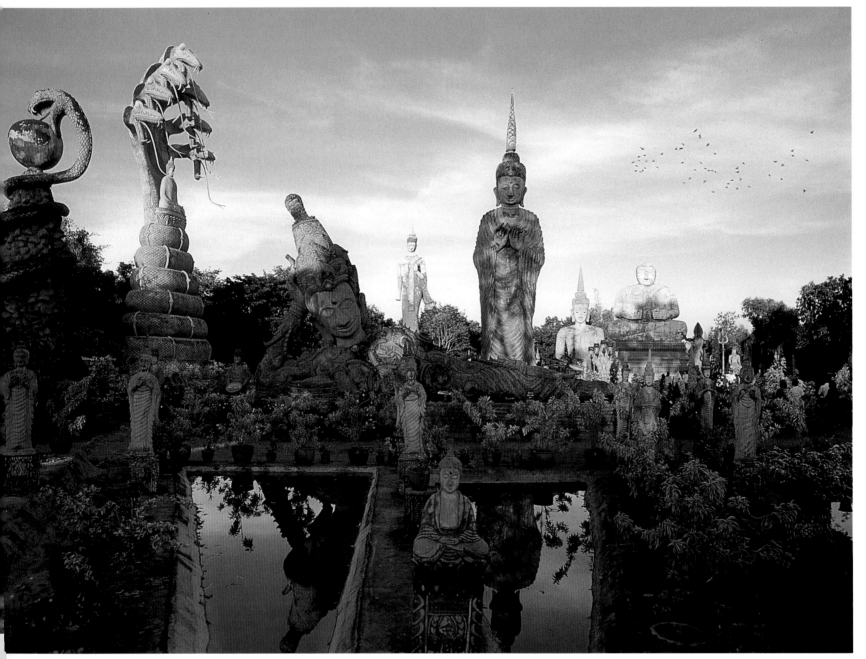

Nek Chand in 1993

3. See John Turner, 'The Buddha Parks', *Raw Vision*, no. 6 (1992), pp.48–51, and Roger Warner, 'The Teaching Gardens of Southern Asia', *The Smithsonian*, vol. 21, no. 12 (March 1991), pp.120–7.

honour of his spiritual master, Keoku, consists of huge figures of Hindu gods, massive Buddhas up to 23 metres (some 75 feet) in height, mythological creatures and sculptural depictions of sin and its punishment. This final theme is a popular one in Thailand and there are several examples of 'learning gardens' which graphically and gruesomely depict the cruel punishments awaiting sinners in the next life.[3] ¶ One of the most spectacular (and vast) visionary environments is that created by Nek Chand Saini (b.1924) in Chandigarh in northern India.[4] Nek Chand, like so many other Outsider artists, was fascinated with strangely shaped stones. These and urban waste—which he feels should be recycled just as nature recycles leaves to enrich the soil—are his main materials. Nek Chand left his home village in what is now Pakistan in 1948 at the time of Partition. He moved to Chandigarh in 1951 to work on the construction of the vast new city designed by Le Corbusier as a showpiece for modern India. (A mass of waste was created by the demolition of over twenty villages, and numerous other buildings, to clear the site of the new town.) In 1958, when Nek Chand was working as a Roads Inspector for the Chandigarh Public Works Department, he made a little clearing in the thick undergrowth outside the city and began to collect stones and waste materials, storing them in a small hut he had built. Following a dream which had revealed that this was once the heartland of a glorious dynasty, Nek Chand chose it as the site for his own kingdom. His job gave him access to his department's waste dumps, and after his working day he brought waste materials and stones back to his clearing on the back of his bicycle. By 1965 he was ready to begin his kingdom. ¶ Before long Nek Chand had set his stones around the small clearing and sculpted his first figures, made of cement with clothing represented by rows of broken bangles. Gradually sculptures and stones covered several acres. After his working day as a Roads Inspector and at night by the light of burning tyres, he worked in secrecy for fear of being discovered by the authorities. (The land was not his own, but a government area where no development or building of any kind was sanctioned.) Apart from his wife Kamla and a few trusted friends, nobody was aware of what Nek Chand was doing. When in 1972 a government working party began clearing the land, they came across acres of stones and statues. Almost two thousand sculptures of various sizes inhabited the undergrowth. Amazed by the discovery, local government officials were thrown into turmoil. Nek Chand's creation was completely illegal—a forbidden development which by rights should be demolished. Within a few days of its discovery, everyone in Chandigarh knew about the extraordinary creation in the forest. Hundreds flocked to see it and Nek Chand received the first public response to his work. ¶ Although many city officials were outraged, local

4. The author met Nek Chand in London in 1992 and Chandigarh in 1994. Information has also come from Professor S S Bhatti, Principal of the Chandigarh College of Architecture. Professor Bhatti has written a 600-page doctoral thesis on Nek Chand's Rock Garden, complete with maps, plans and historical information. Bhatti provides a brief summary of his work in 'The Rock Garden of Chandigarh', Nek Chand's Testament of Creativity', *Raw Vision*, no. 1 (1989), pp.22–31. S S Bhatti and Ulli Beier were the first to make serious studies of the Rock Garden. The first American article on the Rock Garden was Bennet Schiff's 'A Fantasy Garden by Nek Chand Flourishes in India', *The Smithsonian* (June 1972), pp.126–36. It contains some inaccurate biographical information. See also M S Aulakh, *The Rock Garden* (Ludhiana, 1986) and Philip Reeve, 'A Visit with the Master: The Creative Genius of Nek Chand', *Raw Vision*, no. 9 (1994), pp.34–42

216

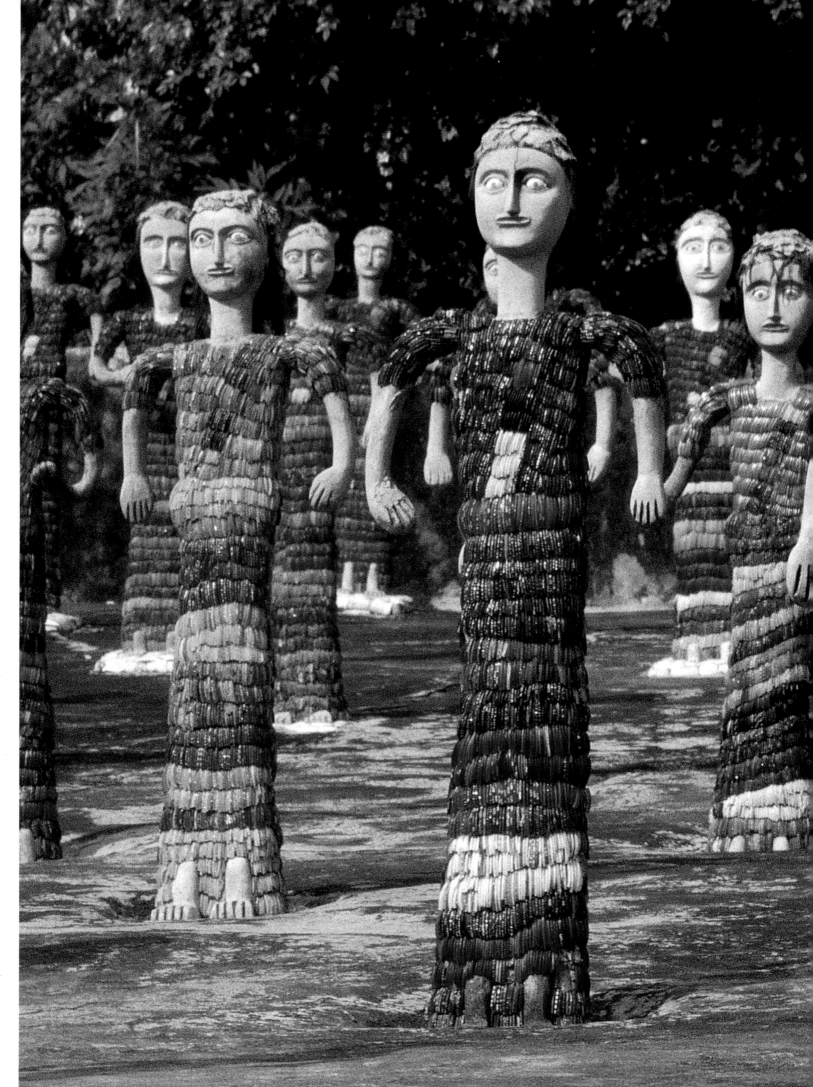

Nek Chand
Queens after
Bathing, the Rock
Garden,
Chandigarh, India,
built from 1965.
The figures are
clothed in broken
glass bangles and
human hair

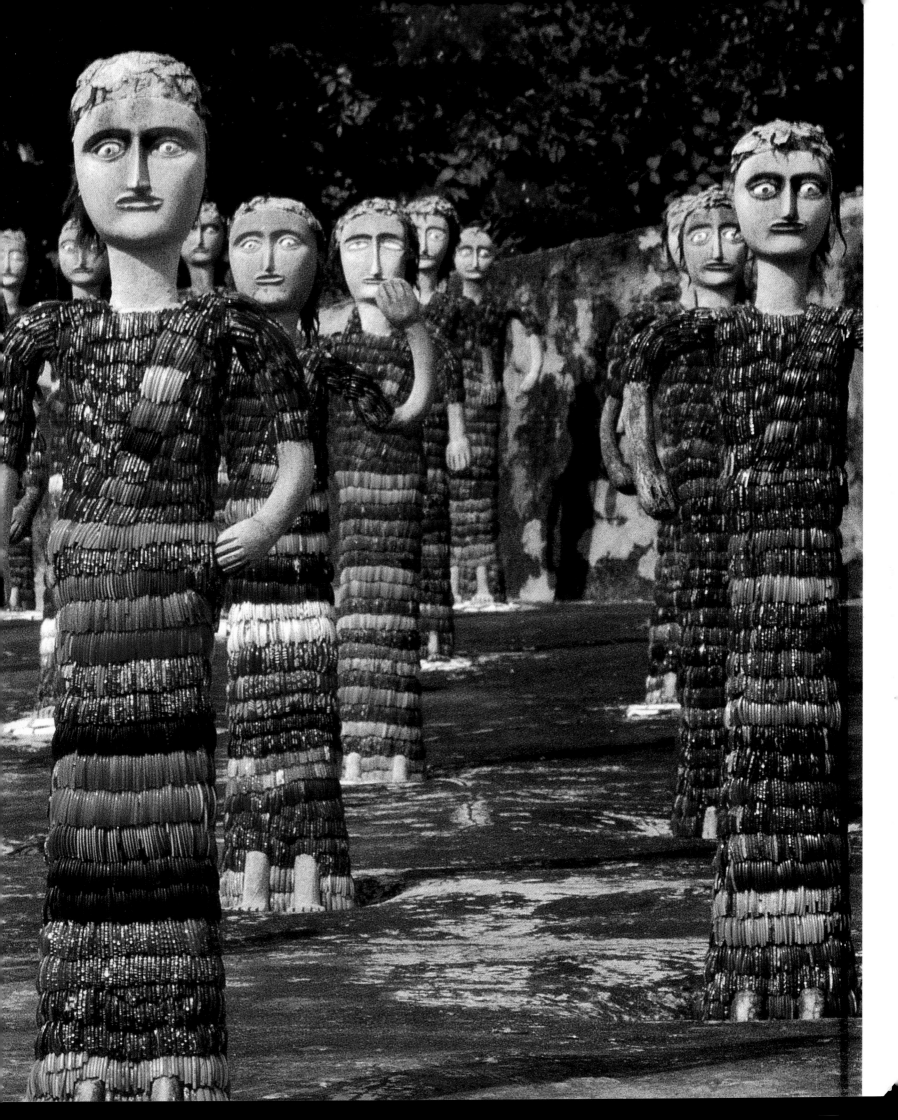

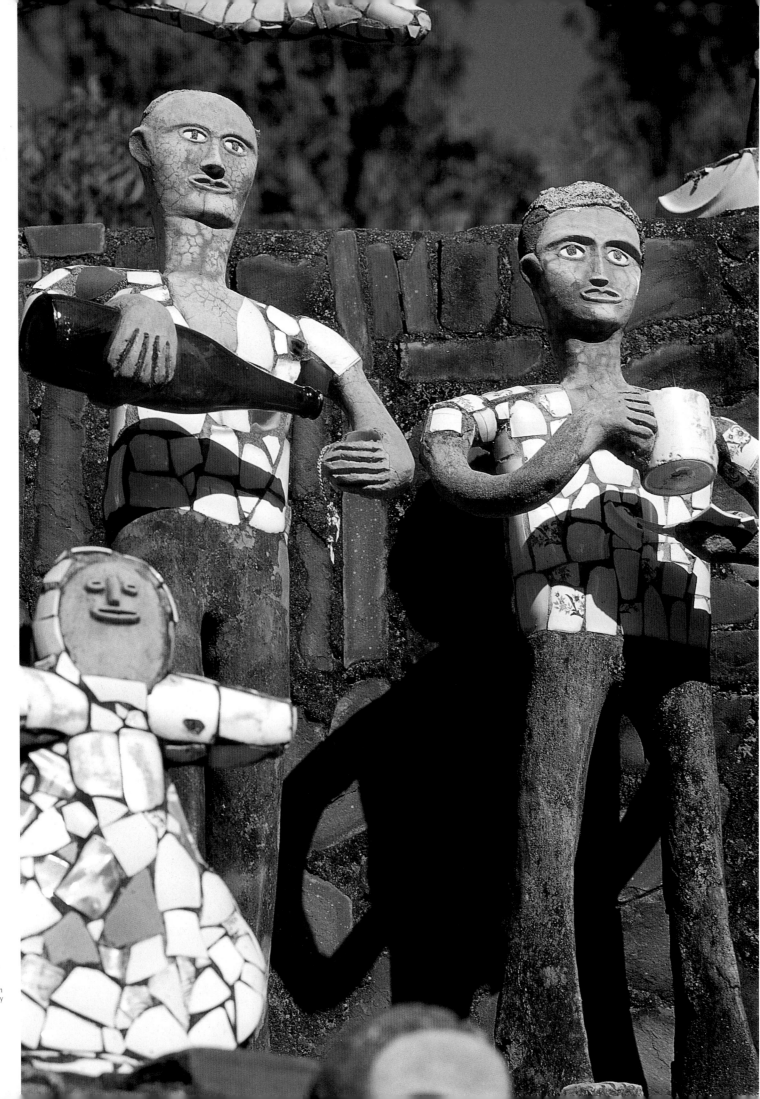

Nek Chand
Sculptures from
the Rock Garden,
Chandigarh
Right
Village revellers in
the Wedding Party
tableaux
Opposite
Female figure

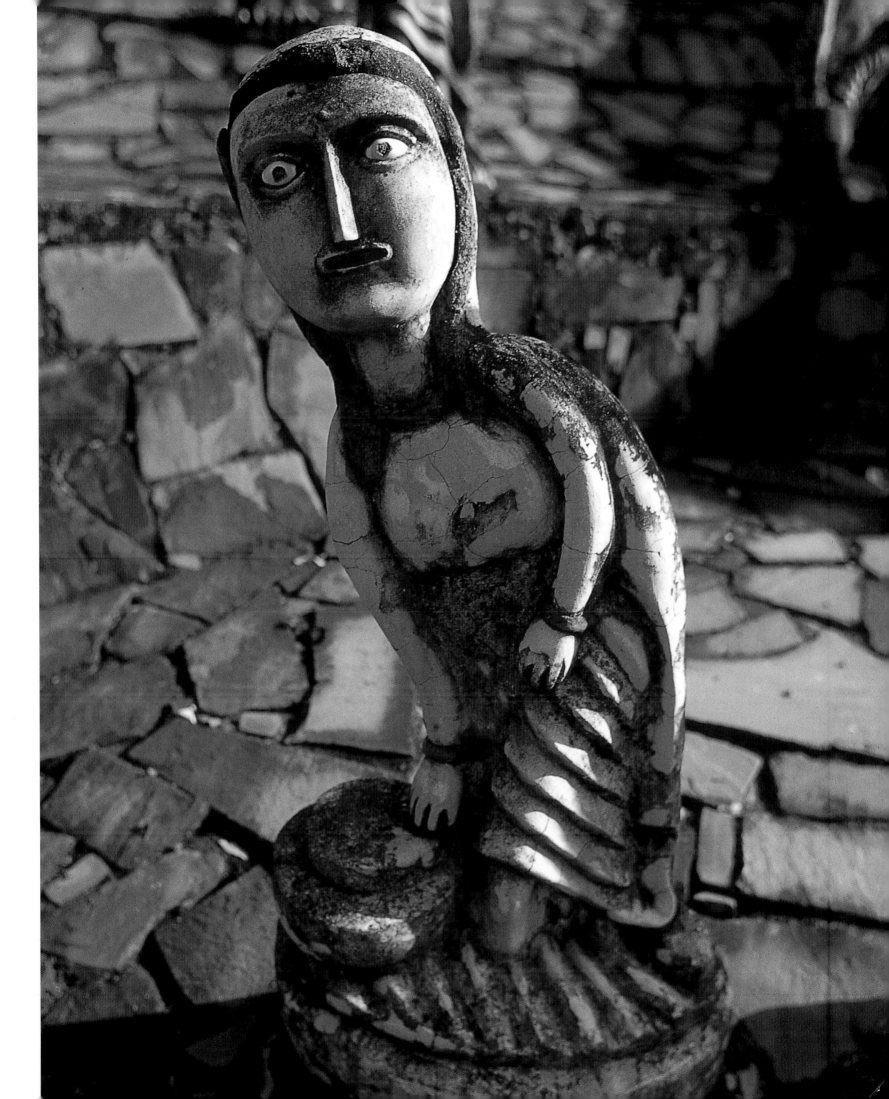

businessmen offered free materials and transport and with this extra assistance Nek Chand was able to embark on the First Phase of the environment proper. He formed a series of small courtyards to display his natural rocks and sculptures. As his creation developed, so did the support and interest of the citizens of Chandigarh. By 1976 the city authorities were forced by public opinion to relieve Nek Chand of his duties as Roads Inspector and give him a salary to continue with his environment on a full-time basis. Nek Chand's kingdom was officially inaugurated as the Rock Garden, to be administered by the city of Chandigarh. Fifty workers and a truck were provided for the project, and electricity and water were made available. He was now in a position to start work on the Second Phase, a series of large courtyards, many coated in a mosaic of natural stone or broken ceramic, linked by winding paths and low archways. He developed a complex and extensive waste collection system with many different collection points, one of the largest recycling programmes in Asia. ¶ The armatures for many of his sculptures were made from old bicycle parts; saddles became animal heads, forks became legs, frames became bodies. For his extensive mosaics he used discarded crockery, tiles and the broken ceramic ware of whole bathrooms. He built walls of oil drums, electric plug moulds and old fluorescent tubes. His figures are clothed not only in thousands of broken glass bangles, but also mosaic, foundry slag, even feathers. He also produces great quantities of human and animal figures out of old rags and discarded clothing. These giant rag dolls have an unusual rigidity and strength provided by strong metal armatures and interiors of hundreds of tightly bound rags. He has made vast sculptures based on the forms of the roots of upturned trees. ¶ Nek Chand's kingdom is set in a total area of 25 acres and the vast Third Phase, started in 1983, was due to be completed by the end of 1995. This new area, which is approached by a deep man-made gorge, is resplendent with great waterfalls and palace-like buildings. Huge pumping stations are at work circulating tons of water around the various waterfalls and fast flowing streams. A series of over fifty large swings hung from giant arches comes alive with the laughter of visitors as they swoop up and down. Figures over 4 metres (14 feet) high and great birds and beasts will eventually inhabit this new area. Lights will shine on the white mosaic domes of a high tower under construction, making them visible from as far away as the Himalayan foothills. Nek Chand says: Nowadays people are calling me 'artist'. I don't like this word 'artist', only God pushed me to do this work. I never knew people would see it, I just made it for my own pleasure.[5]

5. Nek Chand, as quoted in the film *Nek Chand* (1980), produced by Ulli Beier and Paul Cox

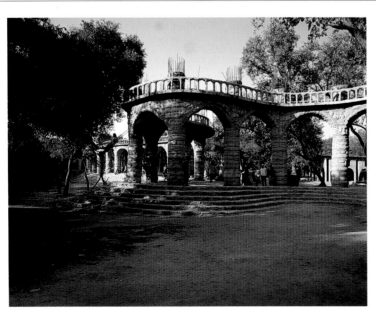

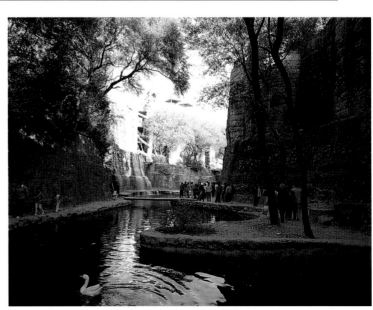

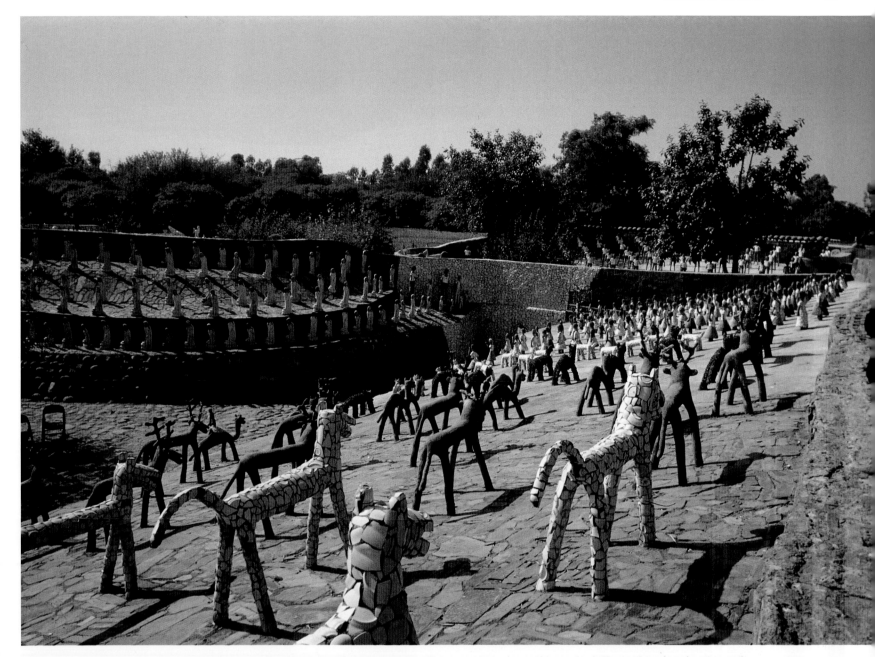

¶ The whole seems no less than an attempt at creating paradise on earth. Nek Chand admits that perhaps his mission is one ordained by God, and some in Chandigarh sincerely believe that he acts as the hand of God. ¶ In recent years Nek Chand's sculpture has become known internationally and has been represented in collections or exhibitions in Berlin, Paris, London, Madrid and Holland. He donated over one hundred sculptures to the Capital Children's Museum in Washington DC and spent six months installing them and running workshops. The Indian government honoured him with the title Padam Shri in 1984, a year after the Rock Garden was featured on an Indian postage stamp. ¶ At the same time he has faced difficulties. City officials held up the

Nek Chand
Opposite, top
Figure covered in foundry clinker (an early sculpture),
backed by a wall of reclaimed fluorescent tubes,
the Rock Garden, Chandigarh
Far left
A winding colonnade with swings,
part of the huge Third Phase,
the Rock Garden, Chandigarh
Left
One of the Rock Garden's large waterfalls
Above
The Animal Kingdom, from the Second Phase,
the Rock Garden, Chandigarh
Right
Indian postage stamp celebrating the Rock Garden

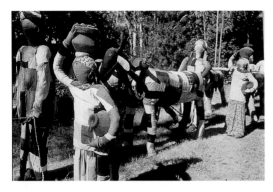

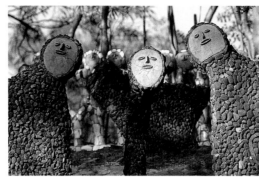

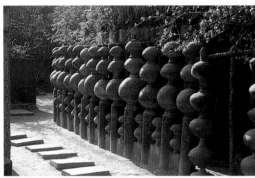

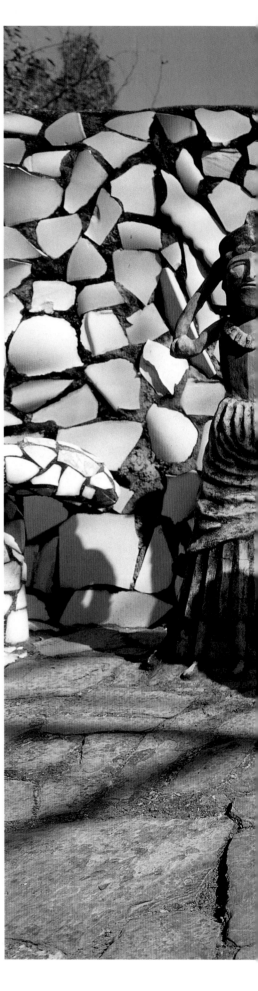

Nek Chand
Above, top left
'Rag doll' figures,
life-size sculptures of villagers and animals
Above, top right
Figures built around bicycle frame armatures,
from the Second Phase of the Rock Garden
Above
A wall of village pots,
from the First Phase of the Rock Garden
Below
Huge cement constructions based on tree and root forms
and a detail from a wall in the café area
Right
Queens, standing before a wall of giant ceramic fragments

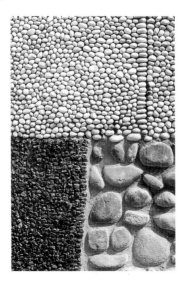

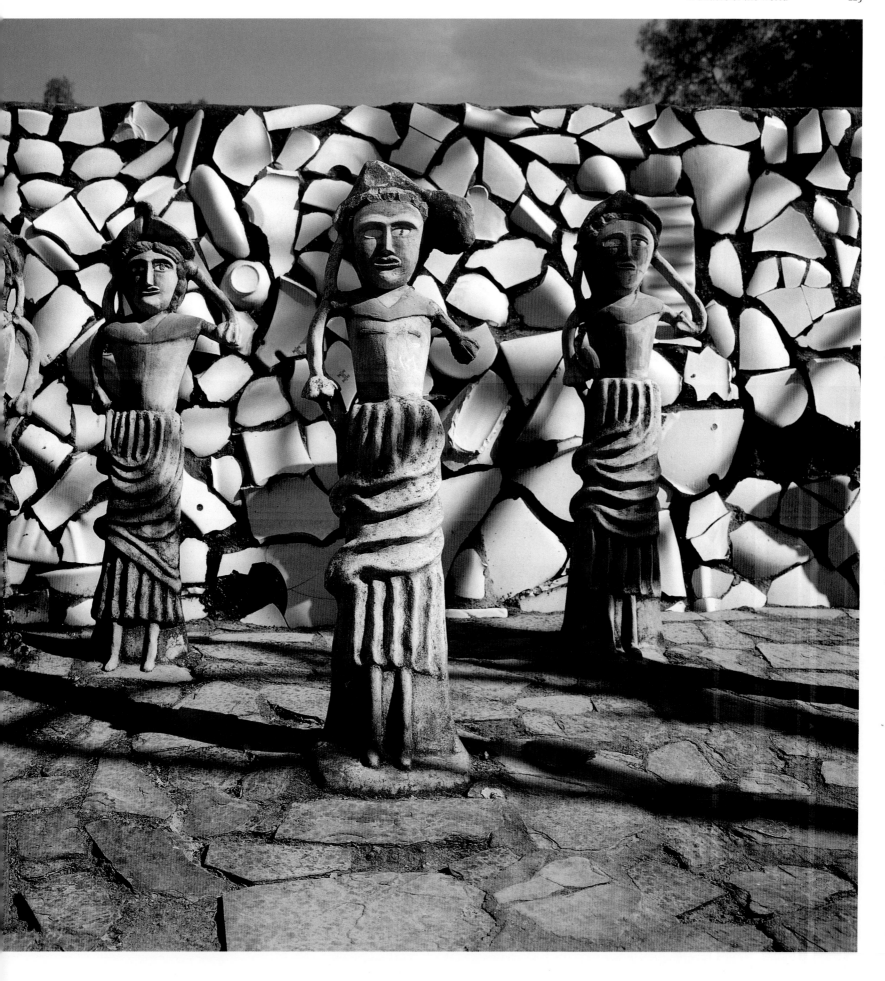

progress of the Third Phase for several years, attempting to run a road
through the Rock Garden and to use part of the area as an official car park.
Bulldozers were even sent to start demolition, only to be faced with a human
wall of local people, including children. In 1989 Nek Chand gave a powerful
address to the Chandigarh High Court at the final hearing of a lengthy court
action and judgement was eventually given in his favour. ¶ In his days as a Roads Inspector Nek Chand observed Le Corbusier's building
methods closely (although he never knew him personally), especially his
imaginative use of concrete. Le Corbusier's buildings in Chandigarh are char-
acterized by flowing curves of concrete, constructed with complex shuttering
to hold the liquid material. Nek Chand has developed Le Corbusier's tech-
niques in the Rock Garden by using a large array of shuttering arrange-
ments—from oil drums to sacking—to produced his own organic masses of
concrete with a variety of textural surfaces. Nek Chand knows Le Corbusier's
buildings inside out. He can explain the hidden vaulting on the roof of the
High Court or the construction of the Secretariat Building. It is extraordinary
that one of the greatest architects of the twentieth century should have had
such an influence on one of the greatest contemporary Outsider artists. ¶ From a genuinely

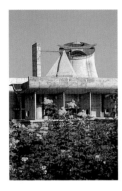

Le Corbusier
Assembly building, Chandigarh

Right
Nek Chand
The Second Phase of the Rock Garden under
construction, with the help of additional labour

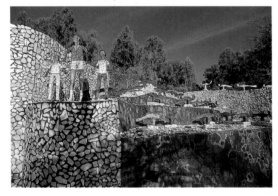

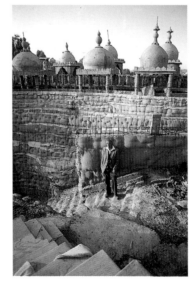

Nek Chand
Above
Animals and figures from the Second Phase
Right
Nek Chand during the construction of the Third Phase
Far right
Sculptural forms based on the human skeleton, the
Rock Garden

Nek Chand
Right
Massed villagers,
from the Second Phase of the Rock Garden
Below
Nek Chand photographed in 1993 with his tree
sculptures, which he constructed in sections in the
Rock Garden

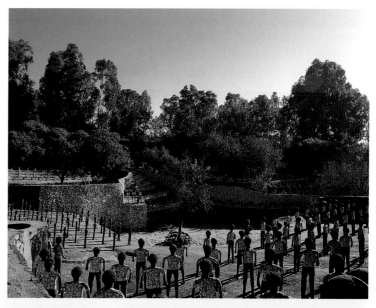

intuitive sculptor and a classic Outsider artist, Nek Chand has developed to
be a visionary architect working on a grand scale. Without using plans he has
been able to direct a work force in a huge building enterprise. Over 5,000 vis-
itors walk around his vast creation each day—in India only the Taj Mahal
sees more. Nek Chand remains a serene and saintly figure totally devoted to
his life's work. He sees the Rock Garden as his kingdom, peopled by kings,
queens, princesses, village people and animals, all of whom will inhabit this
paradise for many years to come. He is aware of the magnitude of his creative
achievement but accepts his work as the will of God, and offers it as a gift to
the world.

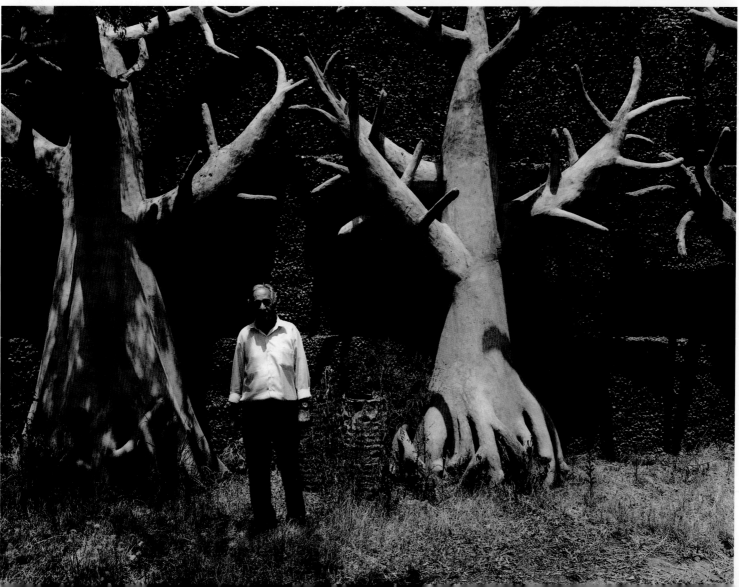

Postscript: OUTSIDER ART AND THE FUTURE

The story of Outsider Art is not only a tale of artists and their creations. It is an epic peopled by all those from a wide variety of backgrounds who have championed the creativity of the Outsider. Many have dedicated their professional lives to this cause; for some it has taken on religious overtones or become a glorious obsession that mirrors the obsessive energy of the artists themselves.

Making known the work of the unknown creates a dilemma, as Dubuffet himself realized. Once the art that has always been made privately moves into the public domain, the artist becomes vulnerable to commercial interests and other forces that affect his or her everyday life and creativity. In the US especially, artists have suffered by allowing their works to be purchased wholesale at low prices by dealers or collectors, leaving them with nothing when their talent has been recognized and prices escalate. A life's works has been sold for a song and environments have been plundered by the over-zealous. Some artists have responded to market demands by mass producing their works, enlisting the help of family members, and thus diluting the full power of their creativity. Some folk artists have found their art has become a job, a production-line routine.[1]

Outsider artists need protection. Often from backgrounds that leave them in financial need, they quite rightly welcome an opportunity to improve their lives, but dealers, galleries, collectors, museums and official bodies need to realize the importance of sympathetic approaches. There have been many in the field who have shown themselves to be aware of the vulnerability of self-taught creators and who have ensured that they are not exploited. Many have become supportive and positive influences in the lives of such artists; it is hoped that a sympathetic attitude will become the norm.

It has been argued that Art Brut is a phenomenon of the past, that the kind of creators that Dubuffet came across are no more, that today nobody can be unaffected by cultural influences.[2] Although society is changing and television, advertising, pop music, supermarkets, fast food outlets and the like have become standard features of the Western world, their effects on some individuals are superficial. Western society has shown that even in a crowded city, people can be as isolated, and the world can be as hostile and uncaring as ever. The strength of cultural exposure can become diluted, with only such things as junk mail or children's TV programmes filtering through, in much the same way as religion or royalty did in the past. This is particularly the case for people whose natural creative drive is all enveloping—so powerful that it sweeps aside all other forces. Works are still being produced out of compulsion, against all the odds. As Roger Cardinal wrote: Totally

alien, the new art (an art that has always been) proliferates quietly around the outskirts of the cultural city.[3]

¶ Billy Morey spent over two decades in English prisons before a

Billy Morey
Below, top
Outside his home, 1990
Below, bottom
View of his sculptural environment,
Borehamwood, Herts, UK

1. Roger Manley, 'Separating the Folk from their Art', *New Art Examiner* (September 1991), pp.25–8

2. Christain Delacampagne, *Outsiders* (Paris, 1989), and 'Beyond Art Brut', *Raw Vision*, no. 8 (1993), pp.16–23

3. Roger Cardinal, *Outsiders* (exhibition catalogue, Hayward Gallery, London, 1979)

vision reinforced his desire to create. He worked initially in a cell using his fingers or a brush made from his own hair to paint. His expressive urge has transformed him from inmate to artist. On release from prison his whole existence, his home and his life, have been overwhelmed by a heroic creative drive. Spurned by his neighbours and ignored by galleries, he is still unable to stop creating, reinforcing the importance of his own personality.[4]

On death row in a Mississippi jail an inmate draws on hidden scraps of paper. Not permitted colours, he presses hard with his pencil stub outlining the birds that could carry him to freedom and the horrors of execution that await him. Befriended by anti-death-penalty campaigner Sam Reese Sheppard, Howard Neal is mentally retarded, a convicted murderer claiming his innocence, whose only way of communicating his inner feelings is through his drawings. He has much in common with Dubuffet's *artistes bruts*.

In San Francisco the architectural fantasies of Achilles Rizzoli (1896–1981) were discovered in 1990, nearly a decade after his death. Proclaiming himself the 'architectural assistant to God', he designed huge architectural complexes in which buildings became the embodiment of privately revered personalities. A temple dedicated to Shirley Temple, called Shirley's Temple, and a cathedral in memory of his mother led on to further designs for heavenly edifices. These became manifestations of the alternative world of YTTE (Yield to Total Elation) that he built up around him.[5]

Human creativity is a basic urge, as Prinzhorn emphasized many years ago. In certain individuals it will inevitably surface and nothing can stop it. Yet there have been profound changes in both the perceptions and the actualities of non-academic art since Dubuffet first championed Art Brut. Following on from Dubuffet's reasoning, one might think of Art Brut as the white hot centre—the purest form of creativity. The next in a series of concentric circles would be Outsider Art, including Art Brut and extending beyond it. This circle would in turn overlap with that of folk art, which would then merge into self-taught art, ultimately diffusing into the realms of so-called professional art. All these concentric circles of creativity have similarities, but they also have essential differences and particular characteristics.

The term 'self-taught' refers not only to the isolated individuals of Art Brut and Outsider Art but to whole new generations of creators who are inspired to find their own way. Art is increasingly being used by new sections of society; it is becoming a more natural form of expression, common outside the confines of museums and galleries. The urban graffiti covering trains and subways in New York or London, the images painted on the Berlin Wall, the pictorial political messages painted on buildings by English anti-demolition protestors, the programmes encouraging the creativity of homeless people in New York[6] all point to a wider and more natural role for art, to art becoming a more universal form of expression.

The future will bring the Outsider and self-taught artist more and

Howard Neal
Below, top
Untitled (Electric chair), 1992
Pencil on paper
21·5×32cm
Private collection
Below, bottom
Untitled, 1992
Pencil on paper
22×28cm
Private collection

4. See John Maizels, 'Against All the Odds: Billy Morey', *Raw Vision*, no. 3 (1990). pp.30–3

5. See John MacGregor, 'A G Rizzoli: The Architecture of Hallucination', *Raw Vision*, no. 6 (1992), pp.52–5. See also *Ames News*, no. 3 (1992), p.3; *Ames News* is the publication of the Ames Gallery, San Francisco, whose director, Bonnie Grossman, discovered Rizzoli's work

6. The Art of the Homeless, a New York programme to encourage homeless people to express themselves, was initiated by Tina White in 1993. It has since been renamed Art on the Edge

more to the fore, with a number of new museums dedicated to these alternatives. The Stadshof in Zwolle in the Netherlands presents a range of changing exhibitions and envisages a growing permanent collection of Outsider Art and naïve art. London should see the opening of the Outsider Gallery and Archive. In Chicago, Intuit: The Center for Intuitive and Outsider Art, was founded in 1991. Under the presidency of publisher and collector Bob Roth, its goal is the establishment of a specialist museum in the city. In New York, too, a campaign for an Outsider Art museum, led by the influential collector Sam Farber, is gaining momentum. Meanwhile a revolutionary new museum, the American Visionary Art Museum, opened its doors in November 1995, the result of a five year fund-raising campaign. Museum president and founder Rebecca Hoffberger has secured over seven million dollars, mainly from individual donations in the state of Maryland, but including a large overseas donation from Anita Roddick. The museum, in the Baltimore harbour area, which sports a huge whirligig sculpture by Vollis Simpson, has been designated by the US Congress as the official national museum, repository and education centre for American visionary and Outsider Art. With folklorist Roger Manley acting as its initial exhibitions' curator, the museum plans a series of huge and broadly accessible thematic exhibitions; the first, centred around visionary creations in wood, also promoted a reverence for nature under the general theme of the Tree of Life. In 1989 *Raw Vision* magazine was founded in London to bring Outsider Art to a wide international public. With a global perspective it acts both as a clearing house for information and as a forum for discussion. A committed campaigner for the appreciation of Outsider Art, it presents the work of a wide selection of self-taught and visionary artists from around the world.

It is no coincidence that the growing stature and influence of Outsider Art has happened over a period when the esteem of professional contemporary art has been held increasingly in question. The great avant-garde movements have faded into history and many feel they are faced today in our museums and galleries with an art which has become increasingly obscure and inaccessible. It is no wonder that an art with immediate appeal and immediate responses, that needs little critical explanation to be fully appreciated, an art that has real meaning, that stems from the roots of genuine creativity, that is forever innovative and original and that truly reflects the individuality of its host of creators, cannot fail to touch an increasing and appreciative public.

Outsider Art has challenged perceptions of visual creation. The sequential version of art history encourages art students to absorb the expressions of their immediate predecessors and to build one step further—to see themselves in an art historical context. Outsider Art shows that rare and outstanding individuals can make their own compelling contributions to our visual awareness, even if their works bear no relation to anything that has gone before. Awareness of this true art can only grow in the years ahead.

The American Visionary Art Museum, Baltimore, with giant whirligig by Vollis Simpson

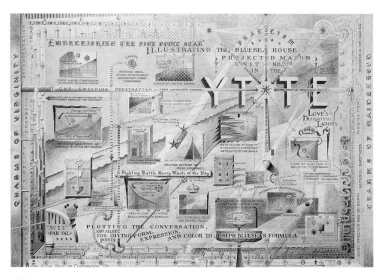

Achilles Rizzoli
Above
Blue Sea House/Charms of Virginity: P23
(Major unit of the YTTE), c.1940
Mixed media on paper
50·8×76·2cm
Courtesy Michael Grossman
Opposite
Shirley Jean Bersie Symbolically Sketched, S16
(Shirley's Temple), c.1939
Coloured ink on paper
96·5×61·0cm
Courtesy the Ames Gallery, Berkeley, California

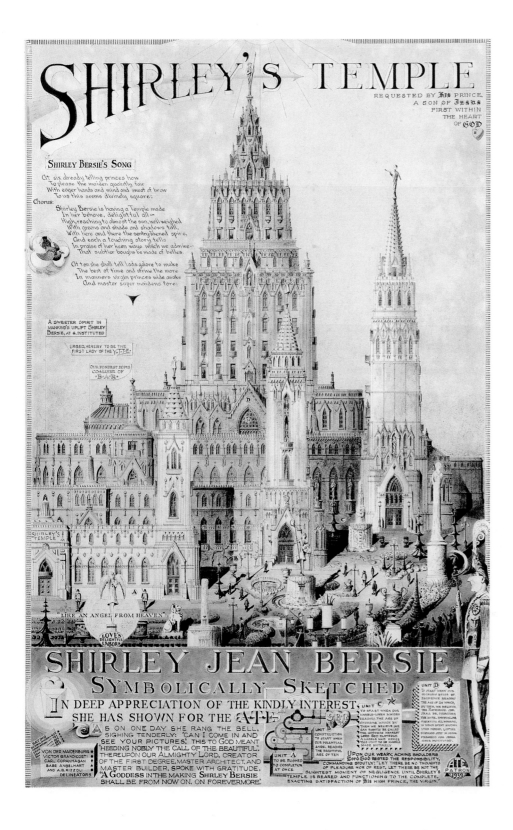

Appendices 1: Museums & collections

Australia

Arts Project Australia
116 High Street
Northcote
Victoria 3070
Patient and art therapy collection

Australian Collection of Outsider Art
PO Box R-217
Royal Exchange
Sydney
NSW 2006
Organizes exhibitions and documentation

Dax Collection of Patient Art
University of Melbourne
Melbourne
Psychiatric collection

Austria

Haus der Künstler
Niederösterreichisches
Landeskrankenhaus für Psychiatrie
und Neurologie
3400 Klosterneuburg-Gugging
nr Vienna
Artists' community within psychiatric hospital

Belgium

Art en Marge
59 Rue de Alexien
1000 Brussels
Regular exhibitions of Outsider Art and art therapy

Brazil

Museu de Imagens do Inconsciente
Rua Ramiro Magalhaes
521 Engenho de Dento
Rio de Janeiro
Large collection of patient art

France

L'Aracine Musée d'Art Brut
Château Guérin
39 Avenue de Gaulle
93330 Neuilly-sur-Marne
Principal French Art Brut collection; closed from March 1996, to reopen at a new location in 1998

Art Cru Museum
47120 Monteton par Duras
Marginal and self-taught art

La Fabuloserie-Bourbonnais
89120 Dicy
nr Joigny
Large private museum and sculpture park

Galerie Imago
Site de la Création Franche
58 Avenue du Maréchal de Laffre de Tassigny
33130 Bègles
Regular exhibitions of Art Singulier

Le Petit Musée du Bizarre
Lavilledieu
07170 Villeneuve-de-Berg
Ardèche
Outsider Art and rural self-taught art

Germany

Iwawela Haus
Münzgasse 9
Bayreuth
Exhibitions of contemporary Third World art

Museum Haus Cajeth
Haspelgasse 12
Heidelberg
Gallery of naïve and Outsider Art, mainly from central Europe

Prinzhorn Collection (Prinzhorn Sammlung)
Psychiatrische Klinik der Universität
Voss-Strasse 4
6900 Heidelberg
The original Prinzhorn Collection, soon to be housed in a public space next to the clinic

Great Britain

Guttmann-Maclay Collection/ Bethlem Archive
Royal Bethlem Hospital
Monks Orchard Road
Beckenham
Kent BR3 3BX
Collection of patient art

Horniman Museum
London Road
Forest Hill
London SE23 3PQ
Exhibitions and collection of contemporary folk and self-taught art of the Third World

Museum of Mankind
6 Burlington Gardens
London W1X 2EX
Permanent ethnographic collection; changing exhibitions include those of contemporary folk art

Outsider Collection and Archive
Opening as a public museum at Spitalfields Market, London E1
Information: 65 Brushfield Street, London E1 6AA

Holland

De Stadshof, Museum voor Naive en Outsider Kunst
Blijmarkt 18–20
Postbus 1508
8001 BM Zwolle
Outsider Art and naïve art

Italy

Cooperativa di Attivita Espressive 'La Tinaia'
Via San Salvi 12
50135 Florence
Hospital art centre

Lombroso Collection
Musi di Antropologia Criminale
Corso Galilei 22
Turin
Mainly prison art; some early
psychiatric examples

Switzerland

Adolf Wölfli Stiftung
Kunstmuseum Bern
Hodlerstrasse 12
3011 Bern
Holds nearly all Adolf Wölfli's
work, although only a small
amount is on public exhibition

Collection de l'Art Brut
Château de Beaulieu
11 Avenue des Bergières
1004 Lausanne
Dubuffet's original collection in a
purpose-built museum

Museum of Psychiatry
Psychiatric University Clinic
Bolligenstrasse 111
Ostermundigen
3027 Bern
Includes artifacts from the Old
Waldau Asylum and the
Morgenthaler Collection

Musée Cantonal des Beaux-Arts
Palais de Rumine
Place de la Riponne
1014 Lausanne
Holds works by Aloïse Corbaz and
Louis Soutter

Stiftung für Schweizerische Naive
Kunst und Art Brut
Museum im Lagerhaus
Vadianstrasse 57
9000 St Gallen
Outsider Art and naïve art from
Switzerland

USA

Abby Aldrich Rockefeller
Folk Art Center
307 South England Street
Williamsburg
Virginia 23187–1776
Antique and contemporary folk art

Akron Art Museum
70 East Market Street
Akron
Ohio 44308–2084
Growing section of folk art

American Visionary Art Museum
800 Key Highway, Inner Harbor
Baltimore
Maryland 21230
America's first museum
specializing in Outsider and
visionary art

Art Institute of Chicago
111 South Michigan Avenue
Chicago
Illinois 60603
Holdings of Outsider Art

Columbus Museum of Art
480 East Broad Street
Columbus
Ohio 43215–3886
Growing section of contemporary
folk art

Craft and Folk Art Museum
5814 Wilshire Blvd
Los Angeles
California 90036

Great Plains Museum of
Grassroots Art
213 Main Street
Lucas
Kansas 67648

High Museum of Art
1280 Peachtree Street NE
Atlanta
Georgia 30309
Contemporary folk art section

Hospital Audiences Inc
220 West 42nd Street
New York
New York 10036
Psychiatric and patient collection

John Michael Kohler Arts Center
608 New York Avenue
Sheboygan
Wisconsin 53082
Regular exhibitions of self-taught
and contemporary folk art

Milwaukee Art Museum
750 North Lincoln Memorial Drive
Milwaukee
Wisconsin 53202
Contemporary folk art section

Mingei Museum of International
Folk Art
4405 La Jolla Village Drive
San Diego
California 92122

Museum of American Folk Art
61 West 62nd Street
New York
New York 10019

Museum of Contemporary Art
237 East Ontario Street
Chicago
Illinois 60611
Holdings of Outsider Art

Museum of International Folk Art
706 Camino Lejo
Santa Fe
New Mexico 87501

Newark Museum
University Heights
Newark
New Jersey 07101–0540
Large contemporary folk art
section

New Orleans Museum of Art
1 Lelong Avenue
City Park
P O Box 19123
New Orleans
Louisiana 70124
Contemporary folk art section

Noyes Museum
Lily Lake Road
Oceanville
New Jersey 08231
Museum of regional folk art

St James Place Museum
Robersonville
North Carolina
Folk art museum

San Francisco Craft
and Folk Art Museum
Fort Mason Center
Building A
San Francisco
California 94123

Smithsonian Institution
National Museum of American Art
8th and G Streets
Washington DC
Contemporary folk art section

2: Organizations

Creahm
Parc d'Avroy
4000 Liège
Belgium
Centre for art therapy

Folk Art Society of America
Box 17041
Richmond
Virginia 23226
USA
Furthers awareness of folk art

Intuit: The Center for Intuitive and Outsider Art
1926 North Halstead Street
Chicago
Illinois 60614
USA
Organizes exhibitions, newsletter

Jargon Society
1000 5th Street
Winston-Salem
North Carolina 27101
USA
Conservation and publications

KGAA (Kansas Grassroots Art Association)
Box 221
Lawrence
Kansas 66044
USA
Preserves environments and other grassroots expressions

Kohler Foundation
104 Orchard Road
Kohler
Wisconsin 53044
USA
Programmes of purchase and active preservation of environments

Orange Show Foundation
2402 Munger Street
Houston
Texas 77023
USA
Manages the Orange Show environment and coordinates preservation efforts and Art Car parades

Sécretariat de la Fondation Jean Dubuffet
137 Rue de Sèvres
75006 Paris
France
Manages the Closerie Falbala, Périgny

SPACES (Saving and Preserving Arts and Cultural Environments)
1804 North Van Ness
Los Angeles
California 90028
USA
Preservation organization

3: Environments

Europe

Filippo Bentevigna
Il Castello Incanto
Sciacca
Sicily

Charles Billy
Le Jardin de Nous Deux
Chemin du Mazard
69380 Lozanne
nr Lyon
France

Fernand Chatelain
Le Jardin Humoristique
Fye
74490 Bourg-le-Roi
nr Alençon
France

Ferdinand Cheval
Le Palais Idéal
26390 Hauterives
Drôme
France

Roger Chomeaux (Chomo)
Village d'Art Préludien
Achères-la-Forêt
77116 Ury
nr Fontainebleau
France

Jean Dubuffet
Closerie Falbala
Périgny-sur-Yerres
nr Paris
France

John Fairnington Sr and James Beveridge
Concrete Menagerie
Braemar
Branxton
Cornhill-on-Tweed
Northumberland
England

Abbé Fouré
Les Rochers Sculptés
Rothéneuf
35400 Saint-Malo
Brittany
France

George E Howard
Shell Garden
Overcliffe Drive
Southbourne
Dorset
England

Freidensreich Hundertwasser
Hundertwasser Haus
Löwengasse/Kegelgasse
Vienna 3
Austria

Raymond Isidore
Maison Picassiette
Rue du Repos
Saint-Chéron
28000 Chartres
France

Danielle Jacqui
La Maison de Celle Qui Peint
11 Chemin de Rollaud
Port de l'Etoile en Provence
13360 Roquevaire
France

Karl Junker
Junkerhaus
Lemgo
Germany

Maurice Lellouche
Petit Musée
Champigny
Paris
France

Bodhan Litnianski
Le Jardin du Coquillage
15 Rue Jean Jaurés
Vitry-Noureuil
02300 Chauny
France

François Michaud
Le Village Sculpté
Masgot
Fransèches
23480 Saint-Sulpice-les-Champs
France

Raymond Morales
Parc Exposition Morales
Route de Fos
13110 Port-de-Bouc
Marseille
France

Billy Morey
Sculptural environment
Walshford Way
Borehamwood
Hertfordsire
England

Raymond Reynaud
Atelier-Musée Raymond Reynaud
Quartier de la Peyronnet
13560 Sénas
Provence
France

Niki Saint Phalle and Jean Tinguely
La Tête
Fontainebleau Forest
nr Paris
France

Tarot Garden
Garavicchio
Capalbio
Grossetto 58011
Italy

Robert Tatin
Musée Robert Tatin
La Frénouse
53230 Cossé-le-Vivien
nr Laval
France

Robert Vasseur
La Maison à Vaisselle Cassée
80 Rue du Bal-Champêtre
27400 Louviers
France

Bruno Weber
Weinrebenpark
Dietikon
nr Zürich
Switzerland

Bogosav Živković
Enchanted Garden
Leskovic
Stepojevac
Serbia

USA

J P Dinsmoor
Garden of Eden
2nd and Kansas Streets
Lucas
Kansas

Howard Finster
Paradise Garden
Penneville
Summerville
Georgia

Ed Galloway
Totem Pole Park
State Route 28A
Foyil
Oklahoma

Leonard Knight
Salvation Mountain
Imperial County
California

Eddie Owens Martin
Pasaquan
Buena Vista
nr Columbus
Georgia

Jeff McKissack
The Orange Show
2401 Mungar Street
Houston 77023
Texas

John Milkovisch
Beer Can House
222 Malone
Houston
Texas

Tressa 'Grandma' Prisbrey
Bottle Village
4595 Cochran Street
Simi Valley
California

Simon Rodia
Watts Towers
1765 East 107th Street
Los Angeles
California

Herman Rusch
Prairie Moon Museum and Garden
nr Cochrane
Wisconsin

Vollis Simpson
Giant whirligigs
off Route 301
nr Lucama 27851
North Carolina

Fred Smith
Concrete Park
State Highway 13
Phillips
Wisconsin

Cleveland Turner
Flowerman's House
Sampson at Francis
Third Ward
Houston
Texas

Fr Mathias Wernerus
*Grotto of the Blessed Virgin and
Holy Ghost Park*
305 West Main Street
Dickeyville 53808
Wisconsin

Elsewhere

Nek Chand
Rock Garden
Sector 1
Chandigarh
India

Edward James
Xilitla
San Luis Potosi
Mexico

Helen Martins
Owl House
Nieu Bethesda
Karoo
Eastern Cape
South Africa

Nukain Mabusa
Painted stones
Revolver Creek
nr Kruger National Park
South Africa
(now overgrown)

Bunlua Surirat
Sala Keoku (Buddha Park)
Nong Khai
Nong Khai Province
Thailand

Bibliography

Books

Edward Adamson, *Art as Healing* (London, 1984)

Claude Arz, *Guide de la France insolite* (Paris, 1990), revised as *La France insolite* (Paris, 1995)

Malkiat S Aulakh, *The Rock Garden* (Ludhiana, 1986)

John Beardsley, *Gardens of Revelation: Environments by Visionary Artists* (New York and London, 1995)

Oto Bihalji-Merin and Tomasević Nebojsa-Bato, *World Encyclopedia of Naive Art* (London, 1984)

Harrod Blank, *Wild Wheels* (Petaluma, California, 1993)

Jorgen Borg and Ingvar Cronhammar, *Gars du Nord* (Paris, 1988)

Peter Brears, *North Country Folk Art* (Edinburgh, 1989)

Guy Brett, *Through Our Own Eyes* (London, 1986)

Robert Brousse et al., *Masgot* (Limoges, 1993)

Roger Cardinal, *Outsider Art* (London and New York, 1972)

Catalogue des travaux de Jean Dubuffet: Habitats, Closerie Falbala, Salon d'été, fascicule XXXI (Paris, 1981)

Pierre Chazaud, *From the Facteur Cheval to Modern Art* (Toulaud, France, 1995)

Bernard Chérot et al., *Chichorro* (Roanne, 1994)

Chomo (Paris, 1991)

Emmanuel Cooper, *People's Art* (Edinburgh, 1994)

Joanne Cubbs, *Eugene von Bruenchenhein: Obsessive Visionary* (Sheboygan, Wisconsin, 1988)

Laurent Danchin, *Chomo* (Paris, 1978)

Laurent Danchin, *Jean Dubuffet* (Lyons, 1988)

Laurent Danchin, *Le Manège de Petit Pierre* (Dicy, 1995)

Francis David, *Guide de l'art insolite* (Paris, 1994)

Christian Delacampagne, *Outsiders: Fous, naïfs et voyants dans la peinture moderne* (Paris, 1989)

Jean Dubuffet, *Asphyxiante culture* (Paris, 1968; reprinted 1986), translated into English by Carol Volk in *Asphyxiating Culture and Other Writings* (New York, 1988)

Jean Dubuffet, *Prospectus et tous écrits suivants*, 2 vols (Paris, 1967)

Alain Foubert, *Forgerons du voudou* (Montpellier, 1990)

Henry Glassie, *The Spirit of Folk Art* (New York, 1995)

Veli Grano, *Onnela* (Lahti, 1989)

Candida Lycett Green and Andrew Lawson, *Brilliant Gardens* (London, 1989)

Michael D Hall and Eugene W Metcalf Jr, *The Artist Outsider: Creativity and the Boundaries of Culture* (Washington DC and London, 1994)

Gerd Hatje, *Adolf Wölfli* (Bern, 1987)

Herbert Hemphill Jr and Julia Weissman, *Twentieth Century American Folk Art and Artists* (New York, 1974)

Adrian Henri, *Environments and Happenings* (London, 1974)

Laennec Hurbon, *Voodoo: Truth and Fantasy* (London, 1995)

Adalsteinn Ingolfsson, *Naive and Fantastic Art in Iceland* (Reykjavik, 1989)

Ferenc Jadi, *Hans Prinzhorn* (Heidelberg, 1986)

Inge Jadi and Ferenc Jadi, *Muzika* (Heidelberg, 1989)

Inge Jadi and Ferenc Jadi, *Texte aus der Prinzhorn-Sammlung* (Heidelberg, 1985)

Anatole Jakovsky, *Dämonen und Wunder* (Cologne, 1963)

Barbara Jones, *Follies and Grottoes* (London, 1974)

Jean-Pierre Jouve, Claude Prévost and Clovis Prévost, *Le Palais Idéal du Facteur Cheval* (1st edition Paris, 1981; revised Hédouville, 1994)

Kathy Kemp and Keith Boyer, *Revelations* (Birmingham, Alabama, 1994)

Monika Kinley, *Outsider Art from the Outsider Archive, London* (Kyoto, 1989)

Doug Kirby, Ken Smith and Mike Wilkins, *The New Roadside America* (New York, 1986)

Karl Heinz Koller, *Hundertwasserhaus* (Vienna, 1990; reprinted 1993)

Lucinda Lambton, *An Album of Curious Houses* (London, 1988)

Jean-Louis Lanoux, *Chomo l'été Chomo l'hiver* (Paris, 1987)

Louanne LaRoche, *Sam Doyle* (Kyoto, 1989)

Orde Levinson, *The African Dream* (London, 1992)

A J Lewery, *Popular Art Past and Present* (Newton Abbot, 1991)

Cesare Lombroso, *Genio e follia* (Turin, 1882)

John MacGregor, *The Discovery of the Art of the Insane* (Princeton, 1989)

John MacGregor, *Dwight Mackintosh: The Boy Who Time Forgot* (Oakland, California, 1992)

Frank Maresca and Roger Ricco, *American Self-taught* (New York, 1993)

Frank Maresca and Roger Ricco, *Bill Traylor: His Art, His Life* (New York, 1991)

George Melly, *It's All Writ Out For You: The Life and Work of Scottie Wilson* (London, 1986)

Thomas M Messer and Fred Licht, *Jean Dubuffet and Art Brut* (Venice, 1986)

Anca Mihailsescu and Gérard Pestarque, *Sapinta: The Merry Cemetery* (France, 1991)

Deborah Mitchell with photographs by Daro Montag, *Facing the Sea/Face à la mer* (London, 1992) [the work of Abbé Fouré]

Walter Morgenthaler, *Ein Geisteskranker als Künstler* (Bern and Leipzig, 1921; expanded edition Bern and Vienna, 1985) translated into English by Aaron Esman as *Madness and Art: The Life and Works of Adolf Wölfli* (Lincoln, Nebraska, 1992)

Henry Muttoo with Karl 'Jerry' Craig, *My Markings: The Art of Gladwyn K Bush, Caymanian Visionary Intuitive* (Grand Cayman, 1994)

Leo Navratil, *August Walla: Sein Leben und seine Kunst* (Nordingen, 1988)

Leo Navratil, *Bilder nach Bildern* (Salzburg, 1993)

Leo Navratil, *Johann Hauser: Kunst aus Manie und Depression* (Munich, 1978)

Leo Navratil, *Schizophrenie und Kunst* (Munich, 1965; revised edition Frankfurt, 1996)

Annick Notter and Didier Deroeux, *Augustin Lesage 1876–1954* (Paris, 1988)

Jane Owen, *Eccentric Gardens* (London, 1990)

Tom Patterson, *Howard Finster: Stranger from Another World, Man of Visions Now on This Earth* (New York, 1989)

Tom Patterson, *St EOM in the Land of Pasaquan* (Winston-Salem, North Carolina, 1987)

Jacqueline Porret-Forel, *Aloïse et le théâtre de l'univers* (Geneva, 1993)

Claude Prévost and Clovis Prévost: *Les Bâtisseurs de l'imaginaire* (Jarville-la-Malgrange, 1990)

Hans Prinzhorn, *Bildnerei der Geisteskranken* (Berlin, 1922; reprinted 1968), translated into English by Eric von Brockdorff as *Artistry of the Mentally Ill: A Contribution to the Psychology of Configuration* (New York, 1972)

Henry Rasmusen and Art Grant, *Sculpture from Junk* (New York, 1967)

Marcel Réja, *L'Art chez les fous* (Paris, 1907; reprinted Nice, 1994)

Selden Rodman, *The Miracle of Haitian Art* (New York, 1974)

Selden Rodman, *Popular Artists of Brazil* (Old Greenwich, Connecticut, 1977)

Selden Rodman, *Where Art Is Joy* (New York, 1988)

Selden Rodman and Carole Cleaver, *Spirits of the Night: The Vaudun Gods of Haiti* (Dallas, 1992)

Seymour Rosen, *In Celebration of Ourselves* (San Francisco, 1979)

Chuck Rosenak and Jan Rosenak, *Museum of American Folk Art: Encyclopedia of Twentieth-century American Folk Art and Artists* (New York, 1990)

Anneli S Rufus and Kristan Lawson, *Europe Off the Wall* (New York, 1988)

Marcus Schubert, *Outsider Art II, Visionary Environments* (Kyoto, 1991)

Thierry Secretan, *Going into Darkness: Fantastic Coffins from Africa* (London, 1995)

Betty-Carol Sellen and Cynthia Johnson, *20th-century American Folk, Self-taught, and Outsider Art* (New York, 1993)

Milton Simpson and Jenifer Borum, *Folk Erotica* (New York, 1994)

Lisa Stone and Jim Zanzi, *Sacred Spaces and Other Places: A Guide to Grottos and Sculptural Environments in the Upper Midwest* (Chicago, 1993)

Lisa Stone and Jim Zanzi, *The Art of Fred Smith: The Wisconsin Concrete Park* (Phillips, Wisconsin, 1991)

Robert Tatin, *Étrange Musée-Robert Tatin* (Paris, 1977)

Michel Thévoz, *L'Art brut* (Geneva, 1975), translated into English as *Art Brut* (London and New York, 1976; reprinted 1995)

Robert Farris Thompson, *Flash of the Spirit* (New York, 1984)

Terry Tillman, *The Writings on the Wall: Peace at the Berlin Wall* (Santa Monica, 1990)

John Turner, *Howard Finster: Man of Visions* (New York, 1989)

Jan Wampler, *All Their Own: People and the Places They Build* (Oxford and London, 1977)

Allen S Weiss, *Shattered Forms* (Albany, 1992)

Sheldon Williams, *Voodoo and the Art of Haiti* (Nottingham, n.d.)

Sue Williamson, *Resistance Art in South Africa* (Cape Town, 1989)

Gavin Younge, *Art of the South African Townships* (London, 1988)

Exhibition catalogues and catalogues of permanent collections

Adolf Wölfli, Adolf Wölfli Foundation, Museum of Fine Arts, Bern, 1976

Africa Explores, Susan Vogel and others, Center for African Art, New York, 1991

Africa Now, Jean Pigozzi Collection, André Mignon and others, Groninger Museum, Groningen, Netherlands, 1991

Aftermath: France 1945–54, New Images of Man, Barbican Centre, London, 1982

Another Face of the Diamond: Pathways Through the Black Atlantic South, INTAR Latin American Gallery, New York, 1988

Another World: Wölfli, Aloïse, Müller, Third Eye Centre, Glasgow, 1978

L'Aracine: Musée d'Art brut, Neuilly-sur-Marne, 1988

Art brut en compagnie, la face cachée de l'art contemporain, Laurent Dachin, Halle Saint Pierre, Musé d'Art Naif Max Fourny, Paris, 1985

Art brut Europa, Galerie Susi Brunner, Zurich, 1994

L'Art brut préféré aux arts culturels, Galerie René Drouin, Paris, 1949

Artist–Lee Godie: A 20-Year Retrospective, Chicago Cultural Center, 1993

Aus Gugging, ACC-Galerie 'Goethe trifft Nina', Weimar, 1993

Baking in the Sun: Visionary Images from the South, University Art Museum, University of Southwestern Louisiana, Lafayette, 1987

Black Folk Art in America 1930–1980, Corcoran Gallery of Art, Washington DC, 1982

Black History/Black Vision: The Visionary Image in Texas, Lynne Adele, Archer M Huntington Art Gallery, University of Texas, Austin, Texas, 1989

Carlo: tempere, collages, sculpture 1957–19774, Museo di Castelvecchio, Verona, 1992

Catalogue de la Collection de l'Art brut, Paris, 1971

Chichorro oder Art Brut, Museum Haus Cajeth, Heidelberg, 1987

Clarence Schmidt, William C Lipke and Gregg Blasdel, Robert Hull Fleming Museum, University of Vermont, Burlington, and elsewhere, 1975–6

Collection de l'Art brut, Lausanne, 1976)

Contemporary American Folk Art: The Balsley Collection, Patrick and Beatrice Haggerty Museum of Art, Marquette University, Milwaukee, 1992

documenta 5, Kunsthalle, Kassel, 1972

Dream Singers, Story Tellers: An African-American Presence, New Jersey State Museum and Fukui Fine Arts Museum, 1992

Driven to Create: The Anthony Petullo Collection of Self-Taught and Outsider Art, Milwaukee Art Museum, 1993

La Fabuloserie: Art hors-les-normes, Art brut, collection rassemblée par Alan Bourbonnais, introduction by Michel Ragon (Paris, 1993)

Gaston Chaissac: First London Exhibition, Fischer Fine Art, London, 1986

The Heart of Creation: The Art of Martín Ramírez, Goldie Paley Gallery, Moore College of Art, Philadelphia, 1985

De l'imaginaire au Petit Musée du Bizarre, Lavilledieu, 1993

In Another World: Outsider Art from Europe and America, South Bank Centre, London, 1987

The Jean Pigozzi Contemporary African Art Collection, Saatchi Gallery, London, 1993

Kentucky Spirit: The Naive Tradition, Owensboro Museum of Fine Art, Kentucky, 1991

Kunstler aus Gugging: Zur Art Brut der Gegenwart, University of Oldenburg, 1989

Lattier: Peintre et conteur, Association de carre d'art, Nîmes, 1986

Lost Magic Kingdoms: Eduardo Paolozzi, British Museum, London, 1985

Made in USA, Collection de l'Art brut, Lausanne, 1993

Magiciens de la terre, Jean-Hubert Martin et al., Centre George Pompidou, Musée National d'Art Moderne, Paris, 1989

Michael Nedjar, Galerie Susanne Zander, Cologne, 1994

Minnie Evans: Artist, Wellington B Gray Gallery, East Carolina University, Greenville, North Carolina, 1993

Naives and Visionaries, Walker Art Center, Minneapolis, 1974–5

Neuve Invention: Collection d'oeuvres apparentées à l'Art brut, Lausanne, 1988

Niki de Saint Phalle, Nassau County Museum of Fine Art, New York, 1988

Not By Luck: Self-taught Artists in the American South, Lynne Ingram Southern Folk Art, New Jersey, 1993

The Other Side of the Moon: The World of Adolf Wölfli, Elka Spoerri et al., Goldie Paley Gallery, Moore College of Art, Philadelphia, 1988

Outsiders: An Art Without Precedent or Tradition, Hayward Gallery, London, 1979

Outsiders: An Exhibition of Art Brut, Kunsthaus St Alban, Basel, 1988

Parallel Visions: Modern Artists and Outsider Art, Maurice Tuchman and Carol Eliel, Los Angeles County Museum of Art and elsewhere, 1992

Passionate Visions of the American South, Self-taught Artists from 1940 to the Present, Alice Rae Yelen, New Orleans Museum of Art, 1993

Periodicals and regular publications

Index

Page numbers in **bold** refer to illustrations

Photographic credits